ON THE SPIRIT
AND THE SELF

© 2019 by Chiron Publications. All rights reserved. No part of this publication may be reproduced, stored in a retrieval system, or transmitted, in any form by any means, electronic, mechanical, photocopying, recording, or otherwise, without the prior written permission of the publisher, Chiron Publications, PO Box 19690, Asheville, North Carolina 28815-1690.

www.ChironPublications.com

Interior and cover design by Cornelia G. Murariu
Printed primarily in the United States of America.

ISBN 978-1-63051-420-4 paperback
ISBN 978-1-63051-421-1 hardcover
ISBN 978-1-63051-422-8 electronic
ISBN 978-1-63051-672-7 limited edition paperback

Library of Congress Cataloging-in-Publication Data

Names: Swan, J. A., author.

Title: On the spirit and the self: the religious art of Marc Chagall / J.A. Swan.

Description: Asheville, North Carolina: Chiron Publications, 2017. | Based on the author's thesis (doctoral--University of Essex, 2013) issued under the title: On spirit and self: Chagall, Jung and Religion. | Includes bibliographical references.

Identifiers: LCCN 2017002771 (print) | LCCN 2017004629 (ebook) | ISBN 9781630514204 (pbk.) | ISBN 9781630514211 (hardcover) | ISBN 9781630514228 (E-book)

Subjects: LCSH: Chagall, Marc, 1887-1985--Criticism and interpretation. | Chagall, Marc, 1887-1985--Religion. | Bible--Illustrations.

Classification: LCC N6999.C46 S93 2017 (print) | LCC N6999.C46 (ebook) | DDC 709.2--dc23

LC record available at https://lccn.loc.gov/2017002771

ON THE SPIRIT AND THE SELF

THE RELIGIOUS ART OF MARC CHAGALL

J. A. SWAN

TABLE OF CONTENTS

Introduction	11
Chapter One: Chagall, Judaism, and Religion	27
Chapter Two: Transforming Images	65
Chapter Three: The Alchemical Couple	91
Chapter Four: Chagall and the Image of Christ	125
Chapter Five: Chagall and the Bible	163
Chapter Six: A Religious Artist	203
Appendixes	209
Appendix A: Movement and Motion in Chagall's Lifespan	209
Appendix B: Chagall's Stained Glass Commissions	210
Appendix C: The Biblical Message Series	211
List of Color Plates	212
References	219
Acknowledgements	224
About the Author	224

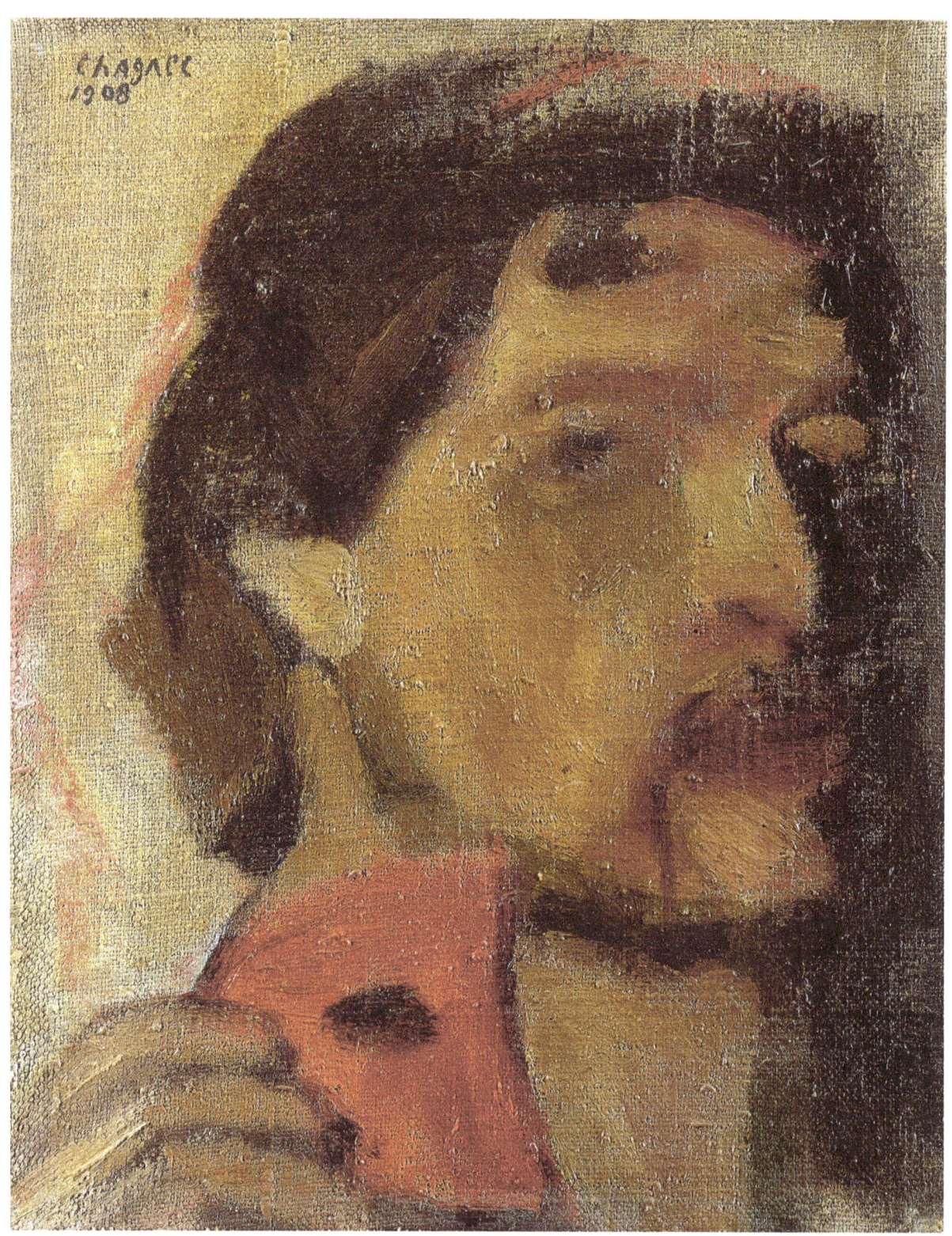

1. *Self Portrait*, 1908

Oil on canvas, 30.2 x 24.2cm

Musee de Peintre et de Sculpture, Grenoble, France

Everything in art ought to reply to every movement in our blood, to all our being, even our unconscious.

Chagall, 1944[1]

1 Chagall interview with James Johnson Sweeney, 1944. (Harshav, ed., 2003, p. 87.)

INTRODUCTION

Images are the dominion of the psyche. We live in an imaginal world, and our lives are filled and colored by the imagery that surrounds us as we move through our lifetimes. The ways in which we experience image and the imaginal world remains a complex and debatable understanding of a cyclical *life-processing-life-reflecting* experience. Finding a path towards such understanding begins at the intersection of the physical sciences and psychologies, the study of aesthetics, and faith. This is Jungian territory, wherein the borders between the individual psyche and the collective world is indistinguishable: Wherein images *become* as a symbolic state, holding the capacity for illumination, and emerge as the life markers and the visual imprints of the psychic current of change through which all transformation takes place.

This *as-yet*-incomplete knowing of the imaginal experience remains a curious human process, as we interact in our conscious life with material images (and in our dreams) through *an encountering* of sorts: the *observing of a visual 'observance' in the material world*. The familiar and demonstrative human emotions we gauge our life responses through and by are present in such imaginal encounters. Rarely, though, do visceral emotions - such as one being brought to tears or to verbal exclamation - surface in definitive or completed ways as we observe our imaginal history during visits to a museum or picture gallery, a library, or even, whilst observing the natural vistas of our earth and skies. Yet, and still, the imaginal world affects us deeply, and collectively: We are united through all of Time as human beings by our symbolic Life images. We hold onto - and carry away - these images that live (now) within us, whether in physical form[2], or by thought, alone. We revisit or refer to an image *in us*, ongoing, perhaps by using its given name in the material world, or, through the essence of description: the idea of this image, what is *behind* this image, the story which it holds, what it communicates, collectively, or *to one alone*.

Most often, what remains of our imaginal encounters is an *imaginal feeling*, a particular presence evoked, provoked, or emoted through an individual encounter with imagery. Creating form through feeling is the spirit of the artistic process. Visual art remains among the most powerful - and demonstrative - imaginal provocateurs of

2 A visit to any museum or picture gallery gift shop reveals the printed post card-sized reproductions from a given collection, that may be purchased, taken away, and kept by the observer.

life feeling: the neutrality of creative materials and the unity present in a cohesive application of the Principles of Design, opens a psychic window for the Observant to gaze through, into the symbolic life of mankind.

The collective vista is a neutral space - as the sum of materials from which it was birthed - yet, in linear time, this organic view contains images that may unite, as well as divide, human perceptions of life observations. The creative spirit has a rhythm of bringing forth such spirit enriching (or, destroying) polarities for artists and writers to explore and to re-create, to *re-imagine*, over, and again. Engaging this life-spirit with creative materials is perhaps the initiation of the imaginal journey - raw image (and, color pigment) connects with the capacity for openness, creating a visual portal with the potential to stimulate and invigorate our psychic lives. Whether naturally, or through force (e.g., 'forcing' an image upon us), the connection between our individual selves and the collective expression of mankind's world is illuminated through exploring image. In this connecting space (or, psychic vista), the patterns of life - Mankind's symbols - live through the processes of repeating, distorting, changing, transforming, and re-merging images over the course of our own lifetimes, and through the ongoing movement of human history.

There is a human tendency to categorize objects in the material world; visual art is not an exception: There are *Faith-based images, Antiquities, Period pieces, Modern works, popular images, realistic images, abstract images, Important images, Lesser works,* and so forth. In secular life, an auction catalogue or exhibition guide explains the provenance of the image, its creator and their creative process. Yet, even the most secular of exhibition rooms is treated as a sacred space, once the pictures are hung. The human appreciation of the imaginal world is rooted deeply in that which is sacred, and even, that which is unknown. We are reverent, in our observing an observant reflection of life. There is the understanding, that the imaginal world continues to reveal and reflect far more about our lives in Time, and an understanding of human life, than we are each able to know.

Some of the earliest images of human lifetimes that remain, survive within the earthly temenos of caves that have lain undisturbed for millennia. The imaginal here is re-imagined, regenerated by our Times, through an understanding of shared symbols: the hunted animals, the worshipped gods, the recording of an ancient lifetime in images. We continue - perhaps now, more than ever before - to reflect and to record our own *becoming process* in the imaginal world. (There is even the thought, that our youngest generation is becoming too image-saturated). We seek out unique places and find curious spaces to record, and then, to present, our personal experiences of a lifetime in the imaginal world.

The connection between images and experiences is potent. There is the understanding of an ongoing, experiential contact - *image encounters* - with the imaginal world. There is, too, the thought that, across lifespan, one comes to understand *an experience of life* through a particular image - or a series of images. Whether such imagery arises with the study of Neolithic forbearers, the story of an historic figure, the life of a Prophet,

the miracles of a Saint, or the Wonder of the Universe; A psychic connection to *an image of a symbol* in one's own personal transformation path is formed, through what one experiences when one is life-observing. Life's symbols remain alive, and, as potent human connectors in the conscious world, - and, between unconscious life - through the creative spirit recording human experiences with images, for the observant to observe: They are carved into stone and stained in glass, sewn together with fabrics and knitted in threads. They are scratched into parchment, rendered on paper, painted onto canvas and tooled into wood. They are sculpted with clay, poured in metal, are photographed, developed, and now, are displayed on electronic screens.

European Modernism emerged in the late 19th Century wherein the changing creative perceptions of a non-linear world collided with our subjective, secular aesthetic tastes: In the history of visual art, until the 19th Century, we had come to rely on the quality, or value, of visual realism in reproducing life images. The turn of the 19th into the 20th Century, in Europe, brought with it a cultural transformation reflected in the dramatic changes in visual art and aesthetics. Wholeness, reflected in an artist's creative and visual treatment of imaginal encounters, was re-considered; its presence elevated by the compositional removal of linear realism. It had been more than half a millennium since such dramatic changes had occurred in our creative perception of the imaginal world: Not since the European Renaissance had our observations and treatment of *Perspective*, been as fluid. A renewal of perspective, a new cycle of change, brought forth a transformation in artists' creative and technical ideas and ideals.

The Impressionists explored the ways in which light quality transformed visual perceptions of landscape and setting. The Cubists and Futurists visually challenged the understanding of physics and mechanics in our experiential environment. Whilst the Surrealists and the Expressionists, among others, prominently sought to deepen (and, to illuminate) the imprint of the human psyche in our material, visual world. The creative Movements of the latter 19th and early 20th Centuries (and, beyond) have continued to reinforce the thought that image - whilst itself, timeless - is receptive to, and reacts with, collective patterns of change. Moreover, that the organic expression of the imaginal world holds - and continues to contain – reflections of the transformation process for both collective and individual lifetimes.

This story, of an artist and the imaginal world, begins in the city of Zurich, where the Limmat River finds its ancient origins in the mountain Lake. A bridge, re-imagined since it formed during the Roman period, crosses the river, connecting the *Old City* complex of Medieval monastic and abbey buildings now repurposed predominantly for secular use. Among these structures, the open space of the Münsterhof shares a side of its central square with a pair of wooden entry doors, brought into sight by plaques and portable signs displaying historical facts and entry times. For the observant, this is a transitional space: Standing before the side portico, the architecture of Fraumünster Church is visually grounded into the Middle Ages. It formed as a Benedictine Abbey, established in the mid-9th Century, and remains an experienced site, with the continued imprints of pilgrims and secular observers held within the stones of

its walls, illuminated through its window panes. The complex has changed its appearance, its role, and its ownership, more than once in Time and now, is perhaps most frequented by those who make a pilgrimage to witness the 20th Century stained glass windows in the surviving sacred building, designed by the Swiss artist, Augusto Giacometti[3], and the Russian-French artist, Marc Chagall.

Accessing the church interior is a quiet affair: There is a door bumper, hung between the handles of the wooden panels. A charcoal-colored cushion to diffuse the quality of the sound made by doors opening and doors closing as one changes states. A cushioning transition, between secular and sacred places, wherein the doors remain open, or, never completely close. Once inside, the geometry of stone walls, and light colored in five full-paned windows, and two rosettes[4], that glow as stained glass does, beyond weather or season. This is a living sacred space. A temenos place, that opens the doors between *our life now*, and our lives in Time, and beyond.

In the study of images, we are sometimes fortunate to experience an unanticipated connection at the symbolic level, one that evokes the feeling of numinosum, an expression that brings us into the current of the psyche: Above the altar place, in the Fraumünster chancel, Chagall's Green Christ[5] is suspended in glass. Murray Stein (1987) reflects that, "The windows were completed in 1970, some thirty years after Jung beheld his vision [of the Green Christ] in his house in Küsnacht… I consider the falling together of these two images to be synchronistic and not merely fortuitous" (p. 13).

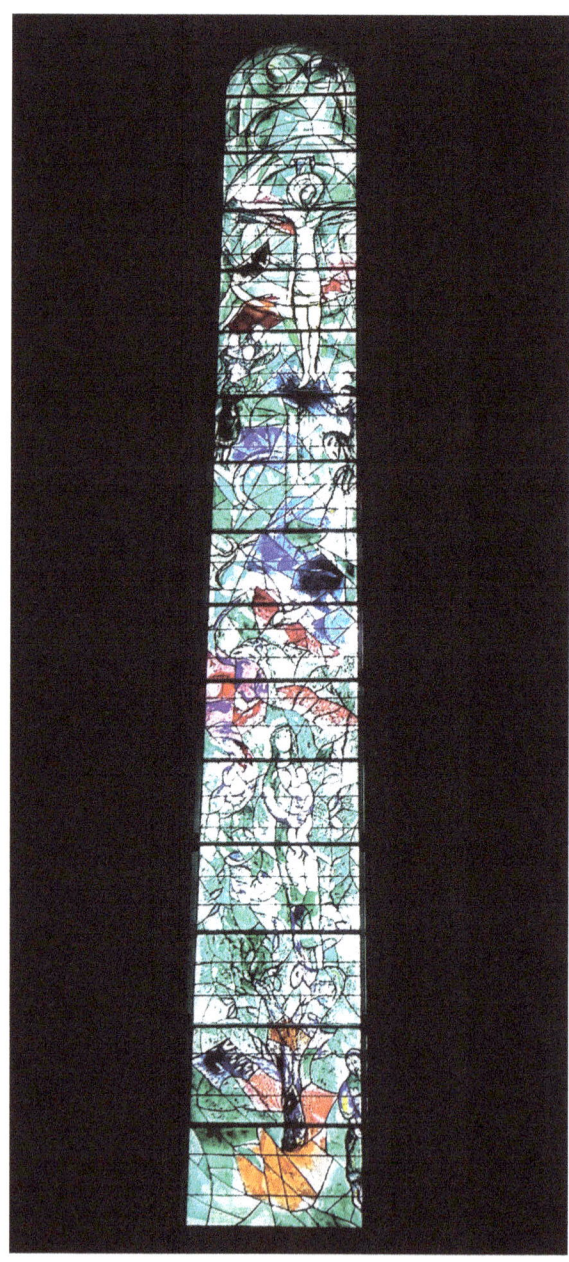

2. *The Life of Christ/Tree of Jesse*, 1970
Stained glass window panel,
Fraumünster Kirche, Zurich
Photo Credit: J. A. Swan

3 Giacometti's (1877-1947) windows are found in the Fraumünster (installed, 1940), and Grossmunster (installed, 1932) church spaces, in Zurich's city centre.

4 Chagall's 1970 installation included five windows in the chancel space, and one rosette in the south transept; Giacometti's window (installed, 1940) illuminates the north transept.

5 This panel, *The Life of Christ/The Tree of Jesse*, is complimented by four additional panes depicting: *The Prophets* (red glass), *Jacob and the Dream* (blue glass), *The End of Days/Zion* (yellow glass), and *Moses and the Ten Commandments/The Law* (blue glass). Chagall began the design in 1968, following a visit to the church. They were installed in 1970, when Chagall was 80 years old.

Carl Jung and Marc Chagall were 20th Century individuals whose lives did not coincide, yet, and still, they share much in their respective experiences, of an individualized lifetime spent observing in the imaginal world. As creative individuals, they each held an understanding about the necessity of communicating their life observations to others, and, were both gifted in the ways they individually went about 'making' their ideas known. The Jungian conceptualization of religion, and, the exploration of the imaginal world through archetypal theory, together, form a particular understanding of creative and religious life though images: Jung characterises the universality of religion, and the interiority of the artist's creative spirit in a way that is both psychologically and visually pertinent when considering the imagery of Chagall. Chagall's work is seen through the presence of religious experience in creative expression.

There is the thought that the telling of any story is not without certain challenges: Chagall, a prolific writer and speaker, particularly during his later life, clearly communicated his views on the application of Depth Psychology in theorizing his works, "I have slept well without Freud" (Harshav, ed., 2003, p. 173). There are, also, no written accounts nor documents from the artist to support the suggestion that Chagall had been directly acquainted with Jung or with Jungian theory. (The Fraumünster windows were installed nine years after Jung's death.) Yet, within Chagall and Jung's visual art and writing, in their talks and speeches, and in interviews, coincidences emerge, over, and again: The shared presence of a universal religion in their lives; the shared imagery of the transforming Self, and the shared creative spirit that engaged their imaginal observations and recordings of life experiences. Stein (1987) remarks upon the convergence of the two men through the curious emergence of their shared Self symbol, the transforming Christ in Fraumünster Church, "Surely Chagall could not have intended, consciously, to smuggle the alchemical Christ into the very heart of Christian tradition through the door of the windows, in the church of the women, in Zurich! Yet that's what he did." (p. 13).

It is with the thought that *connections extend beyond coincidences in the imaginal world* that this story of Chagall as a religious artist begins.

> To my way of thinking, these paintings do not illustrate the dream of one single people, but that of mankind...it is not up to me to comment on them, works of art should be able to speak for themselves. (Chagall 1973[6])

Viewing Chagall's original works constituted the initial fieldwork for this project, and included several trips to witness Chagall's paintings, lithographs, etchings, mosaics, and stained-glass architectural installations in the United Kingdom, the United States, and Europe. As a researcher who trained formally as a painter, it felt essential to experience the physical presence of the paintings - many of which are canvases extending more than a meter in dimension - in their most truthful state, to form an understanding of Chagall's technical methods, color palette, and visual language.

[6] Excerpt from Chagall's 1973 speech at the official opening of his museum, Musee National Marc Chagall, in Nice (Harshav, ed., 2003, p. 173).

When painting, Chagall utilised what may be described technically as an underpainting layer of his canvas wherein he included various images such as architectural structures, animals, figures, and religious iconography. These images were rendered to a point where their physical clarity began to deconstruct, not unlike the recording of a visual 'disappearance'. The overpainting (often) includes a different group of images than those partially revealed in the background, or beneath the primary composition. The resulting canvas is a patina of emerging forms that support the foreground composition as a deceptively solid background. One must be in the company of the paintings to understand this effect, fully[7]. The effect of this technique creates a visual tension between the primary, or foreground, composition and the background content wherein compositional understanding is re-formed by the presence and context of these 'hidden' images in the supporting matrix. This method of working produces a highly animated canvas with a numinous quality. This essence is found in Chagall's own technician's terminology, "La Chimie" (The Chemistry), describing "the living color" in the canvas revealed through the visual perception of the chemical reaction between color pigment and natural light (Harshav, ed., 2003, pp. 131-2, 149).

Chagall's process of painting and the works he created through this technique and style, supported the idea that: Chagall's visual language reflects a projection (or, vista) of the collective and personal unconsciousness', that emerges in the compositional understanding of the artist's technical application of form, and is translated visually to the exterior world. Chagall continued throughout his career to utilise and return to particular groups of images: architectural structures (windows, houses, and cities), animals, zoomorphic creatures and transmorphic figures, brides and wedding couples, hermaphrodites, and crucifixions. These images appear in the background matrix and as part of the compositional focus.

SYMBOLS AND ARCHETYPAL EXPRESSION

The concept of *symbols* and the conceptualisation of *the symbolic* is found in all reaches of Jung's lifework. Jung's belief in the unconscious nature of symbolic expression - and in particular, the objective and unifying features of symbols within the lives of all human beings - delineates his own theoretical and clinical associations from that of psychoanalytical thought[8]. Jung's theoretical approach to symbols and the symbolic was a formidable factor surrounding his professional break from Freud and the Freudian school in the early 20th Century (c.1912) (Bennett, 2001). Jung (*CW15*) explains the differences in their respective theoretical approaches:

[7] I found often in viewing the original work, that much of the texture and visual nuances of the underpainted layer of background images were more dynamic than one might anticipate - that they frequently intermingled between the planes of compositional dimension. True depth of color pigment, and the visual clarity of this depth are often difficult to discern in (even) the most satisfactory reproductions of a painting. In the example of Chagall's paintings, generally, the depth of color is an image-animated depth.

[8] Jung makes the distinction between 'signs' and 'symbols' (CW6:814). This distinction concerns the subjective and cultural appearance of 'signs' in the material world (CW6:815) and the collective, or universal, "living" quality of symbols (CW6:816). Freud's conceptualisation of a 'symbol' is closer to Jung's own definition of a 'sign'. Freudian thought emphasises that a 'symbol' has a determined "material significance" related to individuals or objects which are "quite well known, although not consciously recognized" (Bennett, 2001, p. 24).

A very important source for knowledge of the unconscious contents are dreams, since these are direct products of the unconscious. The essential thing in Freud's reductive method is to collect all clues pointing to the unconscious background, and then, through the analysis and interpretation of this material to reconstruct the elementary instinctual processes. Those conscious contents which give us a clue to the unconscious background are incorrectly called *symbols* by Freud. They are not true symbols, however, since according to his theory they have merely the role of *signs* or *symptoms* of the subliminal processes. The true symbol differs essentially from this, and should be understood as an expression of an intuitive idea that cannot yet be formulated in any other way. (par. 105)

Artists have the capacity through their use of creative languages to illustrate their reflections *into and out from* the experience of life. The appearance and use of these creative images is the process of symbols and the symbolic. Samuels et al. (1986) remark that, "the symbolic process is an experience *in images and of images*" (p.45). This is most essential to an understanding of how and why a material product of art is able to stimulate and to interact with its human audience. This also explains why specific works of art appeal across cultures and remain fresh and relative in contemporary times, independent of when and where they originated.

In his writing about the symbolic, Jung made a clarification between the universality inherent in symbols and how this differs from the immediacy and cultural underpinnings of *signs* (*CW15*: pars. 815-16). He also remarks that the numinous capacity contained in the expression of the symbolic is a temporal feature of the symbolic experience: that symbols have a birth into life and will also die out through fading into another - and new - way of being seen or observed (ibid.). This essence of 'life contacting', which underlies the expression of the imaginal, transcends the features of visual expression through its ability to appear in different understandings or versions, and to manifest across the history of cultures.

Within this process of manifestation, or emergences, and, through the unconscious processing of image connection, the nature of creative and religious life - the *Wholeness* of lifespan - is present. Jung's theory of archetypes develops the numinous features experienced in human imaginal connection, and makes the reasoning as to why this archetypal level of expression is an important part of understanding the way to see a human being *becoming* throughout their lifetime.

There is a substantial collection of scholarly material available concerning Jung's term 'archetype', its relationship to analytical psychology, and the sciences and humanities in general. For an understanding of the differences between Jung's conceptualisation of his own terminology and the Post-Jungian approach to archetypal theory, two passages from Jung are useful: Jung (*CW 11*) clarifies his definition of an archetype within a passage concerning the Trinity as an archetype of religious experience

> Archetypes are, by definition, factors and motifs that arrange the psychic elements

into certain images, characterized as archetypal, but in a way that they can be recognized only from the effects they produce. They exist preconsciously, and presumably they form the structural dominants of the psyche in general. (par. 222)

In translating the connective nature of archetypes within his internal - external model of the psyche Jung (*CW 8*) states:

These [archetypes] are indefinite, that is to say they can be known and determined only approximately. Although associated with causal processes or "carried by them", they continually go beyond their frame of reference, an infringement that I would give the name "transgressivity", because the archetypes are not exclusively found in the psychic sphere, but can occur just as much in circumstances that are not psychic (equivalence of an outward physical process with a psychic one). (par. 964)

In Andrew Samuel's (1989) Post-Jungian thought, Jung's archetypes are relocated to the contact experience of the imaginal within the personal unconscious' connection to life. An internal filtering process, or personal life lens, is present and concordant within the processing of an individual's engagement of and with various external realities. Samuels describes his concept of the archetypal experience as a result of an "affect" or "archetypal filter" belonging to and operated through an individual and their personal experiences: This filter engages with continuous, external reality, and "converts experiences onto the archetypal level" (1989, pp. 25-26).

Samuels (1989) states that:

>...the archetypal may also be seen as a *gradation of affect*, something in the heart and eye of the beholder, and not what he or she beholds or experiences...An analogy would be a filter that is always in place, coloring or otherwise influencing what is seen or experienced. There is a sense in which the filter *is* the experience, or in which the filter is dead without the experience. *The filter is what we term archetypal*. The implication of this is that depth lies in the filter. The filter is a kind of disturbance of attention, distortion even. It is a way of introducing imagery to the world and imposing imagery on the world so that the world becomes an experienced world. (ibid.)

The concept of filters 'filtering' within and through the unconscious realms of the psyche remains a challenging, if not controversial, concept. Yet, more than twenty years since this idea (Samuels, 1989) came to be discussed, and debated, terms such as 'filter' and 'filtering' are utilised universally as technology vernacular to discuss the ways in which human begins capture, and process the (mainly, photo) images we choose: Our filtering the life imagery of our selves, within the infinite threads of technological tapestries. *Change continues to refine perceptions, and to re-define meaning in the Present world*. As a writer observing from the perspective of a childhood in the late 1970's - the last generation to experience childhood without forming contact, ongoing, with the Digital age, - the historical experience of *encountering* image has, observably, in less than three decades, transformed

physically and seemingly, irrevocably. Presently, the possibility of technologically *filtering the Whole world* in which we live, is imbued, and accepted, in the experiential processes of visually capturing and disseminating the imagery of our lifetimes[9]. We continue in this digital realm, to connect images of ourselves to images of others to understand who we are as human beings.

In visual art, Samuel's (1989) descriptive language holds a connotation that is compatible with the translation of the personal stages of creating art, from its origins in the unconscious, through the conscious aspects of the image-making process. The 'lens' is simultaneously Chagall's viewfinder and viewpoint in the psychic process of 'being found' by imagery, capturing the findings, and reproducing a work of art. In Chagall's "Later Life" period (1952-1985), this psychic process predominates his personal experience of contact with archetypes and archetypal life. This observation connects with Stein's (1998, p.10) idea that, in the last third of lifespan development an individual may undergo a second transformative period wherein the process of an *individual becoming* is characterised through the elevated presence of interior religion and religious expression.

To further examine Stein's (ibid.) theory, the historical and personal details of Chagall's biography were compared with the dates of the initial visual emergences and subsequent repetitions of particular images as they formed into a group or theme. A correlation found between the patterns of emergence and repetition and the convergence of internal and external changes in the artist's biography was consistent across lifespan development. Central to this corollary relationship was the concept of transformation: During critical periods in Chagall's biography, the imagery in the work reflected a greater percentage of transformation metaphorically and literally, through the visual content of shape and form. These 'transforming' works contained both secular and sacred content, and included images and themes of:

(1) the Artist's natal faith (Judaism), and *The Bible*

(2) zoomorphic animals, transmorphic creatures, and anthropomorphic beings

(3) hermaphroditic figures, bridal couples, and conjoined lovers

(4) the image of Christ, and crucifixions

TRANSFORMATIVE IMAGERY AND INDIVIDUATION

Experiencing the process of transformation is the function of an analysis, and is recognized and observed by professionals in therapeutic communities as an indication of a patient's clinical progression. Samuels et al. (1986) remark upon the prevalence of the transformation

9 In the technological encounter, rapid exposure to image is the remit of the internet plane. The 21st Century is a world wherein the authenticity of image is difficult to define, and is, more often than not, indeterminately filtered through individual (and, collective) means as a way to control what is *understood to be Known*. There is the thought, that Samuels' (1989) approach to archetypal theory may find resonance within the world of technology, wherein the concept of hyper-saturation of imagery exists. The hyper-satuation of imagery in the psychic world brings with it new paradigms for psychic structures and their functioning. It is possible that the growing (and future) generations may demonstrate a new paradigm through evolution of *the filtering* of life images. Image hyper-saturation has the potential to create a new psychic state: In this paradigm one may not – or no longer - be able to discern or distinguish between true 'connection' to image without the evolution of the psyche to facilitate *a filtering of the connection* between the unconscious and conscious imaginal world.

concept in Jungian theory: That it is a concept which is central to Jung's collected works; That transformation symbolism is used to describe both clinical and metaphysical transitions, as in the example of Jung's writing on alchemy and religious rites; And, that the transformative process can manifest as either as a positive signal of psychic growth, or a negative experience of psychic breakdown.

Jungian theory's use of the terminology is most closely associated with the positive experience - and goal of an analysis - *individuation* (*CW 6*: pars.757-762). The process or "project" (Stein, 2006, p. 4) of individuation takes place through transformations across an individual's lifespan, and for Jung, it is a "natural process" of "self-realisation" most commonly associated with development of identity, and emergence of the adult self, or *imago*, during the second half of one's lifetime (*CW 6*: par. 812; *CW 7*: pars. 186, 267; Stein, 2006, pp. 5-28). Transformation both internally and externally is the means through which individuation occurs.

The individuation process may be divided into two processes, or experiences. The first, being concerned with the deconstruction of the individual, or personal unconsciousness, constitutes the first phase of an analysis:

> This analytic separation includes dismembering both the identities that one has forged with figures and contents that have their primary basis in reality outside of the psyche (i.e., other people and objects) and those that are grounded first and foremost in the psyche itself. (*CW 7*: 387)

The second (and, concordant) process involves considering the emergence of imagery, and the exploring of meaning within these imaginal experiences. Stein (2006) describes that:

> This second movement requires paying careful and continuous attention to the emergence of archetypal images of the collective unconscious as they appear in dreams, active imagination, and synchronistic events. This movement involves taking up this new material into the patterns of conscious functioning and everyday life. (p. 5)

For Chagall, a lifetime of image-making and creative writing produced both visual and narrative paths through which it is possible to follow the transformative nature of the individuation process, for both the artist as creator, and the collective passage of change in a 20th Century of lifetime. It would perhaps be helpful here, as such, to discuss analytical terminology concerning *imagery* and archetypes. The post-Jungian concept of 'archetypal' has its essence in the *personal processing of connecting* through emergences, which are understood through the life filter of the personal unconscious. The emergence is treated as archetypal through the expression of content, though is not considered - as is particularly in Jung's early career (Samuels *et al*, 1986) - independent of the individual's personal unconscious.

Whilst Jung's own theory of archetypes changed during his lifework, his position remained and is reflected in the classical thought that, true 'archetypes' are linked always to the collective unconscious of mankind and thus spontaneous

in their emergence (*CW 7*: par. 185; *CW 11*: pars. 82, 893). The numinous quality of archetypal emergence finds connection to the presence of religion, whether through ancient or contemporary traditions. Thus, the identification of 'sacred' or 'secularized'[10] archetypal imagery, for example, is helpful when considering images which are consistent with Chagall's concepts of religious attitude, ritual and practice (e.g., Christ, Crucifixion, Holy Family, Marriage Rites), or, are related to 'secularised' images within the artist's personal biography (e.g., Home, Family).

The analytic process examines the content and presentation of such archetypal images or experiences in effort to reintegrate the understanding of their symbolism within the conscious layer of the psyche. The personal unconscious psyche works through its contact and unification with imagery of the collective unconscious, *and through this*, the individuation process is reflected as a transformative and whole experience. Stein (2005) considers the transformative image as:

> An image that has the capacity to redirect the flow of psychic energy and to change its specific form of manifestation. The way in which this image relates to the instinctual needs of the individual is critical, for this will determine whether the constellation supports balance and wholeness or represses aspects of human nature. (p. 56)

Identifying the transformative images and defining their functioning as visual or experiential markers - across both biographical and historical timelines - is most critical for an understanding of Chagall's body of religious art.

ARCHETYPAL IMAGES

In Chagall's oeuvre, the most prominent example of a sacred archetypal image and the transformative metaphor is the *Crucifixion*, which Chagall revisited in various forms and materials from 1909 until his death, in 1985. The appearance and strength of the crucifixion theme became an important finding in the research process: Chagall's natal faith was found in the traditions and culture of Hasidic Judaism; And, the artist experienced anti-Semitism whilst living in Russia and France. He was among the Jewish '*Artists in Exile*' who fled from the Holocaust to America, in 1941, with the support of Varian Fry and the sponsorship of the American Emergency Rescue Committee (Meyer, 1964; Barron & Eckmann, 1997; Harshav, 2004; Wullschläger, 2008). In the historical and biographical context of Chagall's natal faith and life experiences, the repetitive use of this most familiar of sacred Christian images provides a curious visual paradigm from which to begin to explore Jung's conceptualisation of the artist and aesthetics:

> Art is a kind of innate drive that seizes a human being and makes him its instrument. The artist is not a person endowed with free will who seeks his own ends, but one who allows art to realise its purposes through him. As a human being he may have moods and a will and personal aims, but as an artist he is 'man' in a higher sense - he is 'collective man' - one who carries and shapes the unconscious, psychic life of mankind. (*CW15*: par. 157)

10 The 'secularizing' of an image is a product of cultural change in religious perspective.

In this study of an artist and his art, the imaginal 'data' is collected through examining the product of Chagall's creative processes, his written and spoken thoughts. Such study of a creative individual contains an element of conscious human subjectivity as well as the objective perspective which transcends all conscious associations, or *the reading into* the work (*CW 15*: 107-11; 157). Both are present within the artist's creative development and execution of a work of art, and within the researcher's recording and reporting upon the observations of that creative product.

For the artist, there are creative times when conscious decisions are undertaken concerning the technical development and execution of a work of art. These may include: the choice of available materials, a particular *style* that translates this *medium* most effectively (*and conversely*), the communication of pigment through the principles of color theory, and the development of the spatial relationships from within the compositional plane on which to mark line or render form. From this conscious perspective of the technical creative process, decisions are made to bring the work physically *into being*. This growth into a 'living painting' relies consciously - and in unconscious moments[11]- upon what has been learned and is known through the training of the eyes and hands to work together, and through experience with the materials. It is the 'technical' intuition and instinct.

In certain instances, the deliberateness of conscious creative technique is transformed - sometimes forcefully - into a palpable urge to create something *out of* oneself, into the world. In these instances, the entire process is driven by a known (but *unknown*) presence. Jung (*CW 15*: 157) refers to this as the creative drive and intuition that is, at once, moving the creative individual through the process whilst present in each step of every technical creative decision. For the artist, this experience is a *creative event* wherein an image or composition may emerge within minutes, or hours, or days, complete.

Jungian aesthetics emphasises the separation of Chagall's images from his role as an accomplished image-maker. The image-making process is the catalytic element in the emergence of archetypal imagery, with the artist functioning as conduit for the collected unconscious and its contents. Philipson (1994) considers that, "Jung conceives the primary concern of an analytical psychological interpretation of art to be with the nature of the psychic significance of works of art" (p. 80), and that the interpretation, "is achieved not by beginning with the process of the artists' act of creation [psychoanalytic aesthetic[12]], but by an inquiry into the different 'roles', 'ends', and 'effects' of works of art." (ibid.).

11 If one has been working at developing their craft over a time, or has a particular talent with a certain material, there is a tendency to work through both the conscious and unconscious aspects of craft simultaneously. For example, there is a point in the active creative process when one becomes aware that they do not notice the presence of 'working with the materials'. The materials become an extension of what it is they are doing and making. In instructing technique, there are particular styles to holding a drawing instrument, tool or paintbrush which increase the extension of the body into the creative instrument, (e.g., 'drawing with the arm' is preferred to, 'drawing with the wrist'). This practical approach to instruments unifies the corporeal aspect of making art with the spirit of the creative movement.

12 A psychoanalytic interpretation of visual art is illuminated in Hogg (1969); Fuller (1980, 1983); Kris (1952); Mayo (1995); Philipson (1994); and Spitz (1985, 1991). Spitz (1985) remarks that, "Almost from its origins, psychoanalytic theory has been applied outside the clinical sphere to works of art and used as a mode of understanding in art in at least three area of major concern to aestheticians: namely, (1) the nature of the creative work and the experience of the artist, (2) the interpretation of the work of art, and (3) the nature of the aesthetic encounter with the work of art." (p. ix).

Jung's observations differed when describing the role of *connection* within an individual's interaction with archetypal images. There is distinction made between the capacity for archetypal images to appear in physical form through the process of image-making, and the exploration of dream and active imagery through an analysis. Unlike the artist, the patient in Jung's theory is encouraged, and expected, to engage with imagery to better understand the personal imprint upon the visual: "The wordless occurrences which are called forth by regression to the pre-infantile period need no substitutes; they demand to be individually shaped in and by each man's life and work." (*CW 7*: par. 120).

The Jungian differentiation between process and product as two separate psychically-driven phenomena in the birth of a work of art is accepted here, with the thought that an artist's creative instinct - the combining of technical craft and their external and internal realities with the personal unconscious - builds an imprint upon the archetypal imagery during the physical process of image-making. The artist as a conduit is creating a physical portal for the visual expression of a psychic concept. The phenomenon of exchange is dependent upon the artist's active and passive engagement and re-engagement with the contents of his personal unconscious psyche, and the collective unconscious. Jung uses the term *transcendent function* to describe this exchange of contents between these two psychic realms (*CW 7*: par.159). The archetypal images which actively come into focus on a canvas have been experienced through the personal unconscious of the artist, and acknowledgement and discussion of the psychic presence or imprint of the artist is significant to an understanding of the ways in which a particular work of art came into being.

Earlier, I explained that in Chagall's oeuvre, a correlation exists between the patterns of emergence and repetition of four distinct themes. The convergence of internal and external changes in the artist's biography and historical lifespan of the 20th century was proximate to the increase in the emergence cycle. In the context of the individuation process, the expression of such imagery surrounding critical points in development is suggestive of transformative imagery. That Chagall's transformative images often *literally* reflect and repeat the 'transforming' process (i.e., bi-morphic creatures, hermaphroditic figures, the Crucifixion) reinforces and strengthens the connotations of their expression.

Of these archetypal images, the Crucifixion is identified foremost with the dogmatic traditions of the Christian faith, and thus translates to an active 'sacred' archetypal image. For Jung, Christ is a universally-symbolic image and corresponds to his conceptualization of the archetype, *the Self* (*CW 11*: pars. 226-42; *CW 9ii*: pars. 68-126). That this image of self could be recognized across a timeline of Chagall's lifespan - and, that its emergence correlates with convergences of interior and exterior transformative events - is most significant in providing an understanding of Chagall's creative lifespan, the processing of image, and the Artist's experience of religion in a century of quickening decline in faith.

1 "It is only with the heart that one can see rightly. What is essential is invisible to the eye." De Saint-Exupery, A (2007). *La Petit Prince*. Paris: Editions Larousse, p. 92.

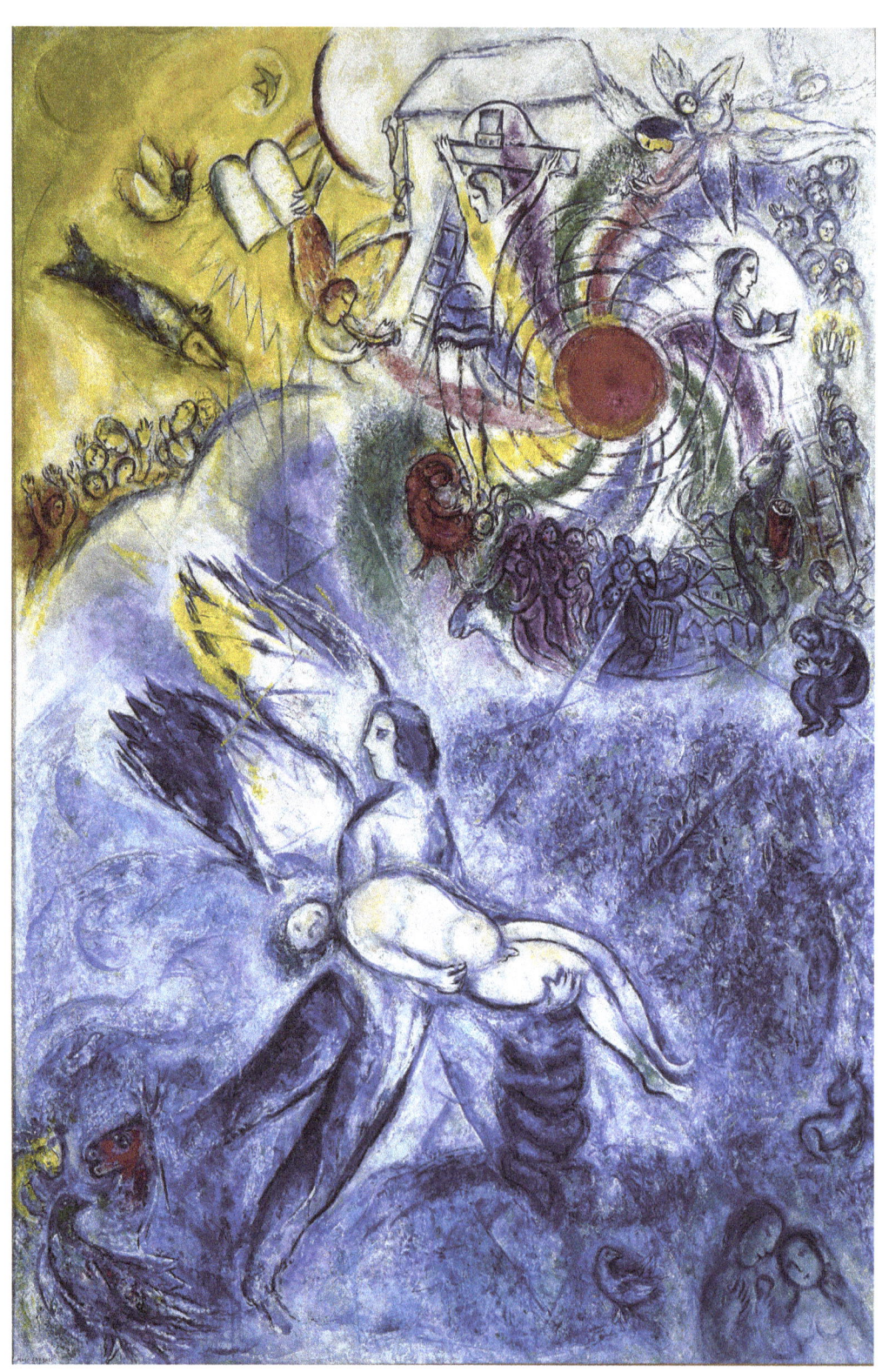

3. *Creation of Man*, 1956-58
Oil on canvas, 300 x 200 cm
Musee National Marc Chagall, Nice

I. CHAGALL, JUDAISM, AND RELIGION

I have only in view what prevents us from raising ourselves towards things more unknown than the stratosphere itself. Those unknown poles are ourselves in the world or the world within ourselves. Basically, we resemble one another in the world, and, perhaps we have nostalgia, not for what we would like to know and for things outside of us, but for our own dreams, for our own swing towards a certain revolution in our inner life which is the discovery of purity, of simplicity, of natural self, such as we find on the face of children or in the voice of the one we are used to call Divinity. (Chagall, 1958[1])

In the autumn of 2015, I found myself in New York, at the entrance to the Jewish Museum on the Upper East Side of the City. The building[2] itself had begun its life as a private home, and the structure now houses an extensive collection of visual art, ceremonial objects, and artifacts that evoke the collective and symbolic world through a celebration of the Jewish culture and faith. Among the levels and spacing of their rooms, a grand hall is filled with sacred cabinets resting beneath candelabras; a place for the furniture of celebrating the Spirit[3].

1 Excerpt from Chagall's 1958 lecture, "Art and Life," delivered at the *Committee on Social Thought*, University of Chicago. (Harshav, ed., 2003, p. 128)

2 The building is a mansion house styled in the European French Gothic 'Chateauesque' (Francois I) manner, characterised by brick stone façade, and an asymmetrical roof line with ornate towers and spires. The site was designed by the American architect C.P. H. Gilbert, and later re-imagined and extended by American architect Kevin Roche. Originally used as a family home (between 1908-44) for the Warburg family of New York City, the structure was later donated by the family to The Jewish Theological Seminary, and began its life as a museum space in 1947. It is the oldest living Jewish Museum in the world. See www.thejewishmuseum.org

3 The museum houses a permanent exhibition across two floors of the interior, *Culture and Continuity: The Jewish Journey*.

The stairs of this space rise into a mezzanine, and one is met on this level by a gathering of gilded menorahs, their burning candles invisible to the eye. The silence of their forms contains the songs of those who stood with them, in sacred spaces, in prayer. They are rare, beautiful objects to observe.

A gentleman of distinguished years entered this space. He spent time with the ceremonial objects, and then turned to approach me. It is a quiet space, and voices echo, yet, we began a soft conversation about what had brought us to this place, today. We sat together on bench facing the objects, and I explained that I needed to come here, to this place, to be in this space, to clarify a feeling about something I was writing. He suggested that I shared with him the celebration of his Jewish faith – the New Year celebrations were soon to be - and was then curious to learn that I actually do not. I explained that he was not the first individual encountered in this research process who considered, or even, expressed to me, the thought, *the Author is writing about an artist whose Natal Faith she shares*. I asked him, "Will it make a difference to the telling of the story?". *It might; it might not.* Like visual art, writing is received through the eyes, individually. It is the human perspective that is fluid. It is our individual internal experience of religion, and our collective connection to the understanding of that which is sacred in life, that resonates. Perhaps, too, it is not the differences between Faiths - the *'How'* we believe, or even, the *'Why'*, - that will matter in decades and centuries ahead in this ever-increasingly secularized world; But, most importantly, that *We still do believe, at all.*

We continued our conversation, for quite some time. An autumn afternoon in New York, spent in the company of a stranger, yet, and still, the meeting filled with a familiar and shared view of the imaginal world, the objects of sacred life before us, and the essence of the religious experience in our minds. This encounter clarified the thought I had come to know: That the feeling of *a connection to beyond one's self* is behind the structures of Belief. And that, belief in all its forms is united by this feeling, of Religion.

Academic, and popular culture sources often share a variant of the defining, mythologizing phrase which identifies Chagall as, 'The Jewish Painter from Vitebsk...' Indeed, it is difficult to discuss Chagall's biography and retrospective without mention of the artist's natal faith and his religious imagery: the historical context of the 19th Century annexed Russian Pale of Settlement; the traditions of cultural Judaism; the artist's paintings, etchings, and lithographs recording Biblical stories and sacred symbolism; stained glass and mosaic installations in Christian and Jewish houses of worship[4]; and his founding of his *Museum of the Biblical Message*[5] in Nice, France.

A paradox underscores the mythological element which has come to define Chagall's biography, as research reveals that the artist left the organized practice of the Jewish faith in his teenage years, and, that Chagall lived in France for fifty-nine of his ninety-eight years (Alexander, 1979; Haggard, 1986; Wullschläger, 2008). Since the artist's final (lifetime) retrospective[6], in 1985, contemporary art

[4] See Appendix B.

[5] This museum was re-named in 2008, as, The National Museum of Marc Chagall. (*see, Chapter Five*)

[6] This 1985 exhibition, '*Chagall*', was held at the Royal Academy, London, and The Philadelphia Museum of Art in America.

historians - including those who have spent their lifework looking into Chagall across decades - have sought to redefine Chagall's identity through acknowledgement of his multiculturalism, and, how this multiculturalism relates to the artist's association with the Jewish faith generally, and Hasidic traditions, specifically (Bohm-Duchen, 1998, 1998a, 2010, 2013; Compton, 1985, 1992, 1998, ed., 1998a; Goodman, 2008,ed., 2008a, Harshav, 1992, 2003, ed., 2004, 2006; Kampf, 1990; Shatskikh, 1991, 1998; Wullschläger, 2008). Their observations of Chagall challenge the mythological reading of his biography, and importantly, illuminate his relationship with Faith.

> Chagall always wanted to be considered an Artist - international, revolutionary, Russian, or French - rather than a parochial, "Jewish" artist. (Harshav, ed., 2003, p. xii)

> Marc Chagall was loath to acknowledge the full extent of his debt to other artists and to cultural movements of any kind... although in his art his Jewishness is everywhere in evidence, he was deeply wary of the label "Jewish artist", choosing instead to stress the universality of his work. (Bohm-Duchen, 1998, p. 35)

> Chagall is a Hasidic Jew, a western Russian, an eastern Parisian, a European visitor to America, and a good friend of Israel who prefers to stay in France. (Compton, 1985, p. 21)

This shift in Chagallian research perspective has been supported by the process of *change*: The death of the artist in 1985 created an opening for unexpurgated biographical studies (Haggard, 1986; Harshav 2004, 2006; Bohm-Duchen, 1998; Wullschläger, 2008). The breakdown of the former USSR in the 1990's, prompted release of historic government documents specific to the artist's life in Russia before 1922, as well as, the emergence of 'missing' artwork, including Chagall's murals for the Moscow Yiddish Theatre (Compton 1992, 1998, ed., 1998a; Bohm-Duchen, 1998a, Goodman, 2008, ed., 2008a; Harshav, 1992; 2006, 2008; Shatskikh, 1998). Perhaps most significant in the context of this study, is the 21st Century compilation of a Chagall archival research project - and the accompanying printed volumes (Harshav, ed., 2003; 2004) - that include the artist's speeches, journal articles, interviews, personal and business letters, poetry, and the original[7] typescript of his autobiography.

Contemporary Chagallian scholarship continues to focus upon the historic multicultural underpinnings in the artist's biography, emphasizing Chagall's faith through the lens of *cultural* Judaism. However, resources that examine the artist's personal experiences from a psychological perspective, or otherwise, remain elusive. This is significant, as Chagall wrote extensively on the topics of faith and religious affect, providing his personal impressions of his early interactions with Judaism, his observations of organised worship and belief in the 20th Century, and his identification with an internalised experience of religion:

7 The still widely-available autobiography, *Ma Vie* (My Life), was translated into French by the Artist's wife, Bella, and published, initially, in 1931. The artist's original typescript, titled, *My Own World*, appears in Harshav (2004, pp. 85-166): This earliest known version (1924) is written in Yiddish; an edited version was then published in Yiddish, in 1925. Harshav (2004) explains that, "In sum, *My Life* is an expanded version of *My Own World* and adds various episodes or anecdotes absent in the first version; in detail and precision, however, the earlier version as published here is closest to Chagall's original autobiography." (p. 84). In referencing quotes from Chagall's autobiography, I have considered, and utilised, details from both versions.

I was overwhelmed by my Grandfather's "Eastern Seat"[8] in the synagogue…Behind me they are starting the Musaf [early evening] prayer, and my Grandfather is called to the podium. He prays, he sings, he trills, and then starts all over again, overflowing in song. As if there was an oil factory in my heart. Such newly gathered honey flows inside me. (Chagall, 1924, in, Harshav, 2004, p. 101)

The refined art of my native land was a religious art, I saw the quality of a few great productions of the icon tradition. But this was fundamentally religious art, and I am not, and have never been religious. Moreover, I felt religion[9]. meant little in the world that I knew, even as it seems to mean little today. For me, Christ was a great poet, the teaching of whose poetry has been forgotten by the modern world. (Chagall, 1944, in Harshav, ed., 2003, p. 84)

We reject any divinity, we even speak of its fall; but we are making an error. We are looking for something which could take the place of this divine sense. We are coldly and mathematically busying ourselves trying to improve the material situation and the fate of mankind. But with all that, we destroy often in ourselves and others, Love or the Divine, call it what you will. (Chagall, 1958, in Harshav, ed., 2003, p. 130)

JUNG AND RELIGION

Jung's conceptualization of religion focuses upon the division between religion as an organised external structure, and the internal spirituality inherent in individual belief, underscored by the psychic experience of the numinous (Bertine, 1958; Harding, 1959; Stein, 1986, ed.1999; Whitmont, 1958). For Jung, *creed* or *natal faith* is seen as an historic element in the development of society and culture, and is centred around and outlined by emblematic dogma which is tangentially linked to the presence of numinosum (ibid.).

> I want to make it clear that by the term 'religion' I do not mean creed…Creeds are codified and dogmatized forms of original religious experience. The contents of the experience have become sanctified, and are usually congealed in a rigid, often elaborate, structure of ideas. The practice and repetition of the original experience have become a ritual and an unchangeable institution. (CW 11, par. 8-10)

Whereas, when Jung writes about 'religion' the reference is to the *religious attitude* (*CW 4*: 555) in human beings, their capacity for spirituality, or the personal experience of the numinous (*CW 11*: 9). Jung characterized the 'religious attitude' as an instinctual drive, a function of the psyche, and an archetypal experience, which exists independent of the practice of creed or an adherence to dogma (*CW 10*: 160; *CW 8*: 111). Jung states (*CW 11*):

[8] Yiddish: Shtot (literally: city), a permanent "Seat" as close as possible to the Eastern wall of the synagogue; such seating was held by "respectable citizens" and reflects social prestige (Harshav, 2004, p. 101).

[9] In this passage, the Artist utilises the generic term 'religion' to describe what is, arguably, the organized Faith of Russian (Byzantine) Orthodoxy, and, the quality of an adherence to Faith, in general. Beyond Jungian studies and scholarship, the use of the term 'religion' continues to reflect in its definition a generality associated with the organised aspect of Faith and systems of belief, rather than Jung's specific appropriation of the term, which imbues a universal connotation, as well as an internal, experiential facet of the Spirit.

A religious philosophical attitude is not the same thing as a belief or a dogma. A dogma is a temporary intellectual formulation, the outcome of a religious and philosophical attitude conditioned by time and circumstances. But the attitude is itself a cultural achievement... (par. 8-10)

For Chagall, it is the *cultural* element in his connection to Judaism - and Hasidism, in particular - which arguably initiated, or activated, the religious attitude and the archetypal lens through which he lived a creative life. The specificity and dogmatic implications of his natal faith are secondary to the existence, function, and achievements of this religious attitude.

> Contrary to stereotypes, Chagall was not specifically influenced by Hasidim. He did not know much about its doctrine, nor could he read its classical books in the 'Holy Tongue' Hebrew-Aramaic. One can only speak of general Hasidic attitudes, abstracted and folklorized, that permeated the daily life of Jews, which may have effected Chagall's attitudes. These include an innate optimism and joyfulness, the love of music and dance...and that feeling and spiritual intention are more important than learning and rational argument. (Harshav, ed., 2003, pp. 5-6)

Reflections on Jung's conceptualization of the religious attitude point to the connection between the inner experience of man as a spiritual being, and the psychology of one's unconscious through the expression of such experience (Aziz, 1990; Dourley, 1994; Ulanov, 1994):

> From the standpoint of analytical psychology, religious experience is seen as an eruption of the unconscious and an expression of latent psychic structures and dynamics. Theological doctrines and rituals, on the contrary, are products of the ego's understanding and represent, largely, the rationalizations of those experiences. (Stein, ed., 1999, p. 16)

In Chagall's lifespan development, the capacity for ego-transcendence through the process of individuation creates a psychic motion towards a universalized appreciation of the function of faith, and is characteristic of the religious attitude. Transcendence of the ego-complex of dogmatized belief results in a *self*-reverential spirituality which is evidenced in the artist's use of sacred archetypal imagery. The emergence of such imagery occurs particularly during 'critical' periods of change in Chagall's biography, wherein, the artist's internal process of personal growth towards self-awareness overlaps with collective transformative events.

Three lifespan stages[10] emerged organically from a Mid-Life centre point, each correlating through the convergence of the artist's physical movement - between cities, countries, and continents - and, the motion of transformative emergences in the imaginal world: Early Life (1887-1922), to aged 36; Middle Life (1923-1951), to aged 65; and Later

10 The stages of Chagall's ninety-eight years have been similarly characterised by all art historians and his biographers; identification of the artist's 'Early' and 'Later' years is, primarily, to discuss the professional stages of the artist's career, and biographical events. This study utilises a new system of dating - synthesized from historical facts and agreed upon dates by Chagall art historians' scholarship - which designates a specific developmental stage of 'Middle' Life, as part of the Whole temporal arc of Chagall's lifespan. *Appendix A* provides details of the interconnectedness between physical 'Movement' and psychic 'Motion', across Chagall's lifetime.

or 'Monumental' Life (1952-1985), to aged 97[11]. In each life stage, Chagall created work which dealt uniquely with religious themes, though there is not one definitive - nor a rigid - sequential pattern within the visual 'eruption' of religion in his retrospective: Archetypal imagery appears and overlaps in certain stages (and even, within the same composition). The creative imprint leaves the residue of a 'symbolic path' towards the ongoing process of individuation. The visual emergences find stages through a greater pattern - of the Whole - and thus, reflect the attributes of the 'processing' of image within the terminology associated commonly with the (Jungian) analytic method. Emergence is linked to pattern with the observation that, during times of critical collective shifts in the artistic, political, and Faith history of the late 19th and 20th Centuries, Chagall's religious imagery appears in greater extent and is, often, the visual focus in the compositions. Furthermore, beginning in the 1950s, the artist's writing begins to frequently reference his observations on the decline of the practice of organised faith in Europe, whilst simultaneously inventing and re-imagining a self-centred vocabulary to discuss the 'spirit' in his art : 'La Chimie' ('The Chemistry').

These observations suggest that Chagall's creative response was particularly heightened during historical periods in the 20th Century that are characterised by extremes or polarities of religious attitude: the emergence of the Parisian Modernist aesthetic, the 1917 Russian Revolution, the Holocaust and the Second World War, the post-war's secularisation of spirituality. As such, the work is seen to demonstrate the attitudinal link between the individual and greater collective psyches. That these works reflect archetypal imagery, and, were created (or, birthed) during periods of external historical disruption and personal change across the artist's biography underscores their duality as image markers for collective and individual development.

> In critical periods where spirituality is no longer felt or readily discerned in official society, it must be named, described, articulated and conjured up, usually by creative artists, writers and individuals working away from or even against the 'progressive' social current. (Tacey, 2004, p. 216)

For Chagall, the transformation of his personal engagement with an increasing presence religious attitude appears, initially, through an early teenage separation, or *moving away*, from natal faith (Tacey, 2004). This motion continues through the *turning towards* the secular in Life, as Chagall formed a professional identification with European culture and ideals and the experience of Communist Russia, through the decade of his twenties (ibid.). The reemergence of a personal, universalised experience of 'spirituality' at Midlife appears following Chagall's permanent return to France, in the 1930's (ibid.), at age thirty-five. This transformation - and *motion towards* - an achievement of universality within attitude and creative expression is most

11 Chagall died on the 28th of March 1985, three months before his ninety-eighth birthday, the 7th of July, 1887. Shatskikh, (1991, pp. 21-22) and Harshav (2004, pp. 57-8; 65) examine a mythological interpretation of Chagall's birthdate - and the artist's use of dates generally, as when dating his works and life events: "Chagall had a remarkable knack for confusing dates. Many of his paintings were backdated several years..Sometimes, perhaps he intended to indicate the time of the first conception of the painting before he actually executed it. This kind of habitual 'lying' about time, which one encounters in the autobiographies of Eastern European Jews, can be seen in a benevolent light if we understand that a date in this perception is not a precise point in a chronological sequel but an emotive marker with a contextual function." (ibid., p. 57).

clearly evidenced in Chagall's *Later Life* through his religious writing and sacred site stained glass commissions.

NATAL FAITH

Chagall's experience with natal faith is centred around his historical connection with Russia. Vitbesk, a commercial and industrial manufacturing centre, was the second largest city in Russia's annexed Pale of Settlement during the late 19th Century (Compton, 1985; Bohm-Duchen, 1998; Harshav, 2004; Wullschläger, 2008). The population (c. 66,000 in 1890) of roughly half Jewish, half Christian inhabitants, shared heritage linked to what now stands as Russia, Ukraine, the Baltics and Poland (Harshav, 2004). In this multicultural community, Chagall experienced his earliest years, from his birth on 7th of July, 1887, to his first journey to St. Petersburg in 1907 (ibid.).

To understand Chagall's upbringing from the context of his natal faith, it is necessary to overview the state of Judaism and Jewish culture of the pre-Revolutionary Pale: The Russia of Chagall's childhood was still a Tsarist Empire, encompassing parts of central and Eastern Europe, and reaching into the Asian subcontinent (Baron, 1964; Compton, 1985, 1998; Harshav, 2004; Kivelson & Greene, 2003, Mendelsohn, 1970). Under the Tsars, a polarity of culture and Faith emerged: a devout, rural peasantry, who continued to follow either Judaism or the 'official' Orthodox Christianity of the Empire, and, an increasingly secularised, multilingual and multicultural proletariat, the expanding bourgeois, and the ruling classes. The latter groups were concentrated in the larger, economically prosperous 19th Century cities of St. Petersburg, Kiev, and Moscow (ibid.).

Until the 1917 October Revolution, Jewish individuals were not recognized as full citizens in Russia; they were discouraged - and (often) prohibited - from travelling within Russia and living within her major cities, relegated to forced settlement in the north-central and eastern European portions of the Empire (Baron, 1964, pp. 205-6; Harshav, 2004, p. 32).

In this cultural model, *The Pale* existed as a "self-contained" Jewish Empire within the macrocosm of the Russian Tsarist empire (Harshav, 2004, pp. 32-34, 2006, pp. 11-16). In this Jewish microcosm, a separate and parallel system of government, culture, and faith flourished, beginning in the early 1800s (ibid.). The religious cultural environment centered around Hasidic Judaism and the peasantry customs consistent with the majority of the population living in rural communities at that time (ibid.)

The Hasidic movement's origin in the early 18th Century is with Ukrainian-born Israel ben Eliezer, or *Baal Shem Tov* 'Master of the Name' (Baron, 1964; Scholem, 1974, 1978). The Hasidism of the 18th Century was characterized by: its departure from an emphasis upon Talmudic orthodoxy and sacred text, devotion to the "immanence" rather than the "transcendence of God" (Scholem, 1978: pp. 176-180; Solomon, 1996, p. 48), and an enculturation of Talmudic teachings and Kabbalah mysticism (Scholem, 1978). The Hasidic tradition's origins in Eastern European peasantry is characterized by the use of story-telling, and to

a lesser extent music, as integral components in the faith teaching process (Harshav, ed., 2003; Wullschläger, 2008).

By mid-19th Century, the Pale Settlement had begun to experience an internal transformation: cultural and economic effects of growing industrialization within its territories precipitated a state of revolution in the organised practice of faith (Harshav, 2004). Whilst Hasidism continued as the dominant sect of Judaism in rural communities through the 19th Century, the Russian Jewish population in large towns and commercial cities were experiencing a cultural and philosophical revolution, characterized as the *"Modern Jewish Revolution"* (Harshav, 2006, p. 15). This cultural transformation experienced by Chagall's parents, had established itself in the Pale Settlement by Chagall's generation[12]. As a cultural movement, the *Modern Jewish Revolution* entailed a *moving away* from the historic devotional underpinnings of daily existence, towards the adoption of a Eurocentric set of secular beliefs. This re-imagined perspective emphasized replacing dogma directed towards devotional piety with a universalised secularisation of Judaic culture. Within this philosophical shift, a division continued between the rural Hasidic peasantry, and the intellectual and bourgeois Jewish communities. (Baron,1964; Harshav, 2006).

As early as 1860 - the generation before Chagall's birth in 1887 - the Jewish bourgeoisie demonstrated movement towards secularisation in their abandonment of strict devotional practices, adopting the Russian language over the Yiddish dialect, and the physical movement of the Jewish elite and academics into major Russian cities (ibid). Despite the historically anti-Semitic Tsarist legislation, the coexistence of Jewish and Orthodox Christian Russian peoples grew into a standard of cultural tolerance initiated by the 18th Century policies of Catherine II (1762-1796) (Baron, 1964). This multi-faith and multi-cultural environment continued to transform towards the period of unrest leading up to, and including, the Revolution of 1917 (ibid.). In particular, the cultural exchange between Jewish and Christian bourgeois communities occurred at both the intellectual and social level, including interfaith marriages (Baron, 1964; Harshav, 2004). This multicultural nature of the bourgeois class, combined with prosperous economic conditions in the larger Pale cities, created an unprecedented Judeo-Christian cultural integration by the late-19th Century (Baron, 1964; Compton, 1985, 1998; Harshav, 2004; Kivelson & Greene, 2003; Mendelsohn, 1970).

It is within the space between the Russian Hasidic Orthodoxy of past generations and the emerging of a contemporary European-Jewish culture proximate to the secularised West that Chagall experiences his initial encounter with natal faith.

Chagall's paternal grandfather, David Shagal, was a Torah scholar and Hebrew teacher in the town of Lyozno (Alexander, 1978; Bohm-Duchen 1998; Chagall 1989; Harshav, 2004; Wullschläger, 2008). Chagall's father, Hatskl had no formal education and worked as a manager in a Vitebsk factory (ibid.). According to Chagall (1989),

12 Changing attitudes towards the devotion to faith practice in the raising of families are reflected in Chagall's memoirs about his early life in Vitebsk (1989).

Hatskl was a pious man who attended synagogue daily. Chagall's mother, Feyge-Ita was a woman of the *Modern Jewish Revolution*: a business woman who managed a store and real estate, raised eight children, and was known for her performance of Sabbath blessings and rituals in the family home in direct contradiction to Orthodox tradition (Alexander, 1978; Bohm-Duchen,1998; Chagall, 1989; Harshav, 2004; Wullschläger, 2008).

Chagall's early faith-based education took place at a Heder school[13] for boys in Vitebsk (c. 1891-1900), until his Bar Mitzvah[14] at age thirteen (ibid.). In a passage that evokes his 1915 composition, *The Mirror* (1915) (PLATE 4), Chagall's adolescent precociousness is subdued with his reflection upon the perceived change in his interior attitude towards Hasidim:

> However, the years were passing by. It was time for me to begin imitating others, to resemble them... With every year that passed, I felt myself moving towards unknown horizons. Especially after the day when my father, wearing the tallit[15], muttered the prayer of expiation over my boyish thirteen-year-old body. What was I to do? Remain an innocent child? Pray morning and evening, everywhere I go, and say a prayer every time I put anything into my mouth or hear anything? Or flee the synagogue, throwing away the books, the holy vestments, and run through the streets towards the river?
>
> I was afraid of my future coming of age, afraid of having all the signs of the adult man in my turn, even the beard. In those sad, lonely days, these thoughts lead me to weep towards evening, as though someone were beating me or announcing the death of my parents...The [drawing room] looking glass, cold and solitary, swinging free, shone strangely...What is the meaning of my youth? As soon as I reach thirteen, my carefree childhood will come to an end, and all the sins will fall on my head. Shall I sin? I burst into loud laughter and splashed the mirror with my white teeth. (Chagall, 1989, pp. 48, 51-52)

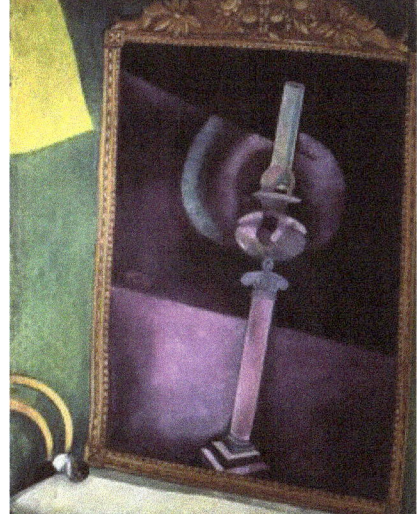

4. *The Mirror*, 1915
Oil on board, 100 x 81 cm
State Russian Museum, St. Petersburg

13 Heder School: "Elementary Education for Jewish boys began at the age of three or four, when a child spent a long day in Heder (elementary school), learning to read, (but not to write or speak) basic Hebrew text - mainly passages of the Pentateuch and the prayers - and socializing." (Harshav, 2004, p. 35)

14 Bar Mitzvah: bar = son; mitzvah = commandment (pl. mitzvot); "A male who is required to keep the religious imperatives, or commandments, of the Torah. The youth's entry into the status of bar mitzvah is celebrated in synagogue worship and through family festivities. In common parlance the term bar mitzvah is also used to refer to the ceremonies marking a thirteen-year-old boy's entry into Jewish adulthood" (Neusner & Avery-Peck, 2004, p. 13)

15 Prayer shawl; four-cornered cloth with fringe worn by adult males during morning worship (Neusner & Avery-Peck, 2004, p. 159)

Following his bar mitzvah, Chagall renounced organised Faith: "Like most of his generation, the boy shed religion overnight, and gravitated toward Russian culture." (Harshav, 2004, p. 8-9). Such rebellion against natal faith would not be unusual for a creative and inquisitive teenager, particularly a young man from a household where established dogmatic traditions were already in transition. For Chagall, this "rejection of creed" (Bohm-Duchen, 1998, p. 17) is not, however, seen as an 'abandonment' of sacred life. Rather, it is the first transformational event in the artist's century of lifespan, leading towards a universal perspective of spirituality, and the development of a religious attitude that was activated and informed by an early immersion in Hasidim.

> The loss of religion in adolescence is not always the loss of faith as such, but the product of an overwhelming desire to belong to mainstream society... religion and religious identification become casualties of socialisation...of being coerced into a secular identity. (Tacey, 2004, pp. 108-9)

Chagall's biography provides further evidence of this "adolescent separation" from his natal faith, and of the 'coercing' in the early stages of a "secular identification" with his external environment (Tacey, 2004, p. 107): The Russian State schools of the Pale Settlement were not obligated under anti-Semitic Tsarist education policy to offer places to Jewish pupils. Chagall's mother successfully challenged the headmaster at the Russian State secondary school in Vitebsk into permitting her son to attend (Alexander, 1978; Harshav, ed., 2003, 2004). Following, Chagall spent five years, between 1900 and 1906, as a Yiddish-speaking teenager in a Russian classroom with students of the Orthodox Christian faith (ibid.).

Chagall 'credits'[16] his Russian classmates with introducing him to the craft of drawing through copying printed images in magazines and books (Chagall, 1989, pp. 56-7). According to Chagall, this experience led to his pursuit of formal instruction, locally in Vitebsk, and to become a professional artist (ibid.).

Chagall's formal art education began with a place in Yehuda Pen's *School of Drawing*, concurrent with his secondary academic studies in Russian State school (Harshav, 2004; Wullschläger, 2008). The artist then travelled from his home in Vitebsk, to St. Petersburg, Russia in late 1907 where he spent three additional years studying painting under various art instructors, most prominently Leon Bakst[17], at the Svanseva Academy (Bohm-Duchen, 1998; Harshav, 2004; Wullschläger, 2008). Chagall broke with formal art training permanently in 1911[18], at age 23, after continued disagreements with his instructors about classical adherence to formal Principles of Design (ibid.).

16 Harshav (2004, p. 169) remarks that although there may be elements of the truth in Chagall's tale, the artist had been drawing and painting prior to his teens. Another interpretation, is that this particular imaginal encounter at the Russian State school stimulated a connection in the young Chagall - to the extent that he included the story years later, in his autobiography. This 'connection' clarified the realization, that he wanted *to be as* a creative individual, and thus, *he decided to become an artist*.

17 Bakst's (1866-1924) significant accomplishments as a visual artist, costume, and set designer for theatre and the Ballets Russes in are illuminated in his biography (see, Spencer, 1973). Baskt was a middle-class Jewish man from St. Petersburg. Harshav (2004) states that Baskt "converted to Christianity" in 1903 following his marriage to the daughter of Pavel Tretyakov, of the Tretyakov gallery, Moscow (pp. 182-3).

18 Chagall attended art college in St. Petersburg and, in 1911, briefly resumed classes in Paris before departing from formally training, permanently.

Funded by St. Petersburg collector and arts patron, Maksim Vinaver, who had taken an interest in Chagall's early works, Chagall was able to work as a painter in Paris between 1911 and 1914 uninterrupted (ibid.). In the summer of 1914, Chagall returned to Russia for a second time during his *Early Life* career. He was married, in 1915, to Bella Rosenfeld in a traditional Hasidic ceremony that took place in Vitebsk (Chagall, 1989). Following marriage to Bella, and later, after their immigration to France, by the mid-1920's, there are no primary source documents that directly state nor suggest Chagall to have returned formally to the regular, organised practice of his natal faith (Alexander, 1978; Bohm-Duchen, 1998; Compton, 1985; Harshav, 2004, 2006; Wullschläger, 2008).

THE DEAD MAN

In 1908, Chagall painted *Death*[19], (PLATE 5) whilst a student at Svanseva Academy in St. Petersburg (Baal-Teshuva, 2003; Compton, 1985). This painting was the artist's first significant work publicly displayed at a student exhibition in early 1910, prior to the artist's departure for Paris (ibid.). Harshav (2006, pp. 71-75) suggests that Chagall was directly influenced by "The Life of Man", a Leonid Andreev play produced in St. Petersburg in 1907.

The play concerns the life of the protagonist, "Man", and his family. Each character or group - "Man", "Wife", "The Child", "Old Women" - is assigned a generic name, or archetypal characterisation. Harshav (2006, p. 72) points out that the play utilises the stations in Man's life across five scenes: *Man's Birth* and *Mother's Suffering*, *Love*, *Wedding*, *Catastrophe* (the loss of a child), and *Man's Death*. He (2006, p. 73) argues that Chagall's exposure to this play initiated a creative response beginning with a series of 'life stations' drawings between 1907-8 which were later translated to paintings[20]. Harshav's (2006) critique of this series indicates Chagall's creative response to the subject matter:

> Chagall produced a series of paintings - in what may be called a Symbolist-Expressionist manner with a mystical aura – on crucial turning points in man's life, translated into concrete images of his own world of Vitebsk...shifting between Jewish and Christian motifs. (p. 73)

The significance of *Death* (1908) in the context of Chagall's early years in Russia, has been noted previously by art historians (Baal-Teshuva, 2003; Compton, 1985; Harshav, 2006; Meyer, 1964; Wullschläger, 2008). Chagall considered this painting to be the work which transformed his status from that of art student to professional artist (ibid.). In dating the artist's retrospective, *Death* (1908) is used by both Chagall and historians as the visual marker to the beginning of the artist's career (ibid.).

19 This painting most often appears in print titled, "The Dead Man". In preparing this manuscript, the Artist's family provided to me a list of revisions, that included the change of title here, to 'Death'.

20 Examples of these 'life-station' works include: Birth (1910), The Birth (1911), Russian Wedding (1909), and The Wedding (1911). *See Plates 6, 7, 8, 9 respectively.*

5. *Death*, 1908
Oil on canvas, 68.2 × 87 cm
Musee National d'Art Moderne, Centre Georges Pompidou, Paris

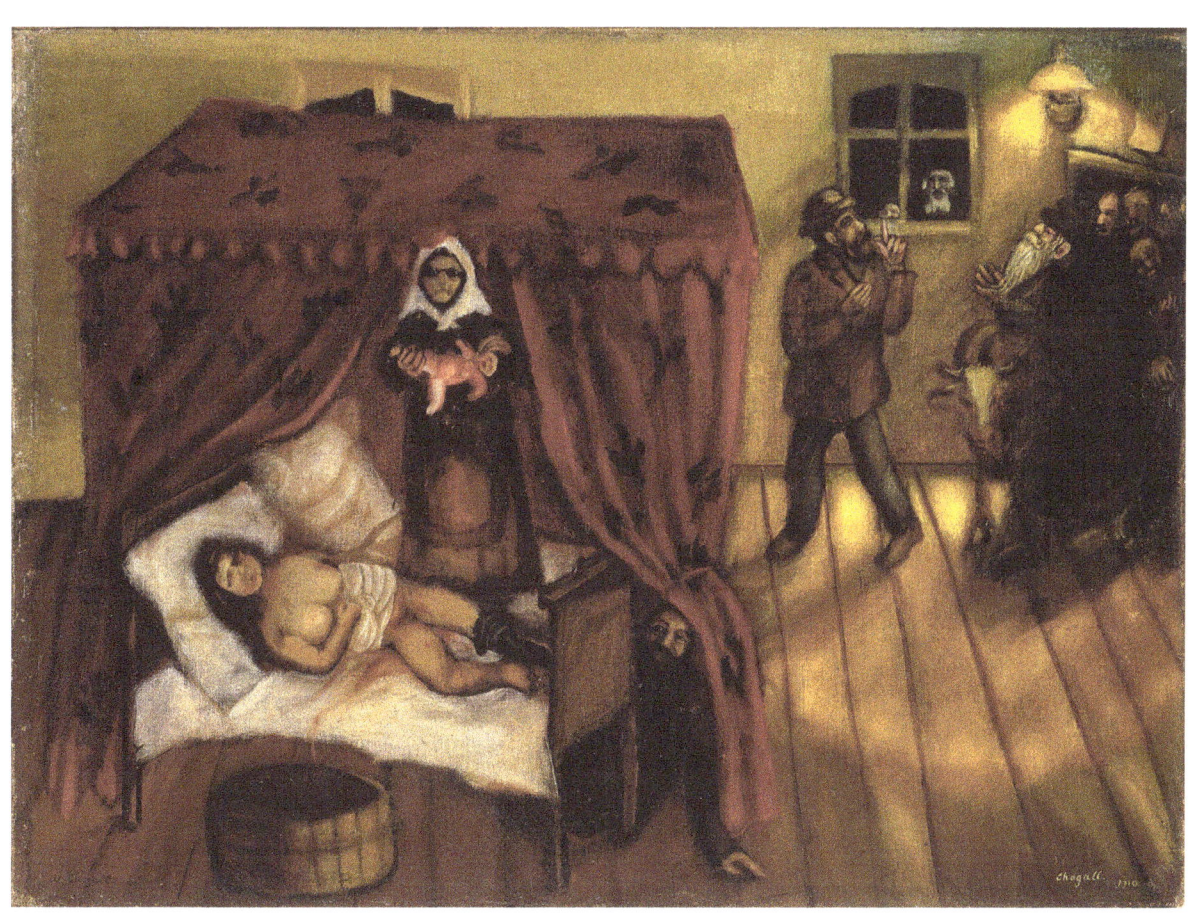

6. *Birth*, 1910
Oil on canvas, 65 x 89.5 cm
Kunsthaus, Zurich

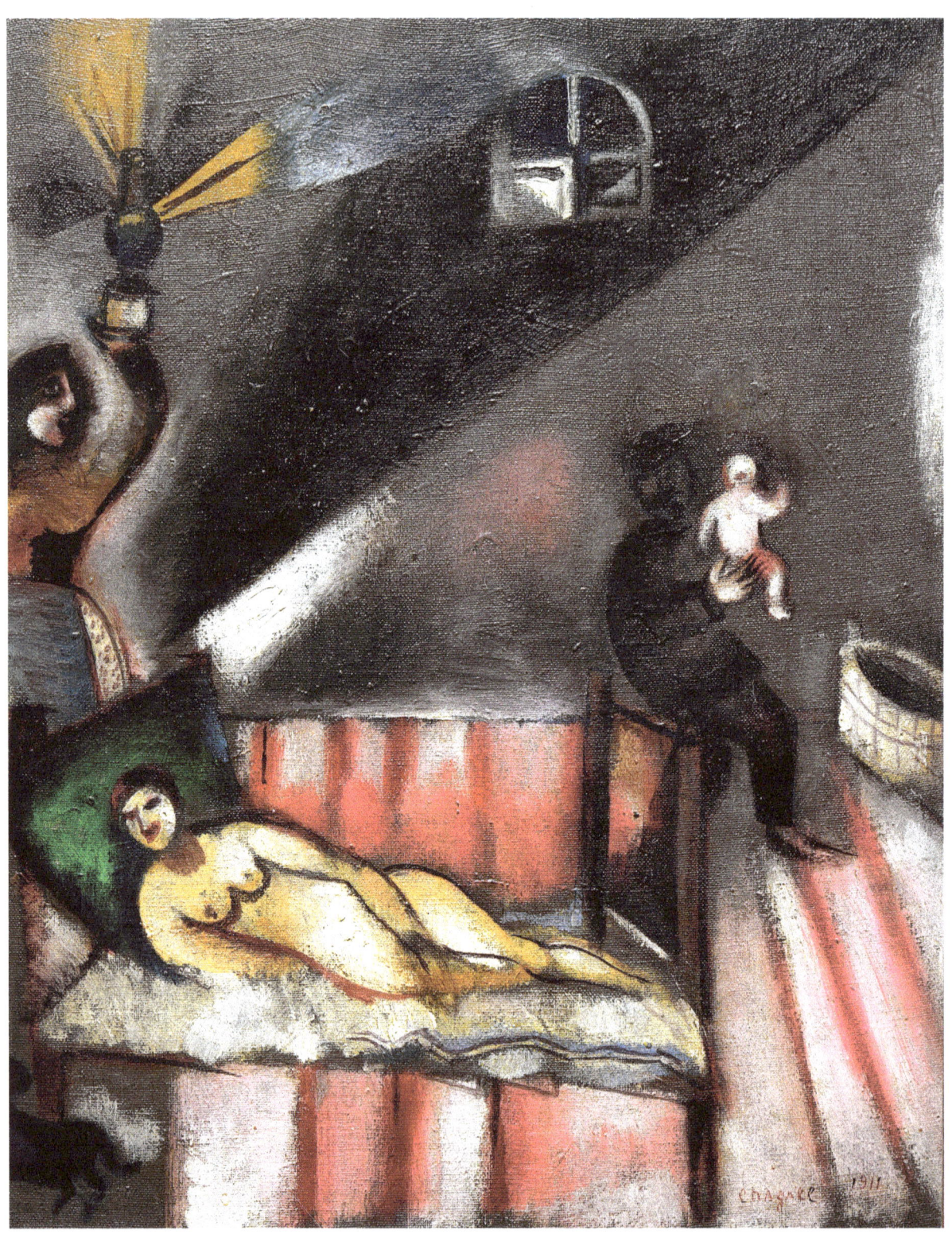

7. *The Birth*, 1911
Oil on canvas, 46 x 36 cm
Private Collection

8. *Russian Wedding*, 1909
Oil on canvas, 68 x 97cm
Foundation E. G. Buhrle Collection, Zurich

42　ON THE SPIRIT AND THE SELF

9. *The Wedding*, 1911
Oil on canvas, 99.5 x 188.5 cm
Musee National d'Art Moderne, Centre Georges Pompidou, Paris

In an interview with his (then) son-in-law Franz Meyer (1964) about the painting, Chagall emphasises, "How could I paint a street, with psychic forms but without literature? How could I compose a street as black as a corpse but without symbolism" (p. 64)?

Whilst Andreev's 1907 play presents a linear sequence of events in 'Man's' life, the artist himself chose to explore this theme in a different way. Examining the dates of the series, the theme of 'Death' emerges in 1907-8, and predates both 'Marriage', and 'Birth' in the creative process. The emergence and repetition of these paintings in Chagall's early Russian years (and, again in *Paris I* during 1911-2) provides visual evidence that Chagall was compelled to engage with themes consistent with lifespan events and development. That the initial - and *the defining* - painting of this 'Life Stations' series focuses upon the life of a man, and *begins with a death*, provides an imaginal connection through alchemical imagery. Jung states (*CW 11*):

> The "washing" refers to the *purificatio*, or to baptism, and equally to the washing of the dead body. The latter idea lingered on into the eighteenth Century, as the alchemical washing of the "black corpse," an *opus mulierum*. The object to be washed was the black prima materia: it, the washing material (*sapo sapientum!*),

and the washer were – all three of them – the self-same Mercurius in different guises. But whereas in alchemy the *nigredo* and sin were identical concepts (since both needed washing), in Christian Gnosticism there are only a few hints of Christ's possible identity with the darkness...("I will be washed") in our text is one of them. (par.423)

In the context of this first transitional period of Chagall's *Early Life*: from student to artist, and from St. Petersburg and Russia to Paris and France, the emergence of the dead man image holds a particular resonance in its definition as the 'visual marker' beginning the artist's professional career.

A SECULAR MODERNISM

Art history scholarship (Compton, 1985; Bohm-Duchen, 1998; Harshav, 2004, 2006; Kamensky, 1989; Meyer, 1964; Wullschläger, 2008) emphasises the 'critical' nature of Chagall's work during his initial years in Paris, 1911-1914, what I have termed here the *Paris I* period. It is clear that Chagall's creative output experienced significant compositional transformation when compared with his work from the early Russian years (1907-1910) in St. Petersburg. The visual experimentation with shape, the use of color, and changes in the application of perspective are attributed to Chagall's immersion in pre-war avant-garde Paris, and the confluence of artistic energies converging at the Modernist aesthetic (Bohm-Duchen, 1998; Compton, 1985; Meyer, 1964).

Chagall's connection to the early Modernist circle in Paris (Silver & Golan, 1985) was a significant and defining experience for the future of both his critical and popular successes: Guillaume Apollinaire, a Parisian art critic and avant-garde poet, met Chagall in 1910 and the two artists forged a professional friendship (Alexander, 1978; Bohm-Duchen, 1998; Harshav, 2004; Wullschläger, 2008). In a critical review of Chagall's paintings for the 1912 *Salon des Independents*, Apollinaire described Chagall's works as 'surnaturel' (ibid.). This popularized term led inaccurately to Chagall's historical association with the Surrealist movement, as the 'first' Surrealist.

Apollinaire was successful at promoting Chagall's work through his poetry and within the European critics' circles. His interest facilitated the most important professional introduction of Chagall's early career, with the German curator, Herwarth Walden. Walden later organised Chagall's first solo exhibition in 1914, at his Berlin Galerie Der Sturm (Harshav, 2004). This exhibition, Chagall's first 'one-man' show, included the painting *Homage to Apollinaire* (1911-2). The painting is an hermaphroditic image of Adam and Eve, and holds the art critic's surname in title, and within initials that appear in the composition.

Primary source documents and art history scholarship (Compton, 1985; Harshav, 2004; Wullschläger, 2008) underscore both Chagall's independence as an image-maker during his *Paris I* years, and the artist's life-long resistance to associations made between his work and any particular artistic movement or 'group' of artists. Chagall reveals:

> ...I was at last able to express, in my work, some of the more elegiac or moon-struck joy that I had experienced in Russia, the

joy that once in a while expresses itself in a few of my childhood memories of Vitebsk. But I never wanted to paint like any other painter. I always dreamed of some new kind of art that would be different. In Paris, I at last saw as in a vision the kind of art that I actually wanted to create. It was an intuition of a new psychic dimension in my paintings. (Wullschläger, 2008, pp. 135-6)

On his association with Modernism, Chagall stated, in 1958:

> I have often been asked why, in periods of different classifications of Art, I do not stress, or do so only lightly, my role in such and such a period…I like to keep silent on that point…and to leave people free to think whatever they like. One does not consciously look for an *ISM*. It comes by itself. Unconsciously, since 1908, I have looked for another realism… to find a psychic form, another reason and other plastic means for the Art of our times. (Harshav, ed., 2003, pp. 128-9)

This 'intuition of a new psychic dimension' and Chagall's ongoing search for 'psychic form' suggests a connection with the unconscious realm: *'I saw as in a vision the kind of art that I actually wanted to create'*. The artist's reflections here support the thought that, Chagall's imagery did not *originate* in a conscious (or, linear) re-imagining; Nor do his 'psychic forms' necessarily emerge solely or directly from seemingly influential external realities, such as, contact with Western European Modernism or Russian Avant-garde traditions; an ongoing professional involvement in the 'Popular' visual arts culture of the 20th Century; or, from sources of critical thought and academic scholarship concerning his early development as an artist, between 1908-1923.

Chagall's acknowledgement of the psychic state through which his work originates - independent of his external life - creates an opening to explore the presence of a religious quality in his creative process and imagery. In these formative *Paris I* (1911-14) years, an "echo of religious life" (Tacey, 2004, p. 110) begins to emerge from what is arguably Chagall's most secularised experience of environment, to that date. These images appear in the form of what I have termed the *Chagallian sacred-secular binary*, and are reflected in the paintings which contain images of Hasidic ritual and identity, Christian iconography, and Biblical allegory.

With the development of Modernist creative ideas, artists were challenged to break from traditions of the past. The compositional deconstruction of historically sacred motifs *into* secularised imagery promoted a visual reality which reinforced this 'new' set of artistic and secular ideals (Bohm-Duchen, 1998; Chip, 1968; Compton, 1985; Meyer, 1964). Observing Chagall's experimentation with sacred and secular images during his *Paris I* period reveals compositions *visually* consistent with this new ideal: It is clear that Chagall was visually responding in an aesthetic consistent with Modernism through the *technical reproduction* of sacred-into-secular visual themes during his *Paris I* years. What is also evident is that Chagall had already been exploring these visual coincidences in his notebooks and poetry as an arts student in St. Petersburg, prior to his initial contact with France and the circle of Parisian Modernism.

In 1912, Chagall painted *Calvary*, his first crucifixion painting, through re-imagining a sketchbook ink drawing of the allegorical Christ (Meyer, 1964)[21]. The artist had been working creatively with this image in his drawings and poetry since 1909. From his poetry notebook of 1909[22], Chagall writes:

> ...The Blue cupolas
> As above Christ
> I am his high pupil
> [Hanging] in tandem, we are lonely
> Forever.
> From the morning I was assigned
> My early destiny was on the cross.
> (Harshav, 2004, pp. 190-192)

This repetitive creative emergence supports the thought that, Chagall was moving through a transformative period wherein the externality of his increasingly secularised life in St. Petersburg - and then, in Paris, from 1911 - began to emerge unconsciously in his art. This imaginal residue appeared in Chagall's visual treatment of the sacred-secular binary in Paris, and, through the appearance of his *Self*-referential symbol, the Christ. To support my argument, that the 'generation point' of the *Chagallian sacred-secular* binary was present in the artist's work prior to his exposure to Modernism during the *Paris I* years (1911-14), a second series of images, *The Holy Family* (PLATES 10,11) are introduced. Meyer remarks (1964):

> At the time he painted this picture [*The Holy Family* (1910)] Chagall had become strongly impressed by icon painting. In St. Petersburg he had often visited the museums, but what he remembers as most striking were the icons in one room of the Alexander III Museum of Russian art. They were not alien, like so much of 'Western' art with which he had first an intimate contact, but Russian through and through. At the same time, they taught him how an inner spiritual reality can be rendered in a simple and telling manner. "My heart was quiet with the icons...," he wrote many decades later. (p. 90)

Wullschläger (2008) provides biographical information that supports the idea of *psychic growth* in the artist's inner spiritual reality: In 1909, Chagall became romantically involved with Thea Brachmann, and considered the relationship, "a turning point in my life" (Wullschläger, 2008, p. 83). Brachmann was a student from a prominent Hasidic family in Vitebsk, who, like Chagall, had come to St. Petersburg to study. Thea posed as an artists' model for Chagall during the course of their relationship, and Wullschläger states (2008, pp. 84-86) that she was the model for the female figures in the 'Holy Family' series of paintings. In particular, Thea appears as the Holy Mother in *The Couple* (1909) (PLATE 10).

21 This painting has appeared under different titles, in a variety of art history books. The Artist's Estate (family) used the title 'Calvary' in their manuscript edits here. Meyer (1964) states that the painting was exhibited by Walden "in Berlin, under the title *Dedicated to Christ*, now called *Golgotha*", and that, "One of Chagall's Russian drawings [of a crucifixion scene, appearing on p. 172 of Meyer's monograph] was used as the starting point for this large picture." (p. 173). This pre-1911 drawing later appears on the cover of Walden's Der Sturm periodical, in 1920 [see, PLATE 45].

22 Miriam Cendras - the daughter of poet Blaise Cendras, with whom Chagall became close during his 1910-14 years in Paris – held in her possession a series of the artist's notebooks and sketchbooks, given to her by her father, as Chagall was presumed dead during his Russian years of 1914-1922. "It contains a collection of poetry written by Chagall in Russia during 1909-10, neatly copied and precisely dated. The poems are filled with metaphors of nature and religion" (Harshav, 2004, pp. 190-1)

Meyer (1964, p. 47) notes that Chagall's use of "anti-realism" functions in accordance with Judaic laws which forbade the depiction of "images of outer reality from weakening the inner reality". In the example of the Holy Family series of 1908-1910, the artist was 'engaging' consciously at that time with imagery consistent with his 'outer reality': painting an image of his lover. The archetypal quality in Thea's depiction as the Holy Mother[23] is reflected creatively through an emerging religious affect, particularly when one considers that that both the artist and model were of a natal Hasidic faith. This intimate contact between the external and internal worlds demonstrates Chagall's early experience with archetypal emergence through the technical process of painting.

A SPIRITED RETURN

In May 1914, Chagall departed Paris for Russia (via Berlin[24]) to attend his sister's wedding with the intent on returning to France within three months' time (Bohm-Duchen, 1998; Chagall, 1989; Meyer, 1964; Wullschläger, 2008). The artist left his La Ruche (Paris) studio unlocked, with the contents - more than 100 paintings, sketchbooks, and notebooks - entrusted to his friend, the poet Blaise Cendrars[25] (ibid.). Chagall reflects in his memoirs (1989), "I didn't realize that, within a month, the bloody comedy would begin that was to transform the whole world, and Chagall with it…" (p. 115). With the outbreak of the First World War in 1914, Chagall was forced to remain in Russia for a seven-year period (1914-1922): through WWI, the Russian Revolutionary period of 1917-1921, and under the newly established Soviet government (Alexander, 1978; Bohm-Duchen, 1998; Compton, 1985; Harshav, 2004; Meyer, 1964; Wullschläger, 2008).

Chagall's memoirs (1989) indicate that the return to Russia was a difficult period for the artist professionally. Living through continental and civil wars the artist was also stationed between two worlds of art and culture - Modernism in Paris and the Russian (later, Soviet) Avant-garde in Moscow. The Russian environment, too, reflected an increasing psychic tension between that which is secular, and that which is spiritual.

Chagall returned initially to Vitebsk, and to cultural Judaism[26] where, in 1915, he married Bella Rosenfeld in a Hasidic ceremony (Chagall, 1989):

> But after the nuptial blessing, my brothers-in-law took me back to my house, while their sister, my wife, remained at her parent's home. This was the height of ritual perfection. (p. 122)

Scholarship has not defined the spiritual element, or religious attitude, in Chagall's work as a contributing factor in his professional conflicts in Russia which are detailed shortly, yet the artist's retrospective during this second Russian period (1914-1922) continued to engage

23 See, Madonna of the Village (1938-42) (PLATE 12), a re-imagining of the Holy Family motif, three decades after the original Holy Family series.

24 Chagall's first solo exhibition was held in 1914 at Der Sturm gallery in Berlin; Chagall recounts (1989): "No presentiment disturbed me enough to stop me from making a trip to Russia. I had been wanting to go for three months; I wanted to go to my sister's wedding for one thing, and, for another, to see *her* again [Berta (Bella) Rosenfeld, who would become his first wife, in July 1915]" (p. 115).

25 During this first stay in Paris, Chagall became closely acquainted with the Swiss poet Blaise Cendrars (1887-1961). Cendrars was influential in naming some of Chagall's most important early works, including, *To Russia, Asses and Others* (1911-12), and *I and the Village* (1911).

26 Whilst there is no documentation to support a return to the organised practice of faith following their marriage, both husband and wife chronicle a culturally Jewish life in Vitebsk, through their respective memoirs (Chagall, 1989; Chagall, B. 1974, 1983).

1. CHAGALL, JUDAISM, AND RELIGION

with imagery using his sacred-secular binary. Chagall's experience of secular identification with Western European culture through his early arts education and professional life - the St. Petersburg years (1906-10[27]), and *Paris I* (1911-1914) years - was arguably impacted by this unplanned re-settlement in Russia. The re-engagement with natal faith through his own marriage rites, and an increased physical proximity to organised faith in the provincial pre-Revolutionary Vitebsk, is re-imagined in the compositional plane. The spiritual element of faith emerges in Chagall's 1914-15 series of *Jewish Men* portraits, and, a new series depicting Hasidic ritual and culture.

[27] Meyer (1964) points out that Chagall's first visit to St. Petersburg as an arts student was in the winter of 1906/7. The artist continued to travel and, at times to live, between Vitebsk and St. Petersburg throughout this period.

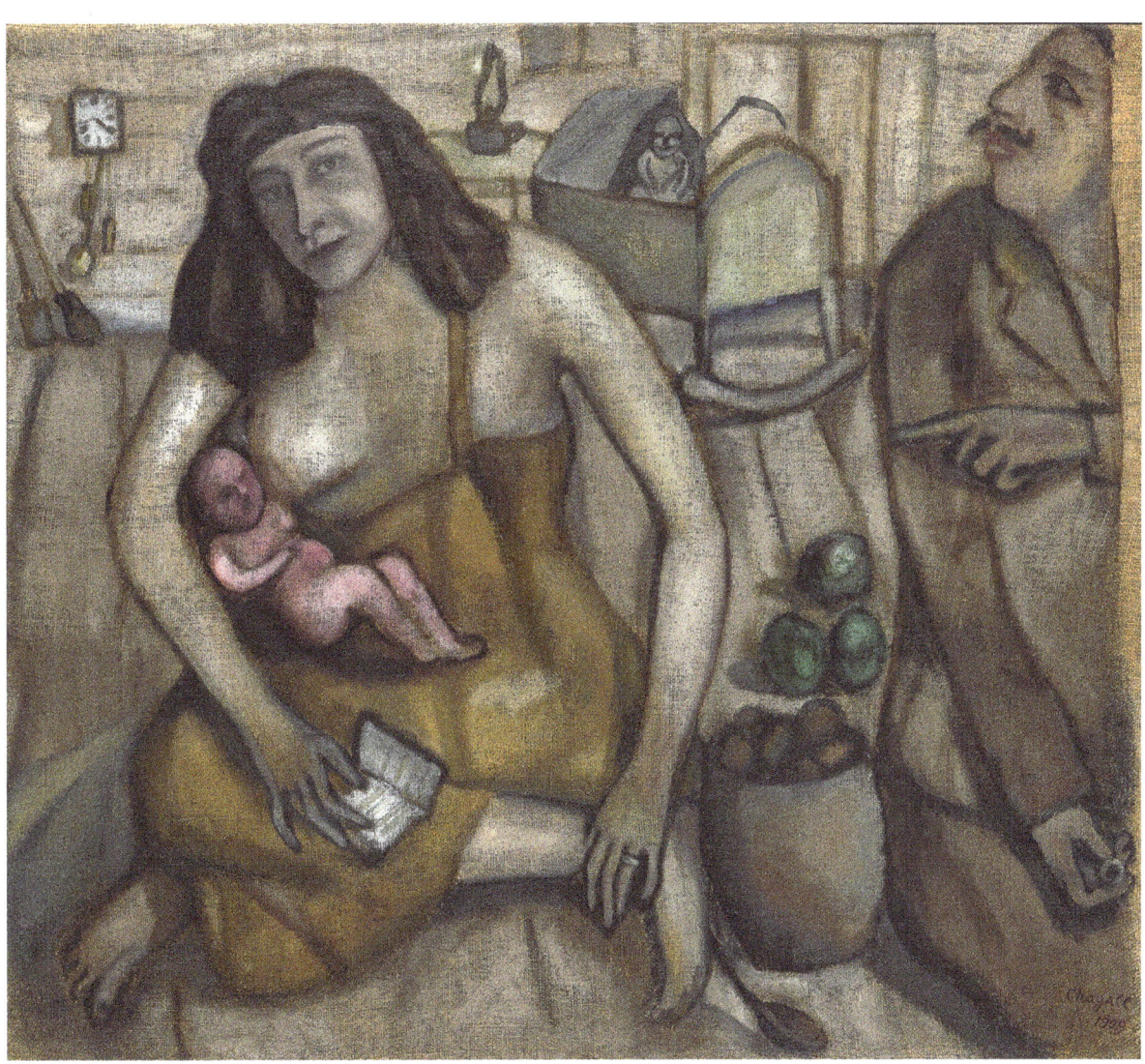

10. *The Holy Family* or *The Couple*, 1908-9
Oil on Hessian, 102.5 x 90 cm
Musee National d'Art, Paris

11. *The Holy Family*, 1910
Oil on canvas, 29 7/8 x 25 in
Kunsthaus, Zurich

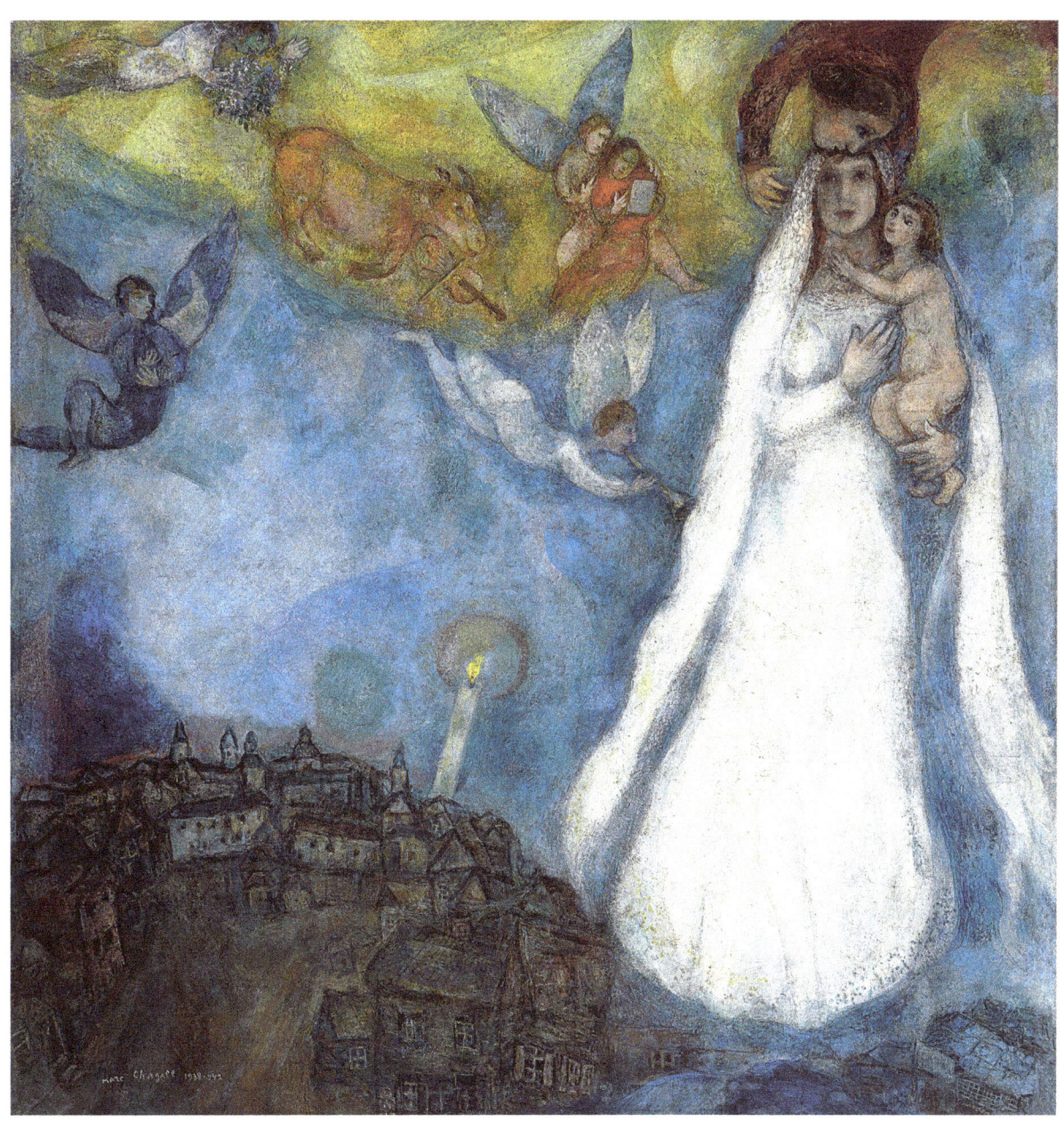

12. *Madonna of the Village,* 1938-42
Oil on canvas, 102.5 x 98 cm
Museo Thyssen-Bornemisza, Madrid

Initiating these works, *The Pinch of Snuff* (1912), is significant as a transformative image: the oil painting's date reflects a connection formed during the artist's *Paris I* period (Bohm-Duchen, 1998; Compton, 1985; Meyer, 1964). The spirit, or essence, of this image is evoked in the series of Jewish Men portraits following Chagall's return to Russia, in 1914[28]. This is not an unusual event in Chagall's creative world - the repetition of form, or the re-embodiment of spirit. This painting was, too, replicated in 1923 as a 'variant'[29] copy of the original. An undated small preliminary gouache study also exists for this piece, and the re-imaginings together form a cyclical commentary (Meyer,1964, catalogue no.128). They are a double-paned expression for observing the archetypal vista, and its living current: In the gouache study, the Hebrew translates to the term "Life"; whereas, in the oil painting of 1912 the Hebrew translates to "Death" (Compton, 1985, p. 177). The visual coalescence of a cyclical process, of an 'ending' and a 'beginning' - whether in Paris, or, later, in Vitebsk - is, in both examples, inscribed upon the same golden hexagram[30].

A second image in the series of 1914-15 is, *Jew in Black and White* (1914) (PLATE 14)[31]. Much has been written about this image, and perhaps most intriguing, is that the painting was modeled by a homeless man who sat for the artist in his mother's shop, draped with Chagall's father's prayer shawl (Meyer, 1964; Wullschläger, 2008). Virginia Haggard, Chagall's partner for seven years (1945-1952), recounts Chagall's connection with his painted images of Holy Men (1986):

> Marc told me that for years he had kept the *Rabbi* under his bed to protect it from the vicissitudes of his precarious life. He prized it as his masterpiece and said it was the closest he had ever come to the sublimity of Rembrandt...[Of the three copies he made] He called these copies "variants" although they were almost exact replicas...In the case of the *Praying Jew*, his favourite work, this meticulous copying was certainly not distasteful to him; perhaps he enjoyed going through the copying a second and third time, trying to probe its mystery. (pp. 61-2)

Whilst Chagall stated that he copied this image on three occasions to supplement income (ibid.), Haggard's observations of an intimate 'relationship' with this image, and the familial contact supporting its creation, suggests a meaningful connection to the subject, beyond the material realm. The imaginal-as-possession transcends to the symbolic through the artist's treatment

28 Harshav (2006) singularly argues that the 1912 oil is dated incorrectly - as Chagall often did not date his pieces until years after their completion - and that this work belongs to the 1914-1915 'Jewish Men' series in Vitebsk.

29 Chagall used the term 'variant' to describe the copying of a painting. There are a number of instances of this practice – and one can imagine the surprise of the collector or auction house to have (later) discovered that an 'original' had another 'original', a twin separated by years, or even, decades, as in the example of *The Pinch of Snuff* (1912 and 1923). The color plate (number 13) is of the 1923 version, a 'variant' of the 1912 composition, and reflects the Hebrew term 'Death', here, seen as a re-birthing of the cycle of the image.

30 The hexagram's archetypal nature transcends organized systems of belief, thereby underscoring the transformative quality of this life cycle image.

31 This painting has also appeared in print as, *The Praying Jew*, and *The Rabbi of Vitebsk*. The Artist's Estate (family) noted for the title to be as it appears here in the text, *Jew in Black and White*. Meyer (1964) notes that, of the 'Jewish Men' series of 1914-15, "The Praying Jew [*Jew in Black and White*] is the only one of the 'old Jew' pictures with a religious theme'" (p.221).

as a personal 'icon'³²: The painting not only compositionally reflects an icon; it is, *as an icon*, protected and revered. This individualised re-framing of the process of prayer - through a tangible repetition and re-working of the form - is consistent with sacred archetypal expression (CW12: 19), and in particular, that such as found within the iconographic image-making:

> The icon painter, like any human being, according to St. John Damascene, is a third type of image: he is, 'created by God in his likeness'. Therefore, he carries the divine image within himself in the sense of an ontological gift, while he is God's likeness in the sense of his potential, his capacity for spiritual perfection. (Tarasov, p. 183)

Jung remarks upon the similarities between mandala creation and the significance of icons (*CW:9i*):

> Usually the mandalas express religious, i.e., numinous thoughts and ideas, or, in their stead, philosophical ones. Most mandalas have an intuitive, irrational character and, through their symbolic content, exert a retroactive influence on the unconscious. They therefore possess a "magical" significance, like icons, whose possible efficacy was never felt by the patient. In fact, it is from the effect of their own pictures that patients discover what icons can mean. Their pictures work not because they spring from the patients' own fantasy but because they are impressed by the fact that their subjective imagination produces motifs and symbols of the most unexpected kind that conform to law and express an idea or situation which their conscious mind can grasp only with difficulty. (par. 645)

The presence of Chagall's religious imagery and themes during this transitional, and, increasingly secular, period in Russian history supports the observation that the artist's creative output maintained an individualized perspective, within (and seemingly, against) the collective current. Tacey (2004) reflects upon the place of internal spirituality, or religious attitude, in a model of secular thinking:

> By imposing secular perspectives on literature, academic study has the effect of repressing and even destroying the spiritual life of literary materials, which is especially harmful to artists for whom spiritual content is important. (p. 57)

Chagall's aversion to the intersection of politics and art, such as, Lenin's images of "Monumental Propaganda" (Guerman, 1979, p. 12), is evident in the artist's memoirs of life in Russia, in the years following the October Revolution (Chagall, 1989):

> Russia was covered with ice. Lenin turned her upside down the way I turn my pictures... The black lettering on the morning posters made me sick at heart...I can forget you, Vladimir Ilytch, you, Lenin, and Trotsky too...Instead of painting my pictures in peace, I have founded a School of Fine Arts... (pp. 135-136; 138)

32 Meyer (1965) observes that "For Chagall what counted was not the specific, dogmatically and iconographically defined statements of the individual motif, but its fullness of statement in itself, which [in the example of Orthodox Icons] it had attained through the long history of Russian Christian art and which overlies its iconographic significance like an aura. For Chagall, each of these motifs was a key to the world of symbolic expression; though it only becomes effective in his sense when released from its usual context and imbued with new life in a new context." (p. 91)

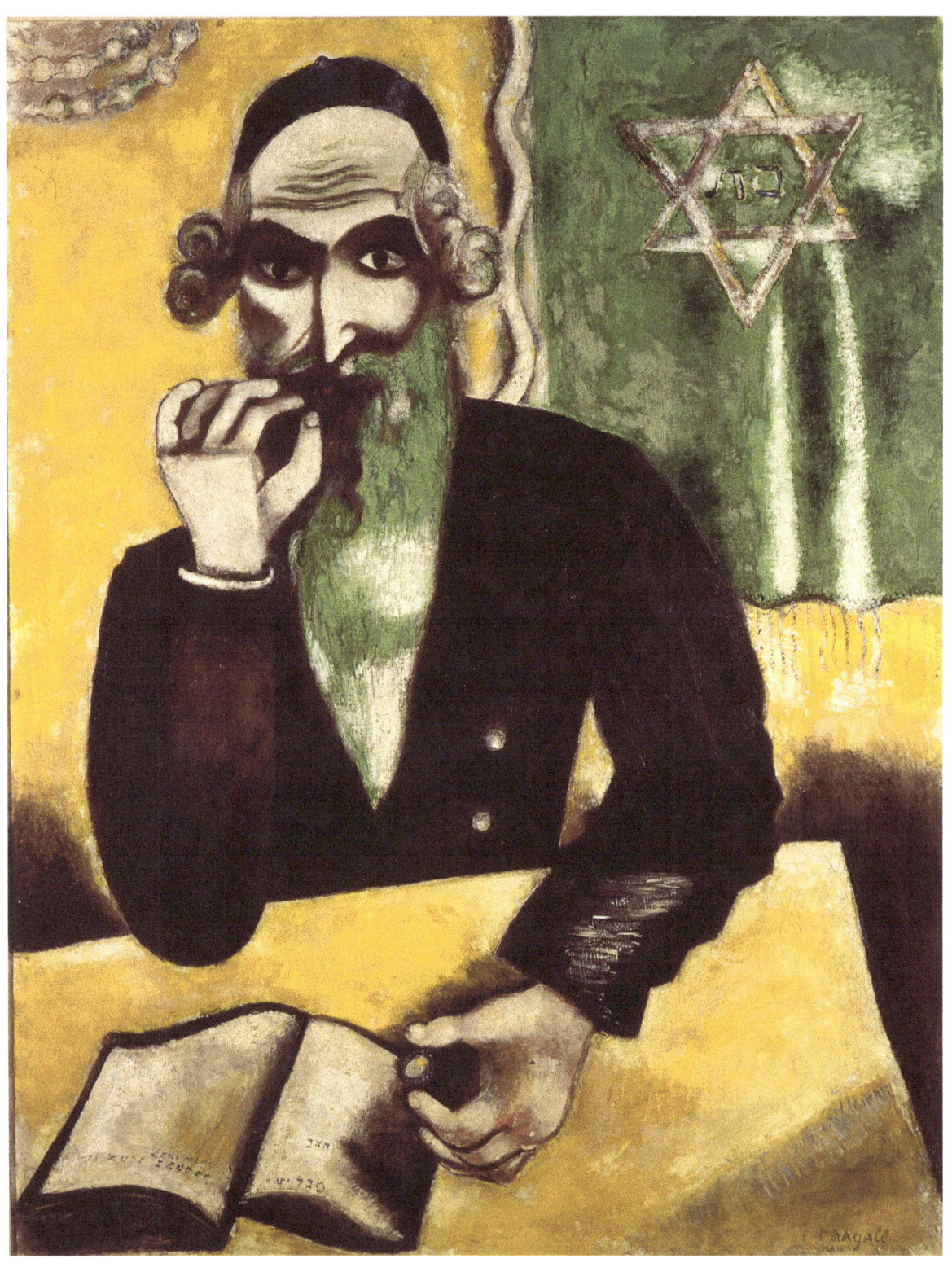

13. *The Rabbi*, 1923-6 (artist's 'variant' of, *The Pinch of Snuff*, 1912)
Oil on Canvas, 117 x 89.5 cm
Kunstmuseum, Basel

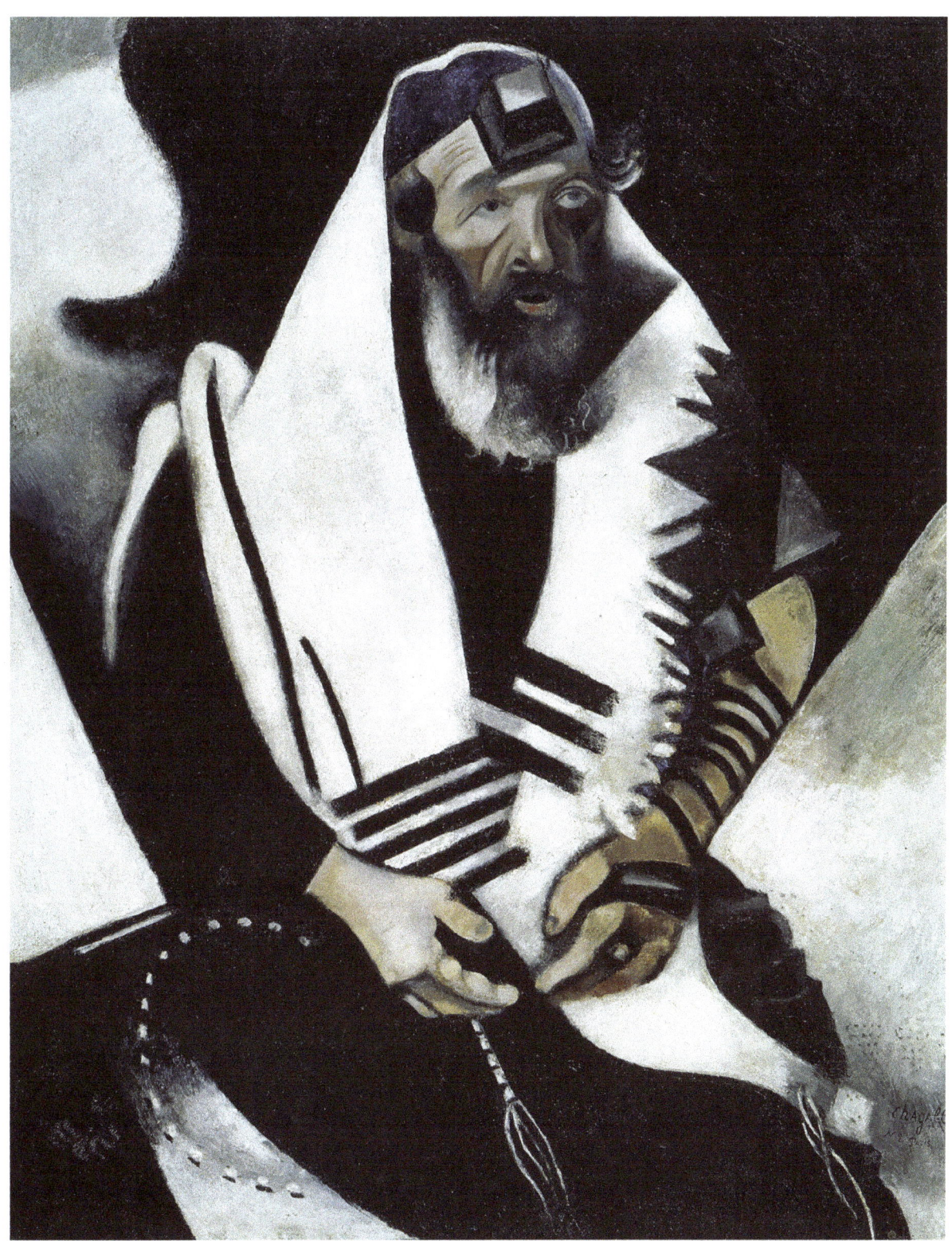

14. *Jew in Black and White*, 1914
Oil on Canvas, 104 x 84 cm
Kunstmuseum, Basel

In his *Later Life*, Chagall refers to his *Russia II* years (1914-1922), as "The most productive years of my whole career" (Baal-Teshuva, 2003, p. 75). Considering the historical facts and personal circumstances encountered by Chagall, this observation is perhaps more revealing as to the productivity of his internal journey, from the identification with European culture and the early Russian Revolutionary zeal, to a disillusionment with secular society's absence of religion, in art and life. Tacey (2004) observes that:

> Beneath the secular persona, there are vague but real resonances, memories and echoes of a religious life, which may serve as a basis for a renewal of faith and spiritual identity at a later stage. As the individual enters maturity, he or she becomes aware of a lost heritage or memory, which continues to resound in the mind or the heart even though a different path has been taken. (p. 110)

THE THEATRE OF RELIGION

Chagall's activity in the newly established Revolutionary government was significant: Initially, he worked as the Commissar of Arts in Vitebsk (1918-1920) and following, as the Artistic Director for two Yiddish theatre companies in Moscow (Bohm-Duchen, 1998; Chagall, 1989; Compton, 1998; Harshav, 2004; Kamensky, 1989; Viedlinger, 2008; Wullschalger, 2008). Concerning the historic underpinnings of the artist's natal faith, Chagall's *Russia II* years, 1914-1922, are significant for the fact that the 1917 Revolution radically changed the legal and political standing of Jewish Russians, temporarily reversing the Tsarist legacy of anti-Semitism. Harshav (2004) comments upon the political and personal shifts that occurred for Jewish Russians:

> A special sense of freedom and participation as equals in the new regime was felt by young Jews, who were liberated from their isolation and second-class citizenship and the need to be trapped into the category "Jewish"; since religion was abolished (and they rejected religion altogether)…they were now Russians, sanctioned by the regime. (p. 241)

Chagall was appointed the Arts Commissar[33] of Vitebsk in August 1918 by Anatoly Lunacharsky[34], following his written proposal for a new arts college (Harshav, 2004). This appointment permitted Chagall to establish both an arts museum and an art and design school that opened in Vitbesk in January, 1919 (ibid.). In his 1918 proposal for the school, Chagall evokes a 'secularised' universality in his appreciation of arts awareness:

> The People's Art College in Vitebsk, fulfilling the needs of the whole Western Land, is a ripe necessity, especially since our Revolutionary time compels us with unusual force to undertake the authentic development and education of the people's knowledge and talents that have been dormant until now. (Harshav, 2004, p. 247)

33 Chagall's official title was 'Plenipotentiary for the Affairs of Art in the Province of Vitebsk'.

34 Anatoly Lunacharsky (1875-1933) was appointed People's Commissar of Enlightenment (Ministry of Education and Culture) by Lenin in 1918.

The collective shift towards a secularised universality during the early years of the Revolution is exemplified by the reversal of aforementioned laws concerning Jewish students. Harshav remarks that (2004):

> [Chagall's art school] was not confined to the Jewish community but was a general Soviet school conducted in Russian, sanctioned by the state. Still, the majority of the students and most teachers were Jews... Chagall himself pointed out that Vitebsk was a Jewish city and the College must emphasize the development of artistic talents among the Jewish masses. (p. 246)

Whilst director, Chagall appointed to teaching posts artists he had previously known, as an arts student in St. Petersburg (Bohm-Duchen, 1998; Harshav, 2004; Meyer, 1964). In letters exchanged between Chagall, Anatoly Lunacharsky and Soviet Party officials (Harshav, 2004), it is observable that the appointments of El Lissitzky and Kasimir Malevich were not as considered, in hindsight, by Chagall: Their theories of Constructivism and Suprematism, respectively, concerned a structured rationality in their approach to design, and were, therefore, in stylistic opposition to Chagall's creative perspective (Bohm-Duchen, 1998; Harshav, 2004). Malevich usurped Chagall's position as Headmaster of the arts college in 1920, and the academy was renamed in favor of Malevich's Suprematism (ibid.). It was later closed by the Soviet Government in the mid-1920's (ibid.).

Between 1919 and 1920, whilst working at the People's Art College in Vitebsk, Chagall took on a brief posting as set designer for the Theatre of Revolutionary Satire (*Terevsat*) (Bohm-Duchen, 1998, 1998a). Unlike his well-documented theatre work with the Moscow Yiddish Theatre (1920-1), Terevsat was a theatre company devoted to the exploration of the satirical genre within the newly formed Soviet State (ibid.). At Terevsat, Chagall created an unprecedented ten set designs in one calendar year, before the company moved to Moscow in 1920, and Chagall with it (ibid). This historically overlooked-in-print tenure in a secular, multicultural setting was Chagall's initial encounter with a 'living' artistic production, for theatre audiences[35].

In 1920, Chagall was invited by his biographer, Abram Efros (Efros & Tugendhold, 1918) to join the Moscow State Yiddish Chamber Theatre (GOSET) as artistic director (Bohm-Duchen, 1998, 1998a). In the climate of cultural and religious freedom which emerged during the early Revolutionary period, GOSET - originally a provincial Yiddish-language theatre company - developed into a Modernist experimental company that sought to integrate themes of cultural Judaism with the Bolshevik, and later, Soviet ethos (Goodman, 2008a).

From examination of his theatre design diagrams, the idea is formed that Chagall sought to imbue the GOSET stage with imagery capable of reproducing the numinous quality associated with the expression of a heightened religious attitude. His choice in imagery reflects his sacred-secular binary through use of provincial shtetl life imagery, Hasidic figures, and Christian motifs, including images of Orthodox churches, and the Crucifixion. This visual expression

[35] This interest in the experience of 'making a stage' would continue for the artist, throughout his lifespan, and includes, the GOSET theatre productions in Moscow, and his post-wars set and costume design commissions for the New York and Paris ballet and opera companies.

is reinforced in Chagall's creative decision to convert the performance stage and the theatre walls into a *living painting space.* Such transformation created a 'whole' environment wherein the members of the theatre company - as well as the audience - were active participants in the visual experience of the painted mural container. The audiences of the 1920-21 GOSET season found the unique visual immersion rewarding, and assigned in name, the concept of "Chagall's Box" to the theatre house (Compton, 1998a, p. 13, 1998; Wullschläger, 2008, pp. 260-1).

Chagall's Box is comparable to a "temenos", or sacred space, wherein the unconscious may be explored (*CW 12*: pars. 63, 170-1, 177). Through the *transcendent function* of imaginal space, Chagall's imagery associated and re-created into a three-dimensional experience. In this paradigm, the psychic interplay between the container of the mural art, and the living stage performance is amplified through the collective audience engagement in the theatre production.

"Temenos" is most often interpreted through its function as a sacred religious space, "reserved for a god" (*CW 12*: par. 63n.6). In the example of the GOSET murals, the context of the theatre experience creates a secularised paradigm: The numinous visual content expressed by the artist is experienced by the actors and their audience separately, and simultaneously, independent of organised faith. The transformative capacity of the space is related to the experience from *within* the process and product of The Arts.

Chagall's Box is the initial example of what I have termed a *Chagallian Temenos site*, wherein the artist's sacred-secular binary is recreated in the physical plane, and experienced by an audience through immersion in an architectural environment.

Chagall's tenure at GOSET was successful, and as stated, well-received by the Muscovite theatre audiences. The artist's appointment as creative director was dissolved, however, after only one season following a series of stylistic conflicts with the members of the GOSET administration and the theatre director, Aleksei Granovsky (Chagall, 1989; Compton, 1998a, Harshav, 2006). For Chagall, this break, and separation, was similar in tone and circumstance to the conflict he experienced with his staff at the Vitebsk School of Fine Arts, who were, by the 1920's, exploring the imported European Modernist expression of abstracted form, and the concept of aesthetic utilitarianism. Following the Revolutionary years, the GOSET company continued to transform the quality of its staging of collective consciousness as the political geography in Moscow - and Russia - turned towards the stage of the Soviet State (ibid.).

Chagall's 1920-21 appointment as creative director for the GOSET theatre was an observable turning point in his professional career, as it marked the final creative work he would accomplish in Russia before immigrating to France in 1922. Chagall's memoirs reflect disillusionment at that time with his secular life in Soviet Russia (1989):

> I've had enough of being a teacher, a director. I want to paint my pictures... You see my friends, I'm unhappy here. The only thing I want is to paint pictures, and something more. Neither Imperial Russia nor Soviet Russia needs me. I am a mystery, a stranger to them. (pp. 169-70)

1. *Introduction to the Jewish Theatre* | 2. *Music, Dance, Theatre, Literature* (between the windows) | 3. *The Wedding Feast* | 4. *Love on the Stage* (exit wall) | 5. Ceiling | 6. Stage

15. *Chagall's Box* Mural Layout for GOSET, 1921
India ink and watercolor diagram, 7 x 7 cm
(Goodman, S.T., ed., 2008: 107)

16. *The Little Goat*, 1921
Sketch for the stage set of *Comrade Klestakov*
Pencil, black ink, gouache and watercolor on paper, 29.2 x 35.6 cm
Musee National d'Art Moderne, Paris

17. Sketch for the stage set of *Baladin of the Western World*
Pencil, black ink, gouache, gold and silver paint on paper, 40.7 x 51.1 cm
Musee National d'Art Moderne, Paris

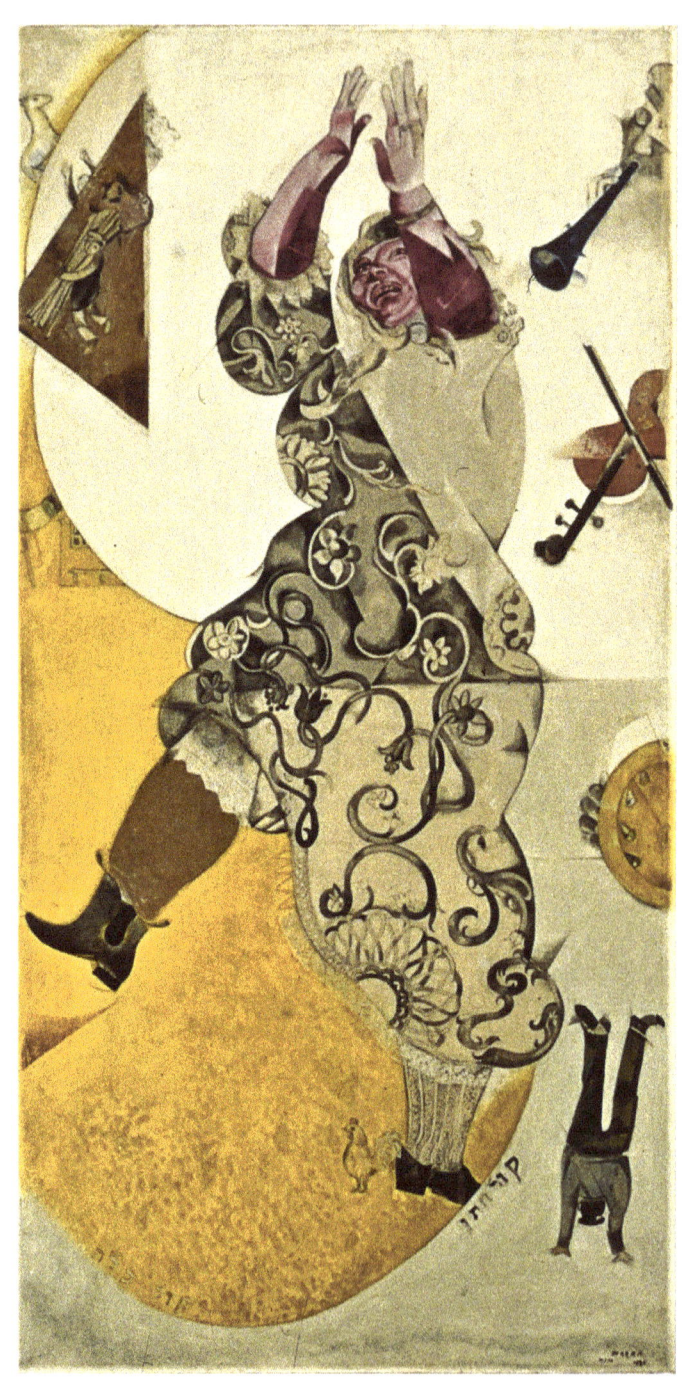

18. *Dance*, 1920
Tempera, gouache and kaolin on canvas, 214 × 108.5cm
Tretyakov Gallery, Moscow

Chagall's *Russian II* years (1914-1922) were significant for the observable fortification of the artist's religious foundation and creative lens through which would emerge a body of work reflecting the transformative process. In 1922, at 35, Chagall departed Russia for the second and final time, entering into his Mid Life period (1923-1951), and, his new professional career as a 'famous' artist (Chagall, 1989):

> My good friend the poet [Ludwig] Rubiner wrote from Germany: "Are you alive? They say you were killed in the war. Do you know you are famous here? Your pictures have launched Expressionism." (p. 169)

During Chagall's seven years in Russia - and unknown to the artist, until 1919 - the paintings from his *Paris I* years had made him a sought-after creative individual in Western Europe[36] (Bohm-Duchen, 1998; Harshav, 2004; Meyer, 1964; Wullschläger, 2008). *Calvary* (1912), *To Russia, Asses, and Others* (1911), and *Dedicated to My Fiancée* (1911) were exhibited at the First German Salon of 1913, and subsequently, formed the basis for the artist's first solo exhibition in 1914 at Der Sturm Gallery in Berlin (ibid.) Perhaps more than a coincidence, is the thought that, this group of paintings are most significant for their sacred-secular transformative imagery - the Crucifixion in *Dedicated to Christ*, a transmorphic horned creature in *Dedicated to My Fiancée*, and a decapitated figure floating above the dome of an Eastern Orthodox church in *To Russia, Asses, and Others*.

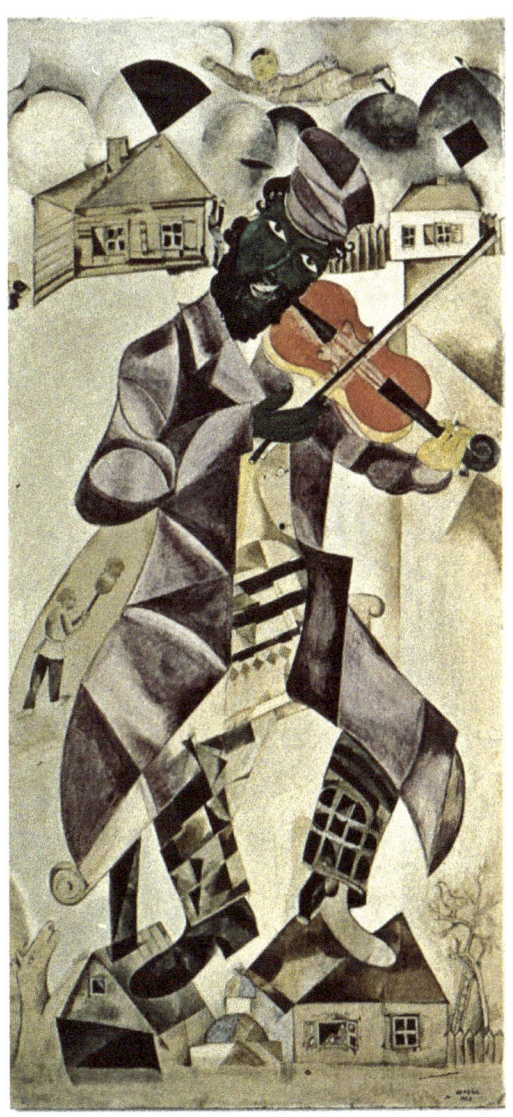

19. *Music*, 1920
Tempera, gouache and kaolin on canvas, 213 × 104 cm
Tretyakov Gallery, Moscow

36 The contents of Chagall's Paris studio had been entrusted to Chagall's friend, Blaise Cendrars, during his seven years in Russia (1914-1922). The studio space was taken apart following Chagall's extended leave in Russia, and the paintings unaccounted for by Cendrars. What happened to its contents are unclear, though historians agree that following the Der Strum exhibition in 1914, Walden and his wife as well as Cendrars were involved in the dissolution and sale of Chagall's collection of work from that period. This process was done without the consent or knowledge of Chagall, who was thought to be dead at that time. Haggard (1986) and Alexander (1979) write about this loss of Chagall's art and the artist's 'superstitious' views about the Paris studio event. It was the second time in his *Early Life* period that Chagall had experienced a loss of his art: In St. Petersburg as a student, the artist had turned over a group of canvases to a framer, who had stolen the art work. Chagall's desire and need for the reproducing of these 'missing works' is reflected in the presence of Chagallian 'replicants' for multiple lost compositions. The majority of these paintings were located subsequently in Walden's wife's personal collection as well as throughout France and Germany. Chagall received a small compensation based on their valuation at the time of their disappearance, and a limited number of the paintings were returned to his own collection.

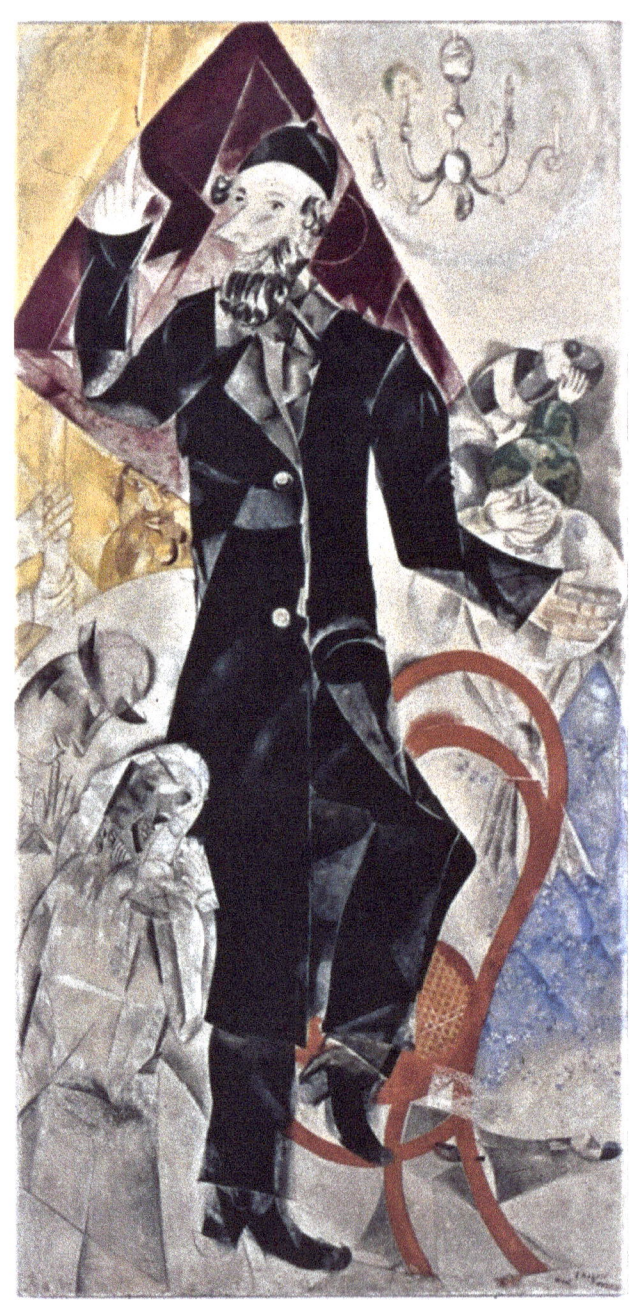

20. *Drama*, 1920
Tempera, gouache and kaolin on canvas, 212.6 x 107.2 cm
Tretyakov Gallery, Moscow

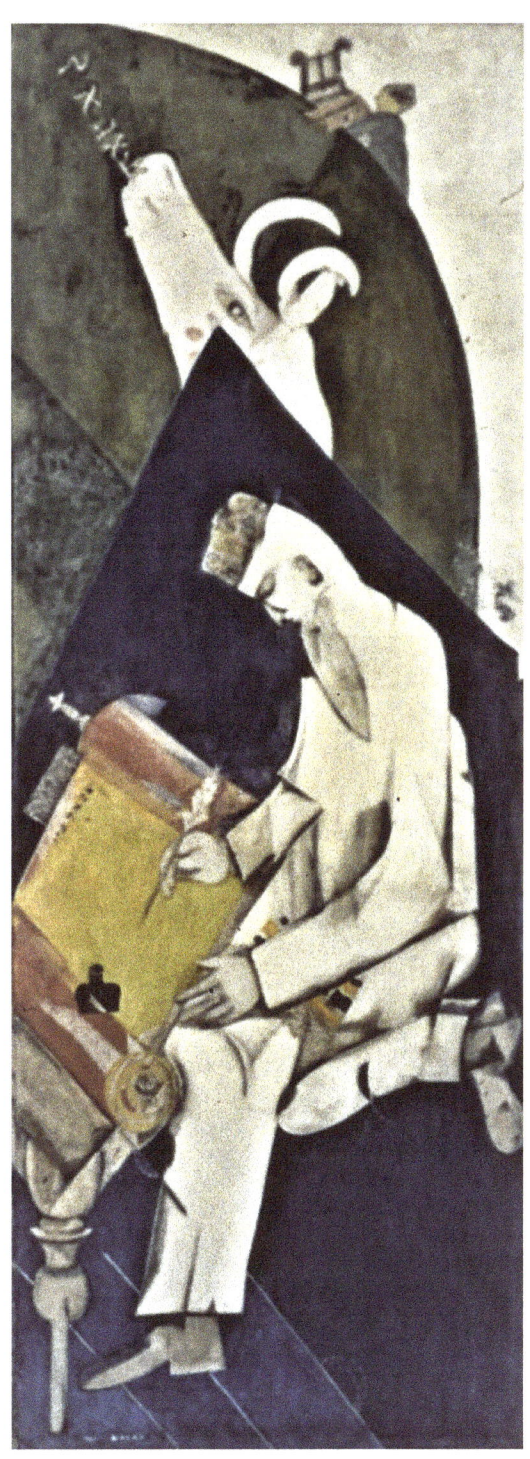

21. *Literature*, 1920
Tempera, gouache and kaolin on canvas, 216 x 81.3 cm
Tretyakov Gallery, Moscow

2. TRANSFORMING IMAGES

I am against the terms "fantasy" and "symbolism" in themselves. All our interior world is a reality – and perhaps more so than our apparent world. To call everything that appears illogical, "fantasy", fairy-tale, or chimera would be practically to admit to not understanding nature. (Chagall, 1944[1])

Earlier, I wrote about Chagall's exhibition at the Der Sturm Gallery in Germany, which was hung in 1914, during a period of significant external change for the artist: He had been living in France since 1911, and had journeyed back in the summer of 1914, to Russia to celebrate the wedding of his sister in Vitebsk. His three-month visa expired during this visit, and was unable to be renewed. Thus, what began as a short holiday, became eight years, until 1922, wherein the artist was contained within Russia whilst the First World War was fought, the Revolution erupted, and the Soviet State was established.

During what I have termed this *Russia II* period, Chagall's connections with his French circle stopped. Following the First World War, it was thought by his Parisian contemporaries that Chagall had died in the conflict. Until 1919, Chagall did not have contact with the Parisian group of artists with whom he shared studio space at La Ruche Studio, nor the German Gallery owner Herwarth Walden. Walden, who had organised Chagall's first solo show in Berlin, in 1914, held

1 Chagall in an interview with James Johnson Sweeney, (Harshav, ed., 2003, p. 82)

at that time, a significant collection of Chagall's *Paris I* work, "forty paintings and 160 gouaches" (Haggard, 1986, pp. 74-5).

In 1919, Chagall received a letter from his friend in Paris (Chagall, 1989), the poet Ludwig Rubiner. Rubiner wrote to Chagall with the hope of ascertaining his whereabouts and more specifically, trying to find out if the artist was indeed alive or dead (ibid.). Rubiner's letter stated that in the years that Chagall had been living in Russia, his works had been noticed, and become sought after, first in German, then Parisian art circles (ibid.). The German Expressionist movement was forming and growing between the wars, and Chagall's work resonated with the German Expressionists, Ernst Kirchner and Emile Nolde, whose manifesto dictated a 'return' to naturalism through observational painting outdoors, and compositions that dealt with 'the symbolic' in landscape imagery (Chip, 1968: 146-192; Fer et. al, 1993, Harrison et. al, 1993). Rubiner's statement to Chagall exclaimed that his "paintings had launched [German] Expressionism", and that Chagall was now a "famous artist" (Chagall, 1989, p. 169).

The paintings to which Rubiner refers are the series that Chagall completed between 1911 and 1914 whilst living in Paris. The paintings were initially exhibited in the 1912 Salon Des Independents in Paris, Chagall's first and successful encounter with critical and public reception (Bohm-Duchen, 2001). Later, this group of paintings formed the foundation of the artist's first solo exhibition in Berlin. The 'major works' of this group included four works completed in Chagall's first year in Paris: *I and the Village* (1911), *To Russia, Asses, and Others* (1911), *Dedicated to My Fiancée* (1911), and *Homage to Apollinaire* (1911-12). *Calvary* (1912, Cover Plate), which Walden had renamed 'Golgotha' for exhibition purposes (Meyer, 1964) will be explored individually, in *Chapter Five: Chagall and the Image of Christ*.

The imagery in these paintings is consistent with the appearance of Chagall's sacred-secular binary, and specifically, evokes the characteristics of transformative images through form and compositional arrangements. It is through these 'transformative marker paintings', that I shall examine the types of archetypal images which emerged during critical periods of Chagall's lifespan development.

THE LANGUAGE OF IMAGERY

The fact that I made use of cows, milkmaids, roosters and provincial Russian architecture as my source forms is because they are part of the environment from which I spring and have undoubtedly left the deepest impression on my visual memory of the experiences I have. Every painter is born somewhere. And even though he may later respond to the influences of other atmospheres, a certain essence – a certain "aroma" of his birthplace clings to his work. But do not misunderstand me: the important thing here is not "subject" in the sense of the pictorial "subjects" that were painted by the old academicians. The vital mark these early influences leave is, as it were, on the handwriting of the artist. (Chagall, 1944, in Harshav, ed., 2003, p. 83)

The use of animal imagery in Chagall's works is most frequently associated with his connections to a rural upbringing in the Pale of Settlement,

and his immersion in the Hasidic culture of the late 19th Century. The Yiddish language is at the centre of the Pale culture. Harshav (2006) explores the concept of language in Chagall's art through the appearance of Yiddish idiomatic phrases which frequently include references to animals. He points to the development of a visual language in Chagall as a means to communicate elements of these idiomatic expressions (ibid.). This development in the artist's *Paris I* (1911-1914) compositions appears as an extension of the "avant-garde language" and is consistent with the confluence of Modernist ideals in European capitals at the beginning of the last Century (Harshav, 2006, pp. 35-6).

A paradigm within Chagall's sacred-secular binary concerns the compositional plane and visually diagrammatic image placement. The diagrammatic representation of Semitic speech patterns are appropriated through a hierarchical, and back-and-forth motion (Norris, 2007). This is different than the 'linear' top-to-bottom or point-to-point diagrammatic model that is typical of the Germanic languages (ibid). (The verbal process of 'moving over' or 'around' the idea in Semitic speech, versus, 'getting right to the point', in Germanic speech, is illustrated.) These linguistic patterns are culturally-oriented phenomena, and similar patterns emerge in Oriental and Romance languages that feature circular, and diverted linear traces, respectively, within the communication of ideas through conversation (Norris, 2007).

In the context of a visual dialogue, or *speaking through image*, the imprint of faith is present through the Semitic (Hebrew) and Iconographic language patterns that appear in Chagall's compositional placement and relationships between forms. This is particularly evident during - and in many examples, following - the *Paris I* period. Between 1911 and 1914 the first evidence of a breakdown in Chagall's picture plane emerges, and the features of 'suspended' animation and hierarchical perspective - consistent with Semitic and Iconographic language - appears in Chagall's communication of the compositional space.

Harshav (2004, pp. 9-17) discusses Chagall's use of spoken languages, beyond that of visual semiotics particular to Yiddish discourse (Harshav, 1990), and idiomatic expressiveness. Chagall's use of the 'living' language was verbally trilingual: He understood life through Yiddish, Russian, and French, though the concept of *fluency* in the understanding of the term as it refers to, *the ability to read and write with ease* is difficult to confirm. I make this point here, as from the *Paris I* stage forward (from, 1911), the artist practiced 'writing' into his works. He wrote into his compositions using Yiddish, Russian, and Hebrew[2] (Harshav, 2004, 2006; Pearl, 2011).

The idea of 'writing into' a work of art draws comparison with what I have mentioned regarding the nature of the iconographic image making

2 Chagall studied Hebrew inconsistently in his early youth at Heder school, and was thus able to reproduce lettering in a simplistic manner, enough to convey meaning (Harshav, 2006, p. 35). Lydie Pearl, in, *Chagall and the Letters of His Name* (2011), presents the thesis that the artist utilized the shapes of the Hebrew alphabet in his imagery, to underscore meaning. She demonstrates, with an imaginal superimposing of Hebrew alphabet characters, that figures (and forms, generally) structurally resonate - and are thus 'shaped' – with the presence of the Jewish Faith. Pearl's (2011) observation is original, and consistent with Harshav's (2006) statement concerning Chagall's familiarity with Hebrew lettering. I have not found corroborating primary source documents that speak directly about this aspect of the artist's creative process; However, Pearl's (2011) visual argument is compelling, and the thought that an imaginal path linking form and meaning is possible through the superimposing of the language of Chagall's natal faith, is significant. Such an observation (Pearl, 2011), suggests a further psychic connection to the language of sacred imagery – and sacred text - in Chagall's work.

process, the icon itself, and the 'spirit' in a living work of art. It highlights a 'dialogue' which exists in a quaternary, or four-part exchange: From the artist to the painting; between the artist and the painting; between the painting and the audience; and, between the artist and the audience. Carried within this process of *speaking through the painting* are three elements of the Chagall's *La Chimie* spirit: of creativity, of audience reception, and the 'living' aspect of the work.

Chagall was critical of the art communities' use of descriptive words, such as "story teller", "literature", or "literary" to define his creative output (Chagall in, Harshav, ed., 2003, pp. 69, 77, 85). He maintained that his imagery emerged unconsciously, and the religious significance was found in his recollection of early life memories, rather than a conscious effort to recreate an individual story depicting Jewish culture or Yiddish language through reference to idiomatic speech (Harshav, 2004, p. 82; Meyer, 1964, p. 153). Harshav suggests that (2006):

> Chagall's projection of a fictional world differs from its use in literature in a key sense: In literature every novel or poem may project its own separate fictional world with its own characters and situations, whereas in Chagall's oeuvre, all paintings refer to one total fictional universe, a construct outside those paintings, but to which all those paintings refer. (p. 53)

This conceptualization of Chagall's visual 'universe' bears a connection to the function and processing of imagery consistent with the model of the transcendent function, between the collective and personal unconscious (*CW 6*: pars. 828-9). The idea that each of the works are connected - and represent a 'whole' - as a response to the creative spirit *from within* underscores the effect of Chagall's archetypal filter and its capacity for 'filtering' imagery consistent with religious-oriented concepts. That Chagall emphasises the *imprint* of memory - rather than the 'capacity' and the 'projection' of memory - as an integral creative element in the *revelation of the story* in his works, reflects his creative perception: Such observation is suggestive of an element beyond the artist's conscious awareness, one that has imprinted an influence upon his view, and thus his creative projections.

With the introduction of Jungian theory, and specifically, the concept of archetypal imagery, it is possible to establish and to extend the religious universality of Chagall's 'handwriting' into the imagery of animals, transmorphic figures, and human coupling. These forms appear, initially, in Chagall's *Early Life* works, and continue to be re-imagined in different compositions across lifespan development, with the 'spirit' of transformation.

ANIMALS AND ARCHETYPES

In his theory of archetypes, Jung references the connection between archetypes and the primordial imagery of ancient myths (*CW6*: pars. 624, 746-7; *CW8*: 342). Meyer's (1964) *Chagall* includes 1,016 examples of work, that date from Chagall's earliest self-portraits created at Yehuda Pen's academy in 1907, to the stained-glass installations of 1961. Whilst the artist lived a further twenty-four years, to 1985, Meyer provides an overview that is not possible without his access to a number of private collection pieces, many of

which are catalogued for the first time in his review (Meyer, 1964, p. 619). Concerning the appearance of animals in Chagall's oeuvre of painted works and prints, Meyer summarises (1964):

> The most characteristic animals in Chagall's pictures are the cow, the bull, the ass, the horse, the goat, the cock, and the fish. The frequency of their occurrence varies from one period to another. Thus, for instance, we find horses and asses chiefly in pictures painted after 1924; cocks and fish after 1928. Between 1910 and 1914 we mostly come across cows, bulls, and goats, more seldom cocks, asses, and fish. (p. 137)

This limitation to five species (considering the cow and bull both bovine creatures, and a binary of male-female expression) focuses the discussion. For example, "between 1910 and 1914" (Meyer, 1964, p. 137) places the emergence of the bovine binary and goats exactly within the *Paris I* period. Chagall did experience direct and ongoing contact with animals: The artist had access to observing farms and abattoirs in Vitebsk (Chagall, 1989), and during his American years in High Falls, New York, he is photographed on a farm located next to his studio building (Haggard, 1986, p. 75). Primary source documents or visual evidence (such as preliminary sketches) have not been found to demonstrate or to suggest that Chagall utilised a 'living' model of an animal in composing his paintings[3], or that, he explored other animal images as repetitively (Haggard, 1986; Wullschläger, 2008).

The initial appearance of archetypal animal imagery in Chagall's compositions coincides with the artist's *Paris I* years. In 1911, Chagall created three of his 'major works' that demonstrate the natural animal, zoomorphic, or transmorphic motifs: *I and the Village*, *To Russia, Asses, and Others*, and *Dedicated to My Fiancée*. The bovine binary of cow-bull imagery and architectural and symbolic references to the Orthodox church and Christianity in these paintings is consistent with the sacred-secular expression that emerged just prior to this time in the 1908-1909 *Life Stations* and *Holy Family* series.

In the context of the artist's creative development, it is the 'whole' of the body of work during a particular life-stage or time period that is taken into account: Like many artists, Chagall was working on a number of canvases at once (Meyer, 1964). Here, the image content and expression of the *Paris I* period generally - and in the paintings that follow, the year 1911-12, specifically - is the temporal focus.

AN EGYPTIAN CONNECTION

Jung's examination of symbols of transformation and archetypal imagery includes significant references to the mythology and pantheon of Ancient Egypt[4]. In Chagall's transformative imagery there is an archetypal and synchronistic[5] thread that

3 There are examples of a house cat appearing in a series of family portraits executed during the artist's 1914-22 period in Russia II, and in *Paris Through the Window* (1913) (PLATE 41).

4 The presence of Ancient Egypt is also underlying much of what is presented about archetypal imagery in Neumann's *The Origins and History of Consciousness* (1989). Neumann wrote about Chagall in, "Note on Marc Chagall" (1959) and "Chagall and the Bible" (1979).

5 My university study included Ancient Near Eastern Studies, with a specialisation in Ancient Egyptian civilization. I have since always 'carried with me' certain books from this time, Gardiner's *Egyptian Grammar* (1927), Hornung's *Conceptions of God in Ancient Egypt* (1971), and Shafer's *Religion in Ancient Egypt* (1991, Ed.). I could not have

became apparent during the research process. Visual patterns appear within Chagall's transformative imagery that connect his work to the mythology of Ancient Egyptian religion[6]: The appearance of sacred animals in Chagall's paintings evoke comparison with the Egyptian religious conceptions, of 'zoomorphic', 'transmorphic' and 'anthropomorphic'. These appear in images of Hathor and her male counterpart, The Sky Bull.

Definitions concerning the deification process in ancient Egyptian mythology would be helpful at this point: 'Zoomorphism' is perhaps the oldest form of ritual worship, with evidence existing in the Ancient Egyptian culture during the pre-Dynastic millennia (c. 5500-3100 B.C.) and within the Naqda period, (c. 4000-3500) (Shaw & Nicholson, 2008; Silverman, 1991). In a zoomorphic presentation of the Divine, the elements and features of a supernatural deity are communicated to the worshipper through the visual association with a 'natural' form, that of an animal. (Wilkinson, 2003). These animal forms:

> ...were merely formalities giving visible recognizable appearances to deities that were often described as 'hidden', 'mysterious', or even 'unknown'. The physical [animal] form allowed cultic or personal interaction with deities, but their real identity was to be found in their own individual roles and characters, which were usually far broader than could be delineated by physical images or representations. (Wilkinson, 2003, p. 29)

A well-known example of the zoomorphic presentation in the Ancient Egyptian pantheon, appears in the Apis Bull cult of Memphis, in Lower Egypt[7] on the Nile Delta, the most important Egyptian cult to originate in pre-Dynastic times (Hornung, 1971; Shaw & Nicholson, 2008). The Apis Bull remained in its animal form as an idol of worship in the early stages of development, in pre-Dynastic periods. Hornung explains (1971) that individual zoomorphic animals, like the Apis Bull, "are not the god, but the god may take up his abode in them; they allude to him, and are images and vessels of him" (p. 137). During the dynastic periods, the belief system transformed into an anthropomorphic pantheon, and the Apis Bull became an animal marker for "heralding" the god Ptah, the Creator god of Egyptian myth (ibid.). Hornung's observation of the containment capacity of a zoomorphic animal is similar to Harries (1993, p. 125) association of the spiritual essence within the contemporary Orthodox Christian icon, as well as, Chagall's own interpretation of visual chemistry (La Chimie) which brings an animated life to an individual painting.

In ancient Egyptian faith, the zoomorphic presentations of deities differ from the later refinement of transmorphic and anthropomorphic visual

anticipated researching this project, then, or, moreover, referencing here, the same material I was introduced to more than two decades ago, in an entirely different context. That the ideas and imagery in these books find resonance in the art of a Russian-French painter, from a monotheistic faith background, who lived 3000 years after the height of Egyptian civilization, and in a different region of the world speaks to the nature of archetypal imagery.

6 Chagall's imagery of the alchemical 'spirit' form is understood through the Egyptian concept and image of the ba, or 'soul-bird'. In Chapter Four, the emergence of Christ is clarified through its association with Jung's archetype of the Self. The Green Osiris of regeneration connects the symbolic nature of this form to ancient myth. The *Chagallian Green Man* and The Green Osiris are together reflected in Chagall's Fraumünster window, *The Tree of Jesse* (1970), depicting the Green Christ. The states of Christ within Chagall's body of crucifixion work, is, too considered through the transformation of color, using the four stages of the Ancient Alexandrian process.

7 'Lower' Egypt refers to the northern geographic region, or Nile Delta area, of the ancient territory, whereas 'Upper' Egypt, refers to the southern geographic region, adjacent to ancient Nubia (southern Egypt and Sudan). This terminology reflects that the Nile River flows in a geographically south-to-north direction. Memphis was the capital of Lower Egypt, Thebes the capital of Upper Egypt.

patterns in the system of belief. In the latter example, the deity could transfer its existence energy through features of appearance consistent with an animal, a human (or anthropomorphic) form, and a transmorphic or combined, expression (Silverman, 1991). Thus, in the example of another bovine deity, Hathor, the goddess appears as a cow-headed female in her transmorphic form; whereas, she is depicted wearing a wig headdress with bovine horns in her anthropomorphic state (Wilkinson, 2003; Shaw & Nicholson, 2008). A distinction is made (Wilkinson, 2003) between the emergence of bovine zoomorphic deities, such as the Apis Bull of the preDynastic period - evidenced in bull carvings on the Narmer Palette of c. 3100 B.C. (Shaw & Nicholson, 2008) – and the refined conceptualization of the goddess Hathor appearing though the form of a sacred cow. The later emergence of the goddess as a cow is depicted in Egyptian art as the life force from which the King suckles life - and in the Osiris myth, the 'womb' of rebirth - during the Middle and Late Dynastic Periods (*CW 5*: pars. 360-2; Shaw & Nicholson, 2008; Wilkinson, 2003)

As a goddess, Hathor is an 'ancient' female deity within the Egyptian pantheon, and of the Egyptian deities, one of the most revered. Temples dedicated to her worship extended into southern Africa, Lebanon, and the Sinai peninsula during the Middle (2040 B.C.–1640 B.C.) and Late (1550 B.C.–1070 B.C.) Dynastic periods (ibid.). In the Greco-Roman period (332 B.C.–395 A.D.) Hathor's cult following was introduced to the Greek civilization, and her identification became with that of the Greek goddess Aphrodite (Silverman, 1991; Shaw & Nicholson, 2008; Wilkinson, 2003). Hathor is a sacred, feminine archetypal image: she exists as the Goddess of Women, female sexuality, and motherhood, as well as, the wife and mother of the King (ibid.). She is the daughter of the sun god Re, and in celestial terms is associated with the sky or 'womb' of creation through the primeval sky-waters in Egyptian creation myth (ibid.).

A relation of the goddess Hathor is a male counterpart image, "The Sky Bull" or "The Bull of the West" (Wilkinson, 2003, pp. 77, 175). Like Hathor, the god appears in the Funerary Text, or *The Book of the Dead*, a compilation of spells the Ancient Egyptians believed would assist in guiding the soul through passage into the afterlife at the *Last Judgment* by Osiris, god of resurrection (ibid.). The Sky Bull is associated with the mystical features of the number seven, "the number of Creation" (Varley, 1976, p. 45): He is depicted in the Funerary Text above the seven concubines in his harem. These *Seven Concubines* are used interchangeably in myth and reinforce the bovine binary model as they also depict the divine aspects of Hathor herself, the *Seven Hathors* (Wilkinson, 2003). The number seven in this instance also represents the divine triad of Osiris, Isis, and Horus, the three "creative principles" of Egyptian myth, that are combined with the quaternity of created matter (Varley, 1976, p. 45).

The mythology of Chagall's biography continues to reflect the birth date of the artist, as the 7th of July (which has been challenged by Harshav, 2004, pp.64-66, and Shatskikh, 1991, pp.21-22). However, the archetypal nature of the number seven remains potent in religious mythologies, in both ancient systems of belief, and contemporary monotheistic traditions, including Judaism, and Christianity.

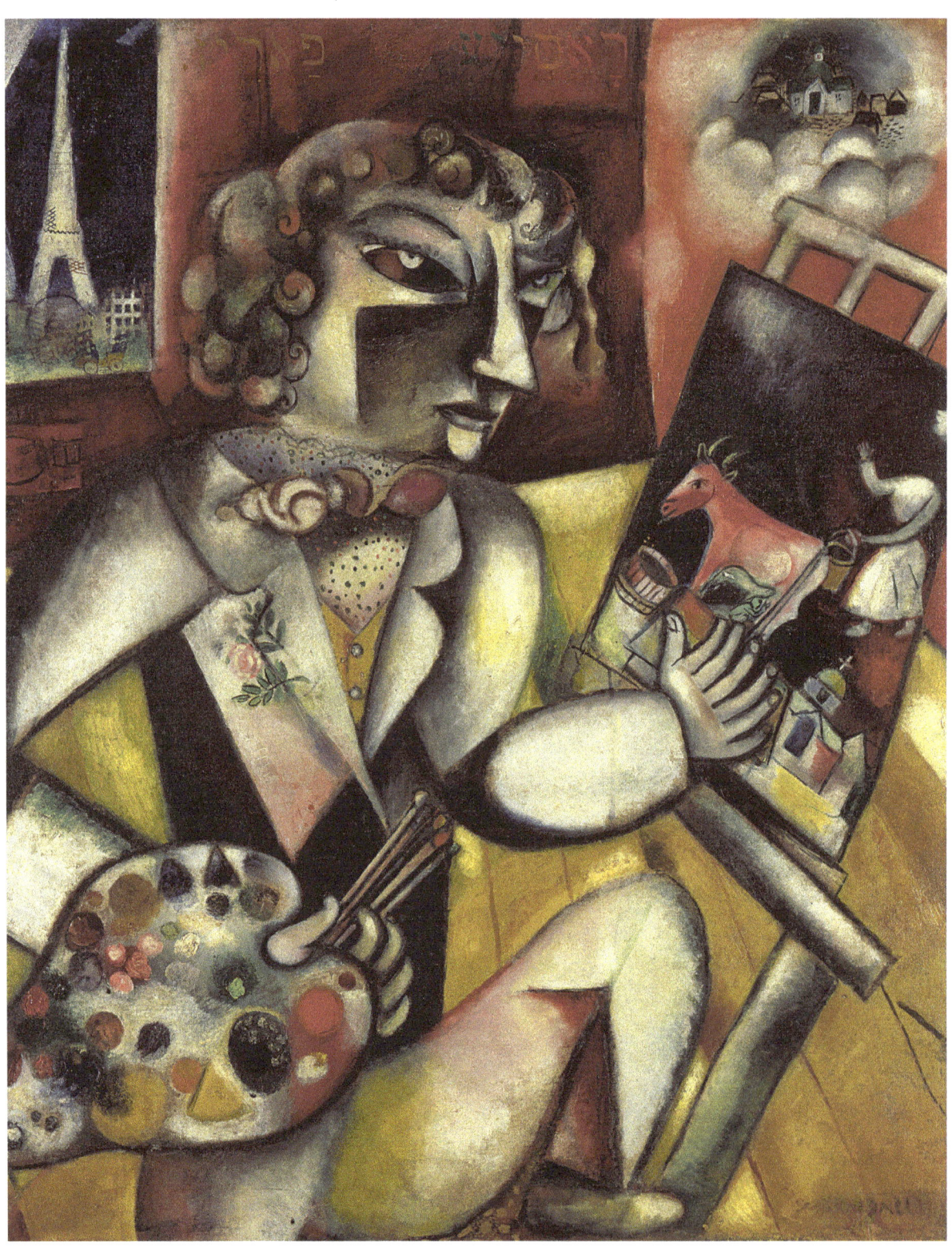

22. *Self Portrait with Seven Fingers*, 1912-13
Oil on Canvas, 128 x 107cm
Stedelijk Museum, Amsterdam

23. *To Russia, Asses, and Others*, 1911
Oil on canvas, 157 x 122 cm
Musee National d'Art Moderne, Paris

24. *Me and My Village*, 1911
Gouache on Paper, 28.3 × 23.5cm
The Jewish Museum New York

A PAINTING WITHIN A PAINTING

I feel myself more "abstract" than Mondrian or Kandinsky in my use of pictorial elements. "Abstract" not in the sense that my painting does not recall reality. Such abstract painting in my opinion is more ornamental and decorative, and always restricted in its range. What I mean by "abstract" is something which comes to life spontaneously through a gamut of contrasts, plastic at the same time psychic, and pervades both the picture and the eye of the spectator with conceptions of new and unfamiliar elements. In the case of the decapitated woman with the milk pails, I was first led to separating her head from her body merely because I needed an empty space there. In the large cow's head in *I and the Village* I made a small cow and a woman milking visible through its muzzle because I needed that sort of form, there, for my composition. Whatever else may have grown out of these compositional arrangements is secondary. (Chagall, 1944, in Harshav, ed., 2003, pp. 82-3).

Self Portrait with Seven Fingers (1912-13), is a painting that Chagall begun during the same creative period as the animal imagery in this discussion. The painting connects some of the ideas that have been presented in this chapter thus far. In this composition, the artist is pictured in his Paris studio in a pose similar to an earlier portrait, created in 1909, during his St. Petersburg years, *Self Portrait with Brushes*[8] (PLATE 31). Whilst the positioning of the artist and his engagement with the viewer remains the same in both works, it is clear from these two examples that the impact of the new Parisian Modernist environment had a significant effect upon the artist's creative viewpoint. This set of portraits is comparable to the 'Life Stations' series where Chagall revisited the imagery of 'Birth' and 'Marriage' in both his early years as a student in St. Petersburg (1908-10), and two years later in Paris, in 1911. The color transformation - as well as the treatment of form - in the re-imagining of the picture plane during the Paris I period is remarkable for the increase in vibrancy of hue, and the dynamic energy that radiates from within the composition.

In, *Self Portrait with Seven Fingers* (1912-13) (PLATE 22), Chagall expresses the technique of 'writing into' the painting with words that appear above the artist's head: On the left, the word "PARIZ", and to the right, "ROSIYE". The text appears as a trilingual conglomerate of Russian and Yiddish, with Hebrew vowel markers (Harshav, 2006, p. 88). A Yiddish idiomatic saying references the Biblical and Hasidic associations to the number seven, "mit ale zibn finger" (literally, "with all seven fingers") (ibid.). This phrase translates to the concept of, "investing in a work one's whole being, one's rational and irrational powers." (ibid.).

If Chagall indeed considered himself as an artist 'investing in a work one's whole being', he has

[8] West (1994) and Wullschläger (2008) compare this portrait to those of the Dutch Masters during the 17th Century. Chagall has stated in the conclusion of his autobiography (1989) that, "I'm certain Rembrandt loves me" (p. 170); Rembrandt was Chagall's favourite Old Master painter, and the artist expressed a connection to him through their similar interest in religious themes, and the illustration of Biblical stories (Meyer, 1964).

made it clear from this painting which image (or from which group, he has invested) up to this creative moment: Upon the easel is a painting of his painting, *To Russia, Asses, and Others* (1911) (PLATE 23).

To Russia, Asses, and Others signals a transformation in the artist's developing style, away from the 'rational', towards the 'irrational' in Chagall's treatment of the compositional space and imagery. The picture plane here is divided geometrically, a feature that would become a more prominent in Chagall's oeuvre as his creative development progressed. The three prominent forms, a milkmaid, a cow, and the dome of an Orthodox Christian church triangulate to reinforce the milk pail held from the woman's outstretched arm. Beneath the cow, a calf and a human being suckle from a teat. The eye focuses (the focal point) where the pail and the cow connect in space, at nearly the centre of the composition.

Chagall's use of color in this composition is consistent with the application of a black primer which creates a 'working canvas' wherein the forms emerge from the negative space or blackened background, rather than recede into a whitened space of the traditionally white gesso-primed canvas[9]. In these Paris I works, particularly *To Russia, Asses, and Others* as well as *Dedicated to My Fiancée* (1911) (PLATE 27), the darkening of the picture plane may be construed as the Nigredo stage of the alchemical metaphor. This observation is supported when a temporal element is applied to the developmental process, where the timeline of work includes *Death* (1908), from the early Russian period, the piece that Chagall and art historians use as the 'marker painting' for his entrance into his professional career as an artist. Jung's observation of the Nigredo supports Chagall's darkening of the compositional space, "Great importance was attached to the blackness as the starting point of the work." (*CW 14*: par. 729).

The visual entrance into the composition is through the breakdown of human form. The milkmaid[10] is painted in a complete bodily state, with her head decapitated from her body. This is the first instance of such physical detachment within a Chagallian composition (Meyer, 1964), and examples continue to appear during Chagall's *Russian II* period (1914-22), in the artist's self-portraits (e.g., *Anywhere Out of the World*, 1915). The decapitation process is at once fatal and transforming, from one state of existence to another. In this instance, there exists facial features which may be interpreted with an element of unease, or even disassociation, as the eyes of the figure are pointed into the night sky.

It is clear that Cubism offered ideas consistent with the "breaking apart" of the picture plane in its manifesto (Chip 1968: 208-9; Lefebvre, 1991). Chagall's interpretation of the decapitation - or more accurately, his 'beheading' of a figure - and his treatment of the bodily form does not bear resemblance, however, to what would be considered a *Cubist* work of art: In the example, *To Russia, Asses, and Others* (1911), the compositional elements which concern the understanding of form are defined through a linear rationality

9 This technique is mentioned in Chapter Five, "Chagall and the Bible", concerning the differences between his *Paris I* compositions and those during the 1930's, following his trip to the Holy Land, wherein the white of the picture plane dominates in a way it had not previously.

10 A study for this composition titled, *Me and My Village* (1911) illustrates the decapitated figure with a head closely resembling Chagall's features (PLATE 24)

within an irrational context, rather than using a Cubist's irrational approach to linear form.

An alternative view considers that, the visual detachment of head from body - a cutting off, or separating - is suggestive of a psychic disassociation between the conscious and unconscious realms:

> Beheading is significant symbolically as the separation of "understanding" from the "great suffering and grief" which nature inflicts on the soul. It is an emancipation of the "cogitatio" which is situated in the head, a freeing of the soul from the "trammels of nature". Its purpose is to bring about...a unio mentalis "in the overcoming of the body". (*CW 14*, par. 730)

Within the detachment symbolism exists an alchemical reference to the Nigredo stage: Jung (*CW 13*: par. 95) remarks upon the "skinning" referenced in the works of the alchemical "Visions of Zosimos", and explains, "the skinning refers to the head, as though signifying the extraction of the soul". A second alchemical and psychic metaphorical reference is to the "black Osiris" or executioner, who, too, befell the fate of beheading, and, like the darkening of the composition, signals the Nigredo (*CW 13*: par. 730).

The outstretched arm of the milkmaid points to the connection between the human form and the zoomorphic cow image. Earlier, the Egyptian goddess Hathor was discussed: in her Late Dynastic representations she appears in the 'natural' animal state as a cow. In animal form, she represents an incarnate of the divine life force, and is often depicted with a small figure of the King beneath her, suckling 'life'. The same image appears in the Brahmanic conceptualization of the divine, of 'rta', the life force of, "established order, regulation, destiny, sacred custom, statute, divine law, right, truth" (*CW 6*: par. 348). In Brahmanic tradition, the metaphor of the "streaming" or "releasing" of energy appears from the "milch-cows of *rta*" (*CW 6*: pars. 351-5). As in the example of Re - the Egyptian sun-god and father of Hathor - *rta* is, "a libido-symbol" of the sun (ibid.). The visual connection to ancient systems of belief, is extended through the Jungian conceptualization of "libido" (*CW 8*: par. 32), or life force. A psychic connection, and a 'release' of libidinous energy is connoted through the sacred cow providing her Life force to the suckling figure. This energetic passage completes the transformative cycle, begun with the psychic 'separation' of the bodily form.

Sharing the compositional space, is a contemporary religious reference, the dome of an Orthodox Christian church. There is a numinous quality that may be drawn from the synergy of the triangulation between the figure's foot atop the church steeple cross, the milk pail, and the contact with the cow. In this visual 'moment' of form, Chagall's imagery connects the transforming 'head', to a contemporary sacred space, and the archetypal expression of ancient religious myth.

The numinous quality of this triangulation is amplified by the visual replication of the *exact* 'moment', expressed within the aforementioned composition, *Self Portrait with Seven Fingers*. In this composition, the seven fingers on the hand of Chagall's extended arm are reaching out to the canvas, and connecting with the painted form of the Orthodox church and the figure beneath the sacred cow. The religious nature of the cycle is visually reinforced in the 'active imagination' or 'dream' cloud, above, wherein the structure of the church is re-imagined.

25. *I and the Village*, 1911
Oil on canvas, 191 x 151.4 cm
Museum of Modern Art, New York

A SECULAR ICON

The sacred-secular imagery of *To Russia, Asses, and Others* re-emerges, again in 1911, through a different treatment of composition in *I and the Village* (1911) (PLATE 25). Here, the hierarchical perspective is replaced with a geometric treatment of the compositional plane, a division into five segments, each bearing a different association with religious imagery. *To Russia, Asses, and Others* (1911) was the "departure point" (Meyer, 1964, p. 164) in Chagall's experimentation with compositional arrangement, and that, following a series of works which explored transformation of the compositional plane, *I and the Village* (1911) was created as the culminating work. Together, they are a 'beginning' and 'ending' to this compositional cycle.

In previous paintings within this cycle, "each form stood out against a ground" (ibid.). In *I and the Village* (1911), the change in the treatment of form creates a composition wherein each of the segments appears as a part of a whole viewing experience. This visual treatment engages the viewer through what Meyer considers an "activation" of all forms, and, a recession of the "ground", or, a de-grounding from reality (ibid). This expression - of an 'activation' through the simultaneity of image - and the 'recession' of the formal grounding in a conscious 'reality' underscores the Whole of the unconscious and archetypal expression.

Among the art historians whose scholarship supports details in this study, Baal-Teshuva (2003, p. 50), Kamensky (1989, p. 120), and Harshav (2006, p. 60) each state that the green-faced figure is Chagall, and that the composition is a self-portrait.

This painting - as well as *To Russia, Asses, and Others* (1911) - was titled by Chagall's friend, the poet Blaise Cendrars (ibid.). The inclusion of the Self-referential 'I' within the title points to the artist. If Chagall was not in agreement with his friend's perception of the imagery, the artist's self-described 'independence' would have been reflected perhaps in the decision not to exhibit this work (or, continue to do so) with a clear self-referential marker.

In his analysis of *I and the Village* (1911), Harshav (2006) explains that Chagall's arts instructor in St. Petersburg, Leon Bakst, was a Jewish man by birth, and had converted to Christianity in 1903. Harshav remarks that Chagall was "exposed to the temptation of Christianity" (2006, p. 62) and suggests that the wearing of a cross necklace indicates the artist's, "effort to identify himself with Christian culture" (ibid). Such a choice would reflect the multicultural environment of the Pale Settlement during the early 20th Century. Harshav (ibid.) also connects the idiomatic speech of Chagall's natal faith to this painting. He describes that, in Yiddish folk semiotics, the term "village" refers to the world of "goyim" and to "Christian peasants" (ibid.) Whether the painting was indeed intended by Chagall to be a 'self-portrait' in the technical sense of the term, the communication of form through emerging religious imagery is consistent with the Chagallian sacred-secular binary present in the *Paris I* (1911-14) works, and the paintings presented in this discussion, thus far.

In analyzing the technical treatment of this composition, the visual imagery reflects an equality of unified segments: The painting is entered through the light reflected in the depth of the calf's eye, with the calf's profile contour

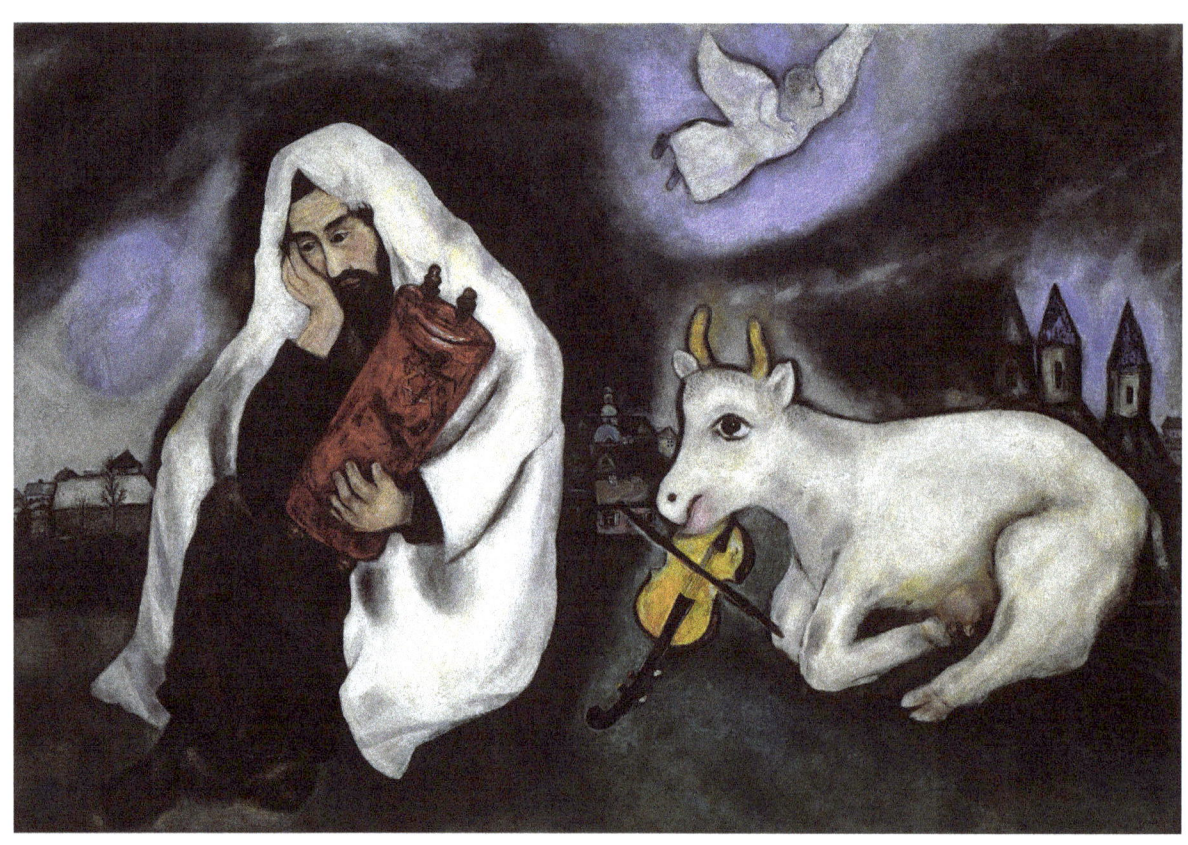

26. *Solitude*, 1933
Oil on canvas, 102 x 169cm
Museum of Art Tel Aviv, Israel

mirroring that of the Green Man's. The calf representation, hearkening to Hathor and 'rta', replicates features of the religious imagery in *To Russia, Asses, and Others* (1911) through the superimposing of a vignette, featuring a milkmaid milking a cow within the head of the calf. This re-imagining of form shares the essence of the painting on the easel, and, the active imagination, or dream sequence, of the church positioned in a cloud, above the visage of the artist. Such a repetition supports the active imprint of archetypal emergence and points to Chagall's efforts, through creative technique, to communicate the psychic process of thought in both the calf and figure heads.

The connection shared between the forms contains the essence of a collective life force shared, between all animals, and the Nature of the spirit in belief. The painting, *Solitude* (1933) (PLATE 26), shares such essence[11]. Here, Chagall has imagined a Rabbi figure, in possession of a Torah Scroll, sharing the picture plane with the form of a sacred cow playing a violin[12]. They are seated upon the Earth, together, in an outdoor landscape of Nature. In the technical composition, the Nature of this connection is reinforced through the eyes: In the 1933 composition, they simultaneously engage and disengage the viewer directly; whilst in the composition of 1911, the forms reflect one another, physically connected by a painted line.

The feminine aspect of the divine (Neumann, 1959), holds a significant presence in *I and the Village* (1911). The sacred feminine is reinforced by the sacred calf and bovine imagery, the appearance of the Sol-Luna segment (*CW 14*: pars. 154-173), and the divine nature of the coupling figure imagery. The inverted couple is a visual derivative of the Kabbalistic symbol of the inverted couple, representative of human love (Harshav, 2006; Scholem, 1974). Chagall returned to the singular expression of this symbol in *The Walk* (1917) and *The Promenade* (1929).

The feminine aspect of life is re-imagined in the 'flowering' process of the tree branch in the foreground segment. The branch appears to spring forth from the base of the figure's hand which is adorned with a ring embellished with a small hexagram[13]. Coupled with the cross necklace, the adorning of the figure resonates as a conscious *wearing of the binary* (here, the symbols of sacred life). With connotations of the "Philosophical Tree", or the symbolism of "The Centre" (*CW 13*: pars. 304-482; Eliade, 1991:44-47), the flowering branch motif is far-reaching into both ancient and contemporary systems of belief. The most common associations across cultures indicate examples of, "growth, life, unfolding of form in a physical and spiritual sense, development...the maternal aspect, personality, death, and rebirth." (*CW 13*: par.350). As an element of unification, or 'grounding' of the compositional plane, the tree archetype is related to "the tetrasomia", or "the reduction (or synthesis) of a quaternion of

11 This painting was composed following the artist's 1931 visit to the Holy Land. Elements of the Bible Series of etchings and lithographs of the 1930's and 1950'/1960's, as well as the Monumental paintings of the Biblical Message of the 1950's and 1960's find a resonance within this early exploration of sacred-secular form reflecting Chagall's Natal Faith, and the connection with the spirit of Nature, and the sacred feminine.

12 Compton (1985) references the "white heifer with golden horns" and the "golden violin" to two passages concerning Chagall's natal faith: She associates the bovine image with the image of Israel, a verse from the Book of Hosea (IV, 16), "Since Israel has run wild, wild as a heifer"; and Sholom Aleichem Stempeni's verse that one may "compare the heart in general and the Jewish heart in particular to a violin with several strings" (p. 213).

13 Harshav (2006, pp. 62-3) notes that the ring was visually diffused in Chagall's later 'variants' of this painting.

opposites to unity" (*CW 13*: par. 358). It is the tree branch which, absent of a linear treatment in perspective, metaphorically 'grounds' the five compositional segments, uniting binaries, human-animal (male-female), and heaven-earth (life-death). This segment thus becomes a metaphor for both a grounding of the religious expression and the unification of the religious imagery. As an archetypal image, it points to the concepts of growth and development, which, in the context of a critical period of change, would reflect upon the ongoing process of individuation.

Of the paintings discussed in this study, *I and the Village* (1911) is the work that arguably most literally reflects Chagall's *Early Life* development of the Chagallian sacred-secular binary. The compositional treatment and visual qualities are evocative of an icon: The picture plane has been 'flattened' in the process of removing the perspective. There is a use of a hierarchical perspective wherein the green man and the calf dominate the work through color and size. And, each segment functions independently to communicate a facet of the religious experience whilst also existing within the Whole of a religious expression. As with his 1914-15 series of *Ḥoly Men*, Chagall created a series of 'variants', or copies, of *I and the Village* (1911), re-imagining this image several times between 1924 and 1926 (Harshav, 2006; Meyer, 1964). These variants were reproduced using a smaller scale, for personal use (ibid.). This repetition of creative process and the replication of religious content evokes collective engagement consistent with both mandala creation and the iconographic arts tradition.

A TRANSMORPHIC CHANGE

A final example of Chagall's animal imagery, *Dedicated to My Fiancée* (1911) (PLATE 27), returns to the discussion of the transmorphic presentation of deities in ancient mythology. I stated that, in the example of Ancient Egyptian religion, the evolution of religious belief brought with it changes in process and appearance of deification. The concept of 'transmorphism' was explained as a sacred image of a god that is illustrated by the merging of zoomorphic and anthropomorphic divine forms. In the Egyptian pantheon, the transmorphic presentations typically reflect an animal head atop a human body.

In *Dedicated to My Fiancée* (1911), the image is that of a horned, transmorphic creature, a bovine head merged with a human body (Meyer, 1964)[14]. The visual association, with 'Primitive' tribal motifs and the 'masking' of form found in Modernist works (e.g., Picasso's *Demoiselles d'Avignon*, 1907) contemporaneous to this piece, is consistent with the artist's experimentation in Modernist aesthetics. The image here reflects the tone of the popular sacred-*into*-secular Modernist ideal (Chip, 1968; Harrison et al., 1993) that Chagall encountered during his *Paris I* years: The concept of 'mask' hearkens to the image of a *soul persona* (*CW 6*: 800-01), or alter-ego, which would be consistent with the Modernist treatment of the mask motif (Chip, 1968); Whilst the archaic and contemporary sacred connotations of the bull echo "masculinity", "virility", and "strength" (*CW 4*: par. 497; *CW 5*: par. 671; Shaw & Nicholson, 2008, p. 65; Wilkinson, 2003, p. 175).

14 Harshav (2006, p.108), uniquely states that the animal is a donkey, and that the painting was originally titled, *The Ass and the Woman*.

It is curious to note that such observation exists in contrast to Chagall's conscious identification with the female aspect of the bovine binary: Chagall states, "I often said I was not an artist, but some kind of cow. What's the difference? I thought of placing her on my calling card" (Harshav, 2006, p. 61). In such context, as a visual marker of the individuation process, the bovine may be read as functioning as an anima-image, appearing in nature and as a sacrificial form, as it does in the Mithraic cult, and images of the Christ figure (*CW 5:* 662-65; *CW 6:* 803-811).

However, unlike the previous paintings, this composition emphasises the unity of form through allegorical (or mythological) transformation—the symbolic deification process—of the figure into a transmorphic form[15]. *Dedicated to My Fiancée* (1911) is the initial emergence of the transmorphic theme, which Chagall would return to in all life stages in his career. It is thought that the artist painted the entire composition in one evening:

> [Chagall]...tells us that it was done in a single night, whereas most pictures take about a week. He adds that he did not even light the lamp in order to check to flow of the creative inspiration, and finished with no light at all, 'entirely by touch'. (Meyer, 1964, p. 150)

In this example, Chagall is bringing forth, through the technical creative process, the "animal kingdom within" (Hillman, 1982, pp. 310-11). That this expression of imagery was brought forth, literally, within 'the dark of the night', amplifies the connotation of the unconscious processing and filtering of the psyche. Here, the blackened background in this presentation remains consistent with the observation that the *Paris I* (1911–14) period coincides with the Nigredo stage in Chagall's developmental process. Concerning archetypal emergence and the transformation theme, this transmorphic presentation physically underscores the process of change: *The coniunctio here is of man and animal*. Varley (1976) examines the concept of the coniunctio of *The Septenary*, and reflects that, it is on the sixth day of the Biblical creation myth when:

Man is created in the image of God, but it is significant that he is created on the same day as the animals. This refers to his dual nature, animal and divine...The symbol of the sexual union here relates to the *conjunctio oppositorum*, the reconciling, in this case, of the animal and the divine, through which man may become whole. This too, is the symbol of Venus [Aphrodite, Hathor]. She is the Love which reconciles all opposites and enables man to become complete – animal and divine – a physical and spiritual whole. (p. 16)

The more "anthropomorphic" the images become, the closer one is to the psychic process of transformation (*CW 16:* par. 353). Hillman (1982) supports this observation of animal imagery as a signal of transformation, reflecting that "the animal is interiorized into the human soul...and from this animal we are descended or instinctually empowered. This is the animal face of the psyche we see in dreams." (pp. 310-11). The bovine (as binary) for Chagall, during this transformative period, is arguably this 'animal within'. As in the other compositions of 1911, *To Russia, Asses, and Others* and *I and the Village*, the artist has created a 'universe' linked to him through the process of self-portraiture.

15 There is the thought that this paradigm is also a reversal of the Modernist aesthetic, when one considers the deification process to be a sacred transformation. Here, it is a human secular image *into* a sacred transmorphic form.

HOMAGE TO APOLLINAIRE

Between 1911-12 Chagall completed what would remain one of his most well-known, and reproduced paintings (Bohm-Duchen, 1998; Compton,1985; Meyer,1964; Wullschläger, 2008), *Homage to Apollinaire* (PLATE 28). The painting was first exhibited in the 1912 *Salon des Independents* and again at the artist's first solo show in Berlin, in 1914 (ibid.). Given the title, one might assume that the painting was intended for the Parisian art critic and poet Guillaume Apollinaire, who, in 1913, was the first individual to observe what he termed the *surnaturel* appearance of Chagall's transformative images (ibid.). However, art history scholarship demonstrates that the painting was actually completed nearly a year before the critic first visited Chagall's La Ruche studio, in 1913 (Bohm-Duchen, 1998, p. 71; Meyer, 1964, p. 154).

Another perspective would be that the image is a memorialization to Chagall's Parisian connection as well as a personal and collective image marker for a transformative creative period in life. It is possible that Chagall, receiving his first significant and positive reviews following the 1912 *Salon des Independents*, wished to commemorate the significance of this painting - which was featured prominently as the largest of his pieces in the exhibition - and thus named the title according to the most obvious supporter of his work at that time (ibid.).

If one examines the preliminary studies for this painting, it is evident that Chagall was experimenting with the male-female binary, and the concept of the shared figure of the sexes during this period. Chagall's use of the male-female binary began in his early works as an art student where he depicts lovers in close proximity (Meyer, 1964). This theme is re-imagined in his *Russia II* period, in the 1914-15 'Lovers' series that depicts Chagall and his wife, Bella, with their heads touching and eyes closed in an intimate moment of embrace.[16] In this 1914-15 series, compositional form and details[17] support the image content within the conscious Chagallian reality of life and love, as it exists in a physical state for the artist and his partner.

In contrast to these works, *Homage to Apollinaire* translates visually through the *removal* of context. This treatment creates a confrontation with the symbolic where little or no interpretation is necessary. The hermaphroditic image here appears without a clear emotional connection or visual context. It is, instead, an imaginal event or moment, the psychic processing of a visual expression that is contained by Chagall's geometric approach to the composition: The treatment of the binary form is 'fused' into a compositional reality within the flattening of the picture plane. This visual essence unifies the composition, and reinforces the impression of the symbolic interpretation.

From a faith-based perspective, Chagall's preliminary studies for *Homage to Apollinaire* (1911) incorporate the Biblical theme, the story of Adam and Eve. Art historians (Bohm-Duchen, 1998, pp. 71-3; Compton, 1985, p. 170; Harshav, 2006, pp. 93-9; Meyer, 1964, pp. 156, 161-2) have considered sacred interpretations of this hermaphrodite image. It is a symbol of the Biblical figures, the

16 *The Lovers* (1913-14) (PLATE 29) was executed before Chagall's return to Russia in 1914. The composition demonstrates a stage in the development of the male-female binary: It shares visual elements which connect it to both the earlier, *Homage to Apollinaire*, and to the subsequent 'Lovers' series begun in Russia, in 1914.

17 Such as, personal physical characteristics, familiar landscapes, or, spatial definition through inclusion of familiar objects.

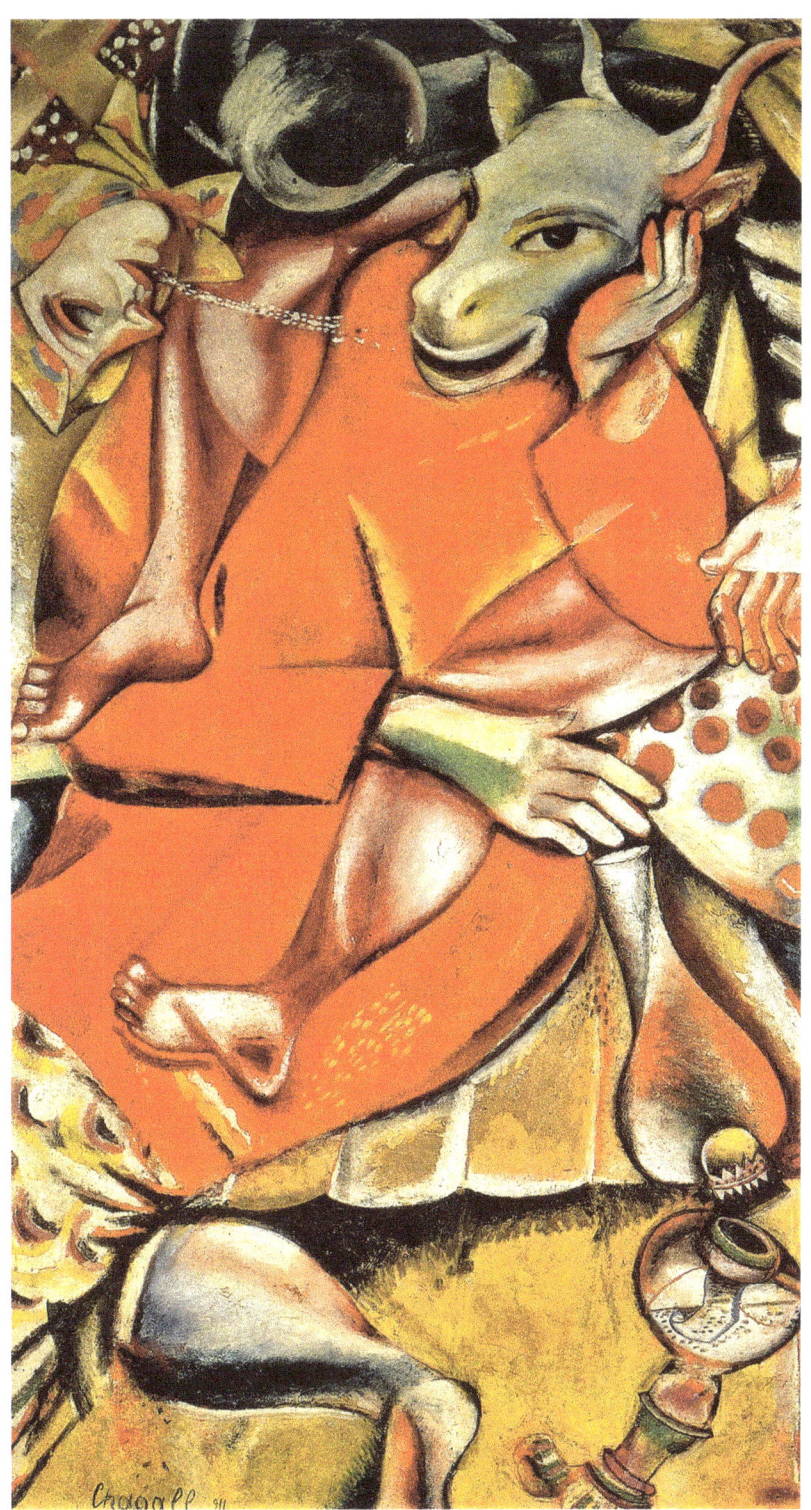

27. Dedicated to my Fiancée, 1911
Oil on canvas, 196 x 114.5 cm
Kunstmuseum, Bern

Cosmic clock, as well as the mystical union of the opposites through the connotations of the 'Zohar' Kabbalistic tradition of the two-into-one sexes binary. Meyer (1964) suggests that,

> [i]t is not God who stands in the centre of the circle [of the clock], but a being that is half the dual-sexed first man, and half the first human couple. This symbol leads us deep into the essence of Chagall's art... The 'unity in duality' they represent is the basis of all the pictures of couples Chagall painted later, for they are all concerned with the reunion of the parted, the victory of love over separation. (p. 161)

The Judaic Midrash (i.e., Midrash Ha-Neelam or the 'Mystical Midrash') interpretation of Genesis (1:27) differs from the Christian belief in the mythology concerning the creation of man: In the Midrash interpretation, Adam appeared firstly as a two-headed figure, an androgyne who was then divided into male and female forms (Harshav, 2006; Scholem, 1974). In the Christian tradition, the creation of Eve was from the rib of Adam (ibid.). From the preliminary drawings and painting of the Adam and Eve coupling, Chagall was exploring imagery consistent with Eve emerging from Adam's side. In the painting, *Homage to Apollinaire*, they are unified in a balanced way that is evocative of the Jewish interpretation of the Biblical story through the Midrash (ibid.).

The preliminary studies and the final composition of *Homage to Apollinaire* collectively exhibit the connotations of a visual transformative marker. The latter's reference to the Biblical Adam and Eve has evolved compositionally, and appears as a binary[18] form (*CW 16*: pars. 337; 526). For Jung (*CW 14*: par. 544), Adam and Eve represent a different interpretation than the Christian Biblical allegory: They are the King and Queen of the alchemical opus. Jung's treatment of Adam and Eve (*CW 14*: pars. 544-653) emphasizes the imaginal connection between the Biblical allegory of the Creation of Man, and the process of transformation, in alchemical text. Adam is considered through the Kabbalistic tradition, as "Adam Kadmon", the "arcane" or "transformative" substance of "Primordial Man", who enters into the unconscious "bath" in order to transform (*CW 14*: pars. 548-551). Here, Jung observes that,

> [t]he relationship between Adam and Eve is as close as it is difficult to define. According to an old tradition [mystical Kabbalah interpretation] Adam was androgynous before the creation of Eve. Eve was therefore more himself than if she had been his sister. Adam's highly umbilical marriage is emphasized as a hierosgamos... (par. 551)

Jung continues, describing a parallel between the creation and transformation of Adam, and the appearance of the tetradic elements of the universe: fire, water, air, and earth (*CW 14*: pars. 553-556).

> The circular arrangements of the elements in the world and in man is symbolised by the mandala and quaternary structure. Adam would then be a "quaternarius",

[18] The union of male and female essences *within the state* of transformation is characteristic of hermaphroditic symbolism. "The hermaphroditic mode is the mode of imbalance, ambiguity, confusion. The hermaphroditic union of opposites is not a true union but a merging of undifferentiated aspects. It is cloudy, chaotic, and yet it is fertile space. Much can grow there as consciousness enters in, nurturing and ordering... In the differentiation of the hermaphroditic anomaly, the way is opened for the recognition and ultimately for the marriage of the pairs of opposites. In this lies the promise of the return to the ideal of true androgyny, in which the masculine and the feminine elements in the human psyche are fused, and not confused" (Singer, 1976, p. 100).

as he was composed of red, black, white, and green dust from the four corners of the earth. (par. 555)

I make this point here as art history scholarship has emphasised Chagall's 'writing into' his paintings and, in particular, about the writing into *this composition* (Bohm-Duchen, 1998, p. 73; Compton, 1985, p. 170; Harshav, 2006, p. 96; Meyer, 1964, p. 161).

As in previous examples, Chagall has 'written into' this composition with both an imprint of culture and Faith: He has added French to the Russian and Hebrew languages reflected in his signature (Harshav, 2006). The numbers of the year, 1911, appear in their Russian form '*911*' wherein the millennium is not recorded (ibid.). Curiously, this numerical sequence also corresponds to the verses of Genesis that describe the story of Adam and Eve: Meyer (1964) suggests that the clock imagery is connected in this way to the Biblical story, that, "Time began with the fall of man" (p. 161).

In the lower left corner, Chagall has created a 'quaternary' structure, a squared heart. This boxing of the heart is created from the surnames of four influential contemporaries in Paris: the poet Blaise Cendrars, the editor Riciotto Canudo, the gallery owner Herwarth Walden, and the critic and poet Guillaume Apollinaire. As in Jung's comparison to the emergence of 'Adam Kadmon', or 'Primordial Man', the names of these individuals may be deconstructed, and reformed, to reference the Four Elements: 'Cendrars' becomes "cendres" ("ashes" or fire); 'Canudo' becomes "l'eau" ("water); Walden becomes "wald" ("forest" or earth); and 'Apollinaire' becomes "air" (Bohm-Duchen, 1998, p. 73; Compton, 1985, p. 170).

As a container for archetypal emergence, *Homage to Apollinaire* is the first space wherein the conjoined, male-female binary is reflected in Chagall's creative imagining of form. In this instance, the appearance of this binary signals a particular synchronistic intuition that reflects 'the whole' of a body of work that re-emerges, and is re-imagined in different stages of the Coniunctio process, during critical periods of Chagall's lifespan development.

There are different perspectives for considering this painting as a reference to transformation: Solvent references to Self-development exist within this piece, such as, the emergence of the hermaphrodite, or rebis, and its connection to Chagall's imago, the Christ figure. There also exists a reference (or, residue) to the individuation process, through the artist's visual association to 'the first' Adam (*CW 14*: pars. 570-84), particularly, as its emergence occurs during a critical period of Early Life. The male-female binary remains a significant re-imagining in Chagall's creative life, throughout his professional career. A final example, here, of the merging of sacred male and female form of Adam and Eve is the image of the binary in the active state of 'transition', imagined in a painting from the Later Life *Bible Series*, *The Expulsion from Paradise* (1961) (PLATE 30). Observation is put forward in the second half of this book to support the alchemical metaphor of individuation development as another perspective towards an understanding of this binary image, and others similarly, 'within' the cycle of transformation.

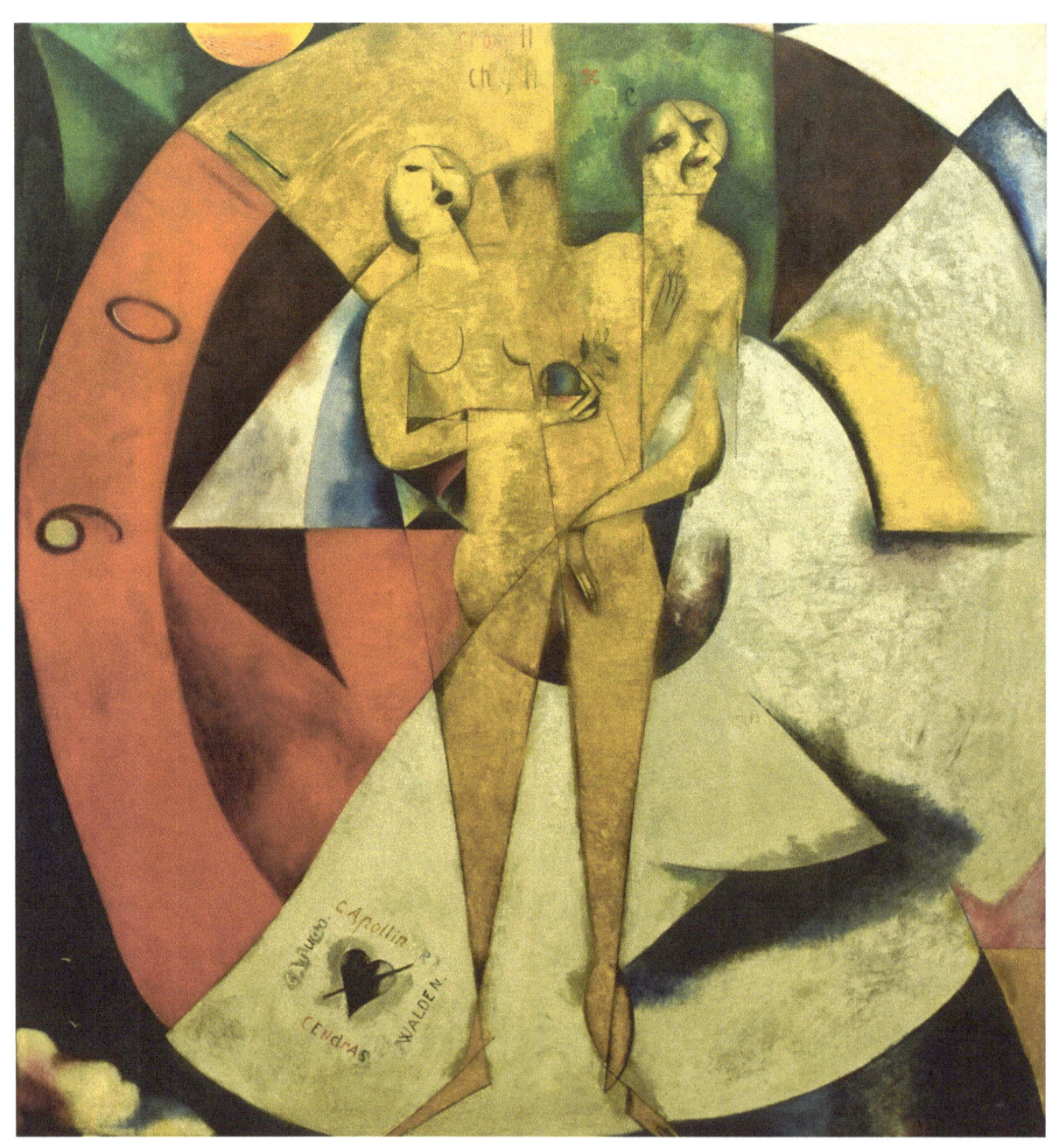

28. ***Homage a Apollinaire,*** 1911-12
Oil, gold and silver powder on canvas, 209 x 189 cm
Stedelijk Van Abbemuseum, Eindhoven

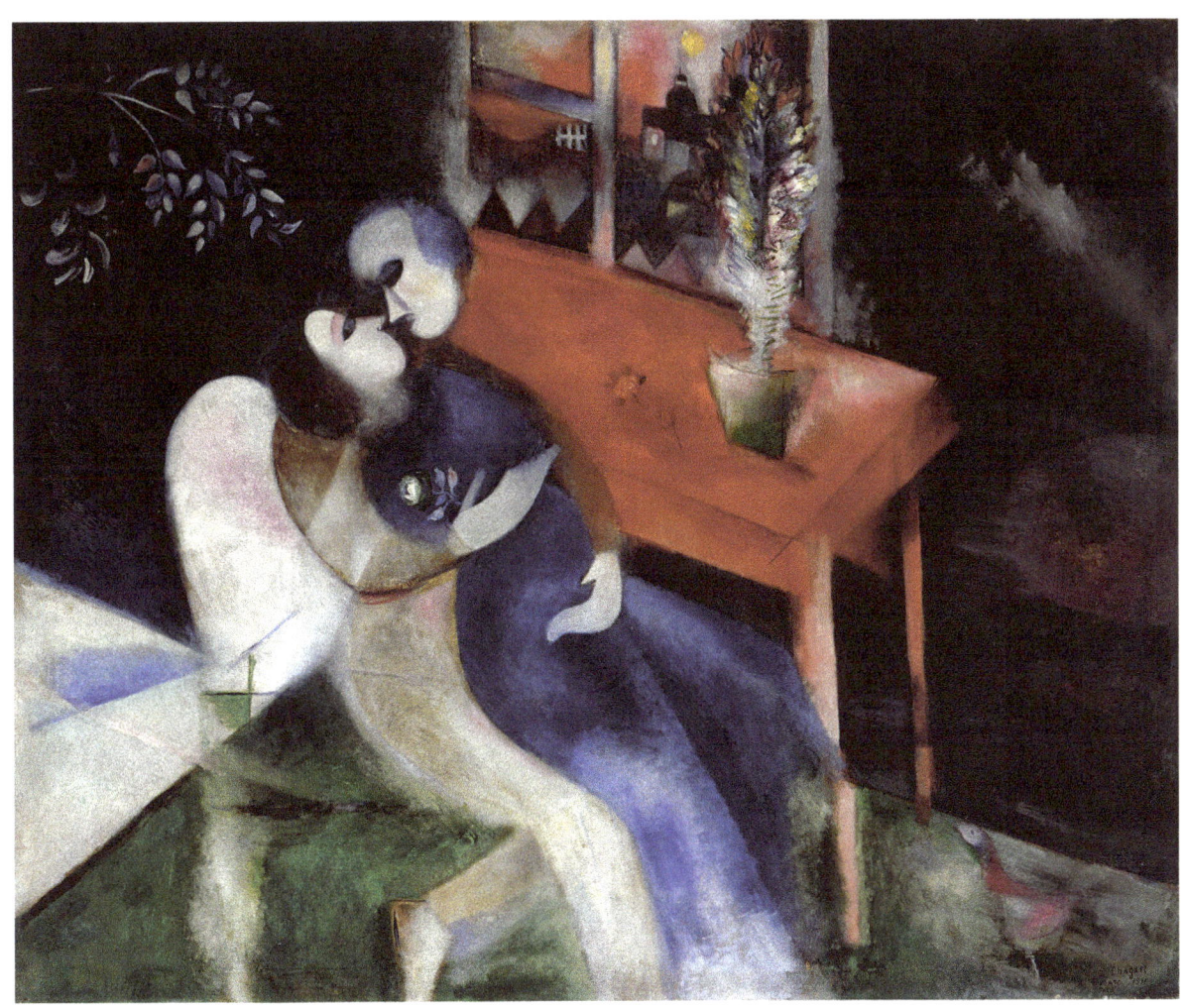

29. The Lovers, 1913-14
Oil on canvas, 109.2 x 134.6
The Metropolitan Museum of Art, New York

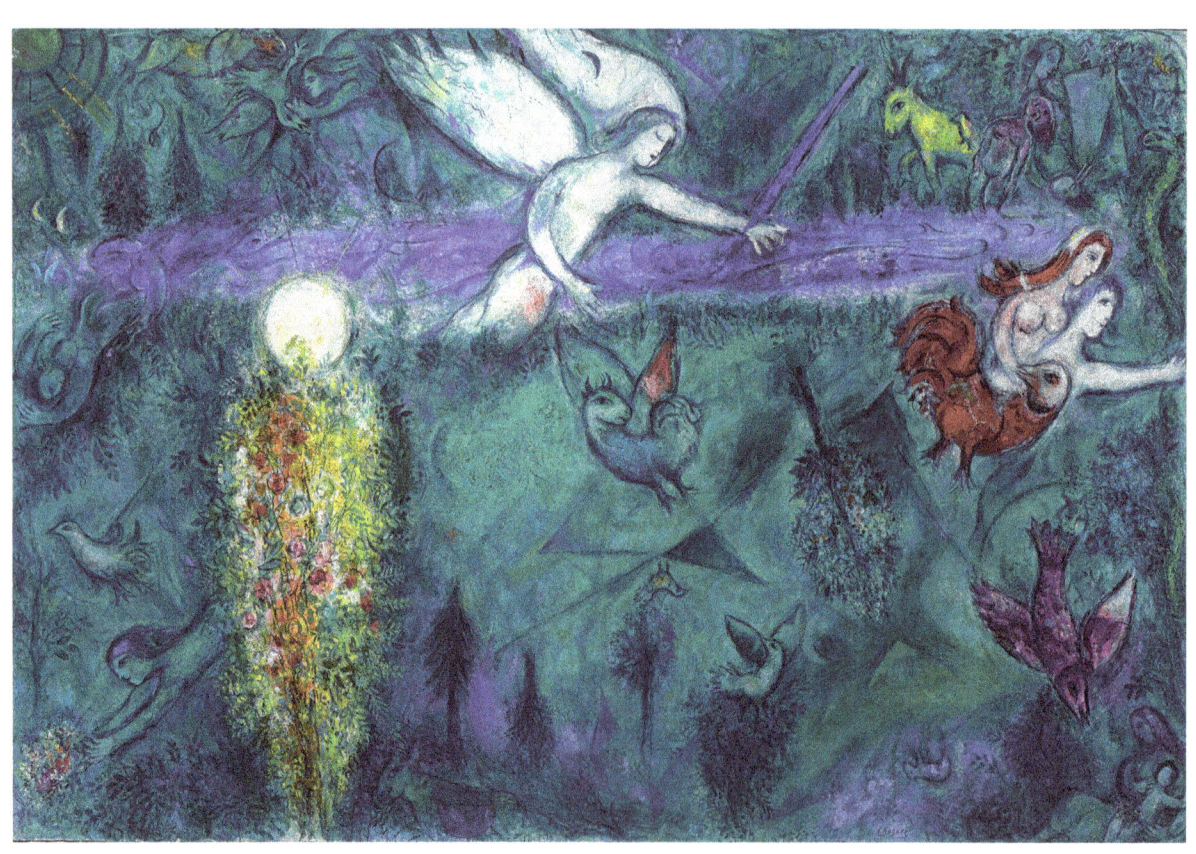

30. *The Expulsion from Paradise*, 1961
Oil on canvas, 190.5 x 283.5
Musee National Marc Chagall

3. THE ALCHEMICAL COUPLE

Earlier, details were given about Chagall's return to Russia in the summer of 1914 (Meyer, 1964) and the fact that, what had begun as a short journey to visit his family for a few months, became instead an extended period of forced settlement, for eight years. Chagall's artistic accomplishments were varied during this period[1], and the artist's life was focused upon creating a sense of personal settlement despite the 'forced' nature of his stead. Chagall initially returned to Vitebsk, where he reconnected with his family, and resumed his romantic relationship with Berta (later, c. 1923 *Bella*) Rosenfeld; They married in July, 1915.

Chagall's return to Russia, or what I have termed the *Russia II* period (1914-1922), has been documented thus far in the book as it relates to: His appointments during the Revolutionary period, as *Commissar of the Arts* for Vitebsk (1918-1920); as the founder and director of an arts academy, in Vitebsk (1918-1920); and, as the creative director for the GOSET theatre in Moscow (1920-21). What has not yet been presented is the period between his initial return and the Revolutionary

1 This experience is remarkably similar to the early *Paris II* years (1923-c.1931), prior to his numinous encounter with the Holy Land (then, Palestine).

period of 1918. This span - from June 1914 until January 1918 - is critical for Chagall's experience of re-immersion into the Hasidic world of rural Pale life, his marriage to Bella, and the re-imagining of the coupling imagery expressed in the Adam and Eve studies, as a hermaphroditic symbol of transformation.

Here, I would like to expand upon the particular appearance of the male-female binary in Chagall's oeuvre through an examination of Chagall's 'coupling' paintings, or dual-portrait paintings, that depict the artist and his wife. Unlike the allegorical *Homage to Apollinaire* (1911), the Chagallian male-female binary that is re-imagined during the artist's *Russian II* period (1914-1922) - and following the family's immigration to France in 1923-4 where they lived until 1941 - imbues the essence of the artist's personal relationship with his wife, their marriage, and the beginning and progression of their lives together.

Examining the imagery of Chagallian coupling paintings led to the discovery that the artist's treatment of form contains visual and metaphorical elements of the alchemical process. Thus, like the animal and transmorphic works explored earlier, these paintings may be viewed through the context of an archetypal expression and, as such, point to Chagall's personal transformation across lifespan development.

To begin to explore this connection between Chagall's coupling imagery and themes of psychic transformation it would be helpful to consider the biographical details underpinning the connection: The artist initiated a relationship with Bella whilst still an arts student in Russia in 1909. Bella was introduced to Chagall through her friendship with Thea Brachmann, the model for the *Holy Family* portraits of 1908-09 described in *Chapter One*.

In their respective memoirs, both husband and wife describe that an instant connection and romantic bond was formed at that first meeting (Chagall, 1989, p. 77; Chagall, B., 1983, p. 205). Shortly after the relationship began, Chagall painted their portraits in commemoration of the event: *Self Portrait with Brushes* (1909) (PLATE 31) and *My Fiancée in Black Gloves* (1909) (PLATE 32) (Wullschläger 2008: 99-100).

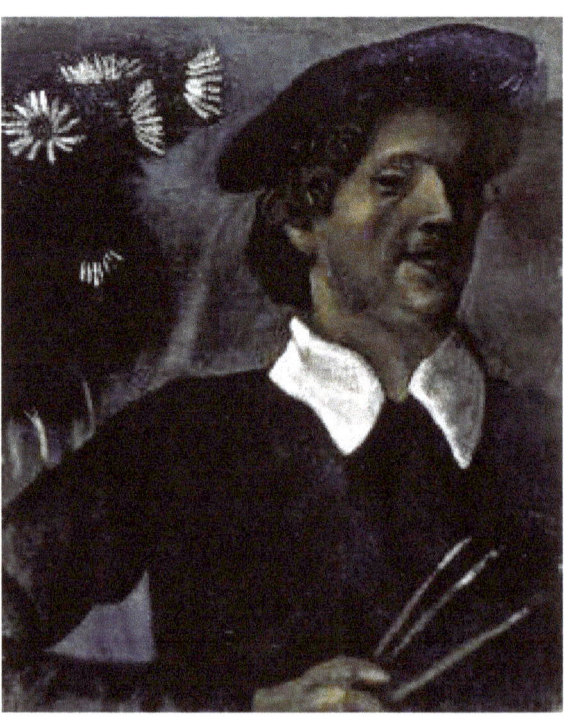

31. *Self Portrait with Brushes,* **1909**
Oil on canvas, 57 x 48cm
Kunstlammlung Nordrhein-Westfalen, Dusseldorf

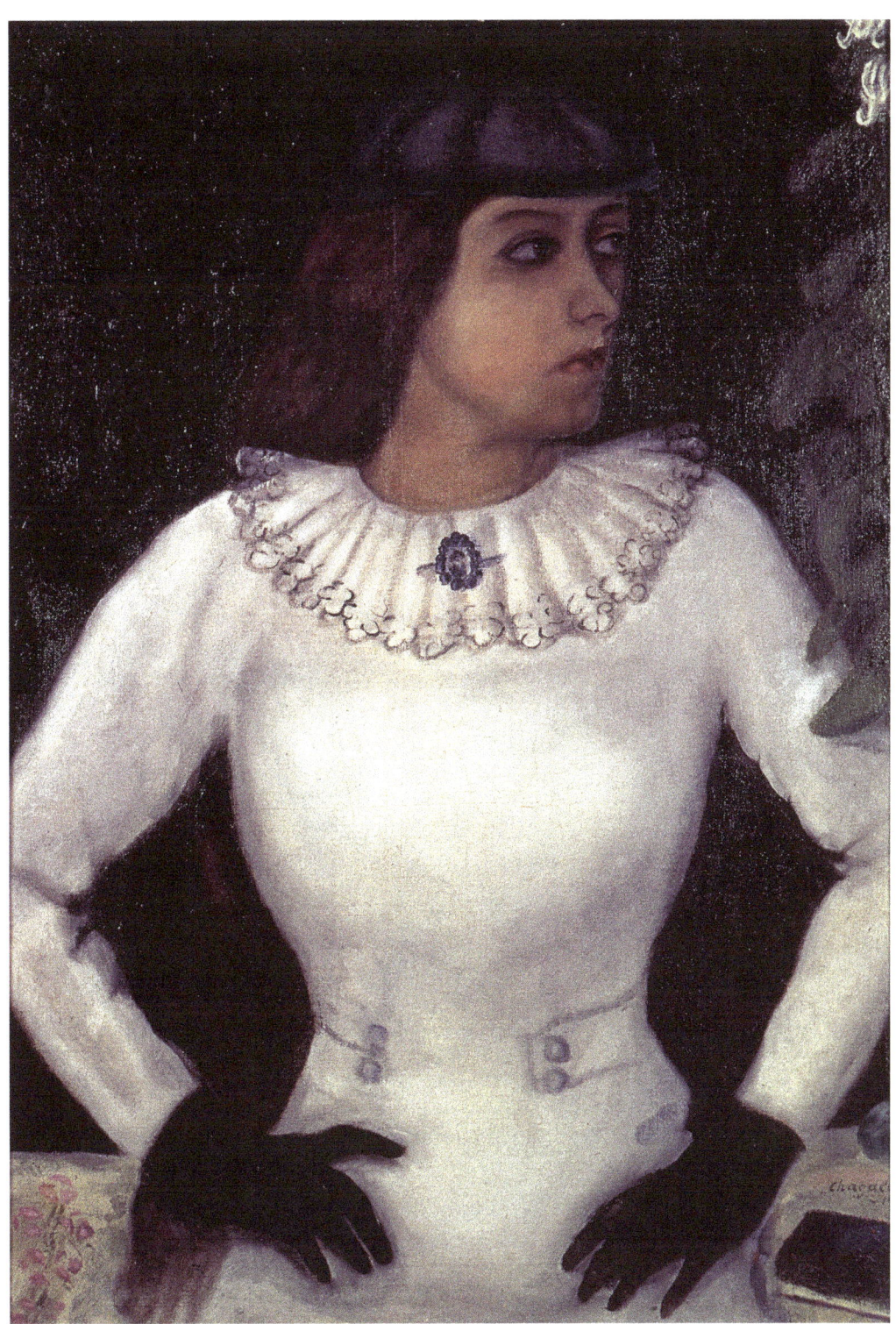

32. *Portrait of My Fiancée in Black Gloves,* 1909
Oil on canvas, 88 x 65 cm
Kunstmuseum, Basel

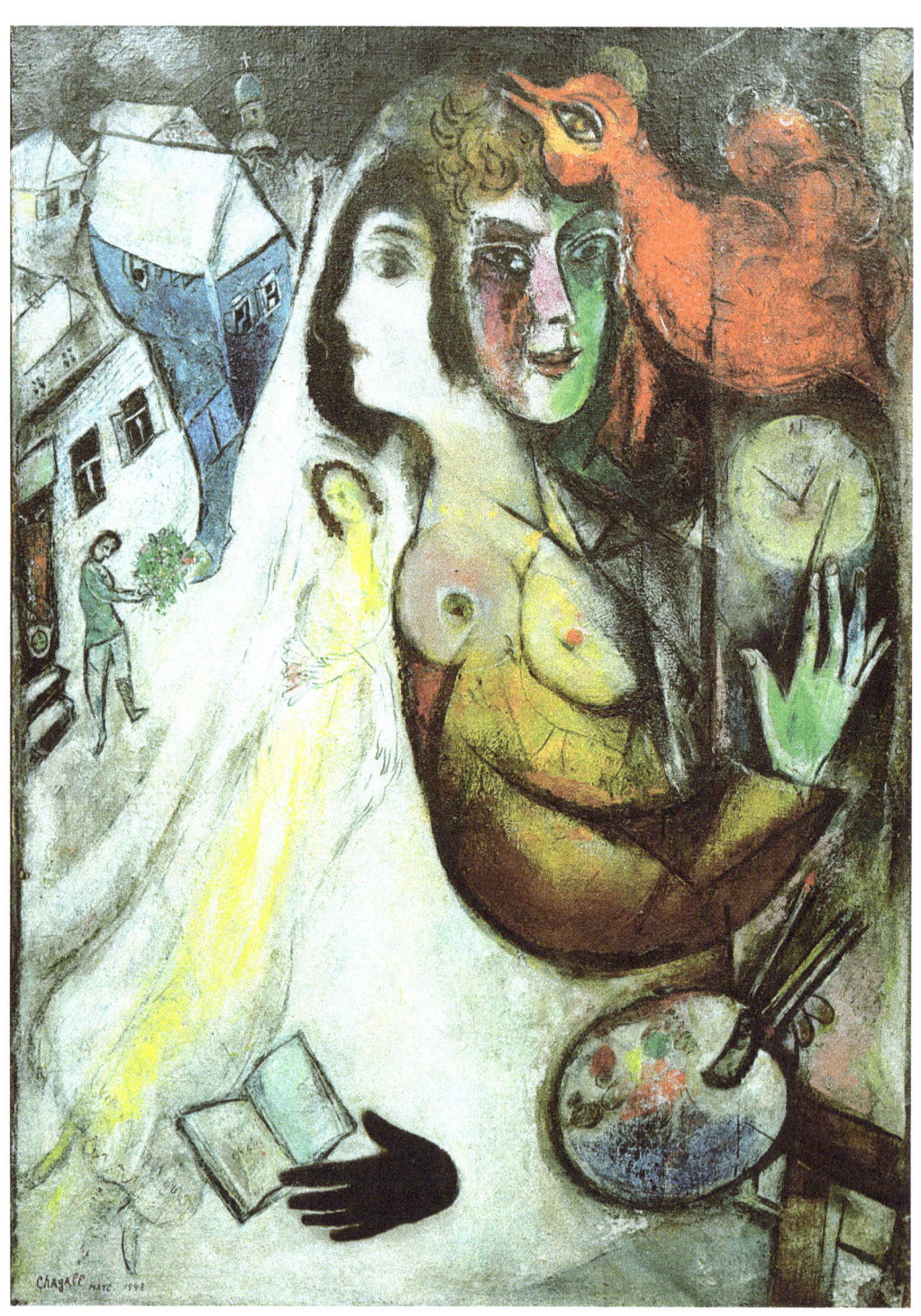

33. *The Black Glove*, 1923-1948
Oil on canvas, 111 x 81.5 cm
Private Collection

Wullschläger (2008) has devoted research to exploring Bella's life, independent of her role as Chagall's wife. She points out (2008, p. 97) that Bella, like Chagall, was a child of the *Modern Jewish Revolution* in the Pale, albeit, that her upbringing was within a well-known philanthropic Vitebsk family. Bella excelled in academia - she was among the top four Gymnasium students in Russia graduating in 1907, despite significant sanctioning upon Jewish students (a majority of whom were men) during the pre-Revolutionary years (ibid.). An interest in writing and the Arts led to her study of Literature and theatre at Guerrier's Girls College in Moscow where she produced a book on Fyodor Dostoyevsky, as well as attended drama classes under the tutelage of Constantin Stanislavsky (ibid.).

Wullschläger (2008) suggests that it was Bella who inspired Chagall's initial physical transformation from a provincial shetl artist to, "the persona of the cultivated oriental bohemian" (p. 99) prior to his 1911 departure for Paris. She (2008) observes that, following their settlement in Paris in 1923, Bella and her husband "together had carefully constructed an image of Russian émigré chic" (ibid.).

Wullschläger explains that little of the couple's correspondence from their early relationship exists (2008). Of the letters surviving from this period, and from later dates, the majority were written by Bella and saved by her husband throughout his lifetime (ibid). In the letters available, it is clear that even at the beginning of their relationship - whilst Chagall was still an arts student in St. Petersburg - Bella was interested in supporting her future husband's creative spirit, and the development of his work as a professional artist. In c. 1914, Bella writes to Chagall:

I will be very strict and demanding, because like myself, I want *something else* from you. Most importantly, I feel from you a sincere desire to struggle for the utmost, pure attitude to art. It is particularly important to reach that soon..Where is the art that gives me existence within it, the hand-made..Any kind of liveliness requires fullness of sound. In order to create it, blood must flow through all the capillaries, it needs this. I am not talking about realism. I don't need anomalies. I need art that can be discreet about its physicality, but is based on it, otherwise I won't believe in it. Or give me your fantasies, starry and echoing, unusual and surprising... (Wullschläger, 2008, p. 102):

Wullschläger (2008) remarks that whilst Bella continued to maintain a written 'correspondence' with Chagall during his Paris I years, 1910-1914, the artist wrote to her infrequently. Her distress concerning his silence is observable in a series of letters from this period. Wullschläger (2008) states that Chagall was "emotionally alone with his painting" (p. 146), and that, "Bella had identified so passionately with his work that it never occurred to her to consider that painting was her rival." (ibid.). Indeed, Bella Chagall would become, in the years following the couple's July 1915 marriage, the artist's most intimate critic[2].

2 What is well-documented in primary and art historical sources is Bella's evolving role as Chagall's 'personal' art critic and confidante during the twenty-nine years of their marriage (1915-1944). Much of what has been written about the Chagall's unique artist-critic relationship indicates that Madame Chagall's role transcended that of an objective critic, or even, a critic with an intimate connection to the painter (e.g., Alexander, 1978, p. 314; Baal-Teshuva, 2003, pp. 75-77, 160; Haggard, 1986, pp. 57-59; Wullschläger,

In her memoir, Virginia Haggard recollects (1986):

> Marc told me that Bella was the first person in his life to play the role of permanent critic. No painting was finished until Bella declared it so. She was the supreme judge; she stuck to her opinion, even if it was different than his, and he usually came around to hers in the end. (p. 108)

Chagall returned to Russia in June 1914, and resumed his romantic relationship with Bella. The couple were engaged the following year, in February 1915, with their marriage ceremony taking place in Vitebsk on 25 July, 1915 (Meyer, 1964). Between 1914 and 1918 the couple moved residences a number of times, from Vitebsk to St. Petersburg, as well as to a countryside property where Chagall continued his "Documents" series of landscapes and portraiture illustrating provincial Russian Pale life (Compton, 1998, pp. 16, 19; Meyer, 1964, p. 219-20). Their only child, a daughter, Ida, was born in 1916 (ibid.).

In 1915, following their engagement, Chagall began to experiment with personal imagery inspired by his romantic relationship with Bella. *The Lovers* series, begun in 1914 (Compton, 1998; Meyer, 1964), utilised a geometric composition, containing the unified form of a male-female coupling in various states of close-focus, intimate embrace. Between 1915 and 1918, Chagall continued with this theme; However, the expression of the coupling pattern shifted away from a use of non-descript facial characteristics (i.e., a man, and a woman) towards a refinement of features, resembling the facial anatomy of the couple. By 1916, *The Lovers* series continued to impart the same compositional approach, a close-focus male-female coupling, and (now, with) clarified facial features of the Chagalls. Unlike their respective early portraits of 1909, the couple were for the first time painted together as one form within the dimensions of one canvas, a shared, dual portrait.

Chagall contemporaneously (in, 1915) embarked on the creation of a series of oversized canvases extending *The Lovers* theme: This re-imagining appeared as full-body dual portraits that explored the couple's romantic connection through realistic form. Central to each composition is the artist's use of familiar Russian landscapes, the physicality of their bodily connection, and the fantastical imagery of the figures joined in flight.

The first of these dual portraits, *The Birthday* (1915) (PLATE 34) memorializes Bella's visit to the artist on his 6th of July birthday, shortly before their late July wedding. In her memoirs, Bella describes (1983):

> I suddenly felt as if I was taking off. You too were poised on one leg, as if the room could contain you no longer. You soar up to the ceiling. Your head turned down to mine and turned mine up to you, brushing against my ear and whispering something. I listened as your deep, soft voice sang to me, a song echoed in your eyes. Then together we floated up above the room with all its finery and flew. Through the window a cloud and a patch of blue sky called to us. The brightly hung walls whirled around us. We flew over fields of flowers, shuttered houses, roofs, yards, and churches. (p. 228)

2008, pp. 90-103). The ways in which she influenced her husband reached into every aspect of his life: his art, his public 'persona', his professional relationship with the art community, and later, his viewing audiences (ibid.).

Compton (1998, p. 21) makes the argument that Bella's feeling of "uplift" is mirrored within the visual expression of Chagall's portraits of 1915-1918 that include *The Birthday* (1915), *Over the Town* (1915-18), *Promenade*, or *The Walk* (1917), and *Double Portrait with a Wineglass* (1917). Compton (ibid.) does not expand upon this argument, and, of the Chagalls' primary source materials available, such as letters and their respective memoirs, the documents do not include such a conscious statement of intent (on the artist's part) to visually reproduce the essence of Bella's written observations concerning the 'uplifting' expression of their love. Their parallel creative expressions through art and writing, and in particular, the personal exchange of a mutual romantic vision - *if there was indeed such a conscious dialogue* - appears to have remained within the boundaries and intimacies of their marital relationship. Evidence of this 'exchange' at an unconscious level, is, however, witnessed in the series of Chagallian dual portrait paintings: Begun in 1909, these portraits spanned the three decades of the Chagalls married life together, and continued beyond their physical relationship, following the death of Madame Chagall, in 1944.

In, "Marriage as a Psychological Relationship" (CW 17: 324-45), Jung describes the psychic underpinnings of the intimate connection between a married couple. He makes a delineation between the coupling of a man and woman at the conscious, biological level, and the deeper, unconscious experience between two psyches unified through an intimate relationship. Jung regards the potentiality in the 'container' of the relationship, and the capacity of this vessel for holding and facilitating the experience of change, wherein both individuals may discover personality growth at an unconscious level (CW 17: 195). Jung reflects that, in a refined model of a marriage relationship, where *positive* growth is experienced and expressed by both partners, the containment space of the relationship will continue to support and relate to - as well as reflect - the process of psychic development at both the individual and shared psychic levels (CW 17: 196-198).

In, "Transformative Relationships" Stein (2005, 69-105) similarly considers the capacity for transformation within the context of personal relationships, including marriage:

> In a transformative relationship, the experience of the archetypal self becomes available to both partners through the symbolic object that forms between them. It seems that human nature is such that the activation of transformative images often (perhaps most frequently) occurs between two people (or more) who are joined intimately at deep unconscious levels. Out of this common psychic matrix arises the imagination that generates symbols which not only bind the pair together for life, and through generations, but also offer them access to the archetypal basis of psychological life itself. (p. 97)

The extent and duration of the Chagalls' intimate connection - both to, and through, the creative process across lifespan development - facilitated a psychological communication wherein the conscious and unconscious aspects of their relationship are able to be visually explored and renewed through the process and product of art. It is implausible to consider the emergence of these archetypal images, and the visual pattern of their development within Chagall's

oeuvre, without making an association to the intimate connection between the Chagalls as a married couple. The Chagalls' 'transformative relationship' of marriage arguably functioned between and through their shared psyches. This connection, or communication, generated a particular 'Chagallian imprint' within the dual portrait paintings.

Acknowledging the transformative imagery which has been discussed thus far, Chagall's oeuvre is a '*Self*-conscious' visual expression, contained within and between the artist and his creative work. There also exists, and is considered here, the influencing relationship of Chagall's intimate connection with his spouse, who, for her entire married life functioned as the artist's lover, friend, confidante, personal critic and liaison between their shared, external reality and, within the unconscious life of their, shared psychic worlds.

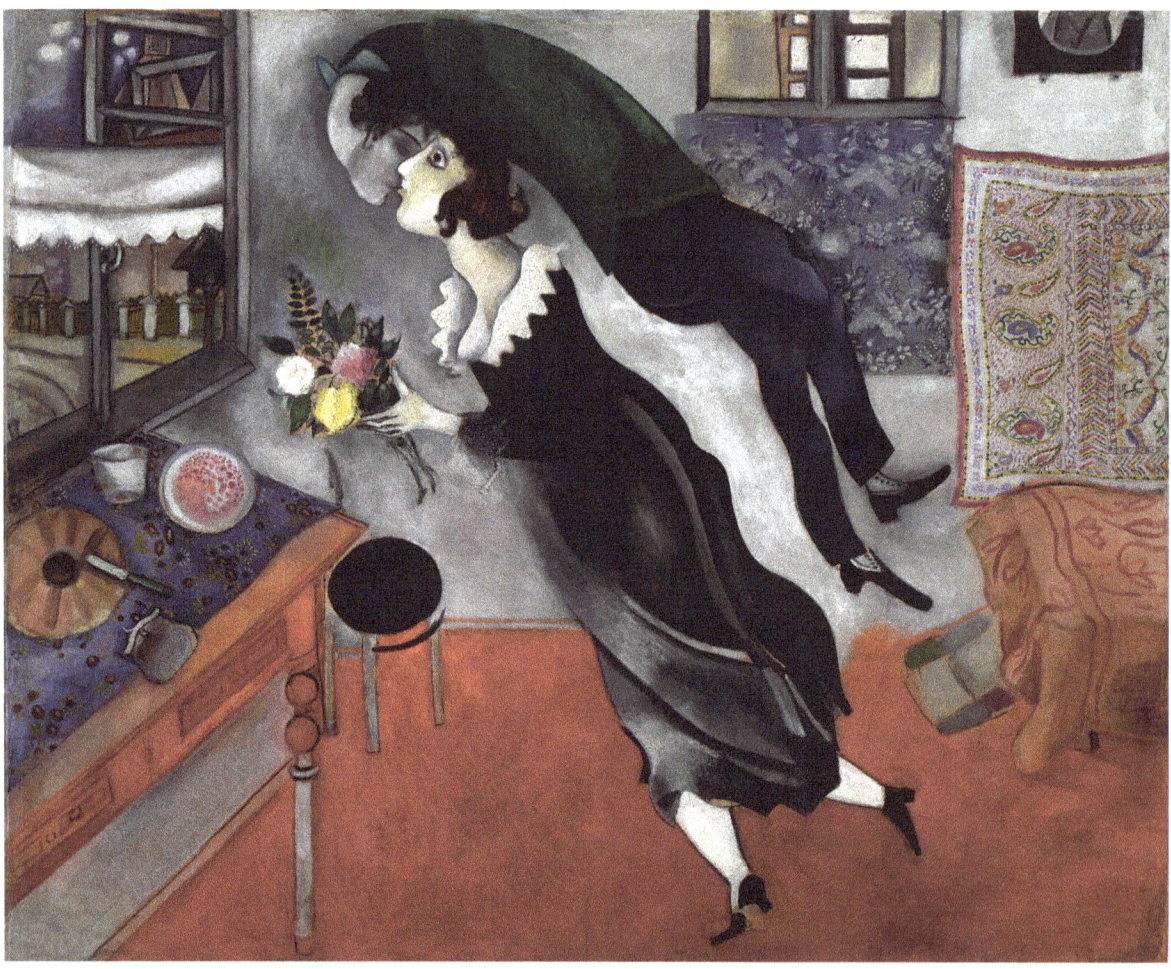

34. *The Birthday*, 1915
Oil on canvas, 81 x 100cm
The Museum of Modern Art, New York

'LA CHIMIE' AND ALCHEMY

In his writing about the process and product of art, Chagall frequently references his own theory of the creative spirit which he terms, "La Chimie" or 'The Chemistry' (Meyer, 1964, p. 542). Chagall used this term in two distinct ways: Early in his career, he applied it to the technical process of art through the use of materials (Harshav, ed., 2003, pp. 130, 132, 135-6, 139, 157). As an artist who was interested in the effect that color pigment has in conveying an energy, or even meaning, to a composition, Chagall referred to 'the chemistry' between the pigments he chose and the light quality which effected their visual reception (ibid; pp. 167-8).

In his second application of the term - which appeared with more frequency in his writing and speeches during the *Later Life* stage of development - Chagall explored the numinous aspect of a work of art, its capacity to hold 'life', or the possibility of a 'living painting' (Harshav, ed., 2003, p. 131-2, 136, 148). He referenced the audience's ability to respond to a work of art, and the possibility of 'connection' with and through a particular piece. Chagall's belief surmised that paintings which evoke such personal interest and numinous quality contain the essence of *La Chimie* (ibid.).

In Chagall's later years, the terms "chemistry", "color", "love" (ibid., p. 168), and "blood" (ibid., p. 165) appear interchangeable in such a way that "color" becomes synonymous for "spirit" or, that which *is spiritual* (ibid.). For example, the artist's 1963 speech, "A Crisis of Color", emphasises the spiritual unconscious of Modern Man, rather than the application of creative materials related to color theory or painting techniques (Harshav, ed., 2003: pp. 147-151).

Chagall's partner Virginia Haggard, herself a trained painter, observed in Chagall, that (1986):

> He had an intrinsic understanding for the life of matter, for its vibrations and transformation... he sought the mystery that lived in his material, and worked in harmony with it. The result is that his works can stand a comparison with nature. His famous test consisted of setting a picture in the grass, or against a tree, to see if it held its own. It illustrated his idea that a good painting is made of authentic, living substances and explained his theory of the indispensable "chemical" quality of a painting. What he meant was there is a mysterious element, without which a painting cannot rise above the realm of pure matter into the realm of pure creation, without which it cannot become a *new living thing*. (p. 104)

Haggard's perceptions of Chagall's *Chimie* share the quality or essence of the 'numinous' discussed earlier in reference to the iconographic nature of Chagall's images of the 'Holy Family' (1908-09) and portraits from the 'Jewish', or 'Holy Men' series of 1915. The observation (Cawthorne, 2005, Harries, 1993, p. 125; Tarasov, 2002, p. 255) is that a living, spiritual quality exists within the process of making iconographic art, as well as within the icon itself.

A further comparison to *La Chimie*, bears its namesake, *The Chemistry*, a term historically used to describe the Alchemical Opus (Eliade, 1978; Pearsall, 1976). This leads to referencing

the association of the historical development of the Alexandrian alchemical process, later Medieval European alchemical texts (ibid.), as well as the Jungian conceptualizations of the Alchemical metaphor of the individuation process (CW 16: pars. 353-538; Samuels, 1989; Stein, 2005). In alchemical terminology, the conceptualization of the 'spirit' is most often found through imagery. The clearest association is through the "spirit" of the Work: Mercurius (CW 13: 239-246) and its derivatives (e.g., Mercurius as Christ, CW: 13: 295-303), and the "spirit" of the mind (CW 8: 102). In this study of, "The Spirit and the Self", the emphasis is upon the metaphorical connotations of transformation through the individuation process, and, the "spirit" of the latter expression, the interior "non-material aspect of a living person" (Samuels et al. 1986, p. 140)[3].

The Jungian conceptualization of 'spirit' is helpful in understanding Chagall's thinking about the process and product of art: The essence of every successful painting - a material object grounded in the corporeal world - holds a particular non-corporeal dimension that affects and generates an external reception, thus creating a 'living' quality, independent from other paintings or works of art. Samuels et al. (1986, p. 26) remark that the spirit is "interdependent" with matter, and therefore, the two, together, form a binary, or set of opposites. Chagall's own observations suggest that without the 'union' of the painting and its spirit 'chemistry', the painting does not have a life of its own in the material world. Whilst Chagall emphasised the distinction between the 'practical' and 'theoretical' aspects within the application of his term, together, these aspects constitute contiguous features in the process and product of art: The cycle of 'bringing together' tangible elements to form a visual reaction that creates or releases a 'spirit' within the physical painting.

An analogy between Chagall's *La Chimie* and alchemical philosophy is an obvious one to make. Considering the breadth of visual documentation available on the illustrative history of this 'sacred art', it is surprising to note that art history scholarship has yet to address the similarities between Chagall's conceptualization of 'The Chemistry' and the practical and theoretical applications of alchemy. Examining Chagall's retrospective, there are significant examples of work that demonstrate imagery which is consistent with alchemical symbolism. Chagall's 'coupling' or dual portrait paintings of himself and his wife Bella present the greatest source and variation upon the alchemical theme and thus, become the second example of transformative imagery within this chapter.

A review of alchemy's associations with Ancient and Christian systems of belief, archetypal imagery, and the 'spirit' in psychic transformation would be helpful at this point to establish connection to Chagall, religion, and his creative methods and output.

Alchemy as a 'theosophical' path of spiritual transformation and enlightenment has an historical presence in all major Ancient systems of belief and cultures, with manuscripts appearing in Egypt, Mesopotamia, Iran, India, and China that predate the Christian era in the West (c. 500 A.D.) by two millennia (Eliade, 1978; Pearsall, 1976). From the practical perspective of *The Art*,

[3] 'The Spirit and the Self' also refers to the creative spirit in man, as well as, the spirit of the religious attitude.

the chemical, or *operational* features - literally, the 'matter' and 'equipment of the trade' - are thought to derive from the adaptation of metallurgical arts utilised by the ancients in preparing tools and weapons (Eliade, 1978). The diagrammatic physical apparatus of alchemy was solidified during the Christian era through the Dominican and Franciscan Orders' medieval translations (12th and 13th Centuries A.D.) of Arabic manuscripts into Latin[4] (Pearsall, 1976). The subsequent publishing of these medieval illustrated manuscripts in the 15th Century, and later, alchemical scholarship in Romance and Germanic volumes for European consumption in the 16th, 17th, and 18th Centuries, provided further scope for visual exploration of this sacred 'art' within the secular art of woodblock and lithographic prints, copper plate etchings, as well as in paintings (ibid.).

Zosimos of Panopolis, an Alexandrian alchemist and scholar of the Graeco-Egyptian period, is credited with the initial written distinction between the practical application of metallurgy and the theosophical foundation of 'true' alchemy in his series of manuscripts produced c. 300 A.D. (Eliade, 1978; Pearsall, 1976). Historically, this distinction has been subjected to erroneous translation wherein there is a minimization, or removal altogether, of the ancient religious (e.g. Gnostic) underpinnings, and a secularisation of *The Work* through appropriation of a literal perspective. This 'literal perspective' emphasises an experimental process designed to accomplish the transmutation of base metals into gold for material gain (Eliade, 1978; Pearsall, 1976).

Such a literal approach to the translation of alchemical text is problematic and has contributed to much of the negativistic attitudes towards alchemy as an established and ancient theosophical discipline (De Rola, 1973; Eliade, 1978).

Examples of a collective, literal reading of the practical aspects in alchemical manuscripts began during the Roman period (Pearsall, 1976) and were initially supported by the Christian church. Those who expressed a *concerned* opinion about the literal approach to the art sought to suppress the implications of a gold-making experiment that could have significant and strategic impacts upon the development of power, and thus European culture, through the injection of a false economy. As alchemy's origins in the West are through the Gnostic tradition of Alexandrian scholars and later, Moslem alchemists who refined the practice, the need of the early Christian church to find a means to suppress the theosophy of an *opposing* religion is also a factor in mis-translation. By the 18th Century, the Roman Papacy, European governments, and their monarchs had, at one time or another, all enacted various bans and legislation prohibiting the practice of the alchemical arts (Pearsall, 1976).

However, a closer examination of the covert dissemination of alchemical materials from the Eastern and Arabic traditions to the European continent during the Middle Ages (c. 1000-1100 A.D.) uncovers that, although prohibitive measures to regulate the study were devised, the interest in both the practical and theoretical (here, philosophical) applications of the art continued to be pursued by European scholars and patrons from the 15th Century forward (ibid.). It is also clear that the Christian church engaged

[4] The Arabian alchemists (Iran and Indian) in the Early Christian era were credited with continuing to perfect the physical apparatus used in metallurgy and alchemical experimentation, and thus their 'imprint' exists in much of what was translated and illustrated by Christian monks during the medieval period (Pearsall, 1976).

in a paradoxical relationship with alchemical scholarship from the outset. On the one hand, the Gnostic and non-Christian origins of the Ancient manuscripts presented a level of challenge to a 'new' religion. The Christian church is also directly responsible for the culminating and translating of alchemical text through the monastic illumination tradition in the Medieval period (De Rola, 1973, see, figs. 29-34, 36; Pearsall, 1976). Without the explicit involvement of Christianity, these illustrated manuscripts that constitute the basis for the European alchemical school - and from where contemporary scholarship supports its continued exploration of the field - would not have existed.

Eliade (1978) provides a concise reflection on 'practical' alchemy, its origins in ancient tradition and myth, and the literal, secularised reading concerning the transmutation of lesser metals into gold:

> To attempt to link up a discipline, which dominated the Western world for 2000 years, with attempts to counterfeit gold is to forget the extraordinary knowledge of metals and alloys possessed by the Ancients. It is also to underestimate their intellectual and spiritual capacity...we are compelled to look elsewhere for the origins of this discipline sui generis. Much more than the philosophic theory of the unity of matter [Chinese alchemy], it was probably the old conception of the Earth-Mother, bearer of the embryo-ores, which crystallized faith in artificial transmutation... It was the encounter with the symbolisms, myths, and techniques of the miners, smelters, and smiths which probably gave rise to the first alchemical operations. But above all, it was the experimental discovery of a living Substance, such as it was felt by the artisans, which must have played the decisive role. (pp. 147-9)

For the European tradition, the Renaissance marked a turning point in the scholarship of alchemy: The Christian church had adopted a level of ambivalence to the "open study of alchemy" by the 15th Century (Pearsall, 1976, pp. 72-75). This was, in part, a concession towards the increasing availability of printed materials on the art, following the widespread establishment in the latter 14th Century of mechanical print-making technology (ibid.). The availability and dissemination of alchemical manuscripts in secular society presented an opening for the Church to re-align itself with the theoretical model of alchemy. In the Christian metaphorical interpretation of alchemy, the Ancient concept of a universal or earth 'spirit' in the opus became an allegorical projection of Christ and the divine cycle of birth-death-rebirth through resurrection. Furthermore, the *transfer* of sacred connotations, from Ancient and Gnostic systems of belief to a Christian perspective of *The Work*, opened a dialogue with Church teachings at the *individual* level of spirituality, thus making the analogy between the alchemical operation and human transcendence into the divine realm of a Christian God.

At this point, I would like to return the discussion to the archetypal perspective and the 'spirit' of individuation development. The Alchemy scholar and painter, Balthus Klossowski de Rola (1908-2001), suggests that the collective nature of the alchemical process is an archetypal expression of a system of belief (1973):

> Alchemy cannot be bound to a single system of thought, any more than it can be reduced to a single symbolic interpretation, because it transcends all dogma and all religions. One must not forget that at one time or another, sometimes in turn, and sometimes simultaneously, Chinese, Indians, Egyptians, Greeks, and Arabs have all practised the art. All of them contributed to making it what it ultimately became in medieval times.... (p. 10)

De Rola's observations underscore the cyclical component in theoretical alchemy: That the process and documentation of the work emerged in different ancient civilizations and through various systems of belief, including most recently the monotheistic tradition of Christianity. In each 'emergence' example, a visual and metaphorical contextualization is present within the theosophical pattern of description. These patterns are expressed and interpreted through different visual or written means across cultures. The appearance of alchemical thought remains unified and connected at the symbolic level through the concepts of spiritual transformation and the transcendence of the human soul. It is in this way that the alchemical process connects with Jungian thought and archetypal theory.

The archetypal nature of alchemical symbolism became the focus of Jung's work during his latter life, and here, I would like to explore the emergence of alchemical symbolism through the creative process. From his extensive research with patients and his own scholarship on the subject, Jung made the observation that alchemical symbols appear within the unconscious dreams, active imagination, and creative output of individuals who have had no connection or exposure to alchemy (Eliade, 1978; *CW 12*: 44-331).

Such an *a priori* expression of alchemical imagery, whether within the externality of the creative process or within dreams of the collective unconscious realm, is referenced symbolically as a transformative image marking the process of individuation development. Observation of the archetypal expression of alchemical imagery also exists as a cyclical projection: an image-marker of psychic transformation within the visual expression of a transformative process.

For Chagall, his *self-initiated* engagement with the alchemical associations in his term *La Chimie* underscores this cyclical model. He is using this unconscious, archetypal metaphor to discuss his practical and theoretical approach to creating images of transformation. The practical process appears in the combining of pigments, underscored by the thought that the origin of natural pigment - which is present in very high quantities within the composition of artist-grade paints and pastels - derives from earth materials, including metals such as cobalt and cadmium. Chagall is using this 'matter' to create or to release the 'spirit' within a work of art, thus transforming the state of original materials - or *prima materia*. Theoretically, Chagall believed that the successful transmutation of this prima materia, or pigment, resulted in the 'release' of a spiritual element within the container of the picture plane. Through such release, the work of art was able to transcend the inanimate boundary of matter and was elevated to the state of a 'living' painting within the natural world.

Chagall's (al)chemically-oriented description of the creative process brings this review forward

to the point where the images themselves become the focus of the discussion. What I have not yet presented is the thought that alchemical illustrations, generally, constitute a reflexive component in their origin, emergence, and reproduction cycle. As fine art illustrations, every wood-cut and etching plate, print, and painting is an individual work of art that has been executed by an artisan specialising in their field. The individual function of each image is to visually communicate a practical procedure whilst illuminating a stage within a metaphorical process. As a series, they tell the story of the process of physical and spiritual transformation. As such, the illustrations are, 'the art' within *The Art*.

Earlier in this historical review, I mentioned that were it not for the monastic translators and illuminators of Medieval Europe, the visual aspect particular to alchemical scholarship would have been diminished. This is not to say that influences from the Chinese, or Arabic, or Indian alchemical schools would have dissipated. Rather, the European school, from which the most prominent and prolific examples of alchemical visual art derive, would not have precipitated the breadth of manuscripts that it has since the 15th Century. And Jung's study of alchemy, including the development of his alchemical metaphor of the transference (CW 16: 353-539), that utilises the woodblock print illustrations of a 16th Century Latin alchemical text, the *Rosarium Philosophorum* (1550), may have been reached through an altogether different means, if found to be, at all.

The overreaching argument in this book is that the emergence and quality of transformative imagery within Chagall's oeuvre may be explored and described in such a presentation that forms his unique pattern of individuation development. In making the association here between the illustrative art of alchemical manuscripts and Chagall's dual portrait paintings, the archetypal nature is found in the fact that, as two unrelated series of works, they are connected *by image* through the creative process, independent of their respective origins or functions. Within this connection is the commonality of a religious or spiritual dimension as it relates to the physical and metaphorical process of transformation.

The alchemical operation itself is a temporal process: It has a definitive start, and a clear ending. As a metaphor, in psychology and in religion, the temporal element of this process may proceed in a non-linear sequence such that each of the stages may overlap, be passed over within the unconscious, or at times, move forwards or backwards to achieve the release and transformation of the 'spirit'. In the discussion of Chagall's alchemical paintings that follow, I have sought to follow *the essence* of the temporal quality contained within the illustrative 'Operation' of the alchemical process.

35. *Self Portrait with Bella by the Stove*, 1915-16
Oil on paper on canvas, 43.3 x 34.7cm
State Museum of Contemporary Art, Costakis Collection, Athens

THE FURNACE AND THE WOMB

Murray Stein (2005), in his discussion of the *Rosarium* series and the alchemical metaphor for individuation development, emphasises the "context" (p. 72) of the transformational experience and considers the role of external relationships beyond the consulting room as a contextual element in the positing of the experience and expression of internal change:

> The transformation process extends over a long period of time but typically begins with a powerful symbolic experience that is triggered by physical and psychological factors which become active during adulthood and behave like change hormones. One of the most powerful of these factors is the experience of intimate relationship. (p. 71)

Throughout this study, the various external factors in Chagall's biography that have created binary conditions or a numinous state consistent with an internal psychic shift, and which correspond to the emergence patterns of archetypal imagery through the creative process, have emerged[5]. In Chagall's first alchemical dual portrait painting, *Self Portrait of Bella by the Stove* (1915-1916) (PLATE 35), the experience of the religious ritual of marriage closely preceded the production of the painting. For Chagall, this passage marked a physical re-immersion into the formal rites and customs of Hasidic Judaism as a means to celebrate an 'initiation', into the life of a married man.

> The uninitiated person who has alchemical dreams and comes close to a psychic integration, also goes through the ordeal of 'initiation': however, the result of this initiation is not the same as that of a ritual or mystical initiation, although, functionally, they are akin. Indeed, at the level of dreams and other unconscious processes, we are dealing with a spiritual reintegration, which has, for the 'uninitiated', the same importance as an 'initiation' on the ritual or mystic level. (Eliade, 1978, p. 224)

Jung has explored the theosophical connotations of the 'initiate' and initiation rites in primitive cultures and ancient religions and brings together the association of this archetypal process with alchemical studies and Christianity (*CW 7*: 176, 384, 393; *CW 9ii*: 414; *CW 11*: 841-2, 854; *CW 12*: 66, 171, 527). Jung's theory of individuation makes the analogy between the 'initiate' as patient, and the 'initiation' into the process of psychotherapy which has, like ancient and modern religions as well as alchemy, the primary goal of 'spiritual' transformation (*CW 11*: 854). For Chagall, the re-immersion into the Hasidic tradition of his Early Life (1887-1922) development brought with it a clarity of artistic perspective, seen in the alchemical works through his treatment of dual portraiture. As an artist, the 'initiation' into the study of the practical aspects of the creative process had begun as a student, in Russia, and continued through induction as a professional artist during the *Paris I* years.

The *Russian II* period (1914-1922) of re-immersion, was also thus a *re-initiation* into working again 'within' Russia.

5 In *Chapter One*, the artist's early immersion in the ritual of Hasidism and its affect upon his creative filtering of life experience is presented. Chagall's numinous encounter, in 1931, with the Holy Land, is considered by the artist as his primary influence in creating Biblical works, and is detailed in *Chapter Five*. In *Chapter Two*, the association is made between the external presence of the sacred-secular binary during Chagall's four years in Paris (1911-14), and the dramatic changes that occurred in his creative style and perspective as a result of his encounter and psychic assimilation within that externality.

In alchemy, the metaphor of 'initiation' appears practically through the presence of the alchemist, or 'initiate', who creates the assemblage of materials and start of the chemical reaction process. This processional initiation marks a critical change in the conditions and perspective of the *prima materia*. In the alchemical opus, this physical change is brought about through the introduction of fire, and takes place within the *vas*, or womb-like container, that 'gestates' the Stone of the Philosophers, consisting of sulphur and mercury (de Rola, 1973).

Surrounding the process of the alchemical opus, and underscoring the study of alchemy, generally, is the thought that the work holds the sacrosanct connotation of ritual. Whilst 'ritual' itself may not connote a 'secret' or even a 'forbidden' association, the underlying thought is that every ritualistic process contains an unknown element of 'mystery' or the capacity to generate a numinous expression or encounter within the experiential level of the process.

Eliade (1978, pp. 53-57) considers alchemy's historical link to the "secrets" of the metallurgy artisan trade in Ancient cultures. The concept of a 'secretive' system developed out of the education, or induction, into the practical elements of the trades skills, and was distilled through the emergence of 'the spirit' through a theosophical perspective. This resulted in the combination of a physical art and a philosophical perspective imbued with the numinous connotation in the expression of the spiritual processes of transmutation and transcendence. The system holds within its origins and archetypal connection a 'mysterious' facet based upon and adapted for the practical process - particularly during periods when *The Art* was forbidden by laws - which continues to evolve and resonate with associations to a 'secret' or 'hidden' perspective of truth.

Self Portrait with Bella by the Stove (1915-16) is itself a 'mysterious' work in that, other than the fact that it is owned by a private collector, there does not seem to be any formal scholarship about its creation or origin (Kamensky, 1989). It is the only work of art that appears in this book which holds such a particularly slim detail of provenance. The execution of the work chronologically overlaps the period in which Chagall was working on *The Lovers* series (1914-1918) as well as the oversized canvases depicting dual portraits of the couple, begun in 1915 (1915-1917). The painting, as previously mentioned, also coincides externally with the artist's engagement period and marriage to his wife in 1915.

Central to the picture plane is the vertical Classical column, or pillar, which orients and stabilizes the composition. A conjoined portrait of the couple appears partially in view to the left of the column, dividing the composition into three sections. Chagall's treatment of this dual-portrait is significant for the appearance of only Bella Chagall's visage, which creates a manqué or theatrical entendre of their two-into-one form. The face and figures as well as the pillar-column are illuminated by the cooling of a light source obscured from view; whilst the central base of the column structure is 'heated' by the color and form of glowing embers within the furnace that reflect across the figures and the compositional space. Visually, the painting stands out within the artist's dual portrait works in that it not only holds the familiar connotation between the reality of the human forms and

the allegorical features of the fire column, but also contains, or evokes, a deeper - perhaps darker - mysticism not readily associated with Chagall. The 'sur-naturel' treatment of the form and space of *Self Portrait with Bella by the Stove* (1915-16) shares the quieter mystical subtleties of a de Chirico landscape, for example, rather than the boldness of Dali's surrealist 'viewscapes'.

Considering the associations with 'initiation' and the temporal process of alchemy, this first example of alchemical imagery within Chagall's dual portraits is significant for its use of form: The visual emphasis is upon the pillar structure and the heat of the fire which, together with the prima materia contained within the vas, points to temporality within the chemical transmutation process, and the metaphorical coniunctio. The furnace, or *the Anathor*:

> ...is devised in such a way that it is able to keep the Egg at constant temperature for long periods of time. The outward fire stimulates the action of the inner fire, and must therefore be restrained; otherwise, even if the vessel does not break, the whole work will be lost. (de Rola, 1973, p. 11)

Using Jung's analogy between the alchemical process and human development, von Franz (1980, pp. 264-6) explores the associations of the pillar, the furnace, and its fire. She explains (1980) that the pillar motif references, both the space (House of Wisdom) and place (vas) of the conjunction, as well as "the fourteen qualities the alchemist must have" (p. 264). In the instance of a pillar-furnace, von Franz (1980) remarks that the implication is one of *processing*:

> ...the fourteenth stone or pillar is *temperatia*, meaning a balanced temperament... The work of transformation can be spoiled with too much heat, just as the process of individuation cannot be forced but depends on time, balance, and patience. (p. 265)

Chagall's decision to include (only) his wife's face in this particular dual-portrait is a curious choice. One perspective is that the artist is, at once, hidden 'within' and 'behind' the creative alchemical change. A different perspective concerns the female element of the 'initiation' process: The emphasis is upon the vas, or womb, which 'contains' the transmuting matter, or process of change. Both observations may function within the temporal connotations of alchemy and lifespan development, if the idea of gestation *before* birth - or in this example, *re-birth* - is considered.

To explore this idea, I would like to return briefly to the discussion of Chagall's Early Life works, and specifically, to the *Stations of Life* series, wherein the artist produced examples of work that dealt with rituals of *Death*, *Birth*, and *Marriage*, within the Hasidic community between 1908-10 and, later, within the secular society of *Paris I*, between 1911-14. Included in the *Paris I* series is a departure - or clarification - from Chagall's original *Stations of Life* visual 'cycle': There is a visual 'marker' inserted into the understanding of the life cycle, with the appearance of the gestational element symbolised in creation myths. In examples from these 1912-1913 paintings, the womb of creation is contained and reflected literally through Chagall's self-portrait from *within pregnancy*.

Eliade (1978) presents the metaphorical association with alchemy and gestation in his discussion concerning the *Bergbuchlien*, a 14th Century alchemical

3. THE ALCHEMICAL COUPLE 109

document (1505) written by Colbus Fribergius, the first such manuscript to be produced in German:

> [Fribergius] recalls the belief, widespread in the Middle Ages, that ores are generated by the union of two principles, sulphur and mercury... [Fribergius states that] 'Furthermore, in the union with mercury and sulphur with the ore, the sulphur behaves like the male seed and the mercury like the female seed in the conception and birth of a child'... The smooth birth of the ore demands the, 'quality of a natural vessel, just as the lodes are natural in which the ore is produced'. (p. 48)

In *Maternity*[6] (1913) (PLATE 37), Chagall explores the gestational stage of the life process through imagery of an infantilised 'self-portrait' within the womb of a mythological hermaphrodite figure. This 1913 oil painting was preceded by two preliminary works: the 1912 gouache, *Maternity* (PLATE 36), wherein the pregnant figure appears anatomically female and, a like-titled 1912 pen and ink drawing (see, Meyer, 1964, p.208), in which the female figure has transformed and appears as a hermaphrodite. In the oil composition of 1913, Chagall refines the compositional elements of color and space with an intensified color palette, and the solidification of an hierarchical perspective. However, the focus, as in the earlier re-imaging of the composition, remains upon the hermaphroditic figure gestating a portrait of the infant Chagall.

Chagall's external 'transforming relationship' within and between Russia initiated the early development of his creative technique and working style. The alternative title of the earliest 1912 gouache, *Russia*, is suggestive of Chagall's physical and psychic connection to his birthplace, as well as the 'gestational' element within the expression of time within Russia, before and after his formative *Paris I* (1911-14) years.

Meyer (1964) remarks on the connection between Chagall's use of the female form, and the artist's "recollection" (p. 203) of the Russian iconographic tradition:

> It may be assumed with virtual certainty that the idea for this picture derived in part from the Maria Blacherniotissa, the Byzantine Madonna type, portrayed as a praying woman wearing on her breast a medallion of the infant Christ as Lord of the World, that reappears continually in Russian art... This woman is a symbol of fertility analogous to all great mother figures in ancient cultures, many of which exhibit bisexual attributes... The physical-psychic event is also expressed in the color – at once familiarly intimate and brightly resounding – which expands at the upper edge of the picture into a broad waving banner of various light yellows, oranges, and reds. (pp. 203-4)

As a binary, the furnace and vas are the male-female instruments of the Whole of the alchemical operation. The 'goal' of the art is reached through the coniunctio oppositorum, or merging of the 'opposing matter', into a new being. The visual 'gestation' of Chagall is not only created from 'matter' by the artist, but also, represents the artist 'being created' from within the womb. The reflexivity of this Self-vas

6 These *Maternity* series of works sometimes appear in print with the title as, *Pregnant Woman*

of the picture plane and the Self-within-vas (*within* Rebis) imagery strengthens the archetypal reading and association to psychic connotations of development: Chagall is both physically and metaphorically *within* the alchemical process, being transformed. Meyer's (1964) description of the colors utilized underscores the 'fire' into which the Hermetically-sealed container of transformation descends. The composition as a whole is an archetypal image through its a priori alchemical references. Unified, these images contain and reflect the physical and chemical elements of the transformative process, as well as the staging of change.

The unification of the picture plane - the unity of form and color, of the furnace and the vas - might exist as an example of alchemical imagery in Chagall without the introduction of further paintings or material. However, it seems most appropriate here to reflect upon what has been presented already concerning Chagall's interest in depicting animals in their 'natural' and transmorphic states[7].

De Rola (1973) considers the image of the Egg as 'vas' within alchemical scholarship. He describes that:

> The Prima Materia is placed in a mortar made of agate (or any other very hard substance), pulverized with a pestle, mixed with the secret fire, and moistened with dew. The resulting 'compost' is then enclosed in a hermetically sealed vessel or Philosophic Egg, which is placed in the Anathor, the furnace of the Philosophers... In the initial stage, the heat is compared to that of a hen sitting on her eggs. (In more ways than one, the natural process through which chickens are born is comparable to the alchemical process). (p. 11)

The first literal depiction of the alchemical image of an egg within a bird, appears in Chagall's 1944 painting, *Listening to the Cock*[8]. Baal-Teshuva (2003, p. 62), Bohm-Duchen (1998, p. 258), and Compton (1985, p. 217) together remark upon the "Mexican influence" of form and make the association between the execution date (1944) and the summer of 1942 Chagall spent in Mexico City working on the stage and costume designs for the American Ballet Theatre's production of *Aleko*. Meyer (1964, p. 462) adds that the artist's treatment of movement in this work was "influenced" by the experience of Mexico, but he dismisses a direct association between the visit and the visual content. A primitivistic treatment of form consistent with the style of traditional 'Mexican' pottery exists in the work, although the direct connection to Mexican craftwork remains unclear, and has not been referenced by the Artist. What is present symbolically here is arguably more consistent with the unconscious emergence of archetypal imagery, particularly, in the context of the alchemical metaphor.

Meyer (1964) approaches *Listening to the Cock* (1944) through the strength of Chagall's colors, which are similar in tone to *Maternity* (1913):

7 Chagall's earliest experimentation with images of gestation, or pregnancy, began *with animals*, in, *The Cattle Dealer* (1912), created contemporaneously with the hermaphroditic *Homage to Apollinaire* (1911-12) (PLATE 28). *The Horse of the Moon*, and *The Dove*, both executed later, in 1943 (Meyer, 1964, in *Classified Catalog*, 1943/44), contain a white or golden orb gestating within an animal form. In Chagall's Later Life years (1953-1985), the image of the white or colored orb becomes more frequent, and abstracted in examples such as, *Green Landscape* (1949), *Le Quai de Bercy* (1953) and *The Dream* (1978). An example of this motif is present in the painting, *Sunday* (1952-54) (PLATE 39).

8 *Listening to the Cock* (1944). Oil on canvas, 92.5 x 74.5 cm. This painting is held in a Private Collection, and was not available for reproduction here. It does appear in books referenced, e.g., Baal-Teshuva (2003, p. 163, as, *At Cockcrow*) and Bohm-Duchen (1998, p. 259), among others, and is also found on-line in a search for the title.

The red and the violet divide the picture plane temporally which is signaled in the presence of the crescent moon and the white sun motifs (ibid.). These images extend the temporal element of gestation and suggest the transformation process with the appearance of a chick hatching from the external egg. The 'Sol' and 'Luna' binary also extends to the transformational image of a transmorphic hermaphrodite, a male-female head, atop the human-breasted body of a cow[9].

A third painting, *Cow with Parasol* (1946) (PLATE 38), utilises a combination of the alchemical imagery that appears within the initial *To Russia, Asses and Others* (1911) (PLATE 23), as well as, in *Listening to the Cock* (1944). Here, the conjoined bridal couple becomes the cow's tail, whilst a singular calf drinks from beneath. The sun-egg and the bird image of the 1944 composition have separated, and recede, in this example, with the focus upon the bovine creature astride in the red sky. Visual examples of the alchemical metaphor, and symbolism of the sacred marriage, continue to be explored and visually re-worked during Chagall's *Mid* and *Later Life* stages of development.

THE SACRED MARRIAGE

In his 1945 essay, "The Psychology of the Transference" (*CW 16*: 353-539), Jung utilises the alchemical imagery of a woodblock-illustrated text as a means to define, through visual metaphor, the process of transference within the analytical model of individuation development. The alchemical illustrative series he has chosen appears in the 16th Century *Rosarium* document. It originates independently of analytical thought as an illustrative sequence of twenty plates which progressively depict the stages, or the 'operation', of an alchemical 'opus'. The series was first published in 1550 (Edinger, 1995), and the visual and metaphorical appeal of these illustrations is evident. Subsequent European alchemical text in the 17th, 18th, and 19th Centuries (de Rola, 1973) share this common imagery of 'processing a process' that Jung describes in his alchemical metaphor of the transference.

In, *Mysterium Coniunctionis* (*CW 14*), Jung expands upon his clinical application of the *Rosarium* series, presenting a detailed study of alchemical tradition and the archetypal nature of imagery within alchemical text. Jung's emphasis in this volume is upon the *coniunctio* stage of the alchemical opus, wherein two opposing forces (e.g., male-female, anima-animus, King-Queen, Sol-Luna), or 'opposites', unite and transform together into a third being, the Rebis.

Post-Jungian scholarship continues to discuss the expression of the transference-countertransference model between analysand and analyst as well as the ways in which this experience constitutes the features of an 'alchemical' process (Samuels, 1989; Schaverien, 1998; Stein, 2005). In "The Alchemical Metaphor," Samuels (1989: 181-193) returns afresh to Jung's essay on transference and, through the *Rosarium* illustrations, explores the clinical capacity for patient transformation as an alchemically-driven expression of processing within the transference-countertransference model.

9 Visually, *Listening to the Cock* (1944) differs substantially from the composition in, *To Russia, Asses, and Others* (1911) (PLATE 23). The paintings share a commonality, however, in their archetypal association with mythology, and the 'life' spirit, or libido. In both examples, the breast of the hermaphroditic and transmorphic cow appear in the same configuration as the life-giving bovine deity.

36. *Maternity*, 1912
Gouache on paper, 27 x 18.2 cm
Modern Museum of Art, Bequest of Helen Serger, New York

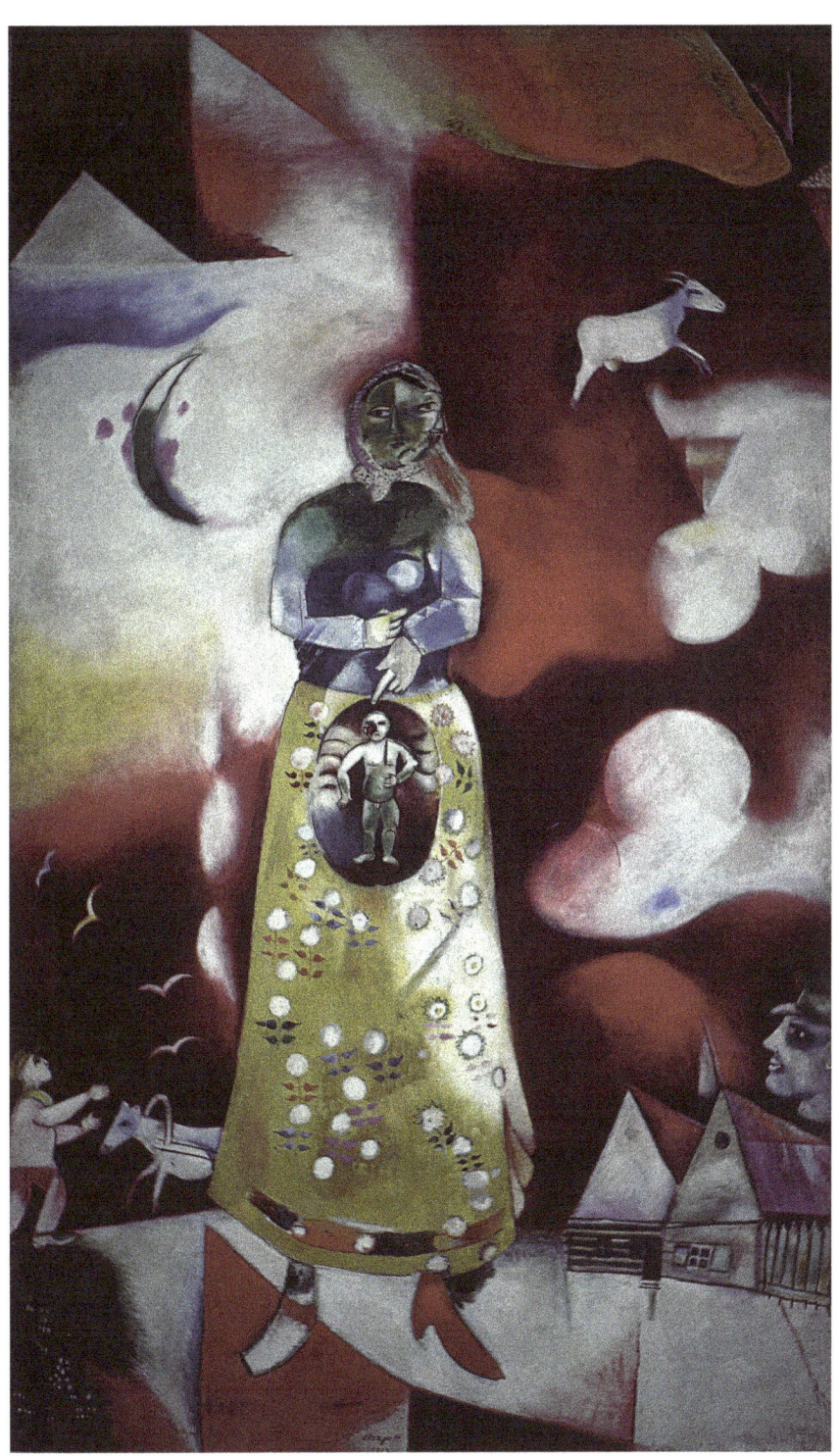

37. *Maternity*, 1913
Oil on canvas, 193 x 116 cm.
Stedelijk Museum, Amsterdam

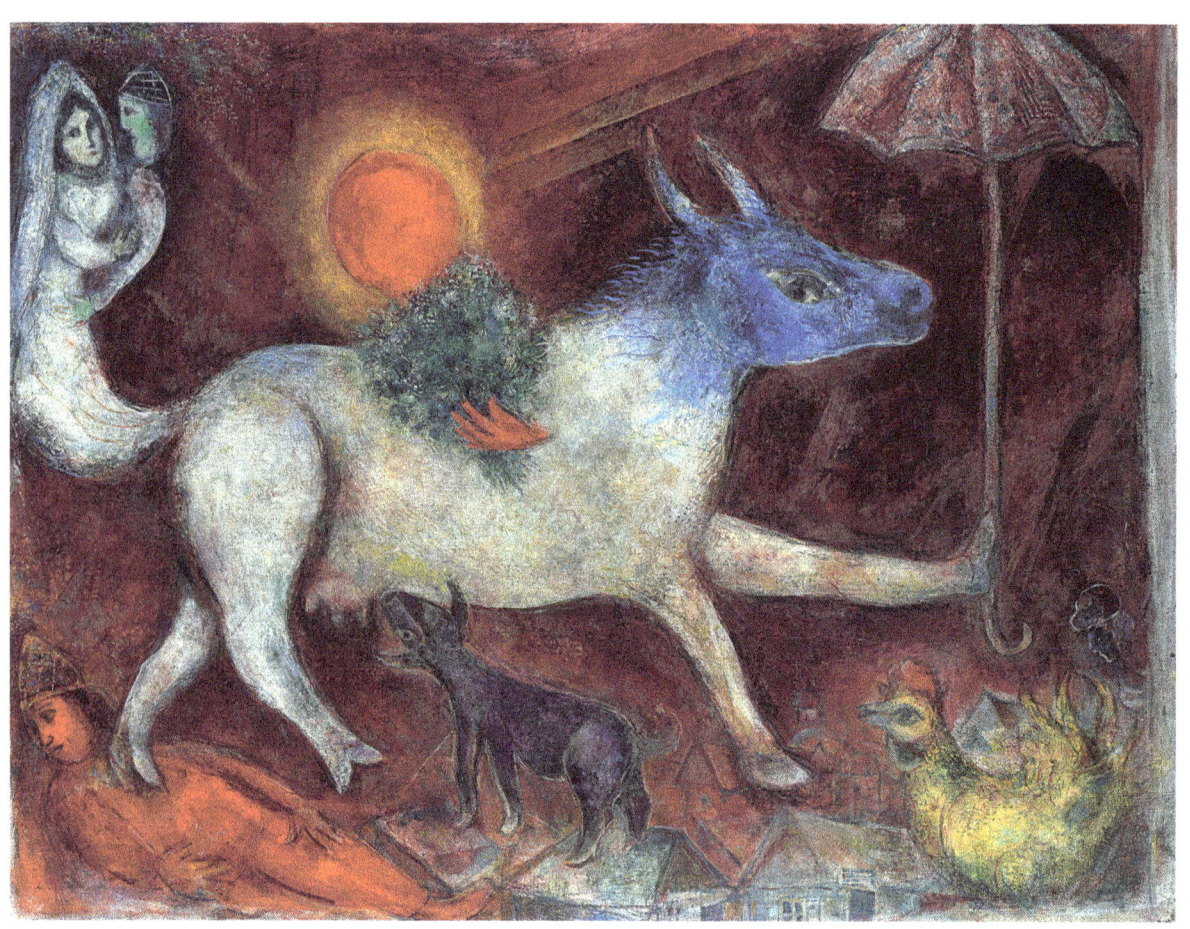

38. *Cow with Parasol*, 1946
Oil on canvas, 81.3 x 108cm
Metropolitan Museum of Art, Bequest of Richard S. Zeisler, New York

39. *Sunday*, 1952-54
Oil on canvas, 173 x 149 cm
Musee National d'Art Moderne, Centre Georges Pompidou, Paris

As Chagall was neither a scholar of alchemy, nor openly championed the process of psychoanalysis, the appearance and continued use of this imagery presents a curious feature in his work. Like his use of zoomorphic and transmorphic figures, as well as the Crucifixion, the emergence of the alchemical couple during periods of heightened internal and external change points to an archetypal expression.

The Wedding (1918) (PLATE 40) is the first portrait to depict the Chagalls as a married couple in the clothing of sacred ritual. The couple are joined through a loose embrace and held together by a winged figure who rises into the sky above the landscape of an outdoors evening. *The Wedding* was completed in Vitebsk during the winter of the Russian Revolution (Meyer, 1964). The treatment of the figures appears similar in clarity and form to *The Lovers* series, also nearing completion at that time[10].

Central to the alchemical process is the unification and transformation of the opposing forces. The 'opposites' appear in different symbolic forms, and Chagall's image of the bridal couple most closely references the symbolic King and Queen of the process (*CW 16*: 410-449). In this dual portrait, Chagall has painted *into* the face of his wife a diminutive male figure. This image reinforces the concept of the *coniunctio oppositorum*: The figure is suggestive of the unconscious processing of the contents of her psyche - her *animus* - appearing, literally, across her visage[11]. The conceptualisation of the exchange of male-female essence appears, however, in the later compositions of the 1940's and beyond, wherein Chagall and his wife are depicted in portraiture with the form of a 'shared' head. Chagall's 'marking into' the head also appears in 1911's *I and the Village* calf form.

Earlier, I mentioned the temporal element within the progression of the opus, and that in certain presentations - particularly when the psychological metaphor is applied - there exists a combining of stages, or even, what appears to be the 'passing over' of an expression as it remains within the unconscious realm.

The Wedding (1918) contains imagery consistent with the (later) stages of the illustrated opus: the emergence of a winged figure, resembling the 'soul image', or imago. The soul-as-bird or winged form is depicted in a variety of presentations in alchemical illustrations (*see*, de Rola, 1973)[12]. The association here is *transformation as an atemporal event*: the 'separation' and 'reunion' of the soul appears as a dual-natured process. As a transformative image, the observation is that, the cycle of development is 'ongoing' for both Chagall and his wife within (and beyond) the containment of the picture plane.

The Wedding (1918) marks the initial emergence of the winged figure within Chagall's oeuvre. Zoomorphic and transmorphic variants of this

10 Bohm-Duchen (1998, p. 107) and Compton (1998a, pp. 22-23) explore the Modernist sacred-*into*-secular comparison between this painting and the religious icon, *The Meeting of Joachim and Anna Outside the Golden Gate* (Nicolas Dipre, c. 1500). The compositions are nearly identical, suggesting that Chagall had been in visual contact with Dipre's work (ibid.). There is also the thought that in the archetypal realm, spontaneous emergences of sacred imagery are not unusual. Independent of the Modernist connotations suggested by art history scholarship, *The Wedding* (1918) contains imagery that makes the composition visually relevant to the historical tradition of the alchemical opus, as well as the alchemical metaphor of lifespan development.

11 This is the only example found of an 'animus figure' in a portrait of Bella.

12 In the *Rosarium* illustrations, for example, the winged form appears in two illustrated plates: *Separation of Soul and Body* (*CW 16*: fig. 7), and *Reunion of the Soul and Body* (*CW 16*: fig. 9).

re-imagining of form appear subsequently in compositions during each of the artist's three lifespan stages. The winged, or transmorphic, figure depicted here features most prominently in the alchemically-referential portraits of Chagall and his wife. Egyptian mythology has already connected Chagall's depiction of 'morphic' transformative imagery in animals and figures. Here, the connection is extended to include Chagall's alchemical 'spirit' imagery, and the Ancient Egyptian concept of the 'ba', or 'soul bird'. The connotations of the mythological soul bird are similar to those of the 'dove' and the winged figure, as the 'spirit' movement of the alchemical opus (see De Rola, 1973, for examples). The 'ba' is an unconscious construct in Egyptian religious belief that shares the modern psychic constructs of "the soul" (Hornung, 1971, p. 123) and "the personality" (Shaw & Nicholson, 2008, p. 51). It is comparable to "the moral essence of a person's motivation and movement, which also enables them to be free within the next world" (Silverman, 1991, p. 145). In *The Coffin Text*, Egyptian funerary art, and hieroglyphics, generally, the ba is most frequently depicted in the transmorphic presentation, as a human-headed bird with arms. The ba takes to flight, to function in the service of the corporeal body of the deceased in the afterlife (ibid.). This underlying - *and all-encompassing presence* - (of the) regenerative cycle of birth, death, and rebirth is central to an understanding of Egyptian religious belief, the practical alchemical opus, as well as (and, in particular) the alchemical metaphor of individuation development.

The Wedding (1918) marks a creative and technical change for Chagall in his use of coupling imagery and the marriage theme. Earlier examples of wedding imagery (e.g., *Russian Wedding*, 1909, and *The Wedding*, 1911), depict the compositional scene from the viewpoint of an 'observer' of the wedding party celebrations. This 1918 composition is the first instance wherein the artist is examining the bridal couple from a close-focus range (as in *The Lovers* series). He has also chosen to incorporate the dual portraits of himself and his own bride, Bella. In the context of psychic development, this re-imagining of composition is suggestive of the artist breaking 'through' and entering 'into' the picture plane. In this visual treatment, Chagall becomes 'one' with the containment capacity of the canvas, and thus is able to project and reflect his position from within the ongoing process of change.

In September 1923, following a year in Berlin, the Chagalls immigrated to Paris where they lived until 1941 (Meyer, 1964). 1923 marks the year of transition for the artist, between his Early Life (1887-1922) and Mid-Life (1923-1951). Chagall's career was fortified through his return to France. He arrived as a critically well-received artist and continued his professional growth through the 1920s and '30s as a painter and printmaker (Meyer, 1964).

To begin to discuss Chagall's alchemical coupling paintings at Mid-Life, it would be helpful to re-visit the first painting in the alchemical coupling series *Self Portrait with Bella by the Stove* (1915-16). In this painting, there is a form that appears at the base of the column, consisting of five dots arranged in a cross or rosette configuration. This five-dotted form reflects the characters found in the alchemical 'alphabet': "lead", "night", and "vinegar" each contain a configuration of similar dots within a geometric

form (Pearsall, 1976, pp. 164-69). Five is also the number of the "Quintessence" (*CW 12*: 310), or, in alchemical terminology, the "spirit" of the alchemical opus (*CW 13*: 268).

A lesser known association with 'five' corresponds to the religious underpinnings of Chagall's natal Hasidic faith: In Kabbalistic numerology, the number-value '5' corresponds to the meaning of "window" (Varley, 1976, p. 112). The creation of stained glass windows is most central to Chagall's creative output during his Later Life period (1952-1985). Imagery of windows also feature prominently in the artist's paintings during his Early (1887-1922) and Mid-Life (1923-1951) periods. In the *Russian II* years before the Revolution (1913-1917), Chagall painted a series of landscapes and portraits whilst living in Vitebsk, and whilst staying in a dacha outside of St. Petersburg. These paintings engage with an inner-outer reversal of composition: They are, more accurately, 'roomscapes' that feature closed windows through which the outside world may be viewed (e.g., *Window in the Country*, 1915, PLATE 42). The compositional tension inherent in these paintings is palpable, and amplified, if one considers that Chagall was living in Russia under enforced conditions of settlement. When comparison is made between these 'roomscapes' and the earlier, *Paris Through the Window* (1913) (PLATE 41) - the final composition of the artist's *Paris I* period - the imagery of a 'containment' process (and cycle) emerges.

In the Russian (1915) example, *Window in the Country*, there is a visual melancholy of cool colors suggestive of a 'static' containment from within the closed windows of the 'roomscape'. Whereas, in the 1913 Parisian composition, *Paris Through The Window*, the window form opens *into* the colored motion of a city space. A dual-perspective, or two-faced visage, reflects the temporality of this motion: Chagallian scholarship has unilaterally compared this dual-faced figure to an image of the god, Janus (Savill & Locke, 1976). What is curious, is this: in the 1915 composition, *Window in the Country*, the Janus figure has been re-imagined in the same compositional placement, appearing as two separate - yet, joined - portraits of the artist and his wife. Here, both faces gaze out from a closed, partially-curtained window separating the interior space, from the natural landscape of the rural Russian countryside. The figures and their mythological evocations coincide with the observation that the window motif suggests a dual perspective of containment: containing the passage of literal time and the *possibility* of passage between the exterior and interior world, into the psychic vista beyond. As a transformative image, the window reflects the 'invisible' boundary of the psychic structure through which the 'spirit' may be released into the external world.

In a painting from 1928, *The Bride and Groom of the Eiffel Tower* (PLATE 43), Chagall incorporates the image of an open window into a composition that appears similar to, *Paris Through the Window* (1913). The imagery in this 1928 painting is re-imagined in a second, like-titled composition, completed a decade later in 1938-39 (PLATE 44). Both paintings of '*The Bride and Groom of the Eiffel Tower*' contain a double-portrait of the Chagalls, as well as the soul-bird image.

40. *The Wedding*, 1918
Oil on canvas, 100 x 119 cm
Tretyakov Gallery, Moscow

In the initial *Bride and Groom of the Eiffel Tower* (1928), the soul bird passes through an opened window pane intuiting the approach of a change in 'state', not yet clarified, until Chagall's creation of the second *Bride and Groom of the Eiffel Tower* a decade later (1938-39). Whilst the paintings do share a 'naming', the imagery, itself, differs significantly. Such change in form is reflected visually in the artist's treatment of detail and perspective: There is a transformation of the couple's appearance, from a 'naturalistic' state in 1928, to the 1938-39 re-imagining of the couple's marriage as an 'icon', through an allegorical energy that enters most often in Chagall's later life works. The motion of change passes through the spirit: The soul bird appears directed towards the couple in the 1928 portrait, while, in the latter work of 1938-9, the soul bird appears to depart the picture plane.

This is the only pair of Chagall's dual portrait paintings to share a title. I do not believe this is merely a coincidence: the 'alchemical bath' of Parisian life and culture between the Wars brought change in both Chagalls' development. In their memoirs and primary source materials, the Chagalls indicate that the Paris II (1923-1941) years were the most productive of their lives, together. The new environment created an external 'containment' for the process of change, and the couple, together, experienced the positive aspects of the 'immersion' experience.

A final exemplar of an alchemical painting here is, *The Black* Glove, 1923-1948 (PLATE 33). The artist began this composition the year he returned to Paris (1923) and continued to re-work the imagery for the next twenty-five years. This painting is the first dual portrait Chagall had executed since *The Wedding* (1918) and the first the artist created in the *Paris II* (1923-1941) period (Meyer, 1964). The deconstruction of perspective in the picture plane extends into the artist's animated treatment of form. This treatment includes the presence a single figure with dual facial features and shared torso, that is, at once, a portrait of the artist and his wife.

Of the coupling portrait paintings the artist created, *The Black Glove* (1923-1948) is arguably the strongest visual reference Chagall made to the alchemical *process* of unification. The two-in-to-one animated duality of the figures expresses the essence of the *coniunctio oppositorum* (*CW 16*: fig. 5). The presence of the zoomorphic soul bird reinforces *the being in* the state of change: The bird appears in its 'natural' state, referencing the early and later stages of the alchemical operation simultaneously. The nakedness underscores the corporeal, sexual unification of the two bodies. Chagall's uncharacteristic use of the unclothed body is significant: The nudity reflects an element of *temporality*, the King and Queen are unclothed in two particular stages of the opus appearing in the Rosarium illustrations[13], corresponding to the concept of 'bathing', or 'purifying', in illuminated alchemical manuscripts, generally (de Rola, 1973).

A further temporal reference to the cycle of ongoing change appears within the composition: Chagall includes the 'recycling' of two images that directly reference the first individual portraits he completed to commemorate the start of his romantic relationship with Bella, in 1909. In the foreground, the conjoined figures are stationed at an easel with a palette and brushes, evocative of Chagall's *Self Portrait with Brushes* (1909)[14]. At the bottom

13 The *Stripping of the Couple* (*CW 16*: fig. 3), and the *Descent into the Bath* (*CW 16*: fig. 4).

14 The hand of the figure has what appears to be six digits, that could

3. THE ALCHEMICAL COUPLE 121

of the painting, a single black glove appears to reference the portrait of Bella, *My Fiancée in Black Gloves* (1909). The presence of these self-referential forms constitute a *transforming painting within a painting* about the unification process of the couple. The focal placement creates an animated, visual connection to the temporal element of personal and collective (couple) development within the container of marriage.

signal a joining of the two bodies – mid-process; The treatment of anatomy in *Self Portrait with Seven Fingers* (1912-13), also comes to mind.

As arguably *the* image of the Chagalls' ongoing transformation process during the *Paris II* years, *The Black Glove* simultaneously *precedes and follows* (whilst also including) the essence of change exemplified between the years of the *Bride and Groom of Eiffel Tower* (1928, and 1937-38) series. Without documentation of the artist's working methods particular to *The Black Glove* (1923-48), it is impossible to know the exact visual evolution of the imagery. What is clear, however, is that *The Black Glove* (1923-48) was reworked in stages, during the whole of Chagall's Middle Life (1923-1951).

41. *Paris Through the Window*, 1913
Oil on canvas,
136 × 141.9 cm
Solomon R. Guggenheim Museum, New York

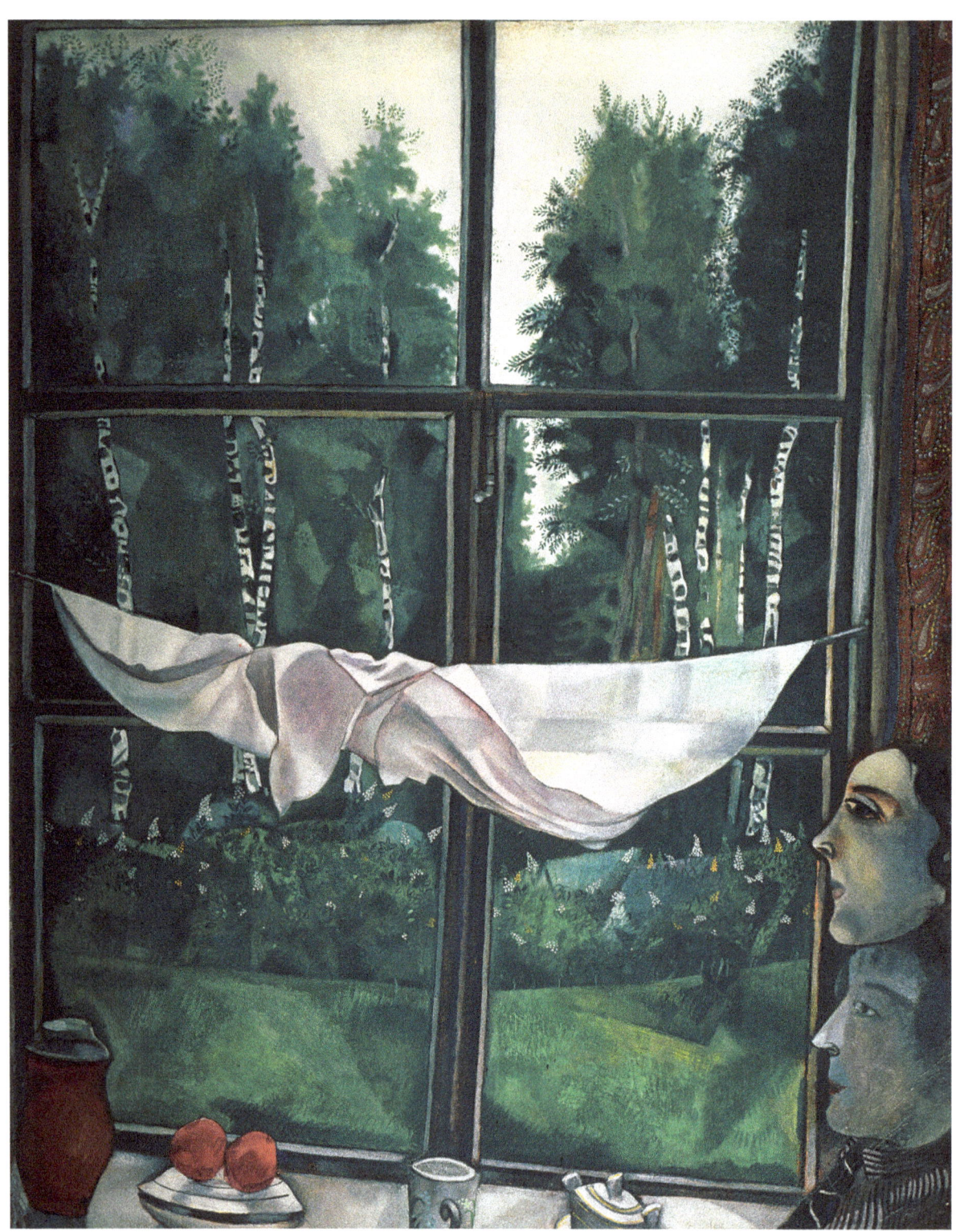

42. *Window in the Country*, 1915
Oil and gouache on cardboard, 100 x 80 cm
Tretyakov Gallery, Moscow

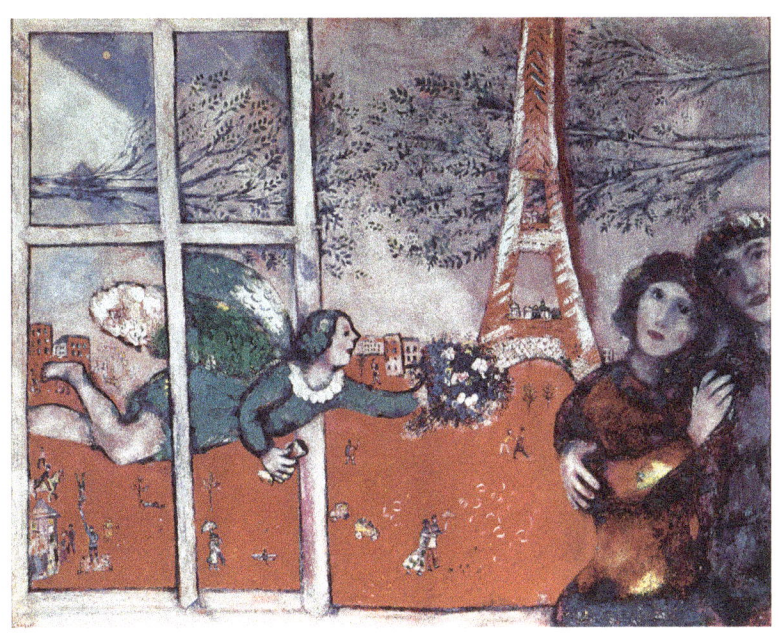

43. *The Bride and Groom of the Eiffel Tower*, 1928
Oil on canvas, 89 x 116 cm
Private Collection

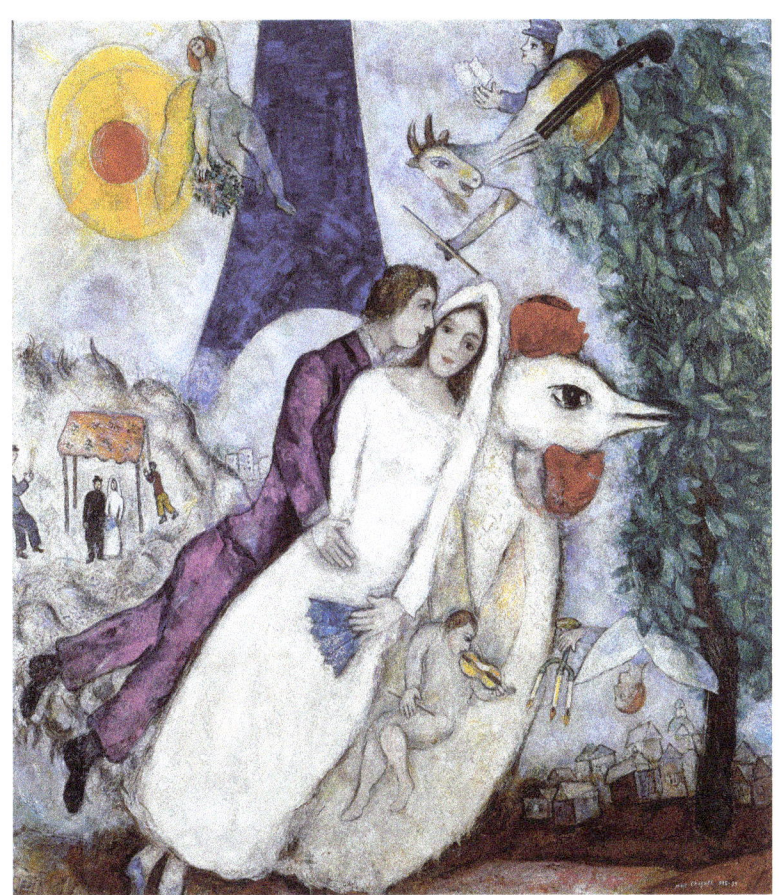

44. *The Bride and Groom of the Eiffel Tower*, 1938-39
Oil on canvas, 150 x 136.5 cm
Musee National d'Art Moderne,
Centre Georges Pompidou, Paris

4. CHAGALL AND THE IMAGE OF CHRIST

I cannot imagine Christ from the point of view of a creed or a dogma. My picture of Christ is intended to be human, full of love and sorrow. I don't want to stress the religious element: art, painting is religious by nature – like everything creative... If I have painted Christ it came about solely through painting, through the brush on the canvas. Perhaps it was necessary for the picture – or for me, who can say. (Chagall, 1957)[1]

The *Introduction* chapter established that, during the initial stage of research for this book, the Crucifixion was discovered to be a prominent theme in Chagall's oeuvre, appearing as it does in a variety of media including, drawings, paintings, printmaking, ceramics and stained glass, and across the three stages of the Artist's lifespan development. This chapter is dedicated to exploring the prominence and prevalence of this transformative image within Chagall's creative output, and to making a new connection between Jungian theory and Chagall's highly personal - as well as universal - approach to the image of Christ.

[1] Chagall in an interview with Walter Erben, (Erben, 1957, p. 18-9)

This is the first exploration of Chagall's crucifixion-themed body of work presented through a Jungian perspective. The topic has been addressed within the art history community previously, and it is not without scope or strength, as contemporary art historians have directed their arguments concerning Chagall's use of Christ through a variety of conditions. These include an emphasis upon: Chagall's self-identification with this symbol through Christ's historic association as prophet of Judaic heritage; Chagall's particular use of this 'Christianized' symbol as a means to reflect upon and commentate about his own life, as a 'Jewish man'; And, the specific expression of Jewish 'persecution' - within Chagall's lifetime - surrounding the anti-Semitic campaigns of the 18th and 19th Century European pogroms and the atrocities of the 20th Century European Holocaust.

There is an element of inclusivity particular to the collective and symbolic nature of archetypal expression, and I will return to these art historical observations and arguments regarding persecution and the Judeo-Christian perspective in depth when I discuss Chagall's crucifixion work of the late 1930's and 1940's. The argument here, and throughout this book remains that as an artist, Chagall's process of individuation development is able to be explored visually through the emergence of transformative imagery, including the use of Christ and the Crucifixion. The first emergence of the crucifixion theme occurred in Chagall's personal drawings[2], and poetry, prior to the Artist's formal beginnings as a professional artist (i.e., pre-1911, in Paris) whilst still a student in Russia. That a consistent re-imagining of this particular image continued for a further eight decades, is evidence of an archetypal expression, and as such, evocative of the personal transformative process. Such expression is universal, as archetypes are characterised by their capacity to transcend associations with the temporal relativity or specificity within a particular time frame of a culture or faith. Therefore, the appearance of the crucifixion in Chagall includes, *as well as transcends*, the microcosm of the Artist's - and the historical Christ's - natal faith.

Before moving forward in this discussion of Chagall and his crucifixion-themed works, it bears mentioning that during the cataloging of the works - and in the subsequent stages of preparing this project - I have not been able to identify a 'portrait' of the literal Christ figure that exists independent of the crucifixion theme, e.g., Christ in the corporeal form of a 'prophet' or human being. Nor, it seems, despite his interest in the 'Holy Family' motif, was Chagall engaged with the artistic renditions of other popular Biblical themes or motifs concerning the Life of Christ.

Chagall did make the distinction between Jesus as a man, or a Jewish "prophet", and the faith based conscription of crucifixion through the Christian tradition (Baal-Teshuva, 2003, p. 265; Kamensky, 1989, p. 131; Meyer, 1964, p. 16). Regarding Christ, Chagall has stated, "Christ is a poet...one of the greatest - through his incredible, irrational manner of taking pain onto himself" (Kamensky, 1989, p. 131; Meyer, 1964, p. 16). In his writing and speeches, Chagall has emphasised the importance he places upon Christ's ideas about life and mankind, as in his words: "the man possessing the most profound comprehension of life, a central figure for the 'mystery of life' " (Meyer, 1964, p. 16).

2 "One of Chagall's Russian drawings [that appears on the 1920 cover of Der Sturm Magazine [PLATE 45] was used as a starting point of this large picture [Calvary]." (Meyer, 1964, p. 173)

45. *Der Sturm* (Cover), 10th February, 1920
Vol. 10, No. 11, Editor: Herwarth Walden
Marquand Art Library, Princeton University

Meyer (1964) states that Chagall's attitude towards the concept of Christ evolved from his natal faith, Hasidic Judaism: He references the Hasidic belief that "not only scholars and lawyers [with their circumstances and opportunities for long periods of study] can come to know God" but that "[t]he weak man too, perhaps especially, has a right to the Divine answer." (p. 16). With the example of Chagall's 'Holy Men' series of portraits (c. 1914-1918), that utilised beggars and the disenfranchised of Vitebsk as models, Meyer (1964) suggests:

> The peace which surrounds them is the expression of an interior life, doubtless without words and even ideas, but saturated completely with that "second reality" which is behind things. Chagall had understood that power and self-assurance can only constrain a true and living relationship with reality; he who wishes to master the world alienates himself from it. That essence is revealed instead to the weak man, those who take pain unto themselves. This concept illuminates the painter's attitude towards Christ. (p. 16)

In the review of Chagall's natal faith and religious attitude, I remarked upon Chagall's lifetime interest in Biblical themes. This is evidenced in the artist's involvement in printmaking and publishing of illustrations for Vollard and Teriade's *The Bible* and by the Marc Chagall National Museum of the Biblical Message (now, Musee National Marc Chagall) in Nice, France. These artistic achievements collectively embrace and celebrate the Biblical stories genre through visual media. The Old Testament stories, the Biblical allegories that Chagall was arguably the most familiar through contact with the Hebrew Bible in his natal faith upbringing, include an allegorical portrayal of humankind through the birth, death, and rebirth cycle of life. The New Testament, in contrast, emphasises Christ's life-cycle, as told in the four gospel accounts. In Chagall's writing, speeches, and interviews, the Artist does not delineate between the Old and New Testaments, nor specifically, does he make reference to New Testament (gospel) material when discussing his observations of Christ. This is not surprising given the Artist's natal faith association with Old Testament tradition. Chagall's understanding of a connection, or continuum, between the Old and New Testament stories resonates visually, in his depiction of 'Life-cycle' itself: images of the birth, death, and rebirth cycle of humankind, and that of Christ and the Passion cycle.

This observation is not to suggest, however, that Christ independent of the cross is therefore 'absent' from Chagall's paintings, or even, that the artist's only visual conceptualization of Christ was through the image of the crucifixion. Rather, it is the absence or 'invisibility' of the independent corporeal Christ figure in Chagall's portraiture that underscores the numinous characteristic of religious transformative imagery and points to, in this discussion of the Artist and his creative religious expression, an archetype of the Self. For Chagall, the expression of Christ that is most familiar on external view is Christ crucified, or the imagery of the crucifixion theme. But this is not the only 'emergence' of Christ in Chagall's oeuvre: If one is willing to engage with the *metaphor of Christ*, then, addressing the presence of physical changes in the coloring of imagery, the appearance of different 'matter' or materials, and the transformative approach to the depiction of

Christ's form - from a symbolic, to a persecutory, to a resurrected and redemptive image - provides entrance into the Artist's self-referential imago.

Jung has explored the theme of Christ throughout his lifework, and he considers the prominent archetype of wholeness, or the *Center*, to be the concept of Christ in the Christian tradition (*CW11*: 226-42):

> The self is no mere concept or logical postulate; it is a psychic reality, only part of it conscious, while for the rest it embraces the life of the unconscious and is therefore inconceivable except in the form of symbols. The drama of the archetypal life of Christ describes in symbolic images the events in the conscious life – as well as in the life that transcends consciousness – of a man who has been transformed by his higher destiny. (*CW 11*, par. 233)

In "Christ, A Symbol of the Self" (*CW 9ii*: 68-126) Jung states that, within his conceptualization of archetypes and archetypal theory, "Christ exemplifies the archetype of self" (par. 70). This essay develops around tenants concerning the relationships between the Christ figure and the psychic construct of the Self: The binary image of the archetype of wholeness (e.g., the union of opposites, Christ and the Antichrist, Good and Evil); the alchemically-driven model of Christ as "quaternion of opposites" (par. 115); and, the application of analytical psychology as it relates to the theology of the Christ figure and the Biblical themes of suffering and restoration through physical, spiritual, and metaphorical redemption. In Jungian thought, an analogy exists between the restorative process of Christ's redemption - seen as a 'return' to wholeness - and a psychic redemption, which, from the analytical perspective is "the integration of the collective unconscious which forms an essential part of the individuation process" (*CW 9ii*, par.72).

For Jung, the expression and experience of the persecution-resurrection-redemption cycle akin to Christ's own life-cycle are necessary components of spiritual and psychological change within an individual's transformation process. This cycle of change is required to transform completely, into the whole-self of the internal, *adult imago*. Of the capacity of an artist to creatively realise the visual interpretation of their "adult imago," Stein (2005) observes:

> When the psychological self – the adult imago – is constituted and fully realized in the second half of life, a person acquires with it the freedom to expand and deploy the expression of psychic energy in a distinctive and highly creative way. The imago opens new vistas, while it also defines the individual's psychic style. It brings this capacity to the personality in the individual psyche – the high and the low, the sacred and the profane, the conscious and the unconscious – into a single pattern. (p. 207)

From the initial emergence of the crucifixion theme prior to 1911, Chagall returned either literally or metaphorically to the image of Christ in every decade, until his death in 1985. Following, I shall examine the psychic and creative quality of this archetypal "expression" (ibid.) and the re-imagining of this image across lifespan development, as Chagall's "adult imago" (ibid.).

THE HISTORICAL CRUCIFIXION

Crucifixion as a public death penalty has roots in ancient civilizations including the Egyptians, Assyrians, Celts, and Persians, the latter of whom are suggested to have passed the practice onto the Ancient Greeks (Merback, 1999). Although the Ancient Greeks did not fully adopt crucifixion as a means of capital punishment, the infusion of the practice reached into Ancient Roman law, and by the 3rd Century AD, the process of public crucifixion was a widespread form of capital punishment for slaves and lower classes utilized throughout the Roman Empire (ibid.).

Whilst the punishment process did experience widespread use in antiquity, it was not without burden or shame given an (already) historically negative connotation and legacy: The cross in the Old Testament (Hebrews 2:2) is referred to as a "sign of shame" (Merback, 1999, p. 201); And, Latin texts refer to it as the "terrible cross" (ibid.), the "criminal" or "barren wood" (ibid.), and the "infamous stake" (ibid.). Due to the legacy of crucifixion and its negative connotation in antiquity little documentation from family or government records survives (Merback, 1999). The only consistent source for crucifixion stories and practices is in the *Passion* narratives of the New Testament (ibid.).

In the 4th Century AD, the Emperor Constantine, a Christian convert, banned the use of crucifixion as a form of capital punishment. The argument for Constantine and subsequent Christian Roman rulers engaged the belief that "confusion would result when slaves and enemies of the State were made to resemble the Savior as they endured [Jospehus'] most wretched of deaths" (Merback, 1999, p. 198).

Following from the philosophical and political views of Christian Rome, the use of crucifixion as a form of public punishment was not widespread until the 16th Century Middle Ages when a re-emergence of the public practice occurred, though varying in style and consistency[3]. For the purposes of this discussion concerning Chagall and the crucifixion imagery, the style of crucifixion used in antiquity, a person nailed or bound to a raised wood cross or post, shall be considered the standard.

The crucifixion image in art first appeared in Roman works during the 5th Century AD. It is depicted in a series of four ivory casket panels[4] and on a carved wooden door at the Church of St. Sabina in Rome. Prior to this time, the population of Roman Christians were focused on assimilation into the Roman culture and were thus reluctant to express personal missive art depicting what was considered a tragic and violent demise, a fate reserved for public punishment (Harries, 2004). For these new Christians, emphasis was upon the positive conditions of resurrection and not the suffering and demise of their savior. Creatively, this translated into a reluctance to visually utilise crucifixion imagery in a revealing fashion. Consequently, crucifixion-themed art is limited in form and frequency during antiquity, prior to the 5th Century AD (ibid.).

The crucifixion imagery consistent with the elated guise of resurrection emerges throughout the history of Western art. It is clear, however, that whilst artists since the era of the Roman Empire

3 A wheel apparatus both grounded and suspended, was widely used during the middle ages, in favor of the cross structure for public torture and punishment. (Merback, 1998).

4 'Christ's Victory on the Cross', Ivory panel, British Museum, London.

have favoured this decidedly 'victorious' resurrection in approaching the crucifixion theme, there have also been departures depicting a suffering, lamentable Christ figure. The earliest evidence of such a departure towards the image of the suffering Christ emerged in the 10th Century, in illuminated manuscripts and altar pieces[5]. Anslem (later, Archbishop of Canterbury), St. Francis of Assisi, and St. Bernard of Clairvaux engaged in theological writing, research, and devotional practices which focused upon the suffering of Christ (Harries, 2004). This movement towards the humanistic interpretation of Christ - the mortal son of God who could save humanity only through his own humanness - initially began as a philosophical construct within the medieval clergy and monastic realm (ibid.). The suffering Christ motif in art moved into public view through a series of manuscripts created for the laity which were produced during the Gothic period of the Middle Ages[6].

This philosophical and visual shift from the victorious, resurrected Christ figure to images depicting the sorrow and suffering of Christ is of particular note, and specific here to the evolution of the crucifixion theme in Chagall's work. Chagall's earliest example of a crucifixion painting - 1912's *Calvary* (Cover Plate) - displays images associated with the redemption theme in Christ's life cycle. Figures consistent with the Holy Family are depicted beneath the crucified Christ, and a retreating Judas is shown in motion across the picture plane. The Christ figure appears as a youth, which suggests vitality or immortality.

In contrast to *Calvary*, Chagall's crucifixion paintings created in the years surrounding the Second World War - in the 1930s and 1940s - do not rejoice in the resurrection theme. Here, the 'Holy light' and redemptive connotations associated with resurrection are conspicuously absent in Chagall's images of secular death and physical destruction. It is in the crucifixion works completed post-WWII, from the mid-1950s to the artist's death in 1985, wherein the positive connotations of resurrection, and the visual 'completion' of Christ's life cycle, re-emerge.

THE SHADOW OF THE ANGEL

Of Chagall's crucifixion-themed work, one particular painting, *The Falling Angel* (1923-33-47) (PLATE 46), has captured the historic 'physicality' inherent in the creative transformation of the Christ motif. The image contained within this composition demonstrates the process of 'The Fall', from the victorious resurrection of antiquity to the persecuted and suffering image of Christ that is most familiar to scholars who write about Chagall's use of the crucifixion theme.

In the context of a 'transformative process', this painting is a companion piece to *The Black Glove* (1923-1948) (PLATE 33). Critically, both paintings were begun during a significant transition year in Chagall's personal biography: 1922-1923

5 The Amesbury Psalter, 1250 in All Souls College Oxford

6 Beckwith (1996) explores this particular genre of illuminated text and the images of Christ's body as a function of identity, culture, and society in the Medieval English writing. Her study focuses upon the depiction of Christ as a collective metaphor for the Medieval life experience. Whilst limited to the historical scope of the 15th Century English experience as seen through religious text and manuscripts, Beckwith underscores the dynamic relationship between images of a suffering Christ and the secular public.

is the year between his *Early* and *Mid-Life* stages of development. It is also the year during which Chagall left Russia permanently, to settle in France with his family as a 'famous' European artist.

Two preliminary paintings of *The Falling Angel* - in 1923 and 1933 - were executed by Chagall to support the ideas that appear in the completed composition of 1947. Meyer (1964) describes that, "New motifs - Christ crucified and the mother and child - were added to the 1933 version." (p. 489). There has also been a progressive "darkening" of the compositional plane and its forms during the twenty-five years in which Chagall 're-worked' the imagery (ibid.). Critically, these decades of 're-working' overlap the entirety of WWII and the Holocaust. The dates also include Chagall's forced migration from his settled life in the South of France to America in 1941 and the unexpected, and tragic, death of his first wife, Bella, in 1944. This painting physically changed as Chagall experienced the effects and affect of war and personal tragedy.

Virginia Haggard (1986) has written about living with this painting in France, after the Artist's War years' exiled in New York and the death of Bella Chagall, in 1944:

> *The Fallen Angel* is now in the Museum of Basel. It had hung for years over the staircase when we had our house in Vence, in the South of France. I had the leisure to examine it daily, and never got over a feeling of slight discomfort at the tortured construction of this painting into which Marc, perhaps aware of its lack of real strength, flung his frustrated rage. But he finally managed to pull it together with cunning refinement. (p. 72)

In this study, much has been suggested already about the appearance of the sacred feminine in: the *Holy Family* and *Birth* series', the alchemical couple, and in Chagall's portraits of the *Sacred Marriage*. Concerning individuation development, the psychic processing of 'the opposites' is approached through examining the emergence and reintegration of the contents of the collective, including the male-female binary, or syzygy[7] (for Chagall, his feminine *anima* image). What has not yet been discussed, is the emergence and integration of the archetypal *shadow* imagery in Chagall's oeuvre:

> There are medieval pictures showing how Christ is nailed to the Cross by his own virtues. Other people meet the same fate at the hands of their vices. Nobody who finds themselves on the road to wholeness can escape that characteristic suspension which is the meaning of crucifixion. For he will infallibly run into things that thwart and "cross" him: first, the thing he has no wish to be (the shadow); second, the thing he is not (the "other", the individual reality of "You"; and third, his psychic non-ego (the collective unconscious). (*CW 16*: par. 470)

As an archetypal image, the shadow expresses visually this thought: 'that which the transforming being is not'. As a binary expression, it is the opposing image of the Self (*CW 7*: par. 78; *CW 9ii*: 79; *CW 11*: 290-91). Haggard's (1986) 'slight discomfort' in the presence of an image that came forth through a 'tortured' process of construction is not surprising. As an archetypal

7 e.g., Jung, *CW 9*: par. 41, n. 5

image, the projection carries with it a numinosity which, in certain instances, is neither positive, nor comforting. The presence of this feeling, however, is real, and is experienced through the interaction with the painting, and what the imagery is revealing about the processing of the 'shadow':

> Everyone carries a shadow, and the less it is embodied in an individual's conscious life, the blacker and denser it is. If inferiority is conscious, one always has a chance to correct it. Furthermore, it is constantly in contact with other interests, so that it is continually subjected to modifications. (*CW 11*: par. 131)

For Chagall, the visual emergence of the shadow archetype is through the image of the falling red angel, or the "Anti-Christ" (*CW 9ii*, p. 79). This form appeared initially during a significant confluence of interior and exterior experiences, in 1923. Chagall's creative technical re-imagining included multiple attempts to re-work the composition, and 'a blackening' of pictorial space synonymous to the increase of external conflict during the years surrounding the Second World War. The artist's creative decision to 'insert' a sacred feminine image as well as Christ on the Cross in the 1933 version is significant as a 'balancing' of the shadow elements within the compositional container. That Haggard (and arguably, others, including the author, who view this work in its natural 'living' state) was physically moved to describe her *a priori* experience indicates that the motion of the psychic processing within the piece continues. The archetypal expression has not been 'flattened' by the container of the painting; nor, have the historically-linked temporal associations - moving forward and away from the 'history' of the image - altered the continued expression of its numinous essence.

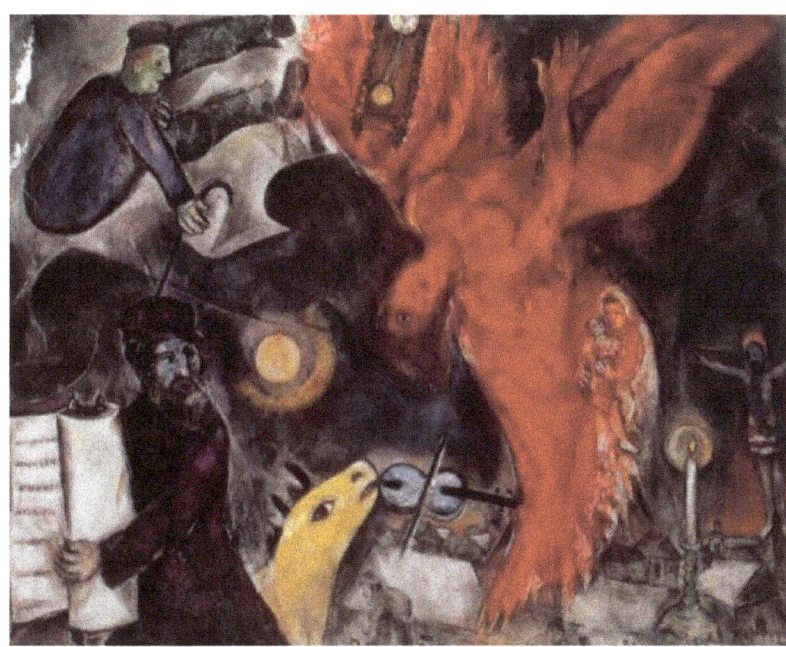

46. *The Falling Angel*, (The Fall of the Angel) 1922-33-47
Oil on canvas, 147.96 × 166.07 cm
Kunstmuseum, Basel

In her description of the painting, Haggard (1986) uses the title, 'The *Fallen* Angel'.

I have examined her memoirs and the painting is always referred to by this name. In Meyer's review of the work (1964, p. 489) he uses the expression of 'state': *Falling*[8]. Perhaps Chagall used the name of the process and the process itself interchangeably when he thought of this piece. Making the distinction between the passive and active process - here, 'a fall' - would change the meaning of the imagery, make it less visually flexible, or even, 'stop' the processing cycle altogether. When I refer to this piece in the book, I utilize Meyer's (1964, p. 489) description of "*The Falling Angel*" (1923-1948)[9]. In the context of archetypal theory and the changing image of Chagall's Christ, it is a container for reflecting the processing of both the 'Good' and 'Evil' within an ongoing, transforming experience of Life.

THE GREEN MAN

In, "Jung's Green Christ: A Healing Symbol for Christianity", Stein (1987, pp. 1-13) concludes his observations by introducing Zurich's Fraumünster Cathedral windows, completed by Chagall and Simon Atelier[10], in 1970. Stein (1987) observes that, the crucified Christ figure in the third window, *The Life of Christ/ The Tree of Jesse*[11] (PLATE 2) appears within a green glass pane, and that this coloring is significant not only for the connotations, "of springtime, of verdant earth, of hope and new life, of the earth reborn" (p. 12), but that, "This is the Christ of the resurrection and ascension, having been crucified and now reborn." (pp. 12-13). Stein makes an association between Chagall's green glass image of the resurrected Christ, and, "the green and gold elements that were found in Jung's vision [of the Green Christ at the foot of his bed, in 1939]" (ibid).

In his memoirs, *Memories, Dreams and Reflections*, Jung (1961) recounts his vision of the Green Christ, making the analogy between the gold-green visage appearing at the foot of his bed, and the '*viriditas* of the alchemists':

> The green gold is the living quality which the alchemists saw not only in man but also in inorganic nature. It is an expression of the life-spirit, the anima mundi or filius macrocosmi, the Anthropos who animates the whole cosmos. This spirit has poured himself out into everything, even into inorganic

8 There are the obvious connotations of mis-translation across language, and the concept of details being 'lost' in the translating process. The thought persists, that, of the sources utilised in this study (beyond the Artist's own primary source material, and the respective memoirs his late wife, Bella) Haggard (1986) and Meyer (1964) are the two individuals who knew Chagall well, and who were connected intimately to the artist and his creative process during the time period of this painting through their personal relationships, as life partner and his (then) son-in-law, respectively. If Chagall had preferred one title to another in the naming of this piece, then it was not identifiable to either of the individuals who were, arguably, at that time in the Artist's life, connected to an authentic examining of the process and the product of his art.

9 A curious observation regarding the state of the process: Art Historian Franz Meyer (1919-2007) was a Director of the Kunstmuseum Basel. In their archive reference for this image, in obtaining the copyright to re-print the painting here, the title appears as, *The Fall of the Angel*; The Chagall Estate, which includes members of the Artist's family, have signaled in their edits of the manuscript that either title is acceptable.

10 See, www.ateliersimonmarq.com

11 The title of this pane is also referred to as, 'Christ Glorified'. Correspondence of Brigitte Simon and Charles Marq (of Atelier Simon Marq) indicate that the pane was generally titled through its connection to the familial tree of Jesus of Nazareth's lineage (Alexander, 1978).

matter; he is present in metal and stone. My vision was thus a union of the Christ image with his analogue in matter, the filius macrocosmi... The emphasis on the metal [through the presence of the 'gold' element], however, showed me the undisguised alchemical conception of Christ as a union of spiritually alive and physically dead matter. (pp. 210-11)

In the alchemical opus, the color green signifies a *material change* in the prima materia, occurring between the Nigredo and the Albedo stages of the process. This *viriditas* (or, 'greeness') appears infrequently, typically in the alchemical texts which do not include *xanthosis*, or the third stage of, 'The Yellowing' (Hillman, 1991; Jung, E. & von Franz, 1998)[12].

In medieval alchemical documents that utilise animal imagery, this 'greening of the Lion', or the 'Green Lion'[13], is an illustrative plate wherein the animal appears 'devouring' the sun and the moon (de Rola, 1973; Underhill, 1911). As a psychological and analytical metaphor, Jung considered this image to be an illustration of "self-impregnation by one's own soul" (*CW 14*, par. 404) as a means to signal the spiritual transition - or transition of the spirit - between the Blackening and Whitening[14] stages of psychic development within the process of individuation[15]. In Jung's (1961) observation of the green-gold Christ vision he reflects, "the emphasis on the metal, however, showed me the undisguised alchemical conception of Christ as a union of spiritually alive and physically dead matter" (p. 211).

It is from Jung's observation here that the discussion returns to Chagall's particular use of color and how 'coloring' itself connects to the image of Christ as an archetype of the Self. In the comparison between Christ, the Holy Spirit of Christianity, and the alchemical spirit, Mercurius, Jung comments upon the state of 'greenness', and, the sacred connotation within the 'spirit' of this color change: "This spirit, coming from God, is also the cause of the 'greenness', the '*benedicta viriditas*', or the process of *sacred greening*" (*CW 11*, par. 151).

12 Zanthosis, or, 'The Yellowing', had become obsolete in illustrative manuals from the 15th and 16th Century forward (*CW 12*, par. 333).

13 Mc Lean (accessed 7/7/14) describes the practical, chemical properties of 'green', using the Green Lion image that appears frequently within the medieval, European alchemical manuscripts: "Physically, the Green Lion was usually a name for Vitriol, or the sulphuric acid created by distilling the green crystals of iron sulphate in a flask. The Green Lion could also be the nitric acid formed from heating saltpeter or nitre and iron sulphate that produced aqua regia, a greenish tinged liquid that could dissolve even the noble metal gold".

14 The Green Lion may appear as a visual substitute in alchemical illustrative sequence with a second chemical reaction that similarly takes place between the first and second stages, the 'The Peacock's Tail'. Here, a release of vapour colors occurs from the reaction of the matter within the sealed vas, signaling the onset of the Albedo stage (De Rola, 1973, p. 11; Mc Lean, 2014).

15 The Green Lion, and lions in general (*CW 14*, pars. 404-14), are one of a number of animals that appear in illustrative sequences of alchemical text, in both Western and Eastern examples of the art. As one visual example that demonstrates the duplicitous nature of alchemical images and their symbolism, the lion has been, since Christian Roman times, an animal associated with the allegorical divine spirit of Christ (*CW 12*, par. 547; *CW 14*, pars. 147, 429, 454). The lion may also be interpreted as a symbol of the prima materia, a stage in the chemical process, as well as symbolize the whole of the process, i.e., "The Hunting of the Greene Lyon" (*CW 12*, par. 173; *CW 13*, par. 383; *CW 14*, pars. 404-5; Underhill, 1911). Here, this 'greening of the lion' points to the practical application of alchemy, and specifically, the reaction of base metals within the vas.

47. *Self Portrait in Green*, 1914
Oil on paper mounted on board on canvas, 50.7 × 38 cm
National Musee Marc Chagall, Nice

48. *The Violinist (The Fiddler)* 1912-13
Oil on canvas, 188 x 158 cm
Stedelijk Museum, Amsterdam

I and the Village (1911) (PLATE 25) and *Self Portrait in Green* (1914) (PLATE 47) present the earliest definitive green-colored self-portraits of the artist. The mythological connotation of the *Chagallian Green Man*, however, originates in a different re-imagining of form: atop a roof, holding a violin (or, fiddle), in, *The Violinist* (1912-13) (PLATE 48). This painting was the first in a series of Green Men with violins, and is complimented by the artist's 'variants' in the GOSET theatre mural, *Music* (1920) (PLATE 19) and later, *The Green Violinist* (1923-24). The original 1912-13 composition, *The Violinist*, was one of the few recovered pieces from Chagall's La Ruche studio during the Artist's period of exile from France (1914-1922) (Compton, 1985, p. 203). This re-emergence of form suggests a significant relationship: On at least three occasions, the image was re-imagined, and, in 1920, it was 'presented' publicly in the theatre setting as a means to convey the essence and vitality of musicality within the experience of a performance.

What is self-referential in this image may not have been known to theatre-goers at the time: Chagall briefly studied music before training as an artist. "A *klezmer*[16] [17] taught me to play the violin. I whittled something...and thought: I'll become a violinist. I'll enter a conservatory." (Harshav, 2004, p. 112). Chagallian mythology suggests that the artist was, too, inspired by his uncle, Neuch, who is the figure most often associated in commentary regarding the origin and inception of the Chagallian fiddler on the shtetl roof (Alexander, 1978; Compton, 1985; Haggard, 1986). This musical Green Man image re-cycles in subsequent theatrical productions, following its appearance in the 1920-21 GOSET season: The popular shtetl-based comedic stage play and the 1971 film, *Fiddler on the Roof,* share the theme in title and visual connotations[18].

Chagall's mythological Green Man transcends its popular association with the artist's natal faith, through its connection to the archetypal image of the transforming Green Christ. This levitating fiddler is the initial Green Man image in Chagall's oeuvre to point directly to a magical or supernatural connotation: a physical body atop a house, engaging in joyful actions, without concern for corporeal reality. The visual appearance of such a corporeal self-defying perspective - which is not dissimilar to Chagall's 'flying' figures in his alchemical coupling portraits - hearkens to the concept of "Jesus the Magician" (Smith, 1985, pp. 81-93), as well as the alchemical Hermes, God of the Magicians (*CW 9i*, par. 553). Chagall remarked that, as a young person, he "wanted to be 'up high'" (Compton, 1985, p. 203). Compton (ibid.) has made the association between the height of the fiddler atop the roof in this trio of works and the visual prominence of Jacob's ladder in Chagall's paintings and stained glass images of Christ.

16 Klezmer refers to the musical and folk dance tradition particular to the Ashkenazi Jewish population of Eastern Europe. In this passage Chagall uses the appropriation of the term to describe a musician who plays the klezmer instrument(s). "For the Jews of the Austro-Hungarian, Czarist, and Ottoman empires in the last half of the nineteen Century and early twentieth Century, klezmer was an important component of all life-cycle rituals...In Yiddish, the word klezmer literally means 'vessel of the music'" (Strom, 2002, pp. xiv, 1).

17 Observing the green-faced King David (in *Song of Songs IV*, 1958) (PLATE 69), Pacoud-Reme (2011) suggests a connection to Chagall's natal faith, that, "David's face is 'green with happiness', as a Yiddish expression has it" (p. 93).

18 Scholem-Aleichem Stempeni, the poet and writer with whom Chagall was acquainted during his *Russian II* (1914-1921) years through the GOSET theatre company, has written in "The Fiddle" (1910) about the image of the fiddle and its connotation of religious expression related to Hasidic ritual and transitional rites.

If one considers the *mortal*-son-of-a-God, or 'God-like' connotations of Christ, the creative expression of an imaginal, transcendent corporeal 'space between' heaven and earth upholds. The idea of the visual prominence of form central to iconographic traditions in the Orthodox cannon of art is, too, plausible, in such examples of the Green Man: The visual communication of hierarchical perspective and its association with an enlarged or oversized figuring of 'the divine' - read as *the* most important 'essence' - is reflected in the elevation and proportion of the green fiddler. In literary association, the Biblical allegories of the life of Christ feature a 'magical' component that is suggestive of supernatural, or divine, qualities exercised by a "God" in mortal form (Smith, 1985, pp. 94-139). [19]

> The coming of the savior signifies the union of the opposites... The savior is always a figure endowed with magical power who makes the impossible possible. The symbol is the middle way along which the opposites flow together in a new movement, like a watercourse bringing fertility after a long draught. The tension that precedes solution is likened to Isaiah in pregnancy... Through the act of deliverance, what was inert and dead comes to life; in psychological terms, the functions that have lain fallow...suddenly burst forth and begin to live. (*CW 6*, pars. 441-44)

As a body of work, the *Chagallian Green Man* portraits underscore the importance of the 'greening' of Chagall's spirit through a period of significant change, the *Paris I* period (1911-1914), and following, the movement from Mid-Life (1923-1951) into Later Life (1952-1985)[20]. The Green Man in Chagall's art evokes the nature of 'natural' growth within the transforming process through the greening of the imago, or image of the adult self.

THE ALCHEMICAL CRUCIFIXION

Between his early years as an arts student (c.1909), and his death in 1985, Chagall completed more than fifty works of art that each depict the image of Christ and the Crucifixion. A 'lifetime of art' for some creative individuals, was, for Chagall, a devotion to exploring one image. The crucifixion theme appears in different styles, colors, and media, and corresponds in its visual changes to particular and critical points in the artist's biography and career. The symbolic emergence is consistent with what Jung has described as an archetype of the Self: The appearance at different times and in different ways is as a 'portrait' of

19 This concept of 'deified' magic in the mythology of a 'God-King' may be extended further into historical time - to include ancient rites and mythology. An association here with the Ancient Egyptians is plausible. (Of the art historians reviewed, Compton (1985, p. 203) makes the generalized observation that the green face of the Fiddler is found within the Egyptian mythology of the Green Osiris.) The archetypal nature of image is reinforced through the visual connection to the Osiris-Isis-Horus 'Holy Family' or 'Egyptian trinity.' Isis, the sister and wife of the funerary deity Osiris, is considered the consummate Egyptian magician (Silverman, 1991). In Ancient Egyptian creation mythology, she is responsible for the physical 'reconnection' of Osiris' corporeal form - dismembered by the vengeance of his bother Seth - and the 'resurrection' of his life-force through the sexual stimulation of 'ka' in her brother-husband, begetting their son, Horus (ibid.). This 'resurrection' of Osiris is signaled by the 'greening' of his corporeal form as it appears in funerary text and tomb murals. The resurrection is depicted in Egyptian creation myth as the physical and metaphorical rebirth of a God - and thus, of life, eternal - through Osiris' connection to the rhythm and cycle of Nature.

20 The subsequent appearance of Green Man imagery in the critical transition years between Chagall's *Mid* and *Later Life* stages suggests a continued personal, self-referential connotation to the image and subject matter (e.g., *Rooster in Love* 1947-50, *The Tree of Life*, 1948; *The Bride Under the Canopy*, 1949).

a symbol, and as such, it corresponds to the concept of a self-referential image or imago. The image of Christ was perhaps the most important symbol for Chagall. It expressed in one single form the symbolic connection to life which he experienced through religion.

The second half of this chapter explores Chagall's imagery of the Christ as it re-emerges in the three stages of his lifespan development. A particular attention is given to the Artist's technical use of color: how the color appears within the emergence pattern of the symbol and why the transformation between colors is significant as a visual marker pointing to a stage in the process of Chagall's development. The Alchemical metaphor has been presented in different developmental context. Here, the Alexandrian model of the opus is used to compare the emergence of color through four stages of transformation: Nigredo, Albedo, Citrinitas (Xanthosis), and Rubedo (*CW 12*, pars. 333-34; Edinger, 1995, pp. 153, 296).

Chagall was an artist who was interested in the qualities of color. He made a connection in his theory of *La Chimie* between the 'life' of colors and the ability (or property) of color to elevate a painting into the 'living' state of being. For a 'colorist', it would not seem unusual that the use of color appears in portraiture to indicate what is behind (or beyond) the meaning of form. The artist's technical 'assignment of color' differs from the collective observation or 'meaning of color' experienced by an audience: An artist has the creative decision about which color is chosen to be placed, and where every color appears within the emergence of a composition.

Chagall, like most artists, used sketchbooks to record his creative life. This process includes the development of compositions and the experimenting with color palettes, even prior to taking a drawing tool or brush to paper or canvas. There is a freedom inherent in the process of being able to think about something and make a drawing or note in a private creative space. It would be rare for a work of art to have not 'begun somewhere'. Often, the place where the first 'mark' happens - where the idea becomes an image - is a drawing within a sketchbook.

An important sketchbook at the beginning of this discussion is one that Chagall was using in as an art student in St. Petersburg. A pen and ink drawing exists from his student years, a self-portrait of Chagall as Christ (Meyer, 1964, p. 172). This private composition would become more relevant, following Chagall's migration to Paris, in 1911. There, the image was re-imagined in subsequent drawings, and re-emerged through the process of painting, within the 1912 composition, *Calvary*, that appears on the cover of this book.

THE NIGREDO

Art historians agree that *Calvary* (1912) was Chagall's first fully realized composition of Christ (Bohm-Duchen, 2001, pp. 89-90; Compton, 1985, pp. 174-75; Harshav, 2006, pp. 86-87; Meyer, 1964, pp. 173-74). The composition is significant for its style which appears in a Modernist treatment, as a synthesis of Cubism and Orphism. In the comparison of the student drawing (see, PLATE 45), and the completed painting of 1912, the visual transformation is evident. Chagall is no longer identifiable within the facial features of the Christ figure. The mythological forms surrounding the Crucifixion motif have been painted in a 'transitional' state; they exist simultaneously within the

foreground and background of the picture plane. This is consistent with the dynamism of the Cubist aesthetic (Chip, 1968) which contributes to the energy of the composition. The painting does not depict a static image of Christ; it is a Christ that is 'within' the process of change.

As in each example of Chagall's art appearing in this study, *Calvary* (1912) has come to be in this space through the practical process of assembling the pages of a book. In this 21st Century version of automated book assembly, oiled inks and copper plates have been replaced by color laser cartridges and programmable machines that organize and analyze a virtual print run before one sheet of paper in a ream bears the mark of a printer. The art of bookmaking has been re-imagined in the digital realm: The image plate itself is now a digital version of the work of art, a high-resolution electronic copy of a photograph of the authentic piece. In certain increasingly rare instances, a wet-processed photograph is scanned by a machine, digitized, before being passed on to a computer, in the next stage of its evolution. In other instances, the once (or twice[21]) removed digital capturing of the original is transferred directly for printing with its coding intact. Thus, the viewers' interaction with the image is the result of a highly manipulated (and invisible) experience. This ongoing transformation of image is a literal feature in the practical printmaking process, that continues to evolve. If one is reading this book in digital format, the reader is examining an image that has been *four-times removed*[22] from the authenticity of the natural work of art[23]. This highlights an important aspect of writing about the experience of visual art and the expression of visual characteristics. Whilst the compositional treatment of style and form remain definable proximate to the clarity of the reproduction process, the presence of color is rarely reproduced exactly, in even the best of quality prints. This is significant: Color is a living experience; it has an organic dimension that requires a live presence with the authentic work, the imaginal emergence, to appreciate the full impact of what the artist is communicating through use of pigments.

Upon examination, the authentic painting of *Calvary* projects a cool, green atmosphere that is seemingly incongruous in color vibration to the redemptive quality depicted in this image of Christ. This atmospheric quality is typically achieved from a technical mixing of two complimentary colors (they appear to be hues of reds and greens) to produce a neutral, or non-hue-driven, application of a grayscale[24]. In the color reproductions of *Calvary*, the essence of depth, acquired from the complimentary neutralisation of color vibration occurring within the deeper passages

21 The digitally photographed image of the original work is typically manipulated in computerized programs to adjust for image size, resolution (dpi), color gradient, and (light) value, before reaching the automated (digital) printing stage.

22 The original photo-capture; the scanning and/or digital manipulating of this image; the re-assembly of this image in the digital print-run; the disseminating of image in digital book through one's tablet or computer screen.

23 1936's *The Work of Art in the Age of Mechanical Reproduction* (Benjamin, 2008) provides a perspective of the changing image, during the early years of photography, and mechanized printmaking. I have often wondered what Benjamin would have observed in his scholarship about the mechanical reproduction of art, in this 21st Century digital age.

24 In theory, two colors which appear as opposites from each other on the color wheel are termed compliments. When complimentary colors are mixed, their properties are neutralized. This results in a neutralizing or gray scale color. The gray scale is the range of values (or lights and darks) that exist between the extremes of white (complete absence of dark) and black (complete absence of light). In this way, the value scale is defined through its properties specific to light, and not color (hue). Black and white are not true colors; they represent tint (white) and shade (black) that may be combined with color (hue) to produce varying degrees of light effects.

of the painted canvas, is not clearly present to the viewer. The painting is less 'alive' in reproduction, than its original, animated state.

Chagall's palette tone shifts dramatically between 1907 and 1914. The warm earth tones that predominate the Vitebsk and St. Petersburg paintings (of 1907-10) are replaced with cool tones during his *Paris I* years, that most often emerge through the canvas from where they began in the underpainting stage of compositional development[25]. The impact of this technique is dramatic, particularly when the observation is made in the natural environment, whilst in the company of a real 'living' work of art.

I mention this aspect of the color application here in detail as it is a significant step in the development of an artist's technical creative process to underpaint a canvas entirely black (or, what appears in this instance to be, a deeply shaded hue) and then work from within the darkness of that space. This essence of the 'working in the black' is consistent with the Nigredo, or 'The Blackening,' and is the first of four stages of Chagall's color transformation of Christ.

In the alchemical metaphor, the Nigredo is associated with the 'breaking down' of the Prima Materia, or matter of the operation (*CW 12*: 334; de Rola, 1973; Samuels, 1989; von Franz, 1980). As a man in his *Early Life* years (1887-1922), Chagall was at the beginning of the process of becoming a developed creative individual. The Artist's creative output during the *Paris I* years have been described throughout this study for their critical and formative features. The experience of this new environment upon Chagall's developing creative spirit is reflected in both the emergence of archetypal imagery, and the visual treatment of image through the technical process of form. In *Calvary* (1912), the reflection of Chagall's adult imago is emerging within the darkening of its compositional space. This metaphor cycles between the artist's connection to the composition of the painting, and the technical process of communicating image in visual art.

THE ALBEDO

There are twenty-six years between the Early Life emergence of Chagall's *Calvary* (1912), and the next significant appearance of the crucified Christ form as a focal image in a painted oil composition, during the Artist's Mid-Life stage. In 1938, at 51 years of age, Chagall completed a new portrait of his symbol, *White Crucifixion* (PLATE 49). The strength in *White Crucifixion* is the color - or the absence thereof - for whilst the events explored are colorful in their connotations of turbulence and violence, Chagall resolves the work in a predominately white composition.

> What is perhaps most remarkable about Chagall's painting is his use of white: the white light coming from the flames of the burning Torah, mingling with the white shaft coming from heaven onto the Cross... this is the smoke, all part of the terrible conflagration and destruction. But it is also the white light of the Torah, the eternal Word of God which stands through all things. (Harries, 2004, p. 111)

[25] An underpainting is a preparatory phase achieved by coloring the entirety of the canvas in a particular color, in preparation for a painting. It may also be a stage wherein the artist executes the lines and shapes consistent with basic imagery, and then blocks in various colors, then painted over in a more defined, detailed manner. In both instances the goal is to produce emanation from the work. Artists may favour colors that will create a glow or aura around objects as the color beneath sets the stage for the composition. An underpainting is helpful to unify the picture plane through color.

This painting is one of Chagall's most published works, and is the standard to which his other crucifixion imagery - particularly in scholarship related to the Holocaust - is compared and discussed. The argument was presented earlier in this chapter that the archetypal nature of the image transcends the personal or individual associations with the culture of faith. Amishai-Maisels (1982, 1991, 1993, 2010) and Bohm-Duchen (1998, 2010, 2013) are two historians who have considered the relevant underpinnings of Chagall's role as a Jewish artist creating a type of art that is expressed through his understanding of the history and culture of Judaism. This approach to image differs from the understanding of the imaginal world utilised in this study which considers the presence and function of archetypal emergences. In the psychic domain, the universal nature of imagery and the atemporal quality of the psychoid formation associated with archetypal expression are beyond the specificity and context of a particular culture or period of human history. This is a significant distinction to consider when exploring universal themes of religious persecution painted by a Religious artist.

It is the nature of the collective unconscious to re-cycle archetypal imagery through the creative processes of individuals. In times of collective religious change or trauma, it is not unusual for sacred images to find contact and connection through the unconscious processes of the personal psyche. In the example of Chagall, this archetypal pattern of the creative re-imagining of the Crucifixion motif is not only a temporally-potent emergence of sacred imagery during critical moments of Russian and European collective history, but also, visually reflects the continuum of an individual's established imago of, *Christ-as-Self*. In the analytical model, it is the greater projection of the unconscious Whole that underlies the conscious description or association with form; the Whole includes, and simultaneously transcends, the specificity and context of one particular cultural origin or, a singularity of reasoning, behind an established emergence (from c.1909, onwards) of an archetypal image of the Self.

The *Albedo* (Whitening) stage is marked alchemically by a further purification of the prima materia, and a washing (*ablutio*) of the matter, constituting a transformation from the Nigredo to the Albedo (*CW12*: 343; de Rola, 1973; von Franz, 1980). In contrast to the Nigredo, the Albedo is characterized in the alchemical metaphor by its psychic movement inward and a withdrawal from the external. This is experienced as a conscious awareness of the soul (*CW 9ii*: 230; Samuels, 1989; von Franz, 1980).

White Crucifixion (1938) was completed at the end of Chagall's most productive creative period whilst living in France (1923-1941). This period was also marked by a progressive turn inward for the artist, initiated by the external experience of a religious pilgrimage to the Holy Land (then, Palestine) in 1931. In this early *Mid-Life* period, Chagall's technical treatment of the composition experienced a whitening of space. This is reflected through the use of a white-gesso primed canvas upon which he painted directly from life observation.

By the mid-1930s, Chagall's physical presence within the externality of the Parisian environment had changed. Whilst he remained at the height of his professional status and reception during this period between the Wars, his ongoing relationship with the Parisian art community was, according to primary source documents and biographical

accounts (Alexander, 1979; Harshav, 2004), filtered through his wife, Bella. Chagall focused upon his commission for Vollard's Bible etchings of the early 1930s, and traveled abroad more extensively than he would at any other time.

Chagall's separation from Paris towards the end of the 1930s was significant. He was, arguably not aware of how precarious his living situation had become as a culturally Jewish man proximate to the German occupation in the capital from mid-1940 (ibid.). A paradox is thus revealed in Chagall's personal life and his work during this introspective period of the 1930s: He displays choices indicative of an internal introspection that is most clearly evidenced in the isolation of the creative process and travel abroad, as well as the conscious removal of external, peripheral - and possibly distracting - influences of Parisian city life. Furthermore, he crucially does not fully engage with the external reality that, as a Jewish man in an occupied country, he was certain to face death should he remain in France[26]. Chagall's creative output from the later 1930's onward, however, begins to externalize through visual means through a growing engagement with the (increasingly) controversial history and collective uncertainty in the European environment between the Wars[27].

In the initial stage of the alchemical change - the psychic 'breaking apart' of the Nigredo metaphor - Chagall was actively 'isolated' from Vitebsk and the culture of Russia, whilst newly immersed within the quickening environment of Parisian Modernism between 1911 and 1914. This breaking down, or apart, from the past is reflected in the creative processing of new forms, evidenced by the emerging cohesion of the Chagallian sacred-secular binary. The Artist's entrance into the Middle Life years, at thirty-five, coincides with his chosen re-settlement in France, in 1923. The fifteen years between this settlement and the execution of 1938's *White Crucifixion*, suggests a space for further creative and psychic growth. In the alchemical metaphor, such processing of the contents of the unconscious may occur across an extended period of lifespan, as it involves the acquisition of introspection required to engage and to reflect upon imagery whilst simultaneously passing through stages of transformative experiences. What is clarified in Chagall's creative output, is the unconscious processing inherent in the experience of psychic change: The re-imagining of the adult imago continues throughout this (Albedo) stage; It is only observable on the physical plane as it emerges creatively at the ending of this phase, expressed through the transformation, *or whitening*, of the Crucifixion.

26 Alexander (1978), Haggard (1986), and Harshav (2004) provide historical details, letters, and personal accounts of Chagall's belief that he and his family would not perish in the Holocaust because he was a famous artist. Harshav remarks (2004, p. 493) that Chagall had to be "persuaded" by Varian Fry of the The Emergency Rescue Committee (US) to leave the South of France in 1941. Fry stated that, "Chagall first hesitated, apparently out of fear of the journey and of losing his recently acquired French citizenship" (ibid).

27 i.e., *Falling Angel* (1923-1947), *The Revolution* (1937) and the *Mid-Life* period Crucifixion series, beginning with, *White Crucifixion* (1938).

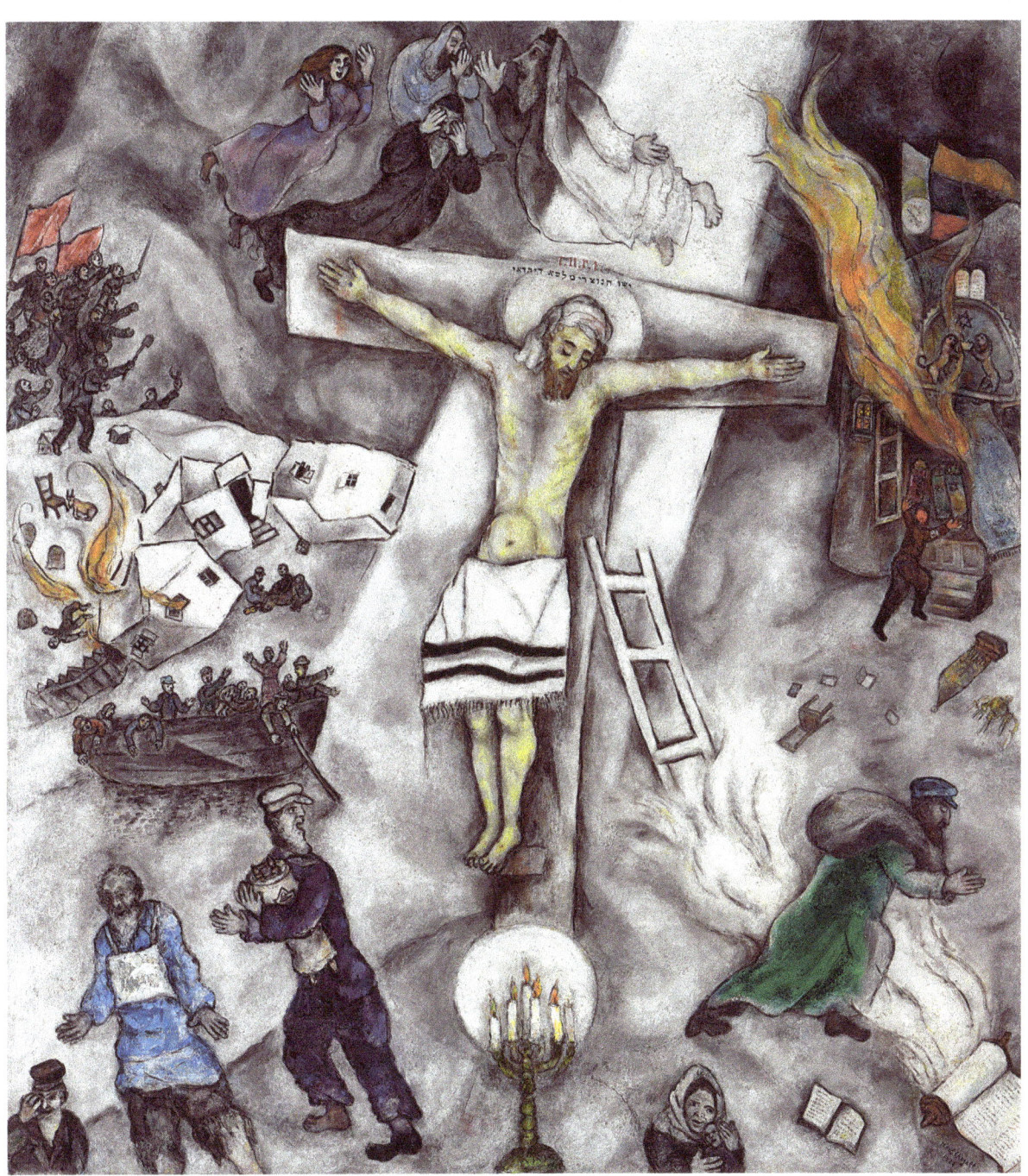

49. *White Crucifixion*, 1938
Oil on canvas, 155 × 139.5 cm
The Art Institute of Chicago

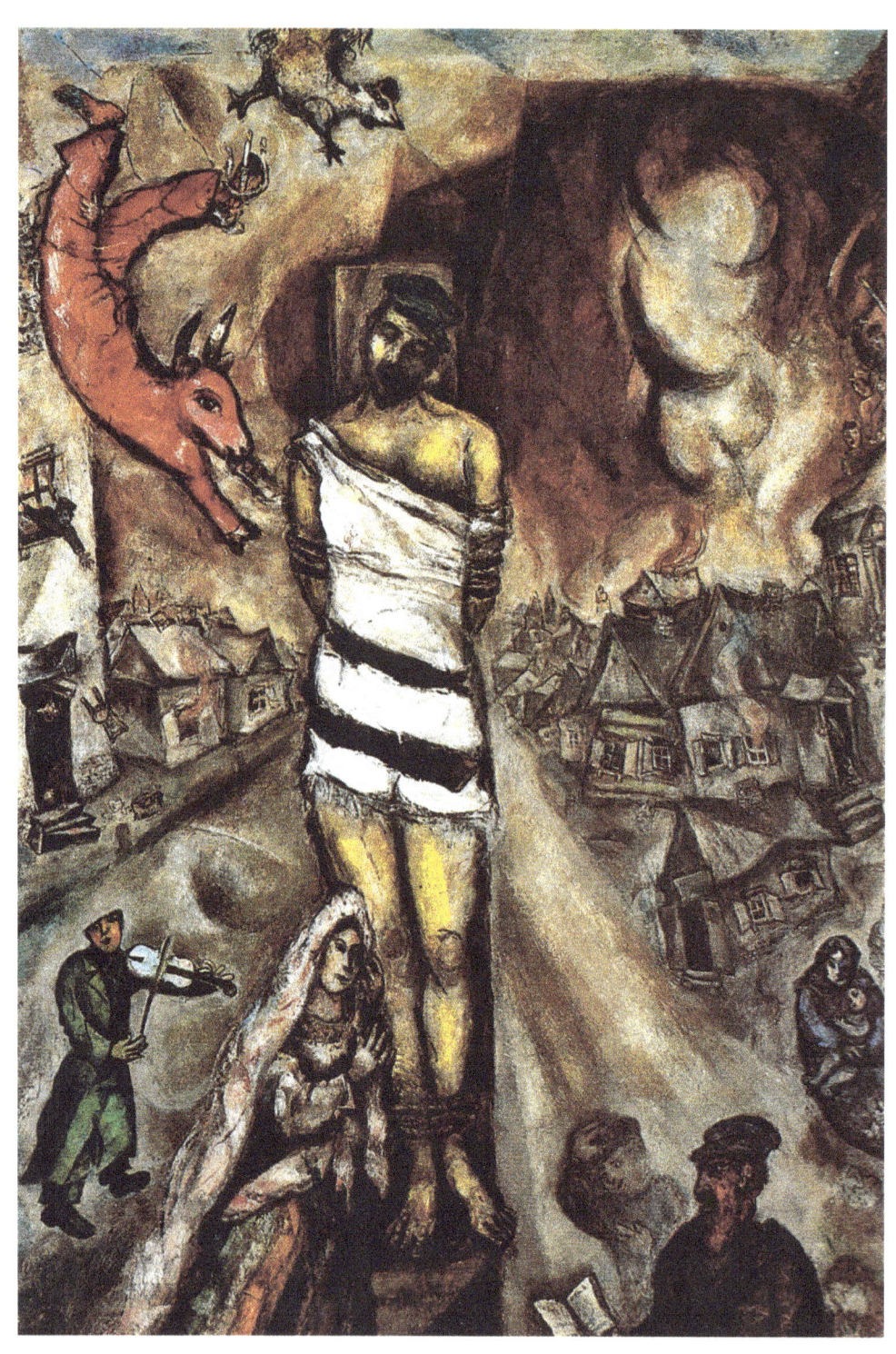

50. *The Martyr*, 1940
Oil on canvas, 164.5 x 114 cm
Kunsthaus Zurich

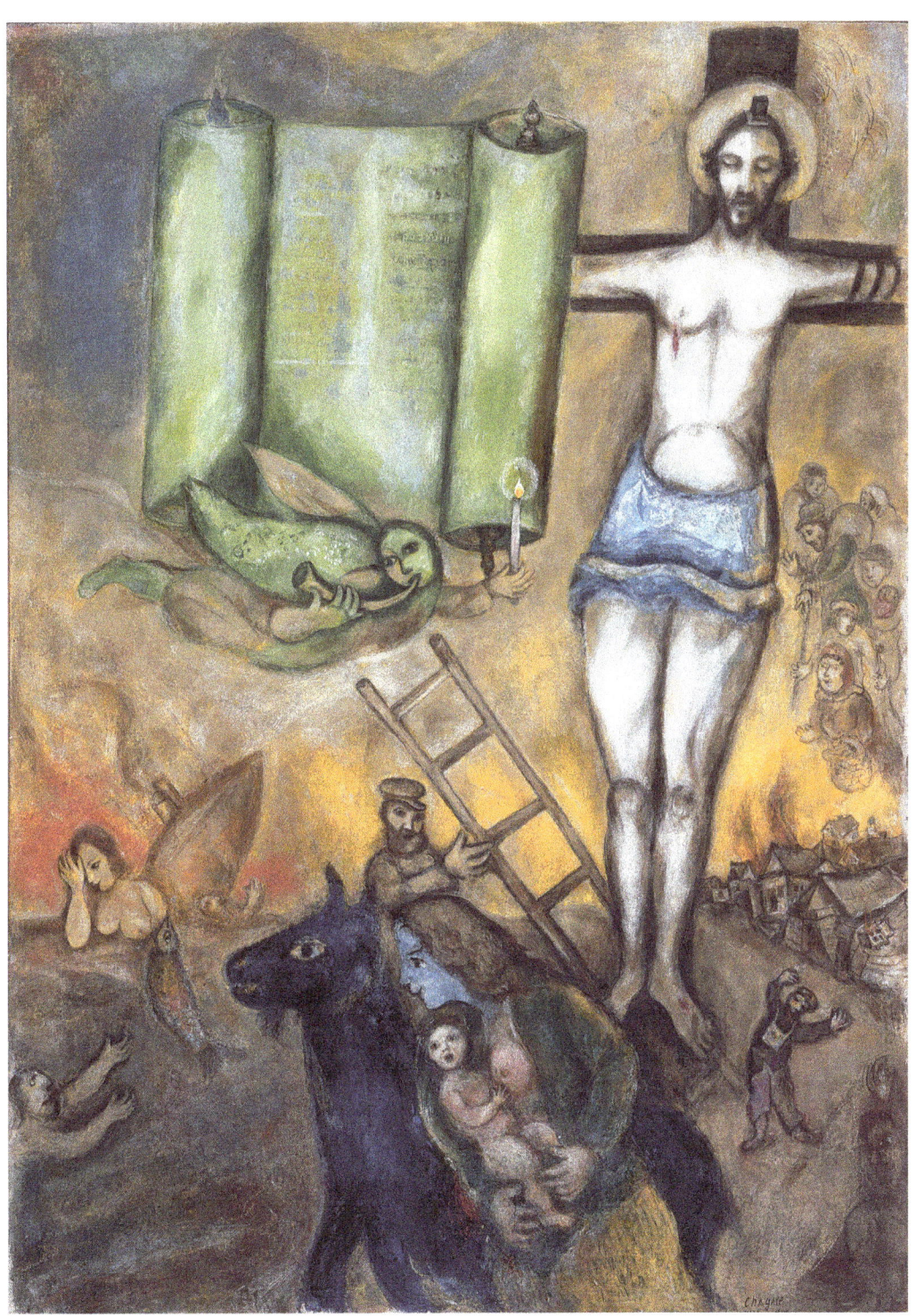

51. *The Yellow Crucifixion.* 1942.
Oil on canvas, 140 x 101 cm.
Musee National d'Art Moderne, Paris

THE CITRINITAS[28]

In the early 1940's, Chagall's Christ was again re-imagined in a series of new compositions: *The Martyr* (1940) (PLATE 50) and 1942's *The Yellow Crucifixion* (PLATE 51) share the compositional forms and the essence of turbulent chaos depicted in *White Crucifixion* (1938). The Artist's emphasis upon hue has returned in the execution of these works, through the introduction of the color yellow, as in the earlier *greening* of *Calvary's* 1912 Christ form. This *yellowing* of the self-imago, is consistent with movement through the third stage of the alchemical transformation process, Citrinitas or Xanthosis (*CW 12*: 333; Edinger, 1995). In, "The Yellowing of the Work", Hillman (1989) reflects upon the experience of this Yellowing process:

> Brighter, more coagulated and more combustible, the yellowed intellect is complicated with emotions, as one is indeed aware and alive in jealousy, cowardice, fear, prejudice, aging and decay. It is like an instinctual smoky light shining through reflections from within – no longer a mere mirroring, but responsive outward, the mind like a smoldering yellow effusion staining with intellect whatever it meets. (pp. 86-7)

The Citrinitas phase of the chemical operation follows the Albedo, with a further purification of the prima materia (*CW 12*: 333; Edinger, 1995).

In this stage of the alchemical transformation, the purified mater of the Albedo reunites with soul and spirit of the alchemist, and acquires a golden color. This reaction is characterized through the psychological metaphor of shifting from introspective reflection to a heightened sense of the Wholeness of being, acquired through Knowledge. The experience of the Citrinitas is both internal and external: The spirit initially experiences a decaying introspective individuality, that is replaced by a synthesis of the internal and external experiences, as a *oneness* (Hillman, 1989). This is observable in Chagall's treatment of the Christ figure who - in both exemplars - appears *staked into the composition*, rather than crucified onto the picture plane.

This physicality of the decay, and the reunification of the matter is further re-imagined in a visceral creative expression, through Chagall's technical treatment of materials during his period of American exile (1941-1948): In 1937, Chagall had painted *The Revolution* (PLATE 52), an allegorical composition that depicts his experience of War in Russia. Haggard (1986) explains that Chagall had carried this painting, rolled for storage, when he left France, in 1941, and later returned to the composition in 1946, during their stay in High Falls, New York. Chagall's treatment of the composition was unconventional, as Haggard (1986) observed at that time:

> He had painted [The Revolution] in 1937 from a series of studies and a small painting of great quality, but this large picture lacked their strength and cohesion. He was puzzled by his failure to enlarge the successful, smaller painting... Marc

28 The images of the yellowing Crucifixion discussed here are hung together in the first space one encounters when entering the museum of his Biblical Message. The room includes, the 1948 triptych, *Resistance, Resurrection,* and *Liberation,* and *Exodus* (1952-66). Chagall's *Self Portrait in Green* (1914) is hung adjacent to the triptych, and faces The *Exodus* (1952-66).

decided to cut the painting into three pieces and suddenly felt liberated. Perhaps that is why the title *Liberation* came to his mind. He gave it to one of the paintings and called the others *Resistance* and *Resurrection*. (pp. 71-2)

The physical tearing apart of painting is a most unusual decision for any artist to make. There is a self-destructive resonance within the action of destroying something one has created through a spiritual process. Whilst Chagall's deliberate action of technique initiated the decaying of the original work, a transformation followed in the Artist's use of imagery. This one-into-three creative processing became a self-reflection: The new compositions of 1948 each contained a different allegorical image depicting a stage in the life cycle of Christ (*Resistance*, *Resurrection*, and *Liberation*) (PLATES 53, 54, 55). The underlying wholeness achieved in this creative process remains invisible however to Chagall's audience; It exists beneath the painted surface, through the physical layering of forms. The wholeness is paradoxically, the containment of a painting - beneath another painting – internally holding the knowledge of the 'Evils' inherent in War, whilst, simultaneously, externally communicating the 'Good-in-Nature' within the life-processing[29] of the transforming, yellow Christ.

29 The 'Yellowing' of the Christ figure continues appears in the later painted examples of Chagall's Crucifixion e.g., from the Bible Series, *Exodus* 1952-66 (PLATE 56) and, *The Village*, 1972. There is an atemporal element to the transformation process: stages within

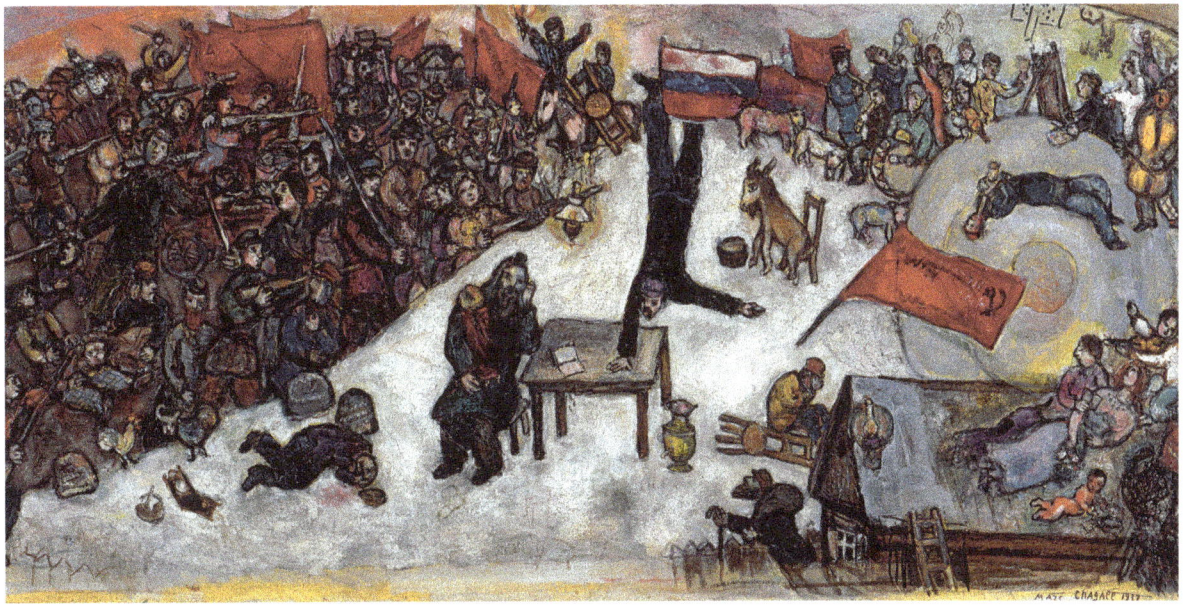

52. Study for *The Revolution*, 1937
(original beneath the *Crucifixion Triptych*)
Oil on linen, 49.7 x 100.2 cm
Musee National d'Art Moderne, Centre Georges Pompidou, Paris

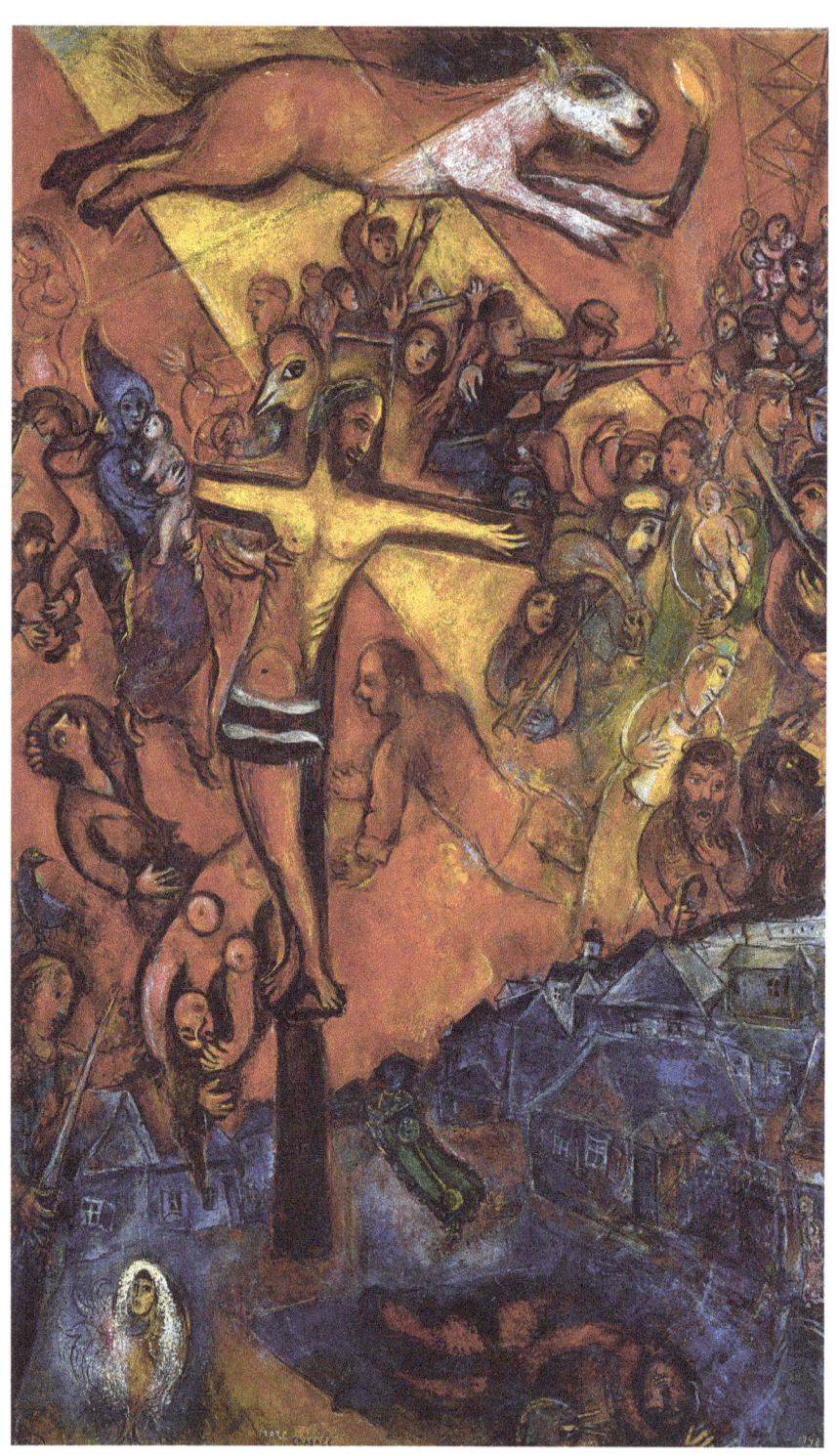

53. Resistance, 1937-48
Oil on canvas, 168 x 103 cm
Musee National Marc Chagall, Nice

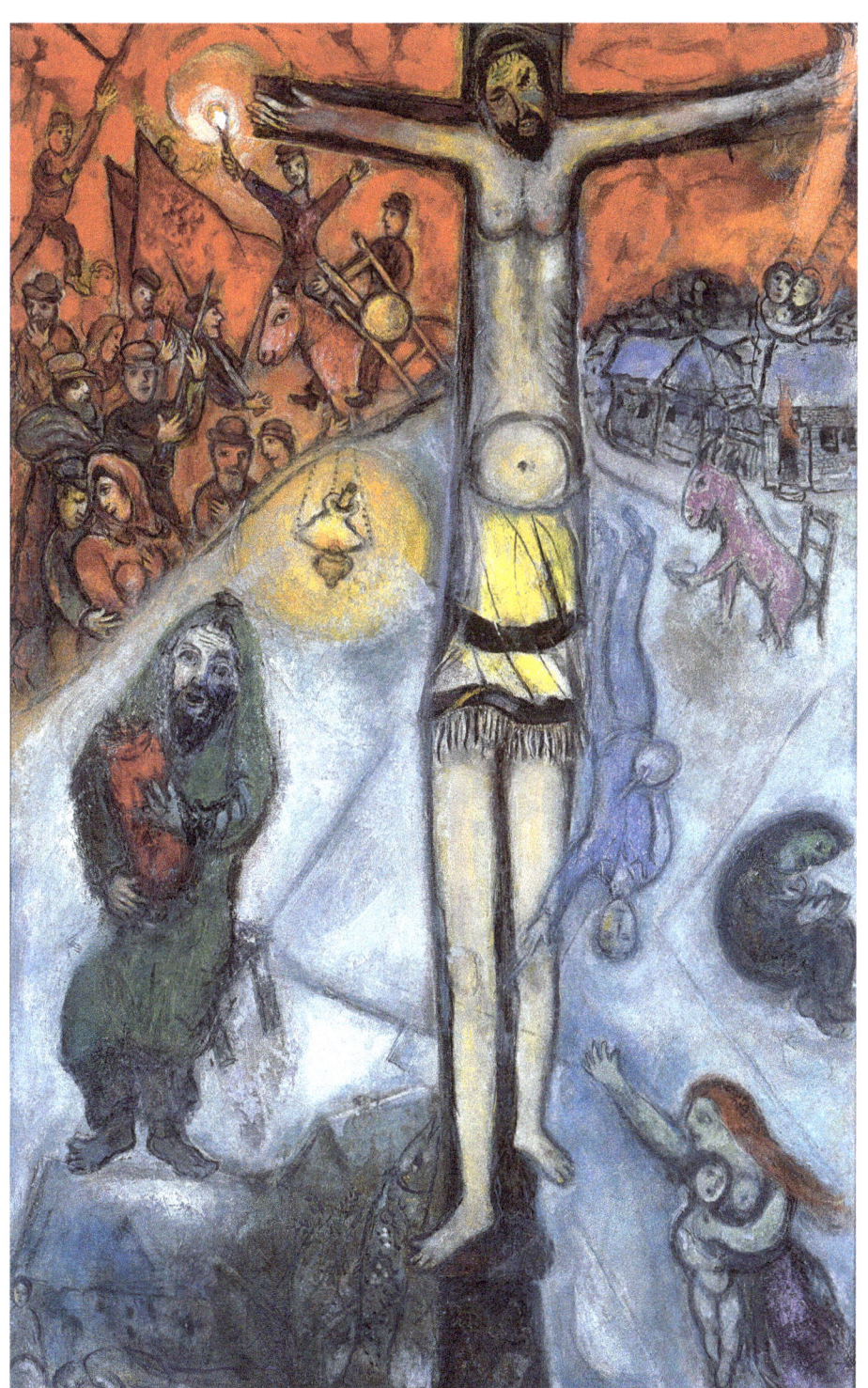

54. *Resurrection*, 1937-52
Oil on canvas, 168 x 108 cm
Musee National Marc Chagall, Nice

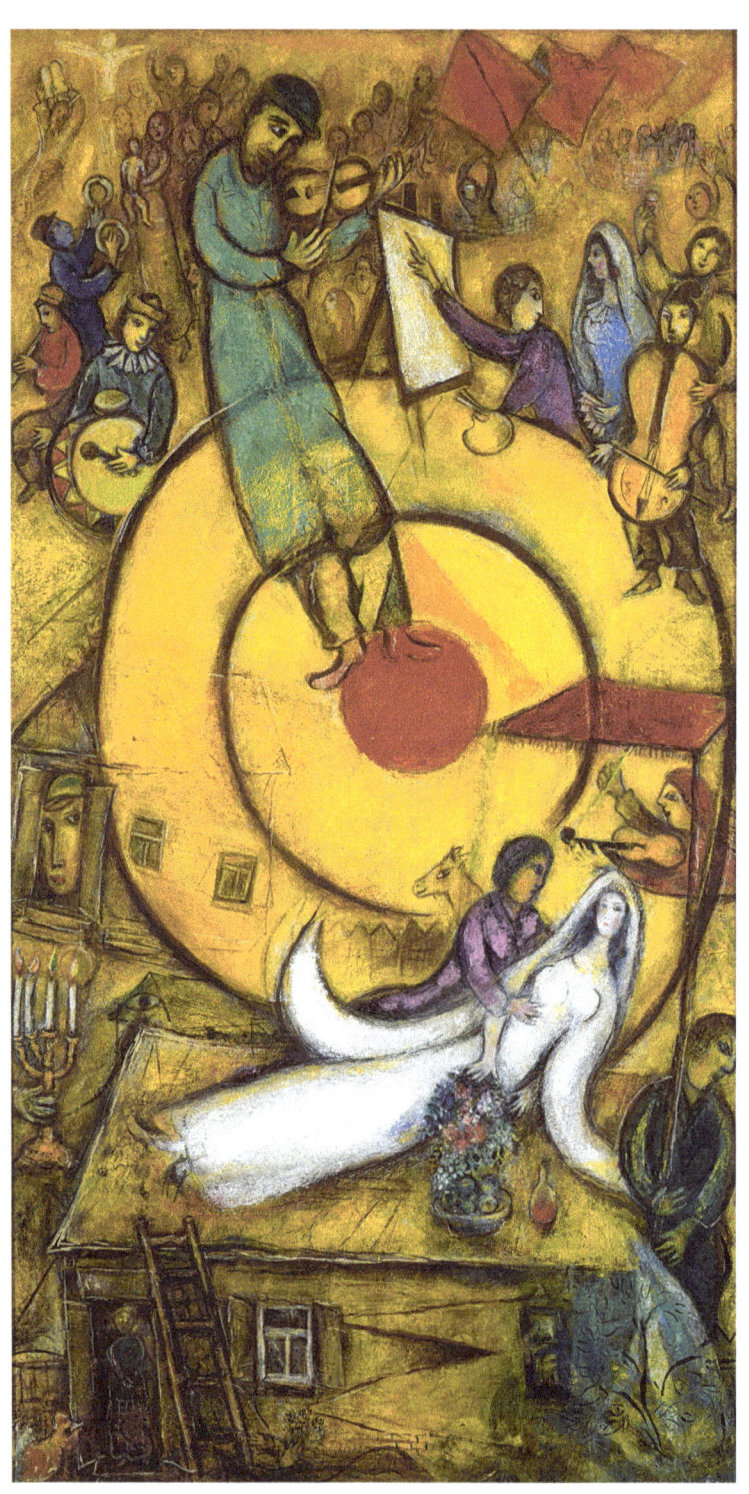

55. *Liberation*, 1937-52
Oil on canvas, 168 x 88 cm
Musee National Marc Chagall, Nice

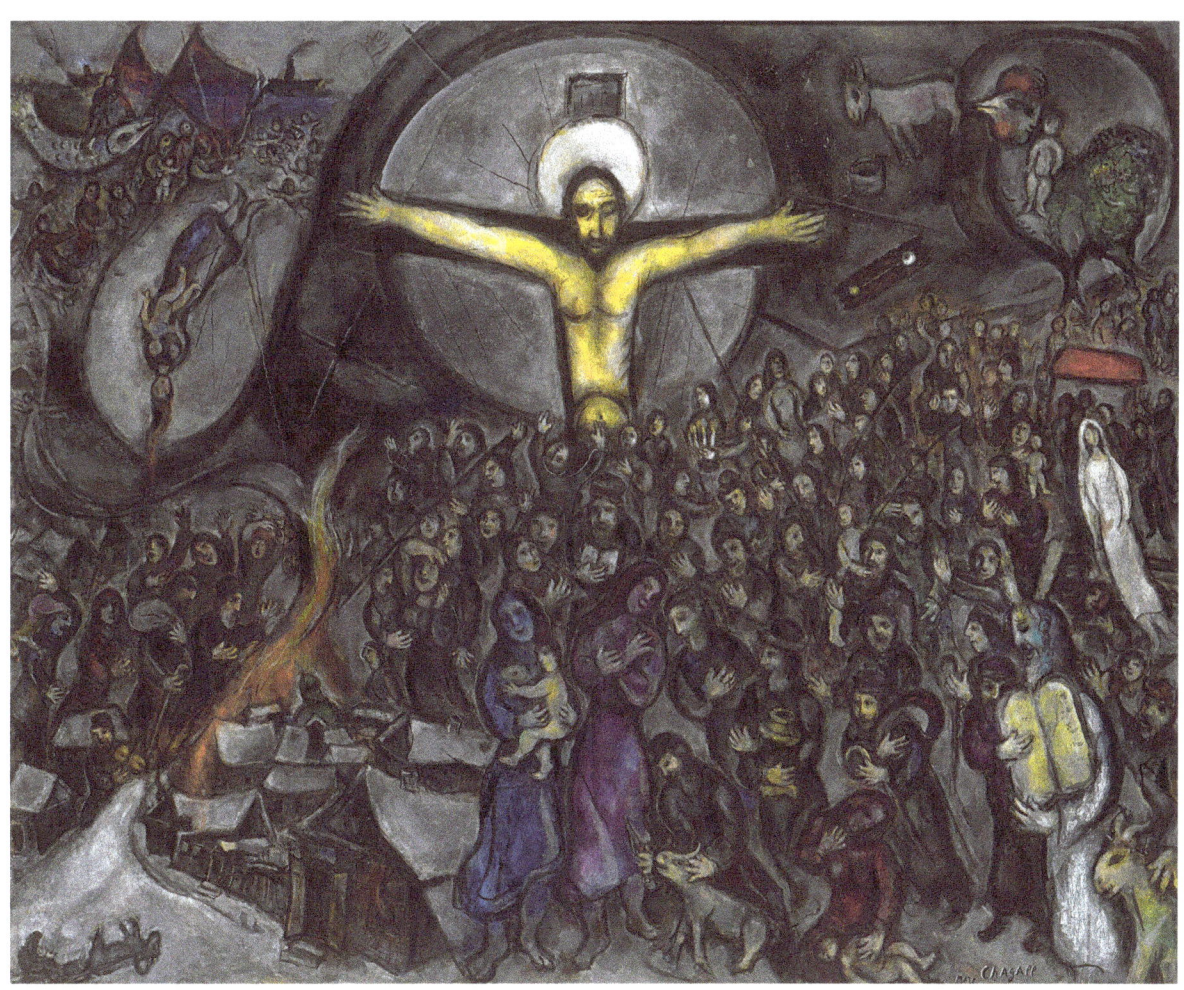

56. *The Exodus*, 1952-66
Oil on canvas, 130 x 162 cm
Musee National Marc Chagall, Nice

THE RUBEDO

The final stage of the alchemical operation is characterized by the re-unification of the alchemist's purified spirit with the physical matter of the body and mind (*CW 12*: 333-34; de Rola, 1973; Edinger, 1995; von Franz, 1980). The illuminated spirit and soul have experienced transcendence through an acquisition of knowledge, or conscious enlightenment, and are now ready to return to the material body and mind (ibid.). In the alchemical metaphor, psychic transcendence is marked by a shift in one's thinking process or perspectives, thereby creating a new level of psychic awareness (ibid.). Such awareness stimulates changes in external behaviors in effort to support the new perspectives, thus creating a new and integrated bodily self (ibid). Jung highlights the connection between the Rubedo, the process of analysis, and the imagery of the *Annunciation*:

> Analysis should release an experience that grips or falls upon us as from above, an experience that has substance and body such as those things which occurred to the ancients. I were going to symbolise it I would choose the Annunciation. (Jung, in von Franz, 1980, p. 269)

Von Franz (ibid.) reflects that, "In alchemical terms [Jung's statement] is the beginning of the Rubedo". The life-cycle of Christ is at once, a beginning and an ending, a sacred transformative cycle that is continuously re-cycling through the religious experience of life. In Chagall's oeuvre, there is a conspicuous absence of a *literal* red crucifixion painting to sequentially - or atemporally - support the continued colored-processing of the transforming imago. There is however, visual evidence that emerges in three creative circumstances, to support the thought that the Rubedo metaphor does indeed resonate through color, particularly during the Artist's Later Life (1952-1985).

The 1943 composition, *L'Obsession* (PLATE 57), reflects the crucifixion paintings discussed thus far, with its historical connections to the Artist's lifespan and the symbolic use of his adult imago form. It is also the only painting of Chagall's crucifixions with a red-hued picture plane – here, the green crucified Christ figure appears uncharacteristically, in an horizontal orientation, and is partially obscured by a burning building. It is perhaps one of the more unusual treatments of the crucifixion motif by Chagall. What is significant in this context of the rubedo, and the alchemical metaphor, is that the composition is an allegorical self-portrait of the Artist's physical transformation, from death *into* life: Chagall's autobiography documents the dramatic occasion of the day of the artist's birth: Not only was a fire burning in the town centre of Vitebsk, but extraordinarily, the Artist was a still-birthed newborn. Chagall describes this event, in July, 1887:

> The town was in flames...The bed and mattress, with me at Mama's feet was carried off to safety...But first of all, I was born dead. I did not want to be alive. Imagine a pale bladder that doesn't want to live in the world...They pricked it with pins, threw it into a bucket of water, and finally it gave out a squeal.

the (alchemical) process – and, imaginal emergences within stages – may overlap, or re-emerge in a re-cycling of form. Such re-emergence, or, re-imagining of form is (typically) considered a positive indication that the psychic 'movement' is ongoing, and, that the transformation continues to reflect the process as a Whole, across all stages of development.

But what's important is that I was born dead. I certainly don't want the psychologists to draw any unfavorable interpretation for me Please! (in, Harshav, 2004, p. 86)

The reddened image of the alchemical green Christ, immersed in the heat of the burning flame is a most potent self-reflection, of the Artist.

During the course of research and the accumulation of time spent with Chagall's images, connections were made that were not initially apparent in the early stages of the project. In 2011, the Philadelphia Museum of Art hosted an exhibition, *Paris Through the Window: Marc Chagall and His Circle*[30]. One of the paintings by Chagall hung in this exhibition was, *In the Night* (1943) (PLATE 58). Painted during the artist's American period as a refugee, the painting shares compositional elements similar to, To Russia, Asses, and Others (1911) (PLATE 23), and *The Wedding* (1918) (PLATE 40): The joined couple dominate the foreground, whilst an image of a lantern is suspended above their heads. A small eye has been drawn into the light source that centrally unifies a triangulation between an Orthodox church structure, a crescent moon, and the outline of a bovine form. The unusual coloring of the female form is significant: she shares the 'greening' of Chagall's self-portraits and Christ figures, and is clothed in a red gown.

My connection experience to *In the Night* (1943) remains a numinous encounter[31], for the thought exists that Chagall's wife Bella passed away prematurely[32] the year following the time of its creation. Discovering this information, I sought to re-examine the appearance of this unfamiliar Red Lady form in Chagall's oeuvre. She appears in works created both before and after this composition, wearing her red gown without her veil: In a 1940 painting entitled, *The Crucifixion*[33] (PLATE 59), she laments at the foot of the Cross; in, *Vision of the Artist's Family* (1935-47), and in *The Dance* (1950-52), she is re-imagined in an animated full-figure form. The Red Lady is a mysterious figure, an other-worldly essence, rather than a ghostly form; she presents a reddening in the re-imagining of the hierosgamos bride, a hearkening to the spirit of the anima, whilst echoing the transformative elements of the feminine in nature and the Divine.

Beyond image, the Rubedo metaphor may be considered further, within the technical materials, or media, of Chagall's Monumental works. Here, the reddening exists within the creative process itself, appearing, as it does, through the transmutation of the matter as the painted image

30 This exhibition considered the creative world of Paris during Chagall's critical Early Life, and the impact such immersion had upon the artist's developing aesthetic using color and form. It included works from a variety of artists living in Paris between the wars, including native Parisians as well as those who came to live and work in the Montparnasse area from abroad, such as Chagall.

31 Not unlike the feeling particular to *The Black Glove* (1923-48) when one considers the replication of forms re-imagined from the two original portraits of Artist and wife, from 1909.

32 Madame Chagall passed away 2nd September 1944, in Cranberry Lake, upstate New York. She had been unwell with a sore throat, caused by a common streptococcal infection. An highly treatable condition became a tragic convergence of external circumstances: The infection had not been diagnosed until it was in an advanced state, and the local unavailability of the penicillin drug (due to War rationing restrictions – this was in the final months of the WWII – and the Chagalls were living in a rural location at that time) meant that the treatment was not able to reach her to save her life. (Harshav, 2004, pp. 541-545).

33 A different composition, a work on paper, entitled, *Christ at Night* (1948), features the dark color saturation as, *In the Night* (1943); However, it depicts a singular greening Christ figure on the cross, and a red soul-bird over his shoulder.

of Chagall's Christ upon the glass window plates are kiln-fired in preparation for architectural installation into sacred spaces of worship[34].

In the example of the glass commission for Chichester Cathedral, Sussex, England, the window pane itself is colored deeply in reds. The image is dedicated to *Psalm 150* and is titled, *The Arts to the Glory of God* (1978) (PLATES 60, 61). Within this reddening, a green-faced musician, King David, appears upon a horse, heralding animals and figures with instruments in a celebration of Faith through the Psalm. Chagall's observation of the window as a psychic vista was included in the *Service of Dedication*[35]:

We wish for happiness – *le bon heur*,
Tinted with color clear
Away from earthy tumult.
This form of art (color) can open up
Paradise to us and, like the Magic Flute
Of Mozart, help us to reach it.
(Foster, 2004, p. 19)

With Chagall's *Later Life* creative movement into the design of Monumental works for public spaces, the intimate containment of his painted picture plane is replaced with an external, collective experience and interaction. The transformed and externalized crucifixion image is found within examples of the painted glass windows Chagall created for sacred sites of worship, in Europe, Great Britain, Israel, and the United States. The material presence of the physically-transformed glass simultaneously contains and reflects the transformation of Chagall's adult imago.

34 From 1958, beginning with his second commission for the windows in Metz Cathedral (1958-68), Chagall collaborated with glass artists Charles and Brigitte Marq, of the Simon Atelier, in Reims. His initial stained glass commission for, *The Church of Our Lady of Grace*, Assy, France (1956-7) was included among a group of 20th Century Modernist artists that took part in a structure dedicated to 'reviving' sacred architecture in the mid-20th Century. Chagall's contribution to the Assy church space included two yellow glass panes, and an Egyptian-styled bas relief. (See *Appendix B*.)

35 *The Service of Dedication* at the Cathedral Church of the Holy Trinity, in Chichester England, took place on 6, October, 1978. Chagall, who was ninety-one years old at the time, did not attend the service; In his Service,

Robert Holtby, Dean of Chichester (1977-89), provided a translation of Chagall's observation of the red glass window.

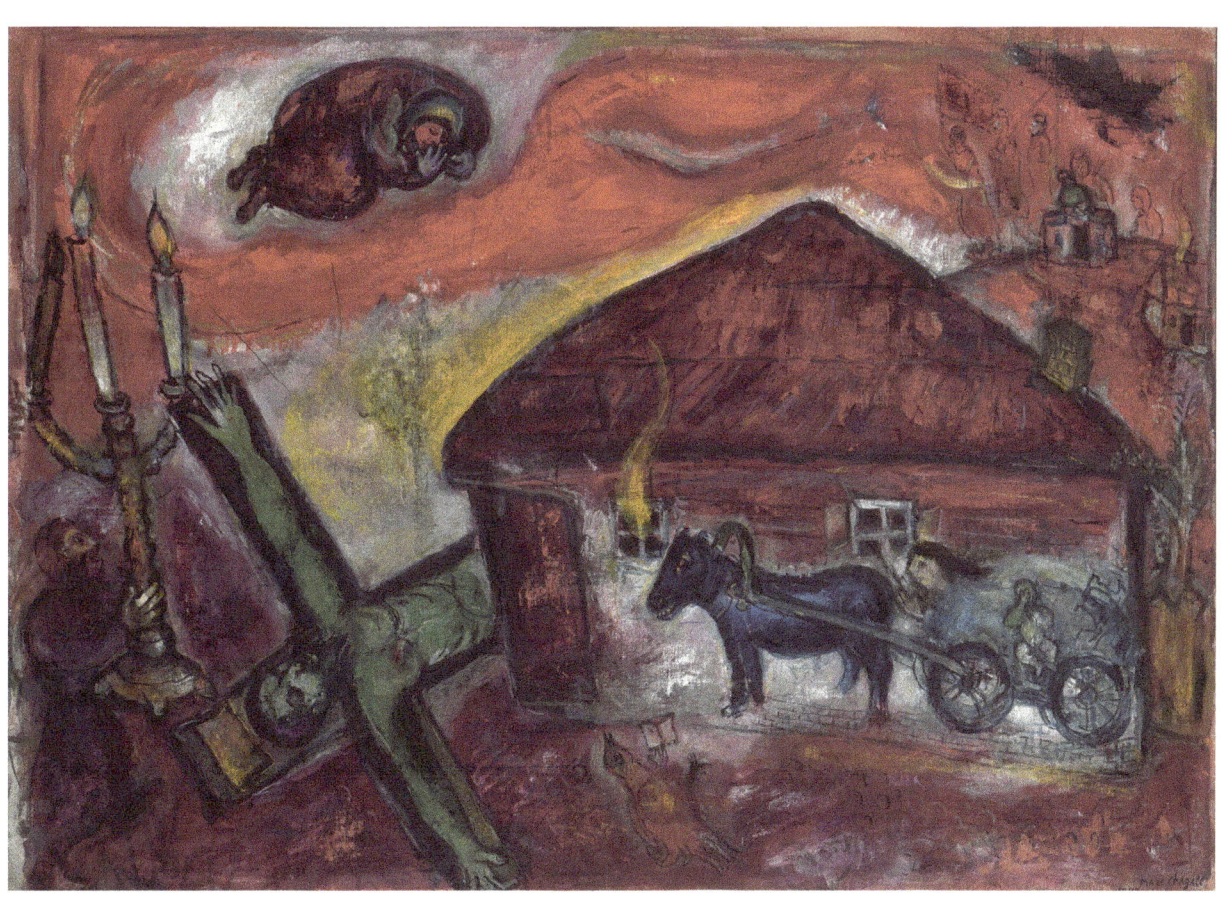

57. *L'Obsession,* 1943
Oil on canvas, 76 x 107.5 cm
Musee des Beaux-Arts, Nantes, France

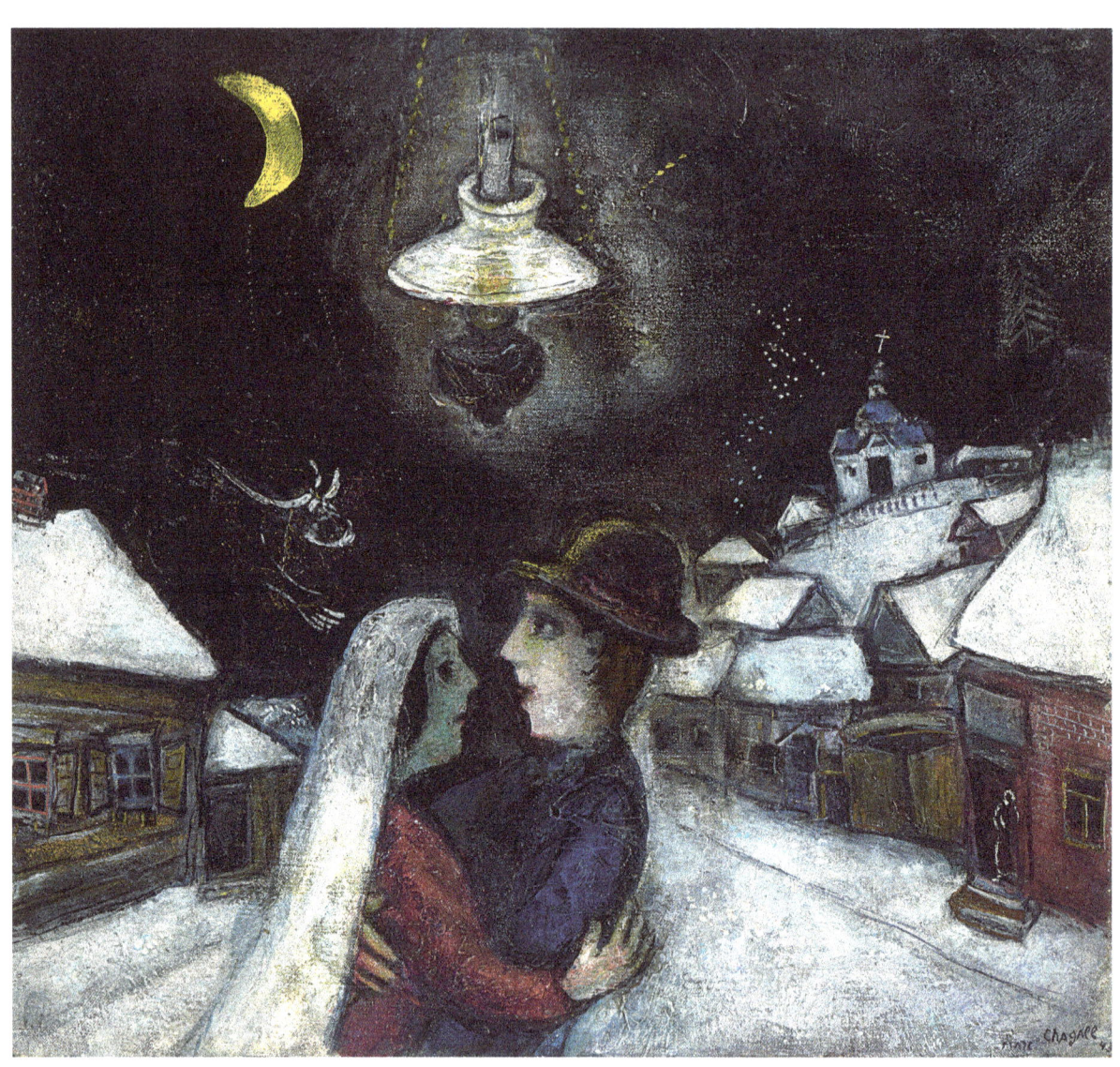

58. *In the Night*, 1943
Oil on canvas, 47 × 52.4 cm
The Louis E. Stern Collection, 1963
Philadelphia Museum of Art

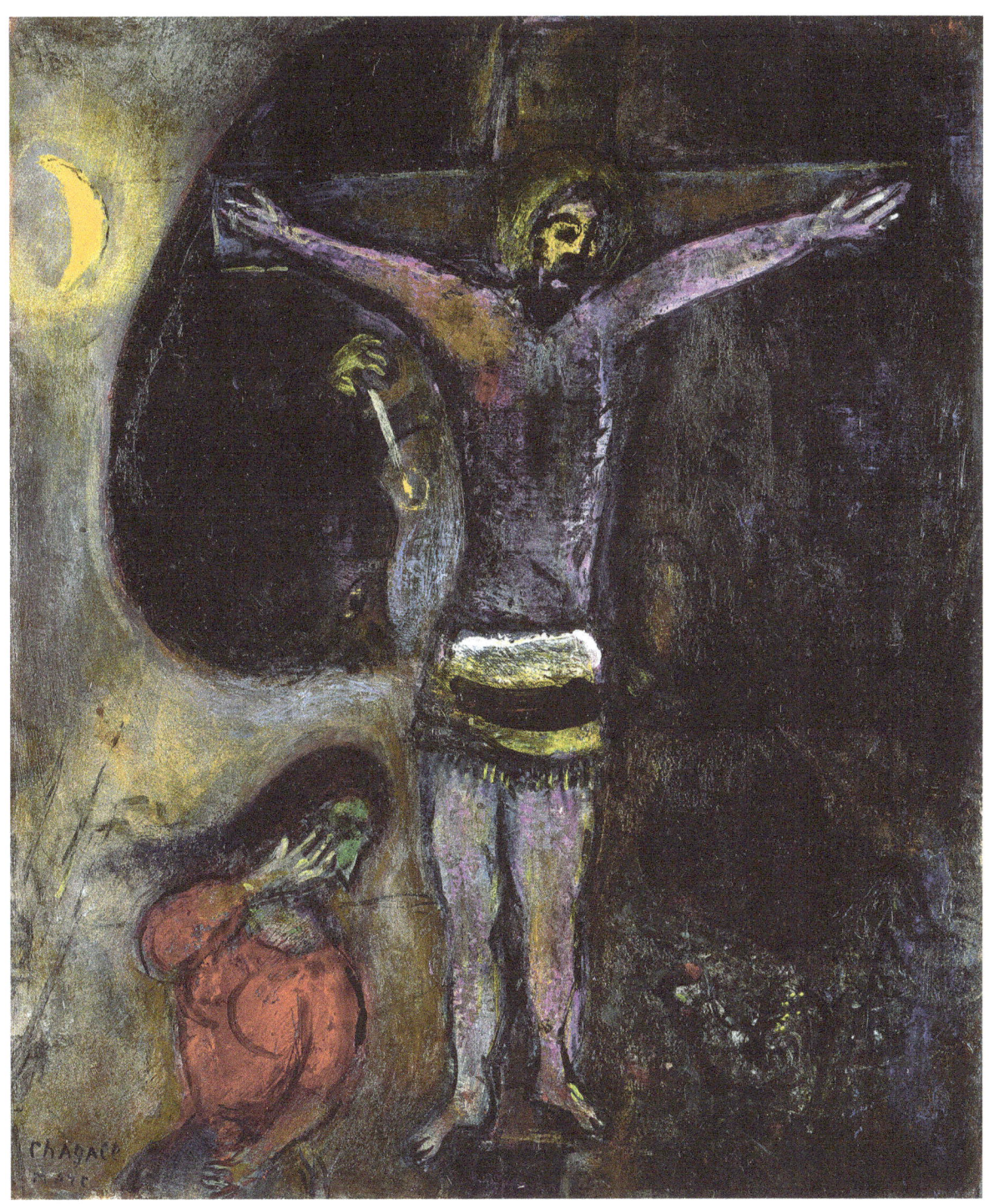

59. *The Crucifixion*, 1940
Oil on Canvas, 34 x 29.4 cm
The Samuel S. White 3rd and Vera White Collection
Philadelphia Museum of Art

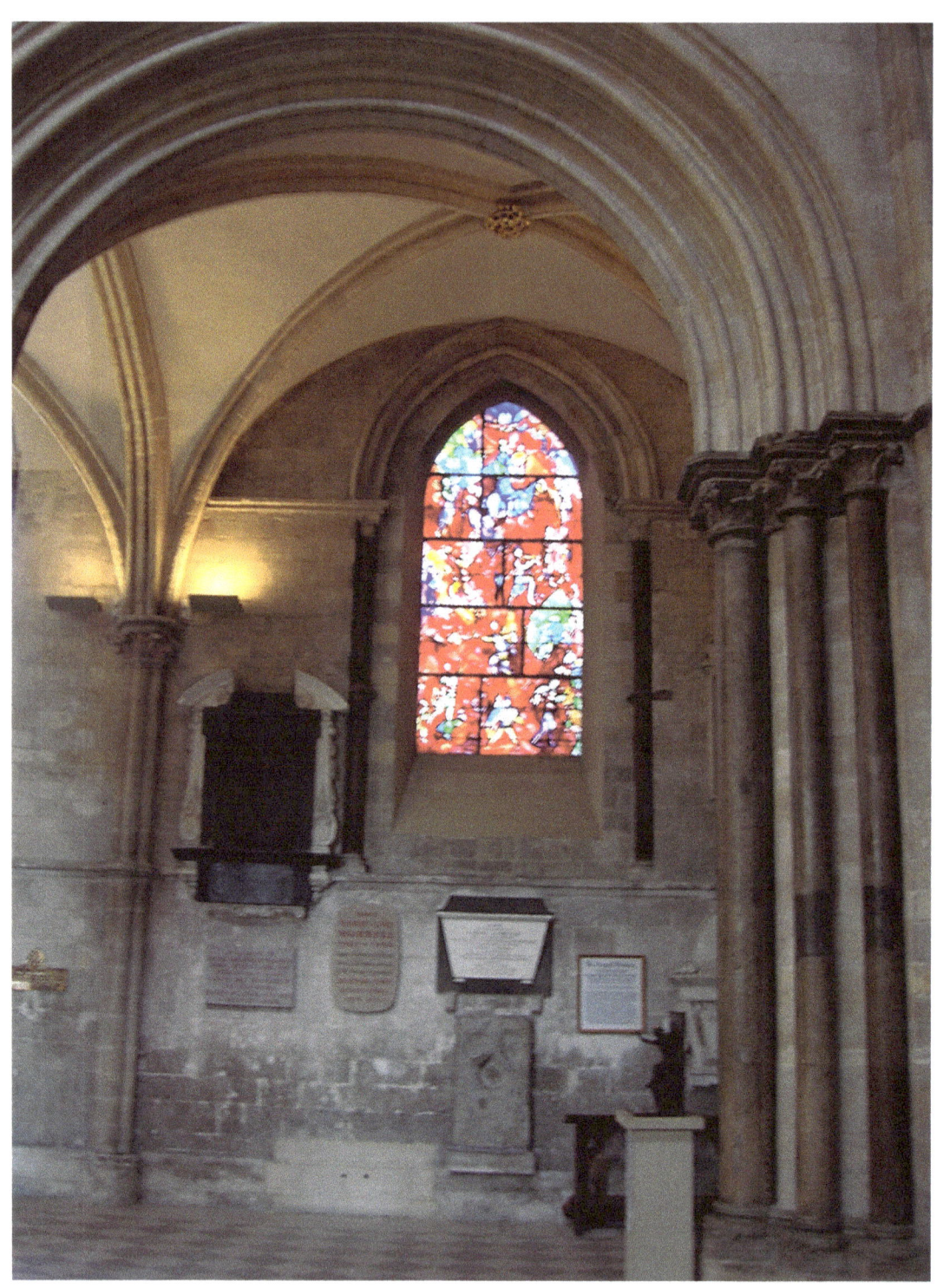

60. *The Arts to the Glory of God*, 1978
Stained glass
Chichester Cathedral, West Sussex, England
Photograph: J.A. Swan, 2008

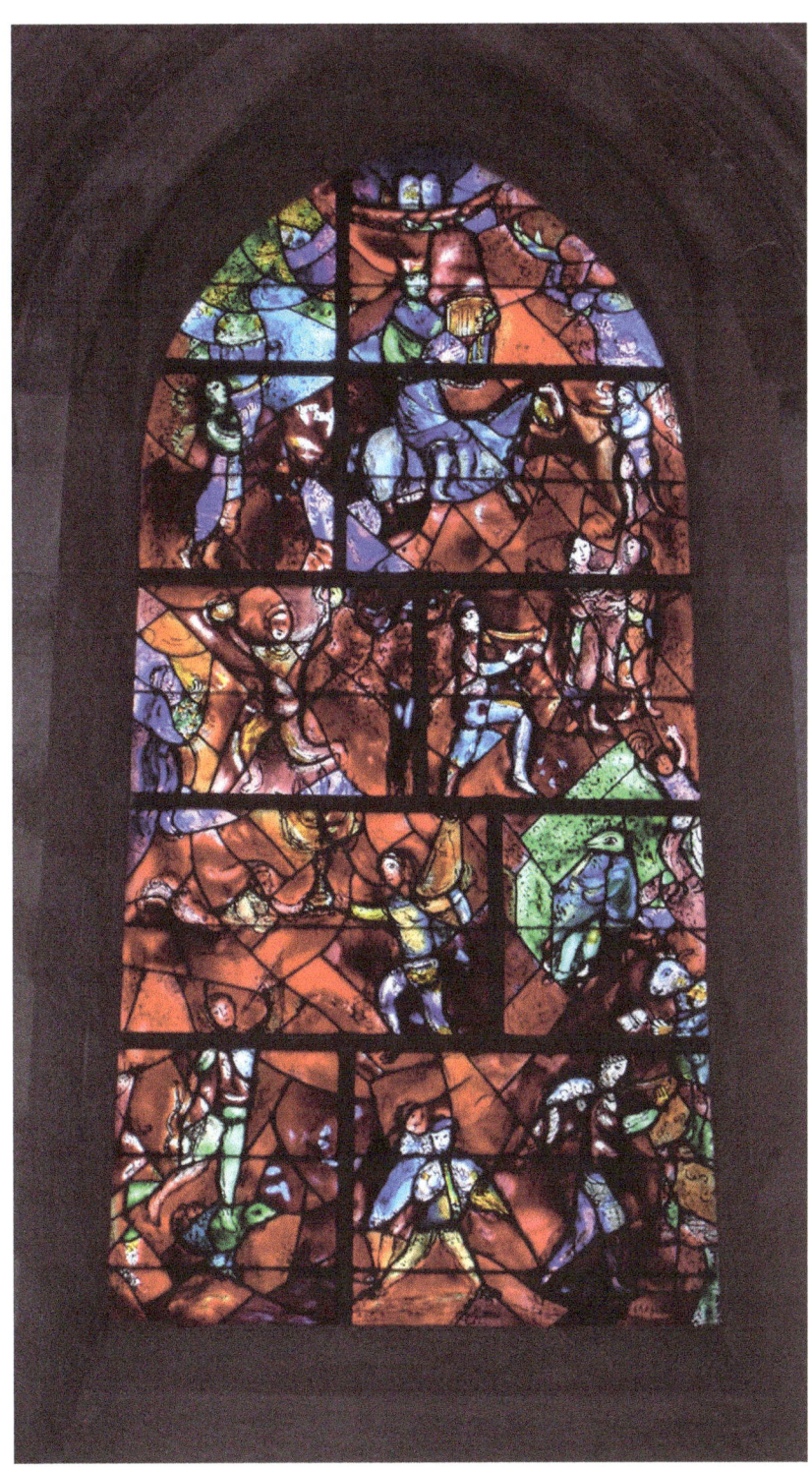

61. *The Arts to the Glory of God*, 1978 (detail)
Stained glass
Chichester Cathedral, West Sussex, England
Photograph: J.A. Swan, 2008

5. CHAGALL AND THE BIBLE

In 1930, Chagall accepted a commission from the Parisian publisher Ambroise Vollard to illustrate *The Bible*. Having completed a series of illustrations for Vollard's publication of Gogol's *Dead Souls* (1925-1927) and later, the *Fables of Jean La Fontaine* (1925-1928), Chagall embarked on what he considered his greatest commission as a printmaker (Meyer, 1964; Wullschläger, 2008).

Chagall's introduction to the printmaking process coincided with the transitional years between his *Early* and *Mid-Life* professional development as an artist. In 1922, Chagall left Russia permanently for France, and spent time in Germany before settling in Paris. In Berlin, Chagall worked with the master printer Herman Struck, who introduced the artist to the process of etching, in anticipation of the illustrations Chagall would create for the 1923 publication of his autobiography, *My Life* (1989) (ibid.). Meyer (1964, p. 318) comments upon Struck's careful tutelage that, whilst Struck emphasised proper technique, he was not compromising of Chagall's talent for the printmaking medium and the Artist's process of image-making. Meyer (1964) suggests, "The prints prove how independently from the very start Chagall approached what was for him a total new medium." (p. 318). Thus began a relationship between Chagall and the printmaking process, which would continue throughout the Artist's *Middle* and *Later Life*, including illustrations for books as well an extensive series of woodcuts, etchings, and lithographs.

62. *Interior of a Synagogue in Safed*, 1931
Oil on canvas, 73 x 92cm
The Israel Museum, Jerusalem

In 1960, Chagall reflected on his creative experience with the technical process of printmaking:

> When I held in my hand a lithographic stone, or a copper plate, I believed I was touching a talisman. It seemed to me that I could entrust them with all my joys, all my sorrows... Everything that has crossed in my path, throughout the years: births, deaths, marriages, flowers, animals, birds, poor people, my parents, lovers at night, the Prophets from the Bible, on the street, in the home, in the Temple, in the sky. And, as I grow older, the tragedy of life that is inside us and all about us. (Harshav, 2003, pp. 144-45):

Chagall began the creative process of his work on *The Bible* etchings by arranging to visit the Holy Land (Baal-Teshuva, 2004; Bohm-Duchen, 1998; Meyer, 1964; Wullschläger, 2008). Chagall's observations point to a primordial connection between image and landscape:

> I never work from my head...I wanted to see Palestine; I wanted to touch the earth. I wanted to verify certain feelings, without a camera, without even a brush... There, in the steep streets, from thousands of years before Jesus walked... Nowhere will you see so much despair, so much joy; nowhere will you be so distressed and so happy as when seeing the age-old mass of stones and dust of Jerusalem, of Safed, of the mountains where prophets are buried over prophets. (Rosensaft, 1987, p. 15):

Between 1923 and 1930, Chagall had settled into his early midlife in Paris and the south of France. His creative inspiration transitioned between an internal engagement with religious attitude from within a secular environment, to an observation and exploration of the natural physical environment. The *Paris II* (1923-1941) years of 1923-1930 are significant for the decline in the artist's use of the sacred-secular binary through images of faith and religious life (e.g., the Holy Family, and Jewish Men/Holy Men series'). The religious quality in his creative output changed during this period, increasingly depicting the subjects of family (i.e., the Alchemical Couple) and landscapes.

63. *The Walls of Jerusalem near the Gate of Grace*, 1931
Oil on canvas, 73.5 × 67 cm
Private Collection

The initial immersion into the sacred environment of the Holy Land (then, Palestine), in 1931, was arguably a numinous experience for Chagall. This encounter appears to have deepened his engagement with religious interiority, and is reflected in his *Holy Land* series of paintings.

The Artist reflects retrospectively, in 1969, upon this initial encounter:

> Over forty years ago, I was invited by the French publisher Vollard to paint the Bible. I was then confused: I didn't know how to begin the work. I was so far from the Biblical spirit, in a foreign land... Since then, I have grown close to the Land of Israel, and have created the Bible. I am born again; I became a different person. It is difficult for me to explain it in words, and do I need to...? Since then, I have always had the desire to express signs of devotion, however and whenever I can. (Harshav, 2003, p. 171)

The paintings Chagall created during his first stay in Palestine are remarkable for the presence of realism: The artist spent much of his travels working en plein[1], and these works - unlike the architectural paintings of Vitebsk resurrected from the artist's memory - are imbued with a clarity of form and brightness of interior light. In the works of 1931[2], the communication of the space is direct and representational; Chagall's visual treatment of the sacred aspect of environment is liberated through use of light in his re-imagining of form. This style encourages individual and independent passage into a living landscape or architectural space, extending the visual experience beyond the canvas. Such visual treatment of form differs from the dark and expressive essence of the *Russian II* period. These earlier images communicate the experiential visual attitude of an action or activity taking place from 'within' the containment of the picture plane.

Many of Chagall's *Early Life* paintings were technically composed by rendering objects from the negative space of a deeply toned gesso-primed canvas. Whereas, in the *Holy Land* series of 1931, the imagery exists as it was painted, atop the natural white of the primer coat, which is able to be seen through the application of oil colors. Such technique is seen most often in the Impressionistic and Post-Impressionistic work of the late 19th Century wherein the communication of the quality of light is paramount to the evocation of color, in its use as a compositional element (the paintings of Paul Cezanne exemplify this treatment).

Chagall's work on *The Bible* illustrations - unlike previous or subsequent illustrative commissions - was impacted by the significant changes in the externality of his environment in France, between 1934 and 1941. In 1934, for example, the effects of the Great Depression in America had reached the art market on the European continent, and Vollard indefinitely suspended Chagall's commission for *The Bible* illustrations (Baal-Teshuva, 2003; Bohm-Duchen, 1998; Wullschläger, 2008). Chagall nevertheless continued with the project, and, as stated earlier, remained in France despite the increasing political tension and historic events that would precipitate the start of the Second World War. He completed sixty-six of the 105 etchings by 1939, before abandoning the work, following Vollard's death, during his American exile period of 1941-1948 (ibid.).

[1] A common abbreviation for the technical term, 'en plein air', or, working from life observation 'in the open air'. In the Modern era, there is a strong tradition of en plein in French Impressionist and Post-Impressionist schools, as well as in German Expressionism. Wullschläger (2008, p. 349) points out the changes in Chagall's color palette during this time.

[2] Such as, *Interior of a Synagogue in Safed* (1931) (PLATE 62) and *The Walls of Jerusalem near the Gate of Grace* (1931) (PLATE 63).

In 1948, Chagall and his (then) partner Virginia Haggard returned to France following the Second World War. As in the transitional years between *Early* and *Mid-Life*, this period was characterized by an external change in environment, followed by a period of settlement, that for the 62-year-old painter would become permanent (Bohm-Duchen, 1998; Haggard, 1986; Harshav, 2004; Meyer, 1964; Wullschläger, 2008). As Chagall entered into his *Later Life* period, exploring the Biblical theme became the focus his creative spirit.

In the context of the individuation process, the *Later Life* period, for Chagall, represents the most distance from the environment of his natal faith and the most significant evidence for the visual expression of his interior religious attitude: In the *Early Life* period (1887-1922), Chagall's biography and lifespan development is characterized by an adolescent break with the practice of faith, the movement away from the culture of Hasidic Judaism, and the early exploration of the sacred-secular binary through immersion in the secular environments of Parisian Modernism, and Soviet Russia. The Mid-Life period (1923-1951) is characterized by the solidification of the artist's religious attitude through a numinous encounter with the Holy Land, in 1931. The reconnection with sacred symbolism and Chagall's use of the sacred-secular binary – as seen in his early *Holy Family* paintings (1908-9) - appears at *Mid-Life* through the series of illustrations for *The Bible* (1931-1939), and the re-emergence of the Crucifixion, in 1938.

In his Later Life period (1952-1985), Chagall's religious attitude arguably experienced a further maturation process characteristic of a "third stage" (Stein, 2005, p. 10) of *Later Life* transformation. This maturity resonated in two examples of creative communication: Through his written observations concerning the decline of faith in the latter part of the 20th Century, and, in Chagall's approach to the technical production of art as a means to communicate a collective message of universal spirituality.

> It may be possible that there is a third caterpillar stage between midlife and old age, when there is yet another transformation. This final metamorphosis typically gives birth to a sense of self that is highly spiritual and oriented to the timeless, as a person prepares for the final letting go and what may be a fourth transformation, physical death. (Stein, 2005, p. 10)

Following a second visit to the Holy Land, in 1951, Chagall returned to his work on *The Bible* illustrations (1952 -1956). These were published by Teriade, Vollard's successor, in 1956 (Pacoud-Reme, 2011; Rosensaft, 1987). The 1950's for Chagall, were an animated decade, wherein the Artist began to vigorously explore the Biblical theme in various ways: Initially, Chagall completed a new set of Biblical-themed prints using the color lithography process - in contrast to the black and white etchings of the 1930's - to reproduce and re-imagine earlier studies that had not been fully realised, or "disregarded before the war" (Meyer, 1964, p. 574).

Neumann (1979, pp. 116-7) remarks upon the 1930's set of Biblical etchings[3], suggesting that Chagall's early use of black and white imagery produces a numinous effect that emphasises the contrast between the *Divine* and Man within the darkened void of the background composition. He states (1979) that, for Chagall, "the creative activity of God has withdrawn into the imageless anonymity of the numinous that is typical of the later Jewish conception of the godhead." (p. 117).

3 See, *Promise at Jerusalem*, 1931-39 (PLATE 64)

64. *Promise at Jerusalem*, 1931-39
Copper plate etching, 22 x 30 cm
The Jewish Museum, New York

65. *Moses and the Serpent,* **1966 (The Story of the Exodus)**
Lithograph, 46.6 x 34.3 cm
The Jewish Museum, New York

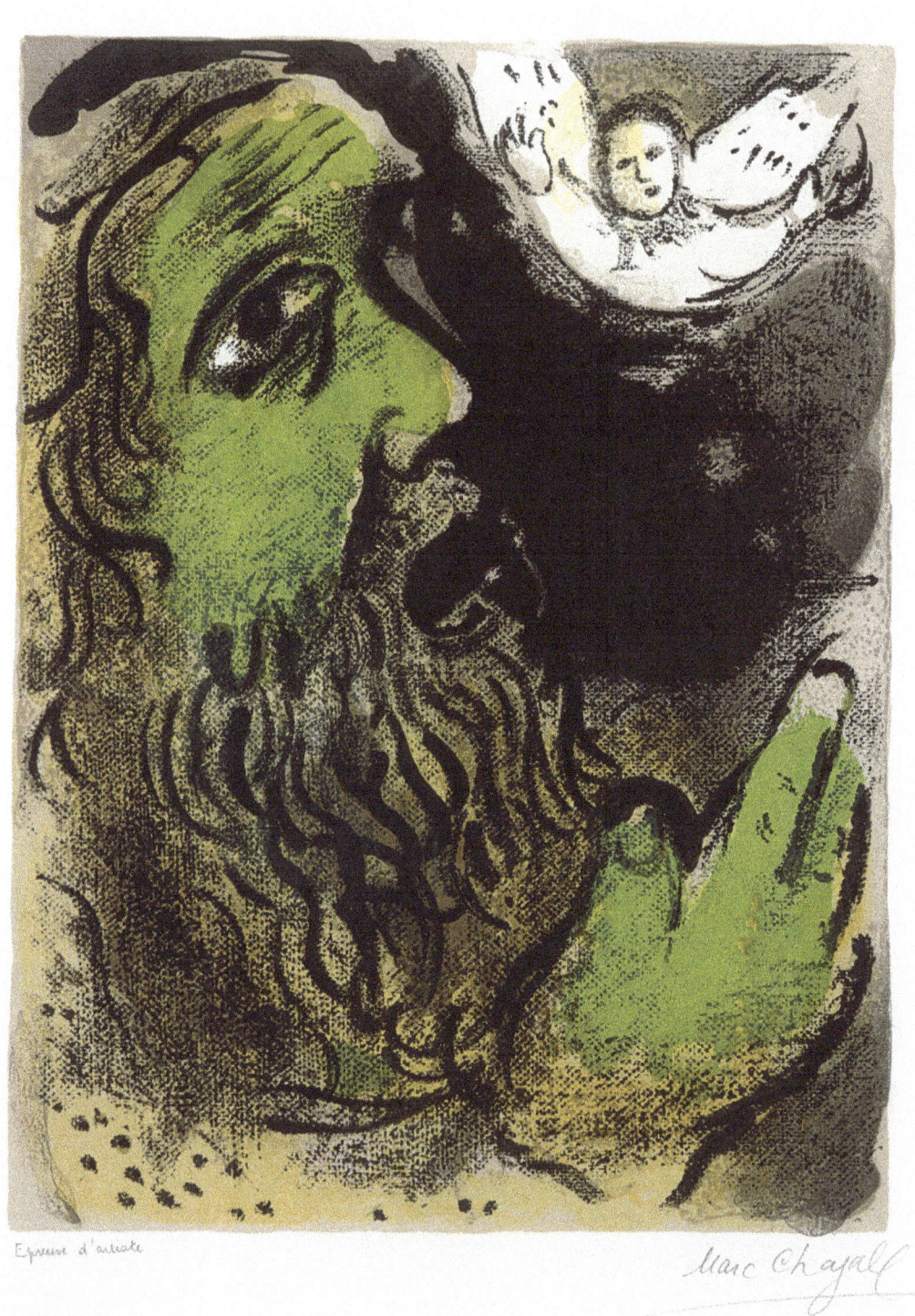

66. Job at Prayer, 1960
Lithograph, 52.5 x 38cm
The Jewish Museum, New York

Meyer (1964) and Neumann (1979) share the observation that the color Biblical lithographs[4], and the *Biblical Message* paintings series of the late 1950s and 1960s are distinct from the Biblical themed works of the Artist's *Early* and *Mid-Life* stages of development. The introduction of pigment into Chagall's Post-War Biblical palette presented the colorful emergence of the sacred feminine in the form of the Madonna, angels, brides, and the re-imagining of the alchemical, or hierosgamos, coupling.

Neumann's arguments (1959, 1979) concerning Chagall's creative process have focused upon Chagall's Jewish identity as an image-maker. In reflecting upon the Biblical series of works, Neumann posits the emergence of the scared feminine as a process of Chagall's own engagement through the religious experience of Judaism. The contact and connection is made through an historical tradition of Kabbalistic mysticism, and Chagall's natal Hasidism. Neumann clarifies (1959, p. 140) that the constellation of this archetypal image is not completely fixed within the realm of Judaism and thus can be considered in a different context, as a universal expression of the union of opposites in the alchemical metaphor for the individuation process.

THE MUSEUM OF THE BIBLICAL MESSAGE

As early as 1950, Chagall was intent on creating a space to house his new paintings from the *Biblical Message* series (1950s and 1960s). These paintings grew from the Artist's creative re-engagement with the preliminary color gouaches for *The Bible* etchings, following his 1948 return to France (Alexander, 1978; Haggard, 1985; Meyer, 1964). Haggard (1983, pp. 127-8) suggests that Chagall's interest in this architectural project was activated by the Artist's visits to sacred sites in Italy during his receipt of the *First Prize* for his Bible etchings at the Venice Biennale in 1948. In particular, Haggard recounts the Artist spending time with the church frescos in rural villages, and experiencing the paintings of Giotto in Padua, and Fra Angelico in Florence's Uffizi Museum (ibid.).

Upon his return from Italy, Chagall had explored a number of small Christian churches and large Cathedrals in France, in search of a site that he could convert into his Museum of the Biblical Message (ibid). In Chagall's own village of Vence, the derelict *Chapelle des Penitents Blanc* and the *Chapelle du Calvaire* were both considered as potential refurbish projects (ibid.).

Failing to find an appropriate or available sacred site which could be converted for his own use, Chagall created a new site in 1969, with the placement of the foundation stone on a hill plot in Cimiez he had purchased from the City of Nice, in the Alpes-Maritimes of Southern France (Alexander 1978, p. 462; Bohm-Duchen, 1998, 306-9; Pacoud-Reme, 2011, pp. 4, 9; Wullschläger, 2008, p. 510). With support of Andre Malraux[5], Chagall's architectural space was imagined and conceived through a creative collaboration with architect Andre Hermant[6].

4 See *Moses and the Serpent*, 1966 (The Story of the Exodus) (PLATE 65); *Job at Prayer*, 1960 (PLATE 66).

5 The French writer and Arts scholar Andre Malroux was the French Minister of Culture between 1959-1969. A friend of the artist, Malroux championed the museum project.

6 The museum is the first in France to be devoted exclusively to the works of a living artist. The work of Belgian architect Hermant (1908-78) is known for its adherence (in construction design and building

In this purpose-built space, Chagall's Bible series and stained glass designs are united with a collection of works-on-paper, and a research archive. Together, they form a House for the artist's conceptualization of, *The Biblical Message*.

> Ever since my earliest youth, I have been captivated by the Bible. I have always thought and still think that it is the greatest source of poetry of all time. Ever since then, I have always looked for its reflection in life and in art. The Bible is like a resonance of nature and that is the secret I have tried to pass on… For me, perfection in Art and in life comes from this source. Without this spirit, the mechanism of logic and construction in Art and in life will not bear fruit… I would like works of art and documents embodying the elevated spirituality of all peoples to be exhibited here… (Chagall, *1973 Inauguration Speech*, Pacoud-Reme, 2011, p. 9)

In the summer of 2016, I found myself ascending a steep set of outdoor steps in a residential location, above the French seaside resort of Nice. The elevated geography of the Alpes-Maritimes, whilst unchanged by the inevitability of the human imprint upon the landscape, has witnessed the clusters of coastal villages transforming into year-round cities and popular travel destinations over the past century. At the top of the rise, one is met by careful foliage prominently scenting the heated air and an unexpected architectural contrast. To the uninitiated, the National Museum Marc Chagall is an incongruous structure in this environment. Its single-storied Modern façade appears dramatic in a road of buildings accessorized in sun-shutters and tinted with the colors of Mediterranean life.

Hermant's building is solid, angular, the rhythm of its patterns reflected in the vertical rectangles of its window glass and the neutral colors of light and concrete stone. In the greenness of its garden setting, it appears to have lasted within time as a modern structure of antiquity, functioning as a secular temple to the Art of Sacred Life. Inside, the space is filled with paintings and light, and the warmth of moving visitors, secular pilgrims who have journeyed to view the work of an important artist, in a region known for its famous creative residents. They stand and sit, in front of the paintings, a cycle of Twelve, in a twelve-sided room. At intervals, those who wish to capture the images do so on tablets and telephones, and, occasionally, cameras with long lenses that electronically collect more information about the details of what is seen, than the human eye is able to observe.

The natural light in the open white space compliments the experience of color. The paintings are large enough to walk into, their Biblical stories[7] are familiar, yet appear as new, re-imagined in their own world of form. The series of paintings are connected together by the handwriting of the Artist who brought them to life. As the room turns a corner in its flow, King David invites one across a passage into a separate space, to listen to the color in the five painted re-imaginings of the Psalm, "The Song of Songs."

technique) to the Modernist aesthetic of functional form. His building designs, including a number of museum spaces, were erected primarily in France, in the immediate post-war era. The structures emphasise a collective utilitarian perspective of urban planning, such as providing open-plan interior space with natural lighting, and use of reinforced concrete and glass building materials. Hermant was a contemporary of Le Courbusier, and worked with Auguste Perret. In 2013, The Musee National Marc Chagall hosted an exhibition celebrating Hermant's work.

7 See Appendix C.

In the organizing movement and shifting of bodies, seats become available, and there is time to pause for thought: This is a secular space in a secular place, yet the essence of sacred exchange from within is real. The paintings are here for their purpose, beyond what is understood in our listening to commentary, our reading through guides, or examining plaques placed on walls to reminds one of the *details of things*. A work of art is a living experience. We are invited into their imaginal spaces to gaze through their windows, to connect with what is inside and to that which is beyond.

Within the encounter of Chagall's Biblical Message, it would not seem unusual to bring a preference for a particular image of a sacred symbol into the visual experience of the narrative. From before the outset of this project, I have kept a small framed image of Chagall's in the place where I write. It is the only work of Chagall's that is on permanent display in my personal space; it depicts an image of Noah's rainbow in a lithograph, a composition that re-emerges in the like-titled painting, *Noah and the Rainbow* (1961-66). Here, a sleeping Noah reclines into a scene of his dream, revealing the changes to come in the world of Man. The rainbow, an arc reaching across the picture plane, is a prism ridden by an angel, reflecting the white light produced by the technical process of combining the "sum of all colors" (Pacoud-Reme, 2011, p. 16).

There is a second re-imagining of Noah in Chagall's Biblical Message (*Noah's Ark*, 1961-66) (PLATE 67): In this composition, a greened-face Noah stands at the centre of his Ark, looking into the eyes of a small calf form, his dove in his outstretched hand. Chagall's re-imagining is significant: Of the plentiful images of Noah's story, this painting is the only known to exist which depicts Noah "from within" the container of the Ark (Pacoud-Reme, 2011, p. 15). It is an image-within-an-image of transformation. It reflects the essence of a temenos expression.

This conceptualization, of a sacred transformative space, is reinforced by the shared presence of a second series of Biblical Images: Five paintings that re-imagine the Song of Songs[8]. They are composed in red pigments, their canvases reflecting the encounter with *L'Obsession* (PLATE 57) and the pane of the red glass window at Chichester Cathedral. Within each composition, exists a multiple re-imagining of the hierosgamos coupling of form. The expression of this alchemical coniunctio is activated by the reddening of the compositional plane, that vibrates with the colored pulse of a sensual, and sexual, unification process. What is perhaps most curious about this series, is the clarity of the couple's presence in the fourth re-imagining: A green King David and his bride Bathsheba are united in corporeal form, as they fly into the night of a red sky. He is clearly a King, and she, his Bride. Yet, observing the original work of art, there is the thought that the visage of the Bride shares facial features *not dissimilar* to those found in Chagall's own self portraits.

The comparison between the Museum of the Biblical Message site and the GOSET theatre, with its murals-as-container (1920), has been made by art historians (Bohm-Duchen 1998: 306-9;

8 Chagall's treatment of the characters represents a re-imagining of the story: The Artist has painted the figures of lovers, King David and Bathsheba. Pacoud-Reme (2011) reflects that in his treatment of the theme, Chagall, "vividly [in reds] conveys the three dimensions of Song of Songs: the musical, sacred, and sensual" (p. 84).

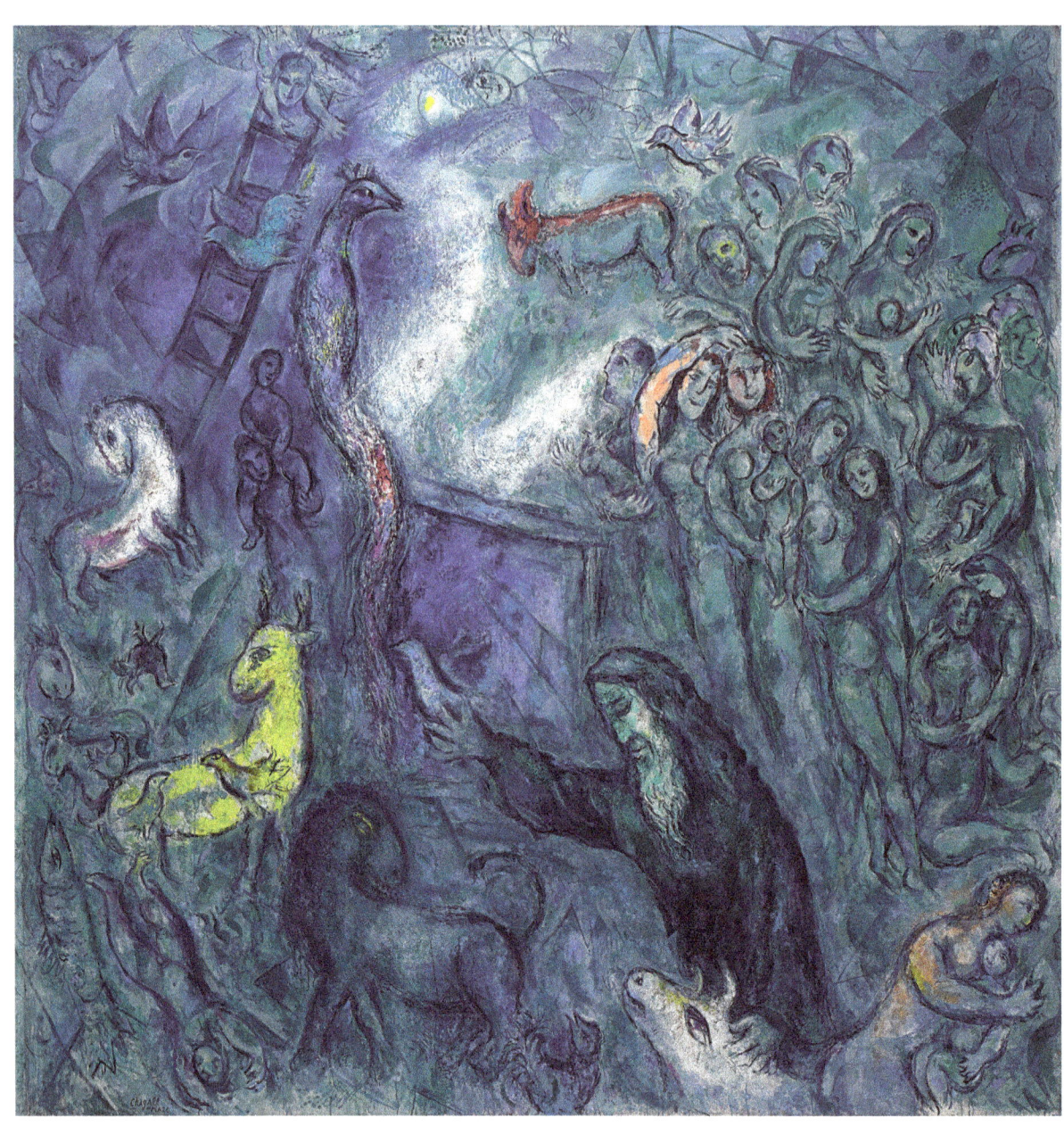

67. *Noah's Ark*, 1961-66
Oil on canvas, 236 x 234 cm
Musee National Marc Chagall, Nice, France

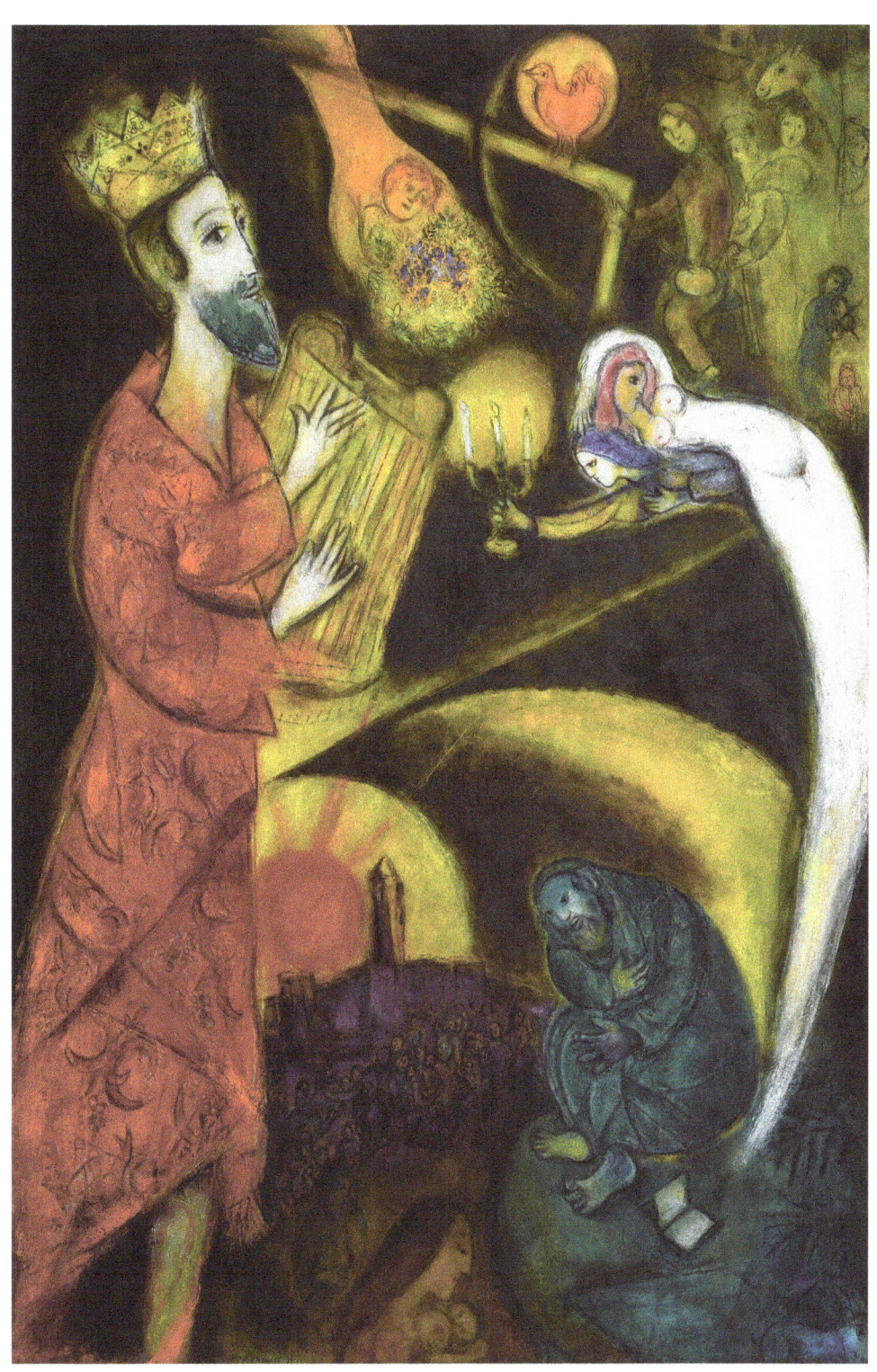

68. *King David*, 1951
Oil on canvas, 198 x 133 cm
Musee National Marc Chagall, Nice

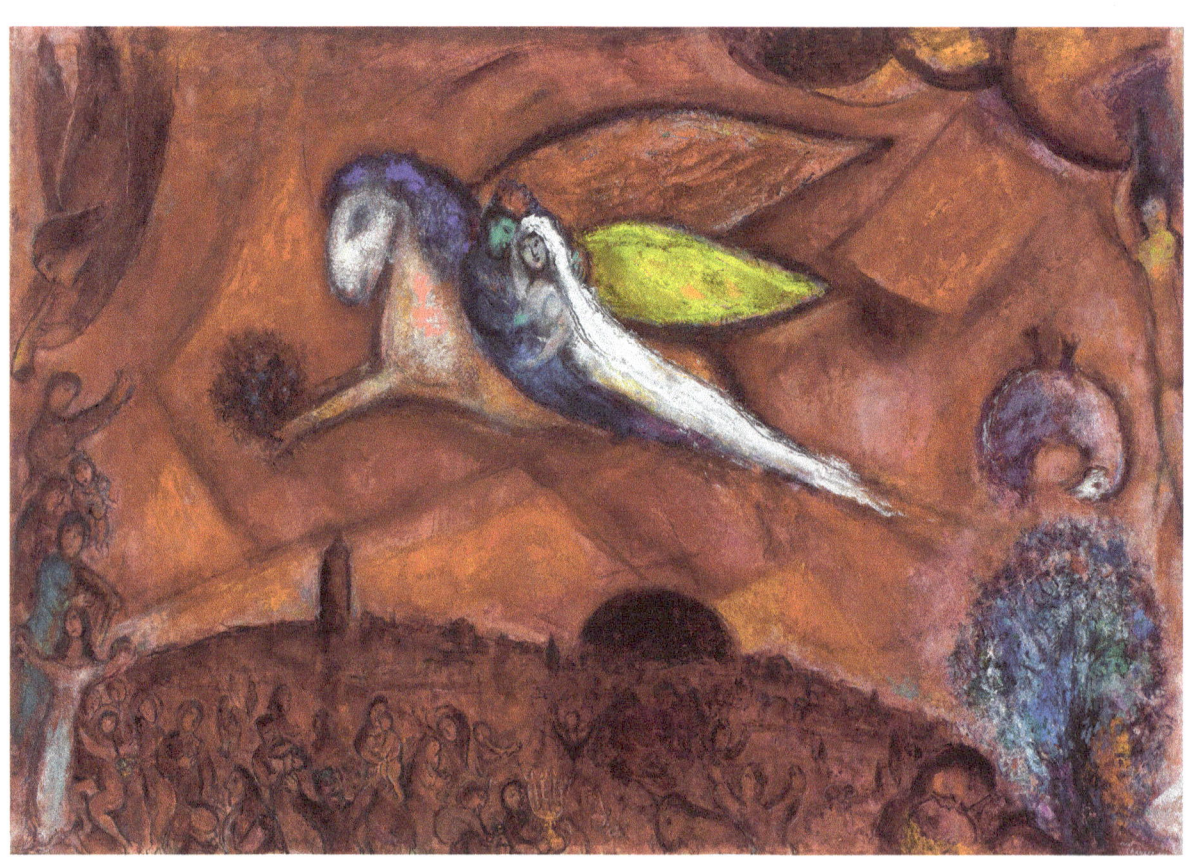

69. *Song of Songs IV*, 1958
Oil on paper, laid down on canvas, 145.5 x 210.5 cm
Musee National Marc Chagall, Nice

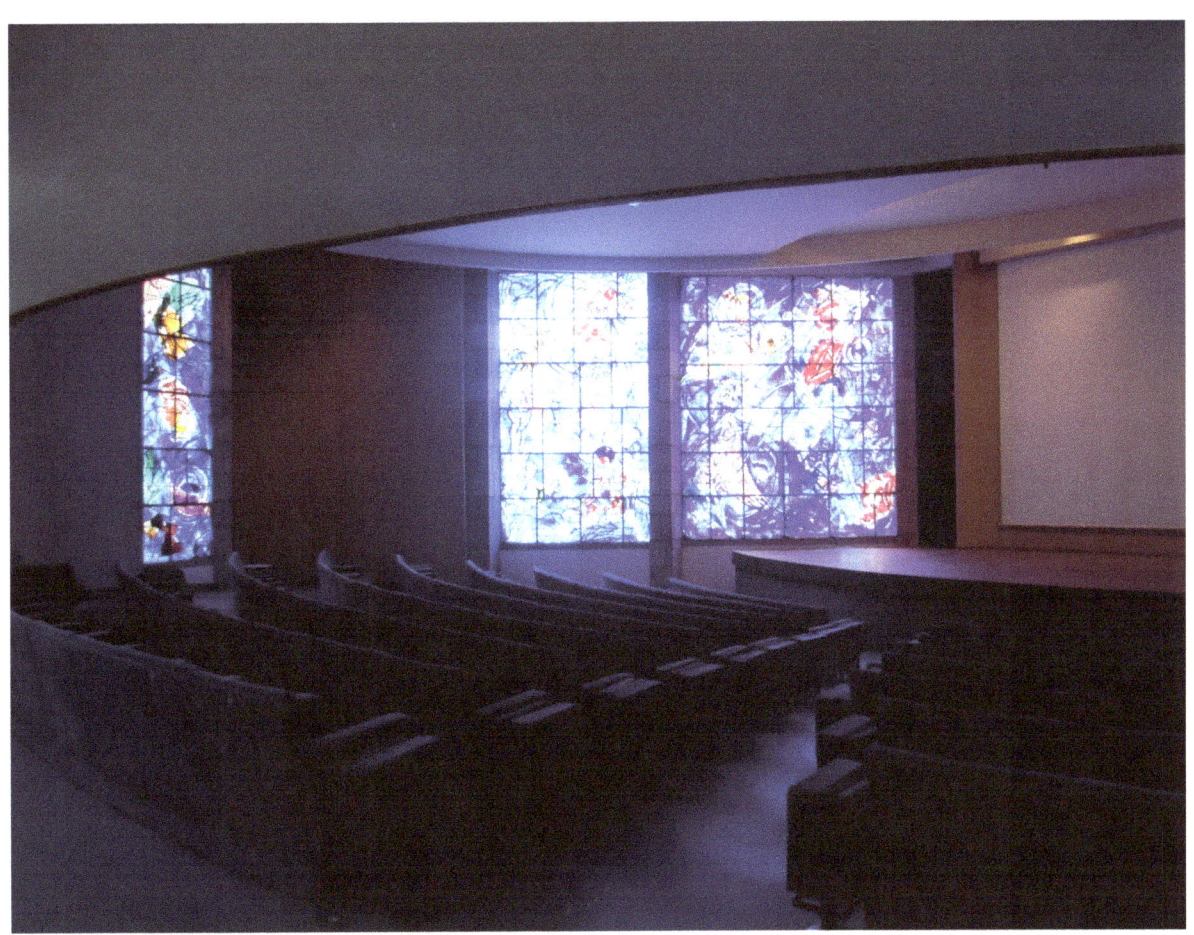

70. *Creation of the World*, 1974
Stained glass triptych
Musee National Marc Chagall, Nice
Photograph: J. A. Swan, 2016

Wullschläger, 2008, p. 510). Wullschläger (2008) suggests that Chagall's Museum of the Biblical message was, "the final, permanent reinvention of *Chagall's Box* fifty years earlier - a set of walls and a stage where he controlled everything" (p. 512). It is accurate, that the spaces share the imprint of Chagall's religious attitude through the creative process. Yet, the implication of a "permanent" *solidification* through the "reinvention" (ibid.) of space challenges the fluidity of a temenos expression: These sites are also connected through the paradigm of continuation. The ongoing creative process of change is reflected in the sites' physical transformation from each site to the next (with the addition of the third site—All Saints' Church—completed in 1985).

The capacity for numinous expression within the memorialized setting of a secular space differs between the first and second Chagallian temenos sites. In the GOSET murals, a temenos structure is achieved through the numinous quality evidenced in the visual repetition of the sacred-secular binary, and through physical immersion into an actively working creative space.

Chagall and Hermant's collaboration on the architectural designs for the Museum of the Biblical Message reflect the sacred-secular binary through a different perspective: The binary re-emerges through the nature of the secular space and the iconic essence of sacred art. The creative re-imagining of architecture and paintings are united through the setting and the purpose of the museum. It is the physical and psychic dimensionality of the paintings, and their capacity for interaction across the collective plane that evokes numinosum. The architectural construction[9] supports the *iconographic* treatment of the paintings. The Whole of this imaginal encounter—between the Artist, the art, and the museum-going audience—is contained from within the purpose-built space that functions to celebrate the religious spirit of the art.

> The icon is a symbol which so participates in the reality which it symbolizes that it is itself worthy of reverence. It is an agent of the real presence. The icon is not a picture to be looked at, but a window through which the unseen world looks through on ours. (Howes, 1992, p. 11)

Chagall's *The Bible* publications (1956, 1964), *The Biblical Message* series of painted images and prints (1951-1969), The Museum of the Biblical Message (1973), and the stained glass commissions of the 1960s, 1970s, and 1980s are together representative of an ongoing transforming visual expression; each, in their own conceptualization and re-imagining, evoke aspects of the Chagallian sacred-secular binary. Through the confluence of religious imagery and the physicality of the architectural site, the expression of the sacred and the secular remains in psychic motion. Each of these 'halves' may be elevated beyond, or descend below, in an exaggerated state phase, during the 'processing' of the unification. It is the collective contact of an audience or parishioners—encountering and re-engaging the imaginal world—that restores, experientially, the sacred-secular binary, to an image of wholeness.

[9] Photographs of the Museum Site, and Interior (PLATES 70, 71, 72, 73, 74, 75)

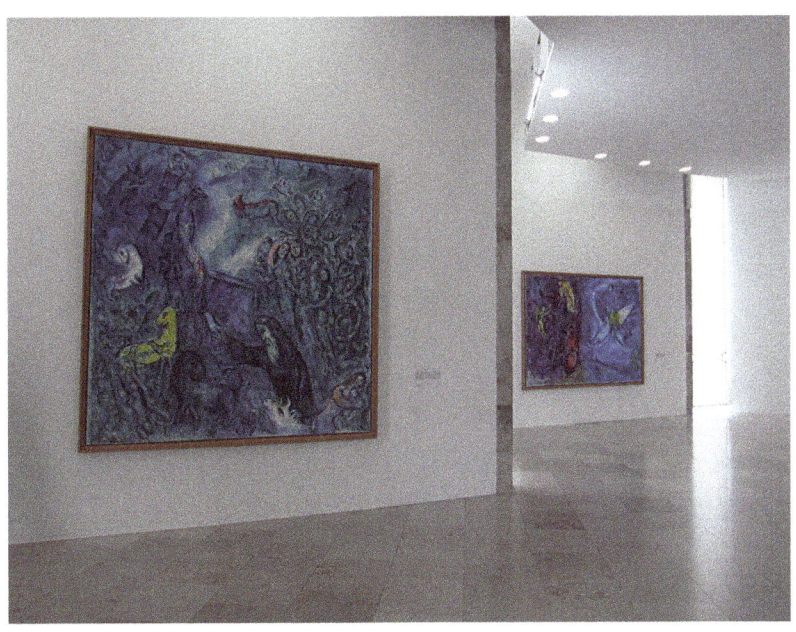

71. Interior photograph of Biblical Message Space with *Noah's Ark*
Musee National Marc Chagall, Nice
Photograph: J. A. Swan, 2016

72. Interior photograph of Biblical Message Space with *Moses Receiving the Ten Commandments*
Musee National Marc Chagall, Nice
Photograph: J. A. Swan, 2016

73. Interior photograph of Biblical Message Space Overlooking the Pool for the external wall mosaic, *The Prophet Elijah*
Musee National Marc Chagall, Nice
Photograph: J. A. Swan, 2016

74. Exterior photograph of museum building and gardens
Musee National Marc Chagall
Photograph: J. A. Swan, 2016

75. Exterior photograph of museum building and entryway
National Musee Marc Chagall, Nice
Photograph: J. A. Swan 2016

76. Steps Pathway, Nice
Photograph: J. A. Swan, 2016

77. *Electrical Notice Sign,* **Nice**
Photograph: J. A. Swan, 2016

THE AGE OF PISCES

Stein's conceptualization (2005, p. 10) of a "third stage" in Later Life transformation occurs "between midlife and old age", and is characterized by a heightened awareness of spiritual matters, as well as the effect of the religious attitude. This phenomena is most significant when making a connection between Chagall and Jung as important 20th Century religious communicators. The observation has been made that, in his *Later Life* stage of development, Chagall communicated his religious thoughts in speeches, lectures, interviews and articles. Collectively, this content emphasises what the Artist perceived as the decline of faith in the middle of the last century, and the continued changes in the cultural experience of religious attitudes in the decades following the Second World War. In the transitional years between the Artist's *Mid-Life* and *Later Life* stages of development, this content is reflected and communicated through the imaginal world in a series of paintings that emphasise a temporal connection to religion.

Time is a River Without Banks (1930-1939) (PLATE 78) was begun prior to the Artist's first trip to Palestine in 1931 and continued to be reworked during the next decade, leading up to the beginning of the Second World War. Meyer (1964) describes the interplay between personal imagery and the symbolic in the painting, stating (1964, p. 379) that the clock is a memory image of a piece that stood in the sitting room of Chagall's family home in Vitebsk. As the focal symbol, the clock transcends to a sacred image through the artist's introduction of the bi-morphic fish motif and the elevation of the conjoined form above the river of *Life Time* (Eliade, 1991). Haggard recounts (1986) a discussion between the couple about a gouache Chagall had created whilst on holiday in St. Jean; it prominently features a fish motif, and she states (p. 128) that Chagall referred to the image as a symbol of Christ[10].

In "The Sign of the Fishes" (*CW 9ii*, pars. 127-161), Jung explores the archetypal emergence of the fish as a sacred image in the millennium before Christianity. In deification, the fish appears in Babylonian (as Oannes), Phoenician (as Decerto-Atargatis), and in Indian (as Manu) pantheons. In the monotheistic tradition, the fish appears in pre-Christian Judaism:

> A fairly old authority which bears striking witness to the antithetical nature of the Fishes is the Talmud… firstly because it takes the battle of the fishes as an eschatological event, and secondly, because it is probably the oldest testimony to the antithetical nature of the fishes. (CW9ii, par.133):

Jung also explores fish symbol as it relates to the Jewish concept of the Messiah. The star of the Christ child has its origin from within the astrological House of Pisces (*CW 9ii*, par. 128). Referring to earlier observations by Meunter and Jerimias (1825) and Abarbanel (1551), Jung explains that in 1396 BC, a conjunction of Saturn and Jupiter took place in Pisces:

10 This association is explored in a 1956 image, a lithographic print, titled, *Christ the Clock* (PLATE 81). Here, the Christ figure's crucified body is combined with the clock pendulum structure (his head is the clock face), and is held within the structure of a clock box. A blue fish overlaps this unified Christ-in-Clock form.

> ...Jewish commentary on Daniel, written in the 14th Century, expected the coming of the messiah in the sign of the fishes... the House of the Fishes is the house of Justice and of brilliant splendor...a great conjunction of Saturn and Jupiter took place in Pisces. These two great planets, are most important for the destiny of the world, and especially for the destiny of the Jews. Abarbanel expects the messiah when there is a conjunction of Jupiter and Saturn in Pisces [and that] Saturn is the star of Israel, and that Jupiter means the "king" (of justice). (*CW 9ii*, par.128)

In Chagall's *Later Life*, (Post-Wars) compositions, the temporality inherent in the collective process of Faith-based transformation reflects, increasingly, through the image of a clock[11] form. In the 1940s,[12] the clock appears inscribed with an hierosgamos couple (and an Orthodox church), in, *Le Matin du Monde* (1948). *Grandfather Clock with a Blue Wing* (1949) (PLATE 79) re-imagines the hierosgamos couple with Ezekiel. A Madonna-Child coupling and ritual sacrifice appear in *New Year's Eve* (1950-51), completed during the linear *year of transition* between his *Mid-Life* and *Later Life*.

> For religious man of the archaic cultures, *the world is renewed annually*; in other words, *with each new year it recovers* its sanctity; the sanctity it that it possessed when it came from the Creator's hands... *before a thing exists, its particular time could not exist*. Before the cosmos came into existence, there was no cosmic time. (Eliade, 1987, p. 75-6)

The clock compositions of the late 1940s and 1950s—the transitional years between the artist's *Middle* (1923-1951) and *Later Life* (1952-1985)—are significant for the physical emergence of the crucified Christ figure within the composition. The treatment of form in *Self Portrait with Clock* (1947), and later, *Christ with Wall Clock* (1956) emphasizes the temporal contact with the Divine through the anthropomorphizing features of the human hand. In *The Bible* series of lithographs, a similar hand appears reaching down from the heavens: In her analysis of the Biblical series, Pacoud-Reme (2011) observes that, "God never appears in any of these images, but is evoked by arms reaching out of clouds" (p. 34).

Such connection through image to the collective life current indicates not only the Artist's understanding of changes within individual lifetime, but also reveals an intuitive visual commentary upon the continuing shift in the contemporary spiritual paradigm (*see* Heelas & Woodhead, 2005; Main, 2004; Tacey, 2002, 2004), from a model based in organised faith, to a personal sense of secular spirituality that would, following the Artist's death in 1985, continue to emerge.

In his 1963 speech delivered at the *Centre for Human Understanding*, University of Chicago, Chagall observes:

11 The initial emergence of the clock form was in, *The Clock* (1914), during a transitional time between Chagall's early Paris years, and his return to Russia, in 1914.

12 A transformative 'imaginal bridge' is formed between *The Clock* (1914), Chagall's Self-portraiture, and the Green Christ, in *Self Portrait with Clock*, 1947 (PLATE 80).

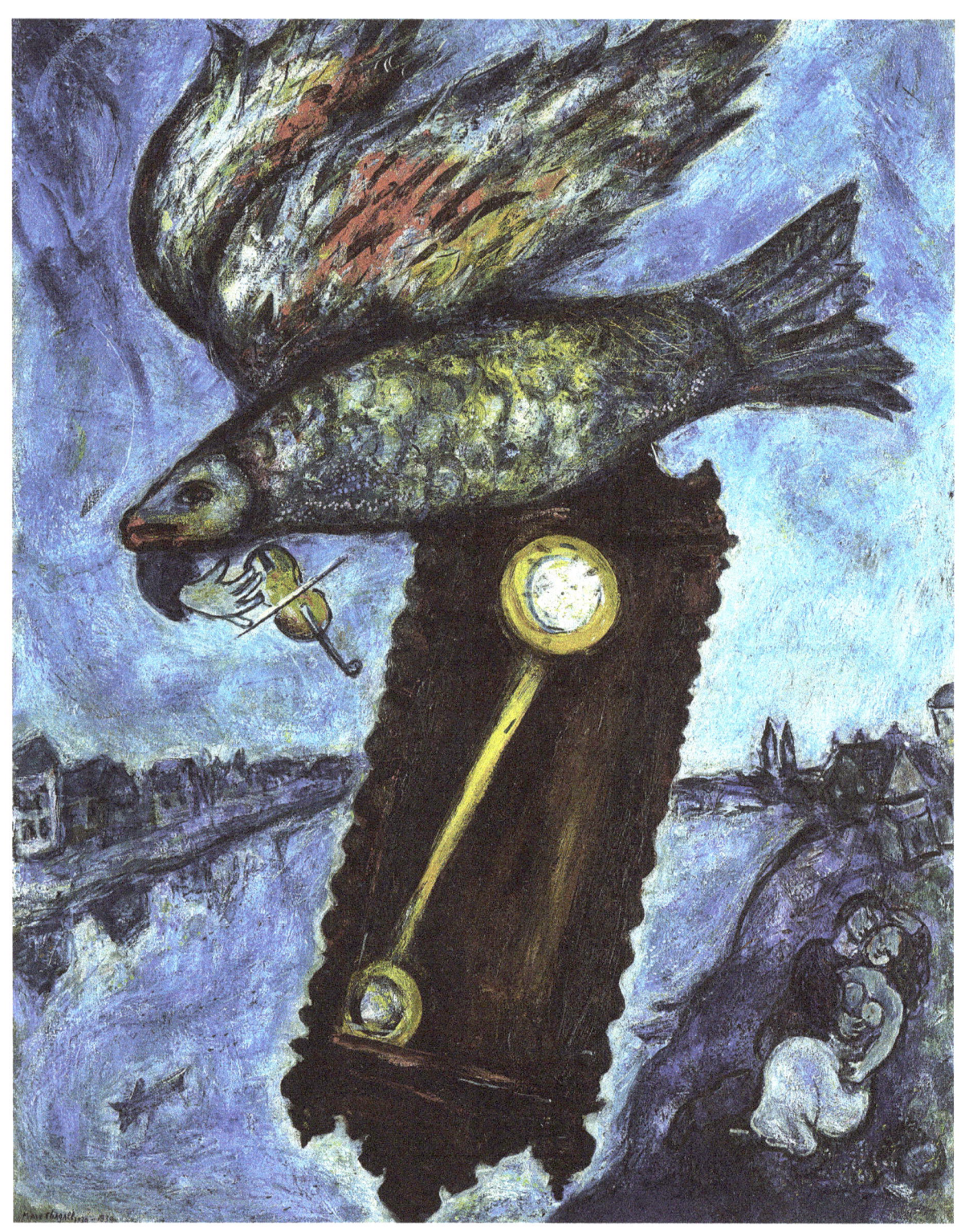

78. *Time is a River Without Banks*, 1930-1939
Oil on canvas, 100 x 81.3 cm
Private Collection

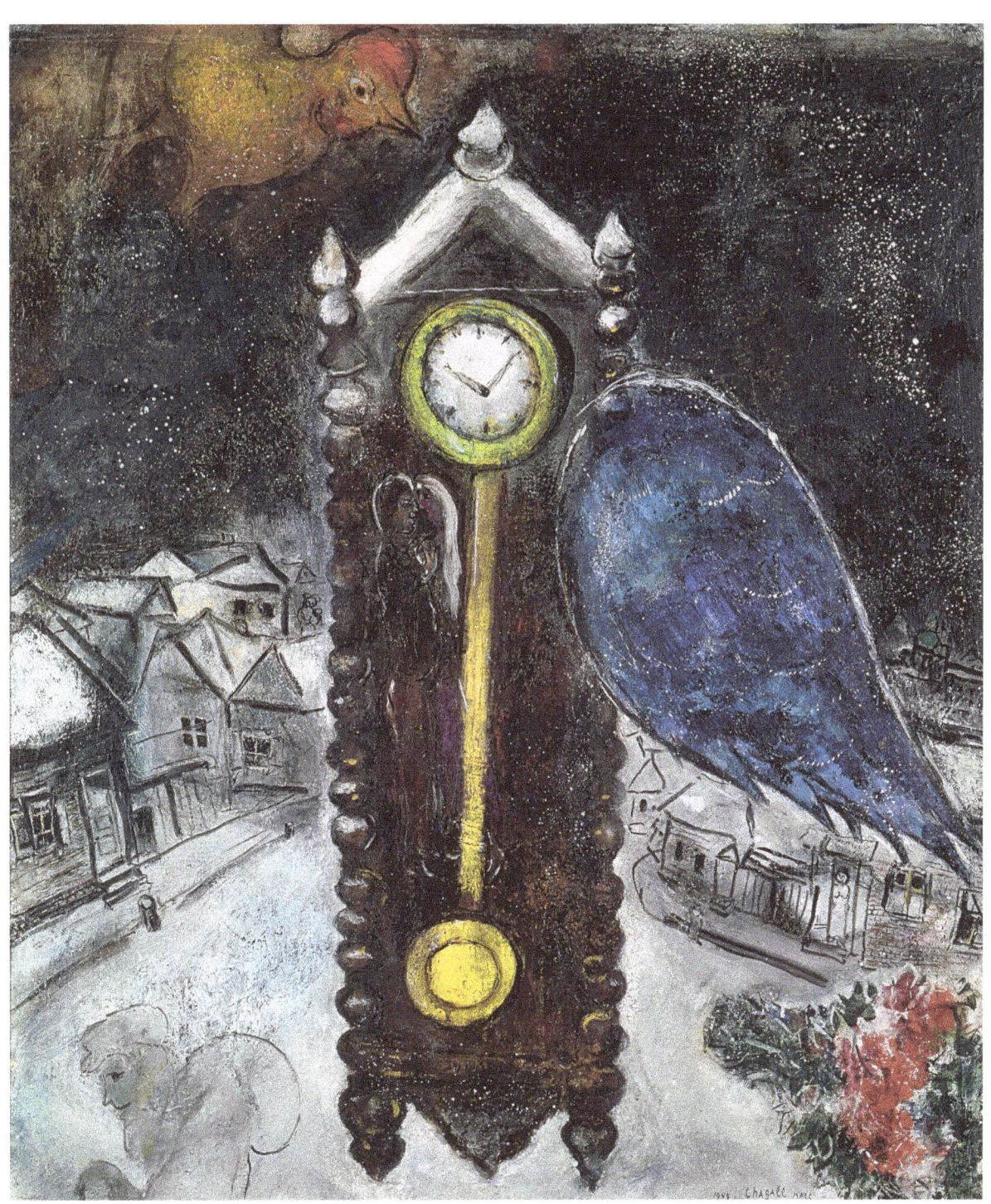

79. *Grandfather Clock with Blue Wing*, 1949
Oil on canvas, 92 x 79 cm
Private Collection

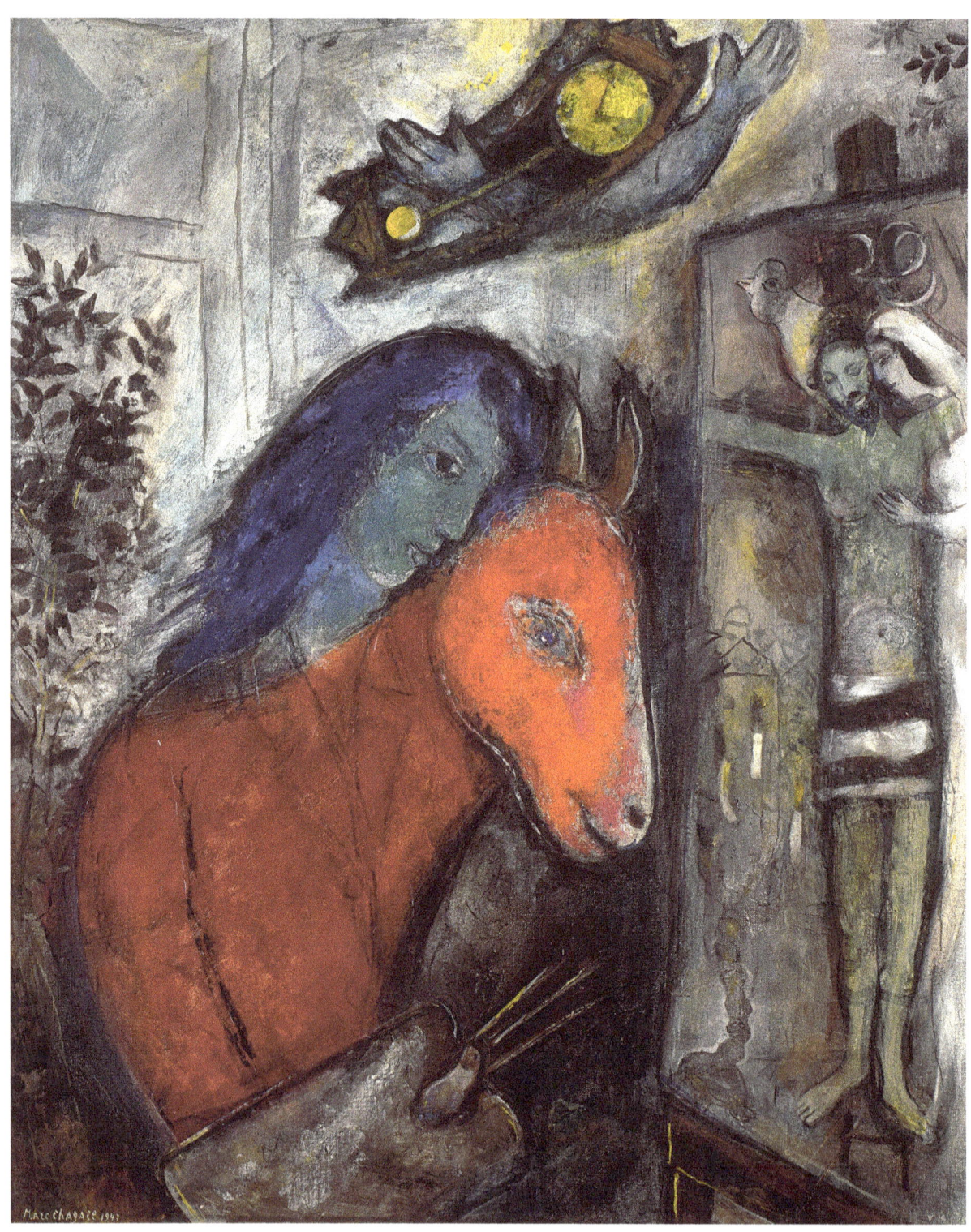

80. *Self Portrait with Clock*, 1947
Oil on canvas, 86 x 70.5 cm
Private Collection

For about two thousand years, a reservoir of energy has nourished us, supported us, given us a certain content in life. But in the last century, a crack has opened in that reservoir. And its elements have begun to fall apart. God, perspective, color, the Bible, form, lines, traditions, the so-called humanistic theories, love, loyalty, family, school, education, the Prophets, and Christ himself. (Harshav, 2004, p. 148)

In the same speech, Chagall (1963) suggests that:

> For hundreds and thousands of years, it was morally easier for a man to live. He had this or that moral ground, deeply anchored in himself. His life and his creative activity were the deep and precise result of his world-view…Gradually, however, in the course of time, those old conceptions became powerless to inspire a living breath in people and fill them with an internal life, not only for their creativity, but simply for their life. (Harshav, 2004, p. 147)

Chagall, like Jung, appears to have been aware of *and concerned with*: the rise of "brutality" in the humanity of the post-Christian era (CW5, par.341); the affect and influence of technology upon the religious and creative spirit (CW18: 1403-1407; *Chagall, in,* Harshav, 2003, pp. 130, 137, 148), and the moral composition of *Modern Man* (CW10, pars.148-196).

In "The Spiritual Problem of Modern Man," Jung culminates his observations on the unconscious shift of the personal psyche of 20th Century individuals. He reflects on a directional change of human perspective and self-consciousness: a flow now directed towards an inner orientation, exploring the selfishness of life, in an "unhistorical" (par. 150) approach to individuality, rather than, reacting with and through the collective nature of the universe. Jung views this insularization process as a result of the increasing hostility towards and with the engagement of collective life in the changing external environment (par. 162). Jung makes the point that this critical change in human perspective is omnipresent, yet unable to be detected clearly, as we are in and of this time of change (par. 148). Jung states that artists, and in particular those associated with the Expressionist movement, "prophetically anticipated this subjective development, for all art intuitively apprehends coming changes in the collective unconscious" (par. 167).

Chagall's reflections and creative output during this transitional period reveal a crucial, and intuitive understanding of the implications of Modernization upon the development of the modern psyche; and, as a religious artist, the effect of such a shift in human perspective upon the creative spirit in an environment of collective spiritual change.

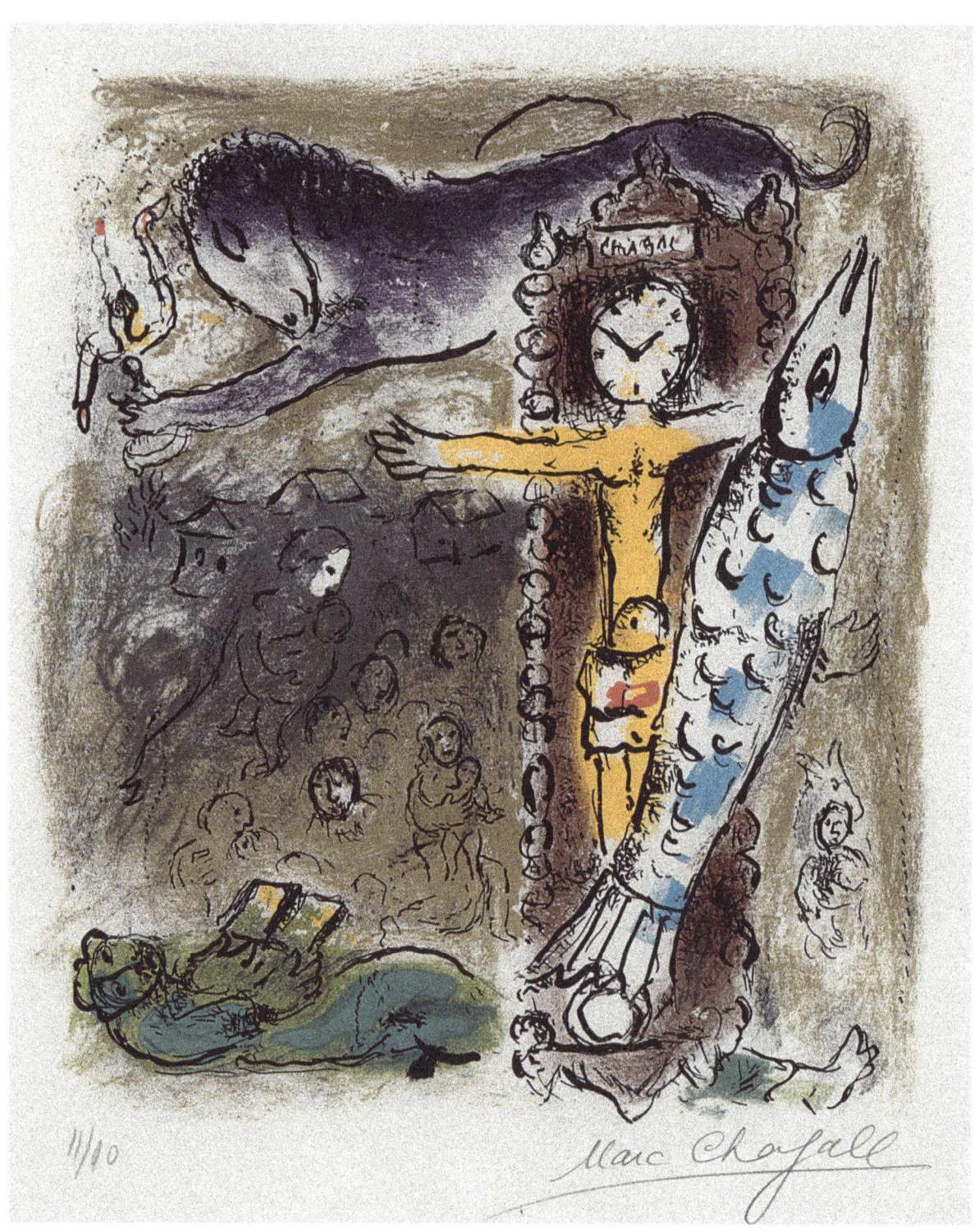

81. *Christ the Clock*, 1957
Lithograph, 48cm x 38cm
Musee National Marc Chagall, Nice

INTO THE WINDOW

In her memoir, *Seven Years of Plenty*, Virginia Haggard (1986) chose to include a series of photographs taken of Chagall in 1951 at his home, *Les Collines*, St. Paul-de-Vence, France, just prior to the ending of their relationship. 1951-1952 is a transitional year between the ending of the Artist's *Mid-Life* (1923-1951) and the start of the *Later Life* (1952-1985) stage of development. Art history scholarship has demonstrated that Chagall's working materials and creative output changed dramatically between the second and third stages of his professional career, from two-dimensional canvases to stained glass commissions in sacred sites of worship. In one photograph from that period, Chagall stands with his paintbrushes in hand, in front of the light of an open studio window. *King David* (1951), the first monumental painting of his post-war Biblical Series, rests against his easel[13]. This portrait of Chagall, who was then sixty-four years of age, is remarkable for the visual tension between the intimate tone of the creative setting, the wall of windows, and the form of *King David* (198cm x 133cm) dominating the photographic compositional space. What is equally remarkable is that Chagall would continue from this point in his life to transform as an artist and as an individual for a further three decades. This *Later Life* stage of development is characterised by the external increase in sacred monumental works and the heightening of the Artist's religious attitude. It is a photograph of endings and beginnings.

In technical craft, Chagall had utilised oversized canvases since the initiation of his professional career. As early as 1911, the trio of critically reviewed works[14] that introduced Chagall to the reception of the Parisian Modernist community were each executed in a larger-than-life format. This technical skill for translating image into large format paintings was exceeded by set design commissions for the theatre and performing arts in each of the three periods of Chagall's professional career. The 1920-21 murals and set designs for the Russian theatre ('Terevsat and GOSET) were paintings executed on bolts of canvas. In America (1941-1949), Chagall accepted two commissions for the American Ballet Theatre dance productions, the elaborate set and costume designs of *Aleko* in 1942, and *The Firebird*, in 1945. He again returned to theatrical design for the Metropolitan Opera's 1965 production of *The Magic Flute*.

An intimacy is always present in the relationship between an artist and his working materials. This physical presence and awareness of the creative matter increases proximate to the scale of the project. In the example of oversized or monumental works, the artist is functioning on a visceral plane that requires an increase of bodily immersion into the creative matter. The physicality of the creative experience is magnified through this increase of contact and arguably has a direct impact upon the artist, his working methods, and the product of art. Chagall's creative interest and technical skill in working with monumental projects facilitated the extension of his religious imagery into a three-dimensional experience—of working creatively *within* the transforming space, or temenos.

13 The series of photographs appear, in Kagan (1989), and include images taken from another perspective of the studio space, wherein the painting of *King David* (PLATE 68) is clearly visible.

14 *Others To Russia, Asses, and Others* (1911) (PLATE 23), *Dedicated to my Fiancée* (1911)(PLATE 27), and *Calvary* (1912) (COVER)

82. *Untitled* (Chagall in his studio, Vence, 1950's)
Photograph
Credit: © Russian Look / Heritage-Images

ALL SAINTS', TUDELEY

In 1965, Chagall was approached with a proposal for a stained glass window commission in a rural English church (Foster, 2004). The d'Avigdor-Goldsmid family, landowners in south-eastern England since the 19th Century, were intent on commemorating their daughter, Sarah Venetia d'Avigdor-Goldsmid, who died tragically as a young woman of twenty-one years, in a 1963 sailing accident (Foster, 2004; Neervoort-Moore, 2014).The family sought to utilise a familiar space which emphasised their connections to the land and rural community—as well as Lady Sarah's admiration of Chagall as a glass artist[15]—through requesting the installation of a memorial window at the local Anglican parish church where their family worshipped[16] (ibid.).

Chagall agreed to the commission of the memorial window which became his first painted glass installation in England. The *Memorial East Window* (PLATE 83), dedicated to the memory of Lady Sarah d'Avigdor-Goldsmid, was unveiled in its position above the altar place at All Saints' parish in November, 1967 (Foster, 2004). Chagall then continued his creative collaboration with Charles Marq's glass atelier in France, designing a second commission from the d'Avigdor-Goldsmid family to include the remaining eleven windows in the church. These windows were subsequently installed in two phases: Seven windows in the north aisle and nave were completed in 1974, and the final installation of the four chancel windows, paired on either side of the *Memorial East* altar window, in 1985 (Foster, 2004, Neervoort-Moore, 2014).

Between 1974 and 1985, the All Saints' parish and the Tudeley, Kent community was engaged in a tentative discourse with the d'Avigdor-Goldsmid family concerning the four remaining chancel windows. These were created locally by the English glass artist Mabel Boscawen in 1875 and depict the four Evangelists (ibid.). Legitimate concerns raised by the Tudeley parishioners included the thought that replacing such historic windows with glass work from a world-famous artist had the potential to create a secularized tourist destination or art gallery in what was a living parish church community[17] (ibid). Opponents to the project also argued that with Chagall's installation, the chancel—and by extension complete the entire church—would resonate as a memorial space to one single individual (ibid.).

All Saints' church is located to the south of central London, in rural Kent, on a plot of land that has been used as a site of worship since the Saxon period[18] (Neervoort-Moore, 2014). The present church complex includes a prayer labyrinth encircled by a grove of pine trees, and a parish cemetery crowded with headstones in various stages of weather. At the rear of the church grounds beyond the cemetery, a countryside

15 In 1961, Sarah had travelled to Paris to view an exhibition about Chagall's glass commission (1960-62), for the Hadassah Hebrew University Medical Centre synagogue windows (Foster, 2004, p. 29).

16 Sarah's father, Sir Henry d'Avigdor-Goldsmid, was a Jewish man, and his wife, a practising Anglican. Both of their children were raised in the tradition of the Church of England, and worshipped at All Saints' church. (Neervoort-Moore, 2014, p. 31)

17 Foster (2004) states, "The parish, at least a significant majority, objected because they saw the proposed completion of the scheme as the final act in a campaign aimed at forcing the exchange of their [church] for what would virtually become a private memorial chapel and a site for international tourism" (p. 33). Neervoort-Moore (2014) reflects, "there is a fine line between appreciation of a building as a place of worship and a building viewed perhaps more as an art gallery, and this was an impediment upon which many sensitivities were bruised (p. 33).

18 The Tudeley site is listed in the *Doomsday Book* of 1080 (Neervoort-Moore, 2014, pp. 6,8)

view includes cultivated fields, staggered farm buildings, and a stream-boundary area marking the remains of a pre-Roman iron foundry that continued as Tudeley Forge until the 16th Century (ibid). The stone foundation of the current All Saints' church structure dates from the Late Saxon Period (c. 1000) and the single-story, open-plan interior is fortified with what remains of a medieval wall and 18th Century tower (ibid.). Following periods of disrepair in the 17th Century, significant restoration works and changes to the architecture of the building were initiated in the late 18th and 19th centuries.

In 1966, the church building underwent its most recent restoration and renovation project with the transformation of the space to accommodate the Chagall-d'Avigdor-Goldsmid memorial glass commission. All Saints' is currently an active place of Anglican worship[19] and parishioners in Tudeley have a unique setting to celebrate their faith, the only church in the world which is illuminated in its entirety through stained glass windows designed by Marc Chagall. Of the glass window commissions for Houses of Worship completed by Chagall between 1956 and 1985, the *Memorial East* window (1967) of All Saints' Church is the only to combine the memorialized image of a secular individual within a sacred architectural setting.[20] The church of All Saints', Tudeley is observed as Chagall's final and culminating work of monumental religious art, exemplifying the unification of the sacred-secular binary, and representing the third stage of transformation in the Chagallian Temenos Sites.

Foster (2004, pp. 30-1) remarks upon Chagall's initial reluctance to become involved with the project, citing the Artist's significant professional commitments to his monumental works of the *Later Life* period. Such reluctance was not without thought if the circumstances surrounding the initiation of the request are considered. The origin of the commission represented a situation that Chagall understood intimately having lost his first wife to tragic circumstances in 1944. In 1966, Chagall accepted the commission, and the resulting transformation of the All Saints' church interior (1965-1985) has created a unique spiritual setting to celebrate the sacredness of life, death, and rebirth.

19 Under the Local Ecumenical Partnership of The Church of England and The United Reformed Church

20 In 1964, Chagall created the 'Peace' memorial glass, in memory of Dag Hammarskjold, for the United Nations building in New York City. This installation shares with the Tudeley memorial window, among other commissions, the crucifixion motif, as well as the compositional use of blue glass.

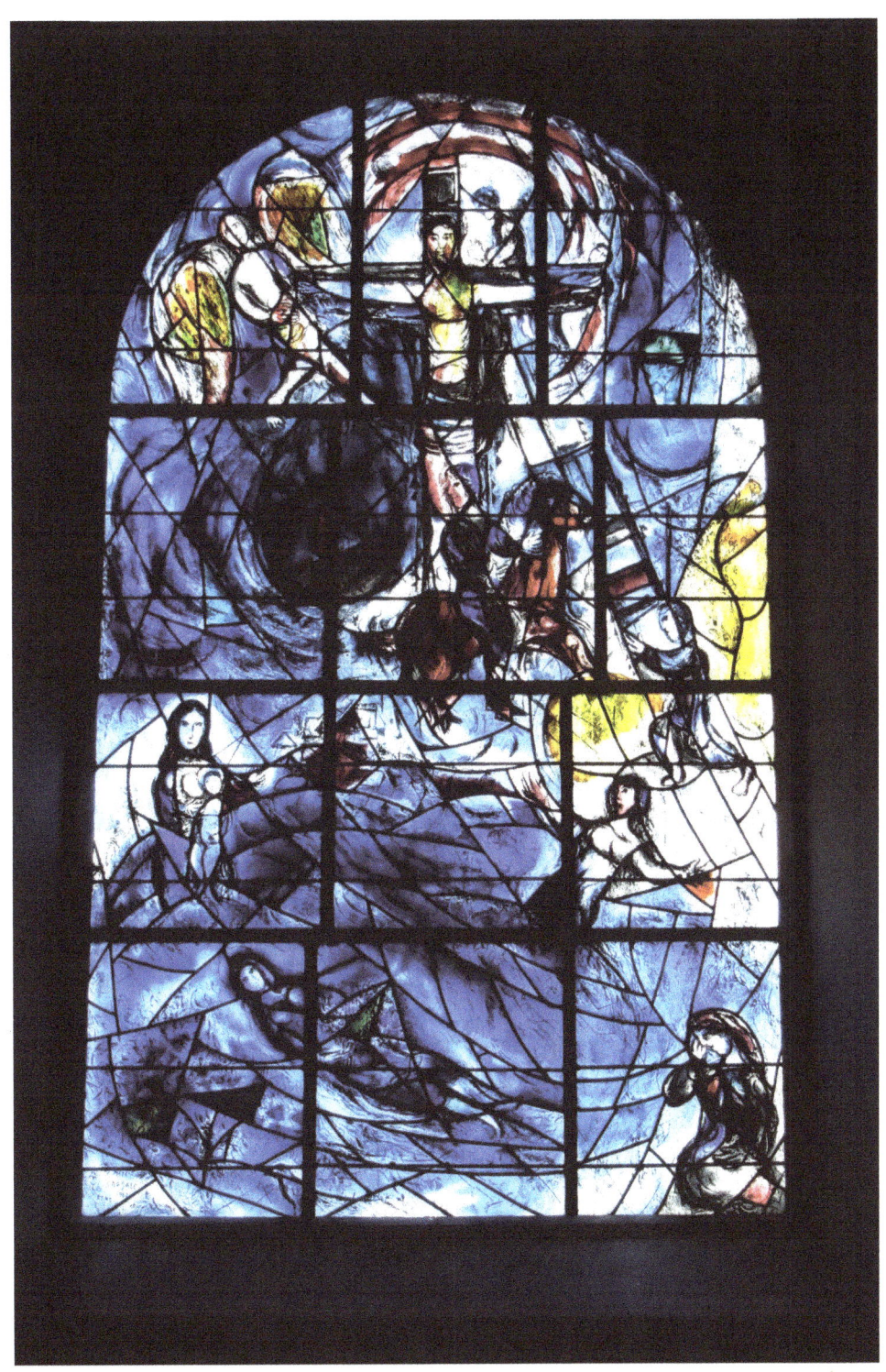

83. *Memorial East Window*, 1967
Stained glass
Church of All Saints', Tudeley, Kent, England
Photograph: © J. A. Swan, 2010

THROUGH THE GLASS

Chagall's creative response to the commemorative element of the commission includes both a literal and metaphorical interpretation of Sarah's story. The *Memorial East* window prominently features the image etched into glass[21] of the drowning event, with Sarah surrounded in the water by female figures who at once reference her family, and the cycle of her life. This secular death scene is juxtaposed with the familiarity of the redemptive Christ figure on the cross. A ladder form bridges the two vignettes using Sarah's figure. She appears partially submerged in the water and rises in full form upon the connecting ladder in her cyclical ascension towards the crucified Christ.

> In describing his work [for Tudeley], Chagall has insisted that his Christ – although portrayed on a cross – is Christ the radiant and personable young man in whose company young people delight. He and his attendant angel stand for the healing power of love and the assurances that our earthly misfortunes do not pass unrecorded. (Tudeley Church, *Historical Notes*, 2008, p. 3)

Until 2012, I lived a short distance from the All Saints' church, and have visited the site on different occasions and in all seasons. The church complex is found on a rural road in a quiet countryside location. Concerns that the site may have become a popular tourist destination are still unfounded. On one visit to the complex, in 2010, a cloth embroidered in both Hebrew and English lettering was lain on the altar beneath the *Memorial East* Window. The unanticipated encounter with the expression of this living image was remarkable: An imaginal form had emerged from within the space of Chagall's three-dimensional painted church, and re-imagined the Artist's technique of writing into his paintings. At the All Saints' site, Chagall's belief in the universality of religion had been elevated to the physical dimension of sacred life:

> The text [on the *Frontal for Ordinary Time*] draws equally on the Jewish and Christian background…[it] is the Jewish call to prayer, the Shema ("hear"). It was quoted by Jesus, who linked two separate commands in the laws of Moses, one from Deuteronomy and the other from Leviticus, to précis the Ten Commandments…The spiral indicates that it all takes its source in the central call of Jesus… It also shows how our obedience to God needs to flow out of the Whole of life. (Ive & Frances, 2016, www.tudeley.org/altarfrontal.html)

The Chagallian Temenos Sites function through the reception and presence of human life. This introduction of the corporeal *into* a functional ritual space provides the conditions for archetypal emergence. What differs in the temenos at Tudeley is the religious quality that is also expressed from within the creative use of building materials. All Saints' is a purpose-built structure wherein the glass of the windows relates as much to the process of ritual as it does to the containment of ritual space.

21 Charles Marq utilised an acid-etching technique, "in order to exactly match the varying shades and tones of the colors in Chagall's sketches. Marq made great use of clear glass, for as he explained, it is the light which makes the colors live." (Neervoort-Moore, 2014, p. 38)

The *Memorial East* window is the most prominent visual feature in the church interior. It is installed in its position above the altar place and extends the height of the eastern wall. Inside the window, Chagall's visual depiction of Lady Sarah drowning is an emotive scene. Death here is not hidden from the viewer's gaze or dissolved within a purely symbolic visual interpretation of the facts. The symbolism in the work appears through the cyclical implication present in Chagall's visual depiction of Lady Sarah's death, resurrection, and rebirth. This visual cycling, through a series of symbolic processes, is reinforced by the appearance of the redemptive Christ figure and cross.

The tension between this living memorial, and the allegorical Passion cycle is surmised in Sister Wendy Becket's (2010) observations concerning the ability of visual artists (here, Norman Adams' *Golden Crucifixion*, 1993) to effectively depict the numinous features of the Resurrection:

> The crucifixion is not the central teaching of the Christian Faith. The centre of the Faith is the Resurrection. This is not apparent visually, because it is the cross that is the ubiquitous sign of the Church, and we can realise why. Death, even as horrible a death as crucifixion, is something we can understand, whereas resurrection is not. We know that Christ rose, but we cannot imagine how. But since crucifixion is merely a prologue to the glory of resurrection, it is the greatest joy to find an artist who can actually make both prologue and climax simultaneously visible. (p. 61)

THE WOMAN OF TUDELEY

In the collection of the Artist's preliminary works on paper for the All Saints' Tudeley commission (1966-85), is a colorful untitled gouache (c. 1966) of a young woman with dark hair, in a white dress. She is standing in front of a circle of light that appears similar to a sun. The circular form appears elsewhere in Chagall's preliminary images of his creative design for the commission. It also appears in a number of his paintings, and especially, during his *Later Life* stage of development.

Of the preliminary images that Chagall painted of Sarah, this was the only in which her figure appears in full form as the focus of the composition. The presence and relevance of this image seems remarkable in the context of the *Memorial East* window design that Chagall eventually installed into the church.

Neumann (1959, 1979) and Meyer (1964) have both observed the presence of the sacred feminine as it relates to Chagall's natal faith and the deeper influence of ancient religion. Although I have mentioned the historic appearance of Chagall's circular forms or 'color disks' elsewhere in this study related to the alchemical 'egg', the relevance of their appearance is amplified in this story of the Memorial Window. The argument here is not about the image, nor the telling of the imagery, but the fact that Chagall did not use this particular re-imagining of figurative design to communicate his sense of 'memorialization' within the Tudeley site. One perspective, is that the fully represented figurative form would have changed the meaning of the window imagery: The transformed, or resurrected figure, is no longer actively moving through the process of

sacred change. This motion is essential for the achievement of spiritual Wholeness. Sister Wendy Becket (2010) observed that the resurrection cycle is the most challenging aspect of *The Art of Christ* to depict visually.

In the Tudeley commission, Chagall has communicated with his imagery that *the cycle itself* is as important as the outcome. This depiction suggests that the Artist's Understanding of this cycle is present: In his final re-imagining of Sarah's form, in, *The Memorial East Window* (1967), the secular life of a human being is depicted processing through the sacred state of Resurrection. The Self-reflective element of this transforming process is reinforced through Chagall's re-imagining of the redemptive Christ figure. At All Saints' Church, Chagall's Christ memorializes the sacred space with a collective purpose, an imaginal recycling of Life, in the encounter of Sarah's image, *through the window*[22]

[22] In the photographs of the All Saints' Church site included here, there are three interior pictures of the church space. These photographs were taken on the same afternoon in October, 2010, with a digital camera using the available natural low lighting characteristic of many old churches. The photos were provided to the publisher, unretouched, as were all images of buildings' interiors that appear in this study.

84. Exterior of Church with *Memorial East Window*, 1967
Church of All Saints', Tudeley, Kent, England
Photograph: J. A. Swan, 2010

85. Exterior of Church site with Prayer Labyrinth
Church of All Saints', Tudeley, Kent, England
Photograph: J. Swan, 2010

**86. Interior of Church building
with window in south nave wall**
Church of All Saints', Tudeley, Kent, England
Photograph: J. A. Swan, 2010

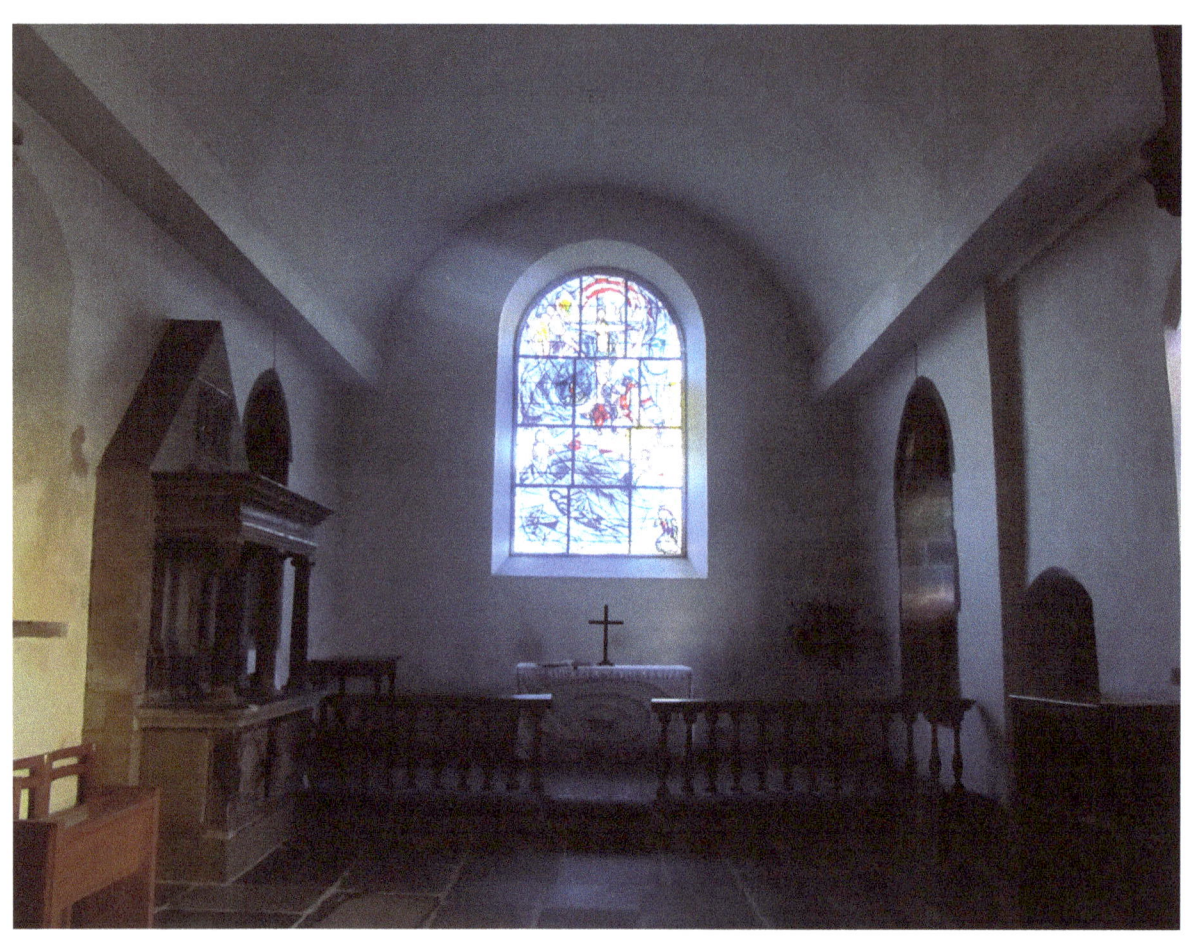

87. Interior of Church building with *Memorial East Window*, 1967
Church of All Saints, Tudeley, Kent, England
Photograph: J.A. Swan, 2010

88. *Frontal for Ordinary Time*, 2005
Dedicated on Trinity Sunday, 22nd May, 2005
Church of All Saints', Tudeley, Kent, England
Photograph: J. A. Swan, 2010

6. A RELIGIOUS ARTIST

Every creative person is a duality or a synthesis of contradictory aptitudes. On the one side he is a human being with a personal life, while on the other side he is an impersonal, creative process. Since as a human being he may be sound or morbid, we must look at his psychic make-up to find the determinants of his personality. But we can only understand him in his capacity as an artist by looking at his creative achievements. (CW 15, par. 101)

At the centre of this story is an artist, Marc Chagall, who for nearly a century created a unique style of art that is characterised foremost by the use of religious imagery and themes. Until quite recently, the History of 20th Century Art has emphasised the categorisation of Chagall as a *Modernist* painter. Chagall's own reflections reveal that he was creatively transformed by his experience of the Parisian Modernist movement during his initial years in the French capital. Stylistically, Chagall experimented with Cubism and Orphism[1] as well as the sacred-*into*-secular religious motifs that featured in the early Modernist aesthetic. The most important exhibition of his Early

1 The artists Robert Delaunay (1885-1941) and Sonia Delaunay-Terk (1885-1979), the co-founders of Orphism, were close friends of Chagall during his 1910-1914 Parisian years. Sonia Delaunay-Terk was a Jewish woman who had, like Chagall, been born in the Pale of Settlement (now Ukraine) and had immigrated to Paris in 1905.

Life (1887-1922), his first one-man show at *Der Sturm* Gallery, Berlin, in the summer of 1914, was directly facilitated through his professional contact with the Parisian Modernist community. Reviews of this show indicate Chagall's creative output was well-received by critical observers during what is perhaps the most significant period of change in the History of Western Art, since the Renaissance.

In 1912, Chagall's own emerging style was pre-emptively deemed *surnaturel* by the Parisian art critic and poet Guillaume Apollinaire (1880-1918). This stylistic observation pre-dates the Surrealist movement of the 1920s by more than a decade and suggests that Chagall was, at the least, a known professional figure—if not an influential artist—to Andre Breton and the Surrealist circle[2]. Professional identification with one particular artistic movement or group was, however, repeatedly dismissed by Chagall, who chose to maintain an independence of creative perspective throughout his career.

In contemporary thought, the art history community—and by extension the general public—has continued to refer to Chagall's natal faith and cultural upbringing as an Hasidic Jewish man in the Pale Settlement of Russia to discuss the derivation and inspiration of his creative output. Since the Artist's death in 1985, a small number of 21st Century art historians and biographers have sought to redress this labelling in two distinct ways: Through introducing the historic and social underpinnings of Chagall's migratory life and multicultural identity; and, through expanding the significance of Chagall's oeuvre with the observation that Chagall was a 20th Century Religious artist whose work reflects both his early exposure to organised faith and the universality inherent in his life-long interest in Biblical themes.

This book compliments and extends the scholarship surrounding Chagall's place in the History of 20th Century Art as a Religious artist. The challenge to Chagall's art historical identification as a secular Modernist is supported by my argument that delineates the sacred-into-secular aesthetic from the *Chagallian sacred-secular binary* of the Artist's own religious paintings. I observed that Chagall's particular use of religious imagery during his 1911-1914 Parisian period (*Paris I*) differs from that of the Modernists' use of sacred-*into*-secular motifs. Evidence is provided that Chagall's experimentation with sacred imagery pre-dates his initial Parisian years with themes first emerging in *1908* (i.e., *The Holy Family series*, 1908-10, and the crucifixion sketchbook illustrations and poetry of his earliest years in Russia) whilst still an arts student in St. Petersburg. That the permissive Parisian environment contributed to—if not facilitated—Chagall's continued exploration of sacred themes remains an agreed upon position.

A new perspective on Chagall's creative output during his *Paris I* (1911-1914) period is presented through the application of Jungian theory: Chagall's religious-themed paintings are a definitive group in their collective expression of archetypal emergence. These images of transmorphic beings, hermaphrodites, and the Crucifixion evoke the numinosum and exemplify

[2] Haggard (1986, p. 36) has stated that Chagall became acquainted with Andre Breton during their years in American exile. Breton had written about Chagall in a publication, "in which Breton stated that Dada and the surrealist movements had underrated the importance of Chagall" (ibid.).

the balancing process of a binary representation through imagery consistent with the concept of Wholeness. I have termed this observation found within Chagall's religious work the *sacred-secular binary model of Chagallian art*.

Chagall's creative contribution as a Religious artist is expanded through the introduction of Jung's theory of religion. Jung identifies a separation between the cultural and historical underpinnings of natal faith, or creed, and the presence of an internal, personal spirituality, or religious attitude. This theoretical approach helps to define Chagall's creative connection to his own natal Hasidic faith whilst clarifying the interiority of his religious experiences as they resonate through numinous encounters with sacred sites and rituals.

The idea that Chagall's individuation development across the whole of his lifespan may be explored through the visual emergence of sacred transformative imagery is a new concept in Chagallian scholarship[3]. An analysis of Chagall's historical and biographical life, and the Artist's primary source materials, indicate that during periods of critical change the patterns of visual emergence and symbolic re-appearances increase. That these transformative images reflect content consistent with ancient mythology and contemporary faiths—zoomorphic, transmorphic, and anthropomorphic beings, hermaphroditic figures, the sacred feminine, Christ and the Passion—reinforces the religious nature of Chagall's creative expression and furthers the evidence supporting the nature of archetypal emergence.

This is the first comprehensive study of Chagall that explores his images of Christ and the crucifixion theme using Jung's theory of archetypes and the alchemical metaphor. Jungian thought has illuminated this challenging and oft-debated aspect within Chagall's oeuvre (i.e., a Jewish man making Christian art) by elevating the imagery to an archetypal level of reading. This approach emphasizes the analogy expressed between the emergence of Christ as a transformative image indicative of individuation development and Chagall's depiction of his adult imago as Christ in his self-portraiture.

In developing the features of Chagall's individuation process from a religious perspective, the argument is presented that the Artist experienced a psychic re-orientation *away* from the organized underpinnings of his natal Hasidic faith *towards* an increasingly universalistic appreciation of religion or a religious attitude. This observation is supported by the Artist's writing and the visual transformation of Chagall's oeuvre, which evolved cyclically: From the expression of secular, to sacred-secular imagery in the Early (1887-1922) and Mid-Life (1923-1952) stages of development, to the sacred images that appear in houses of

[3] It is my hope that studies such as this will continue to encourage scholarship that looks further into the *Wholistic* experience of Art: The psychic spirit of creativity, and the ways creative output and the imaginal reference both individual and collective development across lifespan—and in Life, generally. One of the ideas mentioned to me in the course of this research process, is the thought that Chagall is a Jungian artist. I have not stated this thought directly in my study, but will put forward some thoughts here: There are few artists in the 20th Century History of art that were as prolific—in both visual art and writing—or as well-received in the popular sense, as Chagall. Communicating images and his ideas about Faith, religion, and the creative spirit he experienced was an important aspect in the Artist's life development as a human being. He created visual spaces and places that connected to individuals, and across cultures and Faiths, universally. Forming connections to a particular type of art, or to a particular artist, has an element of numinosity and a psychic imprint through the understanding of a shared image, or set of images. As mentioned in the Introduction, such collective imaginal connection is found within Jungian territory; I do not think it assuming to suggest that Chagall and Jung had much in common in their respective lives as important religious communicators. I would say that they shared the same vista of collective life through their own unique windows.

worship during his Later Life (1953-1985). A new concept emerges from this data, the trio[4] of *Chagallian Temenos Sites*: the GOSET Theatre in Moscow, the Museum of the Biblical Message in Nice, and All Saints' Church in Tudeley, England. These sites are defined and compared to reveal this cyclical progression of creative output as it relates to and corresponds with Chagall's use of the sacred-secular binary.

TOWARDS AN OTHER LIGHT

Whenever possible, biographical details about Chagall *the human being* were presented in the writing to tell the story of the Artist's life within his process of making art. Here, I would like to finish Chagall's story with a reflection about the research process and the ending of the Artist's career and lifespan.

Much of this book concerns the psychic process of individuation and the way in which images appear to depict the deeper changes in our human existence. I have written about the start of Chagall's career as a painter and how his work transformed through materials and imagery to reveal his interior connection to religion. In this study of Chagall, it was important to me to focus on the Whole of the creative life experience. This meant examining not only who he was culturally and biographically, and what type of artist or creative group Chagall was associated with, but also, critically, the life rhythm he led and followed: His physical movements and creative motion, within Russia, and across Europe; his time spent in the United States as a religious refugee and his slowing down; and finally, his stopping to make his final permanent home in France, where he settled in 1952, at sixty-five years of age for the last three decades of his lifetime.

This personal external path of change was remarkable, *particularly when one considers such practical aspects of change* as movement between places and within a variety of spaces, across cultures in different countries and continents—underscored by the marked difference from today, in the experience of travel and the technology of transportation. The practical considerations of re-homing a studio space, re-establishing a creative environment to support the work, re-organizing art materials, books, travelling with or shipping abroad completed canvases—many of these works being more than a meter in dimension. The acclimating and re-acclimating oneself to different cultures, languages, and perceptions of Time. Living without what is familiar, even, without what or whom you Love. Chagall was accomplished in his rhythm, and it is significant that he continued to work professionally and continued to grow and thrive as a creative individual throughout such changes.

What surprised me perhaps the most in this research process, was the prolific nature of Chagall's writing: personal letters, professional papers, speeches, journal articles, educational proposals, and an autobiography. And as such, I have considered foremost Chagall's voice, the words he used to express his thoughts, his beliefs, his feelings on life as a creative individual in the 20th Century. It is clear from his reflections—which,

4 I have explored these three sites as they together form a visual reflection of a cycle that is both literally, and metaphorically, able to be clarified by imaginal resonance. This is not to say, however, that these are the only Chagallian Temenos sites. I believe argument can be made that such an encounter or immersion may present in any or all of the places where one has the possibility of connecting to the sacred through Chagall's imaginal expression. The experience of a temenos site is not a definitive construct. We are moved in different spiritual ways both individually and collectively, and our personal contact experience with the imaginal world remains a subjective phenomenon.

whilst at times are direct and certainly subjective—that he nevertheless remained a positive human being and positive about moving forward with the role that the international public, by the 1930s, had given him as a famous artist. And always, he placed emphasis upon the importance of making art with a universal level of appreciation, not for one Movement, nor for one culture or faith, nor one group of collectors or admirers. In his writing, the most important psychic connection I found was the way in which he experienced religion. He was stimulated and motivated to create art through his connection to religion.

Chagall's last image was a self-portrait[5]. He painted the image of himself upon his self-proclaimed talisman, a lithographic plate. The title of that print is *Towards an Other Light* (1985). I have often thought of whether Chagall was aware of his fate: He passed away the day following the creation of this piece[6]. I have also wondered about the fact that, at the end of Chagall's life, what remained of him physically was buried within the sacred grounds of a Christian cemetery. This final transforming space is hundreds of miles and a century away from where Chagall began on his journey.

In the context of this study, I believe that Chagall was able to achieve both a real and meaningful relationship with the universal nature of religion. This thought is reflected across his lifespan and continues now after his death.

5 In preparation for his last tapestry commission, a scene illuminating the Biblical story of *Job*, Chagall was also working on prints and cartoons for the image of the Biblical figure. Cartoons, which can hand-drawn or printed, are used to inform the weaver how the threads are to be arranged in producing the finished woven tapestry. They are also used in executing the technical processes in monumental works, such as murals, mosaics, and stained glass. The *Job* tapestry was unfinished at the time of the artist's death and was completed posthumously. It hangs in the Rehabilitation Institute of Chicago and is one of three monumental installations in that city, including *The Four Seasons* (1974) mosaic and the *America Windows* (1977), at the Art Institute of Chicago.

6 Chagall passed away at his home in St.Paul-de-Vence, France on 28, March, 1985. He is buried in Saint-Paul de Vence Cemetery. The lithograph is part of the collection of Jacob Baal-Teshuva, who documented the artist's biography and work in his book, *Chagall* (2003). Baal-Teshuva reflects on the provenance of the lithograph in his story of the artist's life (2003, p. 271).

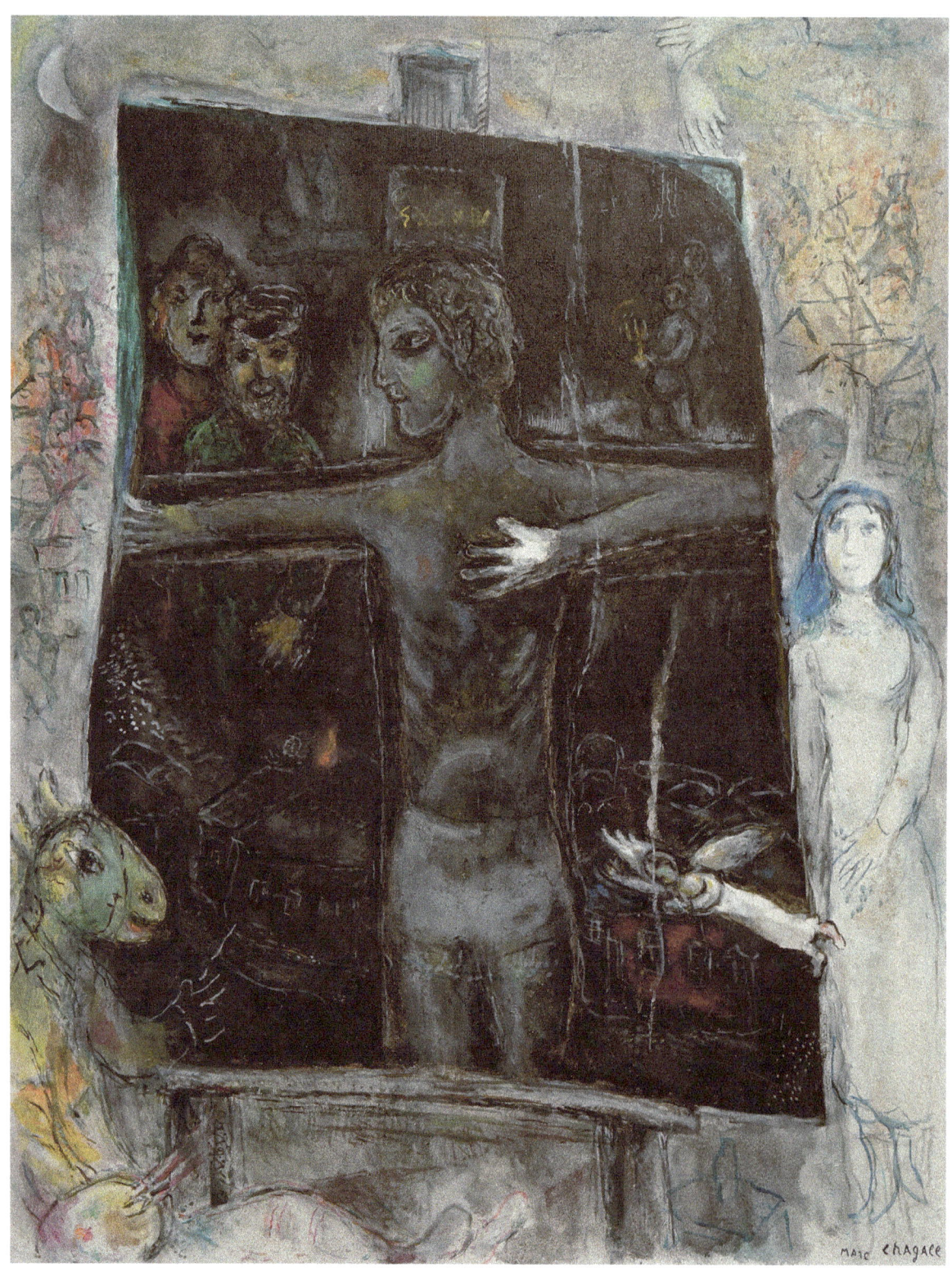

89. *In Front of the Picture*, 1968-71
Oil on canvas, 116 x 89 cm
Foundation Marguerite et Aime Maeght, St. Paul, France

APPENDIX A
MOVEMENT AND MOTION IN THE LIFE OF MARC CHAGALL

EARLY LIFE

1887 (7 July): Birth in Vitebsk, Lithuania as, Moyshe Shagal

1907: Moves to St. Petersburg, Russia to attend Art School

1911: Moves to Paris for four years

1914 (Summer): Returns to Vitebsk, forced settlement throughout WWI, the Revolutionary Period

1915 (July): Marriage to Bella Rosenfeld

1917-1920: Lives between Vitebsk, and St. Petersburg (Petrograd)

1920-1922: Moves to Moscow

1922: Leaves Russia permanently

MIDDLE LIFE

1923: Settles in Paris and later South of France for 18 years

1926: First Solo Exhibit in the US

1931: First visit to Holy Land (Palestine)

1932-1934: Travel in Europe

1941 (June): Leaves France as a refugee, and Artist in Exile

1941- 1948: Settles in New York (city and rural countryside)

1944: Death of first wife, Bella Chagall (nee Rosenfeld)

1948: Permanent Return to France

1948-1950: Moves to different locations in South of France

1951: Second Visit to Holy Land (Israel, 1948)

LATER LIFE

1952: Settled in south of France. Relationship with partner Virginia Haggard ends.

Marries again, to Vava Brodsky. Monumental works, theatre and set design, and stained glass commissions during the later life include travel to Europe and America on a frequent basis from 1953 onward.

1957: Third Visit to Holy Land

1950: Moves to final home, St. Paul de-Vence, France

1969: Foundation Stone for Museum of Biblical Message lain

1973: Inauguration of the Museum of Biblical Message, Nice

1973: Returns to Russia for first time since 1922

1985: Death on 28 March, buried St. Paul-de-Vence Cemetery

APPENDIX B
CHAGALL GLASS COMMISSIONS, WITH CHARLES AND BRIGITTE MARQ, SIMON ATELIER, REIMS

1. Assy, Haute Savoie, France
Eglise Notre-Dame de Toute Grace
Chagall's first two painted glass windows, 1956-7

2. Jerusalem, Ein Karem, Israel
Synagogue of the Hadassah-Hebrew University Medical Centre
Twelve windows on the tribes of Israel, 1960

3. New York NY, USA
UN Building, United Nations
Peace window in memory of Dag Hammarskjöld, 1963

4. Tarrytown NY, USA
Union Church of Pocantico Hills
Nine windows, 1963

5. Metz, Lorraine, France
Cathedral St Etienne
Nineteen windows on biblical scenes, 1958-68

6. Zürich, Switzerland
Fraumünster
Five windows on biblical scenes, 1969-70

7. Nice, France
Musée National Message Biblique
Three windows in the concert hall, one in the permanent exhibition, 1971

8. Reims, France
Notre-Dame Cathedral
Three windows, 1973-4

9. Chichester, Sussex, UK
Cathedral of the Holy Trinity
One window, 1978

10. Sarrebourg, Lorraine, France
La Chapelle des Cordeliers
Five windows, 1976-8

11. Chicago, USA
Art Institute "America Windows"
Six panel works on the arts 1976

12. Le Saillant, Limousin, France Chapel
Six windows on nature, 1978-82

13. Mainz, Germany
Church of St Stephan, 1977-1984

APPENDIX C

THE BIBLICAL MESSAGE SERIES

THE TWELVE IMAGES OF CHAGALL'S BIBLICAL MESSAGE INSPIRED BY THE STORIES OF GENESIS AND EXODUS, IN THE OLD TESTAMENT BIBLE AT, MUSEE NATIONAL MARC CHAGALL, NICE, FRANCE

1. *The Creation of Man,* 1956-58
Oil on Canvas, 299 x 200.5 cm

2. *Paradise,* 1961
Oil on Canvas, 185 x 287 cm

3. *Adam and Eve Expelled from Paradise,* 1961
Oil on Canvas, 190.5 x 283.5 cm

4. *Noah's Ark,* 1961-66
Oil on Canvas, 236 x 234 cm

5. *Noah and the Rainbow,* 1961-66
Oil on Canvas, 205 x 292.5 cm

6. *Abraham and the Three Angels,* 1960-66
Oil on Canvas, 190 x 292 cm

7. *The Sacrifice of Issac,* 1960-66
Oil on Canvas, 230 x 235 cm

8. *Jacob's Dream,* 1960-66
Oil on Canvas, 195 x 278 cm

9. *Jacob Wrestling with the Angel,* 1960-66
Oil on Canvas, 251 x 205 cm

10. *Moses and the Burning Bush,* 1960-66
Oil on Canvas, 195 x 312 cm

11. *Striking the Rock,* 1960-66
Oil on Canvas, 237 x 232 cm

12. *Moses Receiving the Ten Commandments,* 1960-66
Oil on Canvas, 237 x 233 cm

LIST OF COLOR PLATES

Cover: *Calvary*, 1912
Chagall, Marc (1887-1985) © ARS, NY. Calvary. 1912. Oil on canvas, 174.6 x 192.4 cm. Acquired through the Lillie P. Bliss Bequest.
The Museum of Modern Art
Digital Image © The Museum of Modern Art/Licensed by SCALA / Art
Resource, NY

1. *Self Portrait*, 1908
Chagall, Marc (1887-1985) © ARS, NY. Self-Portrait. 1908. Oil on linen canvas.
30.2 x 24.2 cm. AM1988-51. Photo: Philippe Migeat. On deposit from the Centre Pompidou.
Musee de Peinture et de Sculpture
© CNAC/MNAM/Dist. RMN-Grand Palais / Art Resource, NY

2. *The Life of Christ/Tree of Jesse*, 1970
Stained glass window panel, Fraumünster Kirche, Zurich (Photograph: J. A. Swan, 2015)

3. *Creation of Man*, 1956-58
Chagall, Marc (1887-1985) © ARS, NY. The Creation of Man. 1956-1958. Oil on canvas, 299 x 200.5 cm. MBMC1. Photo: Gérard Blot.
Musee National Marc Chagall
© RMN-Grand Palais / Art Resource, NY

4. *The Mirror*, 1915
Chagall, Marc (1887-1985) © ARS, NY. The Mirror. 1915. Oil on cardboard. 100 x 81 cm. Russian State Museum
Photo Credit: Banque d'Images, ADAGP / Art Resource, NY

5. *Death*, 1908
Chagall, Marc (1887-1985) © ARS, NY. Death. 1908. Oil on canvas, 68.2 x 86 cm.
AM 1988-52. Photo: Jacques Faujour. On deposit from the Centre Pompidou.
Musee d'Art et d'Histoire du Judaisme
© CNAC/MNAM/Dist. RMN-Grand Palais / Art Resource, NY

6. *Birth*, 1910
Chagall, Marc (1887-1985) © ARS, NY. Birth. 1910. Oil on canvas. 65 x 89.5 cm.
Kunsthaus Zurich
Photo Credit: Banque d'Images, ADAGP / Art Resource, NY

7. *The Birth*, 1911
Oil on canvas, 46 x 36 cm
© Marc Chagall (1985-1887) /DACS. Private Collection. Photo Credit: akg-images

8. *Russian Wedding*, or, *The Wedding*, 1909
Chagall, Marc (1887-1985) © ARS, NY. The Wedding. 1909. Oil on canvas.
Foundation E.G. Buehrle. Photo Credit: Erich Lessing / Art Resource, NY

9. *The Wedding*, 1911
Chagall, Marc (1887-1985) © ARS, NY. The Wedding. 1911. Oil on linen, 99.5 x 188.5 cm. AM1988-57. Photo: Philippe Migeat.
Musee National d'Art Moderne
© CNAC/MNAM/Dist. RMN-Grand Palais / Art Resource, NY

LIST OF COLOR PLATES

10. *The Holy Family* or *The Couple*, 1908-9
Chagall, Marc (1887-1985) © ARS, NY. The Holy Family or The Couple. 1909. Oil on Hessian, 91 x 103 cm. DMBMC2003.1.1. Photo: Gérard Blot. On deposit from the Centre Pompidou.
Musee National Marc Chagall
© RMN-Grand Palais / Art Resource, NY

11. *The Holy Family*, 1910
Oil on canvas, 29 7/8 x 25 in © Marc Chagall (1985-1887) / DACS. Kunsthaus Zurich. Photo Credit: akg-images

12. *Madonna of the Village*, 1938-42
Chagall, Marc (1887-1985) © ARS, NY. The Madonna of the Village. 1938-1942. Oil on canvas, 102.5 x 98 cm. Inv. N.:1965.6.
Photo Credit: Museo Nacional Thyssen-Bornemisza / Scala / Art Resource, NY

13. *The Rabbi*, 1923-6 (artist's 'variant' of, *The Pinch of Snuff*, 1912) Chagall, Marc (1887-1985) © ARS, NY. The Rabbi. 1923-26. Oil on canvas. 117 x 89.5 cm. Inv. 1738. Kunstmuseum, Basel.
Photo Credit: Scala / Art Resource, NY

14. *Jew in Black and White*, 1914
Chagall, Marc (1887-1985) © ARS, NY.[as,The Rabbi of Vitebsk]. 1914. Oil on canvas, 104 x 84cm. Kunstmuseum, Basel.
Photo Credit: Scala / Art Resource, NY

15. *Chagall's Box* Mural Layout for GOSET, 1921
India ink and watercolor diagram, 7 x 7 cm
© Goodman, S.T., ed., (2008), *Chagall and the Artists of the Russian Jewish Theatre*. New York: The Jewish Museum and New Haven, CT: Yale University Press, p. 107.

16. *The Little Goat*, 1921
Chagall, Marc (1887-1985) © ARS, NY. The Little Goat (La Petite chèvre). 1920.
Pencil, ink, gouache, watercolor on paper, 29.2 x 35.6 cm. AM 1988-230, recto.
Musee National d'Art Moderne. Photo: Philippe Migeat. © CNAC/MNAM/Dist. RMN-Grand Palais / Art Resource, NY

17. Sketch for the stage set of *Baladin of the Western World*, 1921
Chagall, Marc (1887-1985) © ARS, NY. Playboy of the Western World (Le baladin du Monde occidental de Synge) 1921. Pencil, ink, gouache, gold and silver paint on paper, 40.7 x 51.1 cm. AM 1988-255. Musee National d'Art Moderne. Photo: Philippe Migeat
© CNAC/MNAM/Dist. RMN-Grand Palais / Art Resource, NY

18. *Dance*, 1920
Chagall, Marc (1887-1985) © ARS, NY, Inv. AR97897. Detail of Wedding Table/four murals to the Arts. 1920. Tempera, gouache and kaolin on canvas, 214 x 108.5cm
Tretyakov Gallery, Moscow.
Photo Credit: HIP / Art Resource, NY

19. *Music*, 1920
Chagall, Marc (1887-1985) © ARS, NY, Inv. AR97897. Detail of Wedding Table/four murals to the Arts. 1920. Tempera, gouache and kaolin on canvas, 213 x 104 cm
Tretyakov Gallery, Moscow.
Photo Credit: HIP / Art Resource, NY

20. *Drama*, 1920
Chagall, Marc (1887-1985) © ARS, NY, Inv. AR97897. Detail of Wedding Table/four murals to the Arts. 1920. Tempera, gouache and kaolin on canvas, 212.6 x 107.2 cm
Tretyakov Gallery, Moscow.
Photo Credit: HIP / Art Resource, NY

21. *Literature*, 1920
Chagall, Marc (1887-1985) © ARS, NY, Inv. AR97897. Detail of Wedding Table/four murals to the Arts. 1920. Tempera, gouache and kaolin on canvas, 216 x 81.3 cm
Tretyakov Gallery, Moscow.
Photo Credit: HIP / Art Resource, NY

22. *Self Portrait with Seven Fingers*, 1912-13
Chagall, Marc (1887-1985) © ARS, NY. Self-portrait with Seven Fingers. 1912-13.
Oil on canvas. 132 x 93 cm. Stedelijk Museum.
Photo Credit: Banque d'Images, ADAGP / Art Resource, NY

23. *To Russia, Asses, and Others*, 1911
Chagall, Marc (1887-1985) © ARS, NY. To Russia, Asses and Others.
Oil on canvas, 157 x 122 cm. Musee National d'Art Moderne.
Photo Credit: Alinari / Art Resource, NY

24. *Me and My Village*, 1911
Chagall, Marc (1887-1985) © ARS, NY. Me and My Village, c. 1911. Gouache on paper. 28.3 x 23.5 cm. Bequest of Charlotte Bergman, 2005-20.
Photo by Richard Goodbody, Inc. The Jewish Museum
Photo Credit: The Jewish Museum, New York / Art Resource, NY

25. *I and the Village*, 1911
Chagall, Marc (1887-1985) © ARS, NY. I and the Village. 1911. Oil on canvas, 192.1 x 151.4 cm. Mrs. Simon Guggenheim Fund. The Museum of Modern Art
Digital Image © The Museum of Modern Art / Licensed by SCALA / Art
Resource, NY

26. *Solitude*, 1933
Chagall, Marc (1887-1985) © ARS, NY. Solitude. 1933.
Museum of Art Tel Aviv, Israel
Photo Credit: Scala / Art Resource, NY

27. *Dedicated to my Fiancée*, 1911
Chagall, Marc (1887-1985) © ARS, NY. Dedicated to My Fiancée. Oil on canvas, 196 x 114.5 cm.
Kunstmuseum, Bern

28. *Homage a Apollinaire*, 1911-12
© Marc Chagall (1985-1887) /DACS. Homage to Apollinaire. Oil, gold and silver powder on canvas, 209 x 189 cm. Stedelijk Van Abbemuseum, Eindhoven
Photo Credit: akg-images

29. *The Lovers*, 1913-14
Chagall, Marc (1887-1985) © ARS, NY. The Lovers. 1913-14. Oil on canvas, 109.2 x 134.6 cm. Jacques and Natasha Gelman Collection, 1998
(1999.363.14). Photo: Malcolm Varon.
The Metropolitan Museum of Art
Image copyright © The Metropolitan Museum of Art.
Image source: Art
Resource, NY

30. *The Expulsion from Paradise*, 1961
Chagall, Marc (1887-1985) © ARS, NY. The Expulsion from Paradise. 1961. Oil on canvas, 190.5 x 283.5 cm. MBMC3. Photo: Gérard Blot.
Musee National Marc Chagall
© RMN-Grand Palais / Art Resource, NY

31. *Self Portrait with Brushes*, 1909
Chagall, Marc (1887-1985) © ARS, NY. Self-portrait with brushes. 1909. Oil on canvas. 57 x 48 cm.
Kunstsammlung Nordrhein-Westfalen, Dusseldorf.
Photo Credit: Banque d'Images, ADAGP / Art Resource, NY

32. *Portrait of My Fiancée in Black Gloves*, 1909
Chagall, Marc (1887-1985) © ARS, NY. Portrait of a Fiancee in Black Gloves.
Oil on canvas, 88 x 65 cm. Kunstmuseum, Basel.
Photo Credit: Scala / Art Resource, NY

33. *The Black Glove*, 1923-1948
© Marc Chagall (1985-1887) / DACS. The Black Glove.
Oil on canvas, 111 x 81.5 cm. Private Collection
Photo Credit: akg-images

34. *The Birthday*, 1915
Chagall, Marc (1887-1985) © ARS, NY. Birthday (L'Anniversaire). 1915. Oil on canvas, 81 x 100 cm.
Acquired through the Lillie P. Bliss Bequest.
The Museum of Modern Art
Digital Image © The Museum of Modern Art/Licensed by SCALA / Art
Resource, NY

35. *Self Portrait with Bella by the Stove*, 1915-16
© Marc Chagall (1985-1887) /DACS. Self Portrait with Bella by the Stove. 16-1915. Oil on paper on canvas, 43.3 x 34.7 cm. State Museum of Contemporary Art, Costakis Collection, Athens
Photo Credit: akg-images

36. *Maternity* 1912
Chagall, Marc (1887-1985) © ARS, NY. Maternity. 1912. Gouache on brown paper, 27 x 18.2 cm. Bequest of Mrs. Helen Serger in honor of William S. Lieberman.
The Museum of Modern Art
Digital Image © The Museum of Modern Art / Licensed by SCALA / Art
Resource, NY

LIST OF COLOR PLATES

37. *Maternity*, 1913
Chagall, Marc (1887-1985) © ARS, NY. Maternity. 1913. Oil on canvas, 193 x 116 cm.
Stedelijk Museum, Amsterdam
Photo Credit: Album / Art Resource, NY

38. *Cow with Parasol*, 1946
Chagall, Marc (1887-1985) © ARS, NY. Cow with a Parasol, 1946. Oil on canvas, 81.3 x 108 cm. Bequest of Richard S. Zeisler, 2007 (2007.247.3).
The Metropolitan Museum of Art
Image copyright © The Metropolitan Museum of Art. Image source: Art
Resource, NY

39. *Sunday*, 1952-54
Chagall, Marc (1887-1985) © ARS, NY. Sunday, 1952-54. Oil on canvas, 173 x 149cm. AM1988-82.
Photo: Philippe Migeat.
Musee National d'Art Moderne
© CNAC/MNAM/Dist. RMN-Grand Palais /
Art Resource, NY

40. *The Wedding*, 1918
Chagall, Marc (1887-1985) © ARS, NY. The Wedding. 1918. Oil on canvas, 100 x 119 cm.Tretyakov Gallery, Moscow
Photo Credit: Scala / Art Resource, NY

41. *Paris Through the Window*, 1913
Chagall, Marc (1887-1985) © ARS, NY. Paris Through the Window. 1913. Oil on canvas.136 x 141.9 cm.
Solomon R. Guggenheim Founding Collection,
By gift, The Solomon R. Guggenheim Museum
Photo Credit: The Solomon R. Guggenheim Foundation / Art Resource, NY

42. *Window in the Country*, 1915
Chagall, Marc (1887-1985) © ARS, NY. The Window at the Country House, 1915. Oil and gouache on cardboard, 100 x 80 cm.Tretyakov Gallery, Moscow
Photo Credit: Scala / Art Resource, NY

43. *The Bride and Groom of the Eiffel Tower,* 1928
Chagall, Marc (1887-1985) © ARS, NY. "Les Maries de la Tour Eiffel". 1928. Oil on canvas, 89 x 116 cm.
Private Collection
Photo Credit: Bridgeman-Giraudon / Art Resource, NY

44. *The Bride and Groom of the Eiffel Tower*, 1938-39
Chagall, Marc (1887-1985) © ARS, NY. The Couple of the Eiffel Tower (Bride and Groom of the Eiffel Tower). 1938-1939. Oil on linen, 150 x 136.5 cm. AM 1988-67.
Photo: Philippe Migeat. Musee National d'Art Moderne
© CNAC/MNAM/Dist. RMN-Grand Palais /
Art Resource, NY

45. Der Sturm (Cover), 10th February, 1920
Vol. 10, No. 11, Editor: Herwarth Walden
© Marquand Art Library Archive
Princeton University, Princeton NJ

46. *The Falling Angel*, (The Fall of the Angel) 1922-33-47
Chagall, Marc (1887-1985) © ARS, NY. The Fall of the Angel, 1923-47. Oil on canvas, 147.96 x 166.07 cm.
Kunstmuseum, Basel
Photo Credit: Josse / Scala / Art Resource, NY

47. *Self Portrait in Green*, 1914
Chagall, Marc (1887-1985) © ARS, NY. Self-portrait in Green. 1914. Oil on cardboard laid down on canvas, 50.7 x 38 cm. Inv. AM1988-59. Photo: Gérard Blot.
On deposit from the Centre Pompidou.
Musee National Marc Chagall
© CNAC/MNAM/Dist. RMN-Grand Palais /
Art Resource, NY

48. *The Violinist* (The Fiddler) 1912-13
Chagall, Marc (1887-1985) © ARS, NY. The Violinist (Fiddler), 1912-1913. Oil on linen, 188 x 158 cm.
Stedelijk Museum, Amsterdam
Photo Credit: Art Resource, NY

49. *White Crucifixion*, 1938
Chagall, Marc (1887-1985) © ARS, NY. White Crucifixion, 1938. Oil on canvas, 154.6 x 140 cm. Gift of Alfred S. Alschuler, 1946.925.
The Art Institute of Chicago
Photo Credit: The Art Institute of Chicago /
Art Resource, NY

50. *Le Martyr*, 1940
Oil on canvas
164.5 x 114.0 cm
Kunsthaus Zürich
Donated by Elektro-Watt AG, 1973

51. *The Yellow Crucifixion*, 1942.
Chagall, Marc (1887-1985) © ARS, NY. The Yellow Crucifixion. 1942. Oil on canvas, 140 x 101 cm. AM1988-74. Photo: Philippe Migeat.
Musee National d'Art Moderne
© CNAC/MNAM/Dist. RMN-Grand Palais / Art Resource, NY

52. Study for *The Revolution*, 1937
(original beneath the *Crucifixion Triptych*)
Chagall, Marc (1887-1985) © ARS, NY. Sketch for The Revolution. 1937. Oil on linen, 49.7 x 100.2 cm. AM 1988-66. Photo: Philippe Migeat.
Musee National d'Art Moderne
© CNAC/MNAM/Dist. RMN-Grand Palais / Art Resource, NY

53. *Resistance*, 1937-48
Chagall, Marc (1887-1985) © ARS, NY. Resistance, 1937-1948. Oil on canvas, 168 x 103 cm. DMBMC1990.1.3. Photo: Gérard Blot.
Musee National Marc Chagall
© RMN-Grand Palais / Art Resource, NY

54. *Resurrection*, 1937-52
Chagall, Marc (1887-1985) © ARS, NY. Resurrection. 1937-52. Oil on canvas. 168 x 108 cm. DMBMC1990.1.1 Photo: Gérard Blot.
Musee National Marc Chagall
© CNAC/MNAM/Dist. RMN-Grand Palais / Art Resource, NY

55. *Liberation*, 1937-52
Chagall, Marc (1887-1985) © ARS, NY. Liberation. 1937-1952. Oil on canvas, 168 x 88 cm. DMBMC1990.1.2. Photo: Gérard Blot.
Musee National Marc Chagall
© RMN-Grand Palais / Art Resource, NY

56. *The Exodus*, 1952-66
Chagall, Marc (1887-1985) © ARS, NY. The Exodus. 1952/1966. Oil on linen canvas. 130 x 162.3 cm. DMBMC1990.1.7. Photo: Philippe Migeat.
On deposit from the Centre Pompidou.
Musee National Marc Chagall
© CNAC/MNAM/Dist. RMN-Grand Palais / Art Resource, NY

57. *L'Obsession*, 1943
Chagall, Marc (1887-1985) © ARS, NY. Obsession. New York, 1943. Oil on canvas, 76 x 107.5 cm. AM1988-76. Photo: Philippe Migeat.
Musee des Beaux-Arts
© RMN-Grand Palais / Art Resource, NY

58. *In the Night*, 1943
Chagall, Marc (1887-1985) © ARS, NY. In the Night, 1943. Oil on canvas, 47 x 52.4 cm. The Louis E. Stern Collection, 1963.
Philadelphia Museum of Art
Photo Credit: The Philadelphia Museum of Art / Art Resource, NY

59. *The Crucifixion*, 1940
Chagall, Marc (1887-1985) © ARS, NY. The Crucifixion. 1940. Oil on canvas, 34 x 29.4 cm. The Samuel S. White 3rd and Vera White Collection, 1959. 1959-133-1.
Philadelphia Museum of Art
Photo Credit: The Philadelphia Museum of Art / Art Resource, NY

60. *The Arts to the Glory of God*, 1978
Stained glass
Chichester Cathedral, West Sussex, England
Photograph: © J.A. Swan, 2008

61. *The Arts to the Glory of God*, 1978 (detail)
Stained glass
Chichester Cathedral, West Sussex, England
Photograph: © J.A. Swan, 2008

62. *The Interior of a Synagogue in Safed*, 1931
Chagall, Marc (1887-1985) © ARS, NY. The Synagogue at Safed, Israel. 1931. Oil on canvas, 73 x 92cm.
The Israel Museum, Jerusalem
Photo Credit: Album / Art Resource, NY

63. *The Walls of Jerusalem near the Gate of Grace*, 1931
Chagall, Marc (1887-1985) © ARS, NY. The Walls of Jerusalem near the Gate of Grace. 1931. Oil on canvas. 73.5 x 67 cm. Private Collection
Photo Credit: Banque d'Images, ADAGP / Art Resource, NY

LIST OF COLOR PLATES

64. *Promise at Jerusalem*, 1931-39
Chagall, Marc (1887-1985) © ARS, NY. "The Promise at Jerusalem" from The Bible. A suite of 105 etchings, Paris, 1931-1956. 22 x30cm.
The Jewish Museum
Photo Credit: The Jewish Museum, New York / Art Resource, NY

65. *Moses and the Serpent*, 1966 (The Story of the Exodus)
Chagall, Marc (1887-1985) © ARS, NY. Moses and the Serpent. Lithograph, 46.6 x 34.3 cm. Photo by Ardon bar Hama.
The Jewish Museum
Photo Credit: The Jewish Museum, New York / Art Resource, NY

66. *Job at Prayer*, 1960
Chagall, Marc (1887-1985) © ARS, NY. Job at Prayer, 1960. Lithograph, 52.5 x 38.0 cm. MBMC437. Photo: Gérard Blot.
Musee National Marc Chagall
© RMN-Grand Palais / Art Resource, NY

67. *Noah's Ark*, 1961-66
Chagall, Marc (1887-1985) © ARS, NY. Noah's Ark. 1961/1966. Oil on canvas, 236 x 234 cm. MBMC 4.
Photo: Gérard Blot.
Musee National Marc Chagall
© RMN-Grand Palais / Art Resource, NY

68. *King David*, 1951
Chagall, Marc (1887-1985) © ARS, NY. King David. 1951. Oil on canvas, 198 x 133 cm. DMBMC1990.1.4.
Photo: Gérard Blot.
Musee National Marc Chagall
© RMN-Grand Palais / Art Resource, NY

69. *Song of Songs* IV, 1958
Chagall, Marc (1887-1985) © ARS, NY. Song of Songs IV. 1958. Oil on paper, laid down on canvas, 144.5 x 210.5 cm. Photo: Gérard Blot.
Musee National Marc Chagall
© RMN-Grand Palais / Art Resource, NY

70. Museum Auditorium with *Creation of the World*, 1974
Musee National Marc Chagall, Nice
Photograph: © J. A. Swan, 2016

71. Interior photograph of Biblical Message Space with *Noah's Ark*
Musee National Marc Chagall, Nice
Photograph: © J. A. Swan, 2016

72. Interior photograph of Biblical Message Space with *Moses Receiving the Ten Commandments*
Musee National Marc Chagall, Nice
Photograph: © J. A. Swan, 2016

73. Interior photograph of Biblical Message Space Overlooking the Pool for the external wall mosaic, *The Prophet Elijah*
Musee National Marc Chagall, Nice
Photograph: © J. A. Swan, 2016

74. Exterior photograph of museum building and gardens
Musee National Marc Chagall, Nice
Photograph: © J. A. Swan, 2016

75. Exterior photograph of museum building and entryway
National Musee Marc Chagall, Nice
Photograph: © J. A. Swan, 2016

76. *Steps Pathway, Nice*
Photograph
© J. A. Swan, 2016

77. *Electrical Sign, Nice*
Photograph
© J. A. Swan, 2016

78. *Time is a River Without Banks*, 1930-1939
© Marc Chagall (1985-1887) /DACS. Time is a River Without Banks.
Oil on canvas, 100 x 81.3 cm. Private Collection
Photo Credit: akg-images

79. *Grandfather Clock with Blue Wing*, 1949
Chagall, Marc (1887-1985) © ARS, NY. Grandfather Clock with Blue Wing. 1949. Oil on canvas, 92 x 79 cm.
Private Collection
Photo Credit : Bridgeman-Giraudon / Art Resource, NY

80. *Self Portrait with Clock*, 1947
Chagall, Marc (1887-1985) © ARS, NY. Autoportrait à la pendule (Self-portrait with Clock). 1947. Oil on canvas, 86 x 70.5 cm.
Photo Credit: Banque d'Images, ADAGP / Art Resource, NY

81. *Christ the Clock*, 1957
Chagall, Marc (1887-1985) © ARS, NY. Christ the Clock, 1957. Lithograph, 48cm x 38cm. Inv# MBMC411. Photo by Gérard Blot.
Musee National Marc Chagall
© RMN-Grand Palais / Art Resource, NY

82. *Untitled* (Chagall in his studio, Vence, 1950's)
The Artist March Chagall in his studio in Saint-Paul-de-Vence. 1950s.
Credit: © Russian Look / Heritage-Images.
Photo Credit: HIP / Art Resource, NY

83. *Memorial East Window*, 1967
Stained glass
Church of All Saints', Tudeley, Kent, England
© Chagall Windows Memorial Trust, UK

84. Exterior of Church with *Memorial East Window*, 1967
Church of All Saints', Tudeley, Kent, England
Photograph: © J. A. Swan, 2010

85. Exterior of church site with *Prayer Labyrinth*
Church of All Saints', Tudeley, Kent, England
Photograph: © J. A. Swan, 2010

86. Interior of church building with window in south nave wall Church of All Saints', Tudeley, Kent, England
Photograph: © J. Swan, 2010

87. Interior of Church building with *Memorial East Window, 1967*
Church of All Saints', Tudeley, Kent, England
Photograph: © J. A. Swan, 2010

88. *Frontal for Ordinary Time,* 2005
Embroidery thread and white cloth
Church of All Saints', Tudeley, Kent, England
Photograph: © J. A. Swan, 2010

89. *In Front of the Picture*, 1968-71
© Marc Chagall (1985-1887) /DACS. In Front of the Picture. 71-1968. Oil on canvas, 116 x 89 cm. Foundation Marguerite et Aime Maeght, St. Paul, France
Photo Credit: akg-images

REFERENCES

A

Alexander, S. (1979). *Marc Chagall*. London: Cassell Ltd.

Aziz, R. (1990). *C.G. Jung's Psychology of Religion and Synchronicity*. Albany, NY: State University of New York Press.

Amishai-Maisels, Z. (1982). The Jewish Jesus. *Journal of Jewish Art* (IX), 84-104.

Amishai-Maisels, Z. (1991). Chagall's White Crucifixion. *Chicago Art Institute Bulletin* (17), 138-53.

Amishai-Maisels, Z. (1993). *Depiction and Interpretation: The Influence of the Holocaust on the Visual Arts*. Oxford: Oxford University Press.

Amishai-Maisels, Z. (2010). The Crucifixion in a Holocaust Context. In *Cross Purposes: Shock and Contemplation in Images of the Crucifixion* (pp. 18-22). London: Tadberry Evedale Ltd.

B

Baal-Teshuva, J. (2003). *Chagall* (2nd Edition ed.). Koln: Taschen GmbH.

Becket, S. W. (2010). Norman Adams: Golden Cruicifxion 1993. In *Cross Purposes: Shock and Contemplation in Images of the Crucifixion* (pp. 60-1). London: Tadberry Evedale Ltd.

Beckwith, S. (1996). *Christ's Body: Identity, Culture and Society in Late Medieval Writings*. London: Routledge.

Benjamin, W. (1936, 2008). *The Work of Art in the Age of Mechanical Reproduction*. J.A. Underwood (trans.). London: Penguin Classics

Bertine, E. (1958). Jung's Approach to Religion: An Introductory Paper. *Spring 1958*, 1-16.

Baron, S. (1964). *The Russian Jew Under the Tsars and Soviets*. New York: The Macmillan Company.

Barron, S., & Eckmann, S. (1997). *Exiles and Emigres: The Flight of European Artists from Hitler*. Los Angeles and New York: Los Angeles County Museum of Art and Harry N. Abrams, Inc.

Bennett, E. A. (2000). *What Jung Really Said*. London: Little, Brown Book Group, Ltd.

Bohm-Duchen, M. (1998). *Chagall*. London: Phaidon Press Limited.

Bohm-Duchen, M. (1998a). The Quest for Jewish Art in Revolutionary Russia. In S. Compton (Ed.), *Chagall: Love and the Stage* (pp. 35-45). London: Merrell Holberton Publishers.

Bohm-Duchen, M. (2010). Images of Jesus in the Work of Marc Chagall: Christian Redeemer or Jewish Martyr?. In *Cross Purposes: Shock and Contemplation in Images of the Crucifixion* (pp. 18-22). London: Tadberry Evedale Ltd.

Bohm-Duchen, M. (2013). Marc Chagall: Russian Jew or Citizen of the World? In, S. Fraquelli, E. Braun-Kalberer, & F.Lentzsch, (Eds.). Chagall: Modern Master.(pp.43-55) London: Tate Publishing.

C

Cawthorne, N. (2005). *The Art of the Icon* (2nd ed.). London: Bounty Books.

Chagall, B. (1974). *Burning Lights* (7th ed.). (N. Guterman, Trans.) New York: Schocken.

Chagall, B. (1983). *First Encounter*. New York: Schocken.

Chagall, M. (1989). *My Life* (2nd ed.). (D. Williams, Trans.) Oxford, UK: The Alden Press.

Chipp, H. B. (Ed.). (1968). *Theories of Modern Art*. Berkeley and Los Angeles: University of California Press.

Compton, S. (1985). *Chagall*. London: Royal Academy of Arts.

Compton, S. (1992). Chagall's Auditorium: An Identity Crisis of Tragic Dimensions. In S. R. Foundation, *Marc Chagall and the Jewish Theater* (pp. 1-13). New York: Guggenheim Museum.

Compton, S. (Ed.). (1998). *Chagall: Love and the Stage 1914-1922*. London: Royal Academy of Arts, London with Merrell Holberton Publishers.

Compton, S. (1998a). Marc Chagall: Love and the Stage. In S. Compton (Ed.), *Chagall Love and the Stage 1914-1922* (pp. 13-25). London: Merrell Holberton.

D

De Saint-Exupery, A. (2007). *La Petit Prince.* Paris: Editions Larousse.

Dourley, J. P. (1994). In the Shadow of the Monotheisims: Jung's Conversations with Buber and White. In J. Edinger, E. F. (1995). *The Mysterium Lectures: A Journey through C.J. Jung's Mysterium Coniunctionis.* Toronto: Inner City Books.

E

Efros, A., & Tugendhold, Y. (1918). *The Art of Marc Chagall.* (F. Rubiner, Trans.) Moscow: Helicon.

Eliade, M. (1978). *The Forge and the Crucible: The Origins and Structres of Alchemy* (2nd ed.). (S. Corrin, Trans.) Chicago: University of Chicago Press.

Eliade, M. (1987). *The Sacred and the Profane: The Nature of Religion* (2nd ed.). New York: Harcourt, Inc.

Eliade, M. (1991). *Images and Symbols: Studies in Religious Symbolism.* (P. Mairet, Trans.) Princeton, NJ: Princeton University Press.

Erben, W. (1957). *Chagall.* (M. Bullock, Trans.) London: Thames and Hudson.

F

Fer, B., Batchelor, D., & Wood, P. (1993). *Realism, Rationalism, Surrealism: Art Between the Wars.* New Haven: Yale University Press.

Foster, P. (Ed.). (2004). *Chagall Glass at Tudeley and Chichester* (3rd ed.). Chichester, UK: University College Chichester.

Fuller, P. (1980). *Art and Psychoanalysis.* London: Writers and Readers Publishing Cooperative Ltd.

Fuller, P. (1983). *The Naked Artist.* London: Writers and Readers Publishing Cooperative Society Ltd.

G

Gardiner, A. *Egyptian Grammar.* (1988) 3rd ed. Oxford: Griffth Institute, Ashsmolean Museum.

Goodman, S. T. (Ed.). (2008). *Chagall and the Artists of the Russian Jewish Theater.* New Haven, CT: The Jewish Museum, New York with Yale University Press.

Goodman, S. T. (2008a). Soviet Jewish Theatre in a World of Moral Compromise. In S. T. Goodman (Ed.), *Chagall and the Artists of the Russian Jewish Theater* (pp. 1-13). New Haven: Yale University Press.

Guerman, M. (1979). *Art of the October Revolution.* (W. Freeman, D. Saunders, & C. Binns, Trans.) New York: Harry N. Abrams, Inc.

H

Haggard, V. (1986). *My Life With Chagall.* New York: Donald L. Fine.

Harding, M. E. (1959). Jung's Contribution to Religious Symbolism. *Spring 1959*, 17-32.

Harrison, C., Frascina, F., & Perry, G. (1993). *Primitivism, Cubism, Abstraction: The Early 20th Century.* New Haven: Yale University Press.

Harries, R. (1993). *Art and the Beauty of God.* London: Continuum Books.Harries, R. (2005). *The Passion in Art.* Aldershot, Hans, UK: Ashgate Publishing Ltd.

Harshav, B. (2008). Art and Theater. In S. T. Goodman (Ed.), *Chagall and the Artists of the Russian Jewish Theater* (pp. 68-87). New Haven: Yale University Press.

Harshav, B. (1990). *The Meaning of Yiddish.* Stanford, CA: Stanford University Press.

Harshav, B. (1992). Chagall: Postmodernism and Fictional Worlds in Painting. In S. R. Foundation, *Marc Chagall and the Jewish Theater* (pp. 15-27). New York: Guggenheim Museum.

Harshav, B. (Ed.). (2003). *Marc Chagall on Art and Culture.* Stanford, CA: Stanford University Press.

Harshav, B. (2004). *Marc Chagall and His Times.* (B. Harshav, & B. Harshav, Trans.) Stanford, CA: Stanford University Press.

Harshav, B. (2006). *Marc Chagall and the Lost Jewish World.* New York: Rizzoli International Publications.

Heelas, P., & Woodhead, L. (2005). *The Spiritual Revolution: Why Religion is Giving Way to Spirituality.* Oxford: Blackwell Publishing.

Hillman, J. (1982). The Animal Kingdom in the Human Dream. *Eranos Yearbook*, 279-334.

Hillman, J. (1991). The Yellowing of the Work. *Spring*, 77-96.

Hogg, J. (1969). *Psychology and the Visual Arts.* London: Penguin.

Hornung, E. (1971). *Conceptions of God in Ancient Egypt.* (J. Baines, Trans.) Ithaca: Cornell University Press.

J

Jung, C. (1959). Christ, A Symbol of the Self. In *Aion: Researches Into the Phenomenology of the Self* (R. Hull, Trans., Vol. 9ii, pp. 68-126). Princeton, NJ: Princeton University Press.

Jung, C. (1954). *Collected Works* (Vol. 17: The Development of Personality). (R. Hull, Trans.) Princeton: Princeton University Press.

Jung, C. (1956). *Collected Works* (2nd ed., Vol. 5: Symbols of Transformation). (R. Hull, Trans.) Princeton: Princeton University Press.

Jung, C. (1966). *Collected Works* (Vols. 15: The Spirit in Man, Art, and Literature). (R. Hull, Trans.) Princeton: Princeton University Press.

Jung, C. (1966). *Collected Works* (2nd ed., Vol. 7: Two Essays on Analytical Psychology). (R. Hull, Trans.) Princeton: Princeton University Press.

Jung, C. (1967). *Collected Works* (Vol. 13: Alchemical Studies). (R. Hull, Trans.) Princeton: Princeton University Press.

Jung, C. (1968). *Collected Works* (2nd ed., Vol. 12: Psychology and Alchemy). (R. Hull, Trans.) Princeton: Princeton University Press.

Jung, C. (1969). *Collected Works* (2nd ed., Vol. 9ii: Aion: Researches into the Phenomenology of the Self). (R. Hull, Trans.) Princeton: Princeton University Press.

Jung, C. (1969). *Collected Works* (2nd ed., Vol. 9i: The Archetypes and the Collective Unconscious). (R. Hull, Trans.) Princeton: Princeton University Press.

Jung, C. (1969). *Collected Works* (2nd ed., Vol. 11: Psychology and Religion: West and East). (R. Hull, Trans.) Princeton: Princeton University Press.

Jung, C. (1970). *Collected Works* (2nd ed., Vol. 10: Civilization in Transition). (R. Hull, Trans.) Princeton: Princeton University Press.

Jung, C. (1970). *Collected Works* (2nd Edition ed., Vol. 14: Symbols of Transformation). (R. Hull, Trans.) Princeton: Princeton University Press.

Jung, C. (1971). *Collected Works* (Vol. 6: Psychological Types). (R. Hull, Trans.) Princeton: Princeton University Press.

Jung, C. (1982). *Collected Works* (2nd ed., Vol. 16: The Practice of Psychotherapy). (R. Hull, Trans.) Princeton: Princeton University Press.

K

Kagan, A. (1989). *Marc Chagall*. New York: Cross River Press, Ltd.

Kamensky, A. (1989). *Chagall: The Russian Years 1907-1922*. London: Thames and Hudson Ltd.

Kampf, A. (1990). *Chagall to Kitaj: Jewish Experience in 20th Century Art*. London: Lund Humphries with Barbican Art Gallery.

Kivelson, V. A., & Greene, R. H. (2003). *Orthodox Russia: Belief and Practice Under the Tsars*. University Park: The Pennsylvania State University Press.

Klossowski de Rola, S. (1973). *Alchemy: The Secret Art*. London: Thames & Hudson.

Kris, E. (1952). *Psychoanalytic Explorations in Art*. New York: International University Press.

L

Lefebvre, H. (1991). *The Production of Space*. (D. Nicholson-Smith, Trans.) Cambridge: Blackwell.

M

Main, R. (2004). *The Rupture of Time: Synchronicity and Jung's Critique of Modern Western Culture*. Hove and New York: Brunner-Routledge.

Mayo, D. H. (1995). *Jung and Aesthetic Experience*. London: Peter Lang Publishing.

McLean, A. (2012, 3 25). www.levity.com/alchemy/symbolic.html. UK.

Mendelsohn, E. (1970). *Class Struggles in the Pale: The Formative Years of the Jewish Worker's Movement in Tsarist Russia*. Cambridge: Cambridge University Press.

Merback, M. B. (1999). *The Thief, The Cross, and the Wheel: Pain and the Spectacle of Punishment in Medieval and Renaissance Europe*. Chicago: University of Chicago Press.

Meyer, F. (1964). *Marc Chagall*. London: Thames and Hudson.

N

Neervoort-Moore, M. (2014). *The History of All Saints Church Tudeley*. Oxford, UK: Shire Publications, Ltd.

Neumann, E. (1959). *Art and the Creative Unconscious* (3rd ed., Vol. 61). (R. Manheim, Trans.) Princeton, NJ: Neumann, E. (1979). *Creative Man* (Vol. 2). (E. Rolfe, Trans.) Princeton, NJ: Princeton Univeristy Press.Princeton University Press.

Neumann, E. (1989). The Origins and History of Consciousness. London: Karnac Books Ltd. Neusner, J., & Avery-peck, A. J. (2004). *The Routledge Dictionary of Judaism*. London: Routledge.

Norris, P. (2007). *INSEARCH Essex Foundation English Tutorial*. Colchester: University of Essex.

P

Pacoud-Reme, E. (2011). *Musee Marc Chagall, Nice*. Paris: Editions Artlys.

Paloutzian, R. F., & Park, C. L. (Eds.). (2005). *Handbook of the Psychology of Religion and Spirituality*. New York: The Guilford Press.

Pearl, L. (2011). *Chagall et les lettres de son nom*. Bordeaux, France: Presse Universitaires de Bordeaux.

Pearsall, R. (1974). *The Alchemists*. London: Weidenfeld and Nicolson.

Philipson, M. (1994). *Outline of a Jungian Aesthetics*. Boston, MA: Sigo Press.

R

Rosensaft, J. B. (1987). *Chagall and the Bible*. New York: The Jewish Museum New York and Universe Books.

S

Samuels, A., Shorter, B., & Plaut, F. (1986). *A Critical Dictionary of Jungian Analysis*. London: Routledge & Kegan Paul, Ltd.

Samuels, A. (1989). *The Plural Psyche*. London: Routledge.

Savill, S. & Locke, E. (1976). *Pears Encyclopedia of Myths and Legends*. London: Pelham Books, Ltd.

Schaverien, J. (1998). The Embodiment of Desire: Art, Gender, and Analysis. *Harvest*, 44(1), 82-102.

Scholem, G. (1974). *Major Trends in Jewish Mysticism* (3rd Revised Edition ed.). New York: Schocken Books

Scholem, G. (1978). *Kabbalah*. New York: Meridian Press.

Shafer, B.E. (Ed.).(1991). *Religion in Ancient Egypt: Gods, Myths, and Personal Practice*. Ithaca: Cornell University Press.

Shatskikh, A. (1998). Marc Chagall and the Theatre. In S. Compton (ed.), *Chagall: Love and the Stage* (pp. 27-33). London: Merrell Holberton Publishers.

Shatskikh, A. (1991). "When and Where was Chagall Born?". In, *Marc Chagall: The Russian Years 1906-1922*. Christoph Vitali (ed.). Frankfurt: Schirn Kunsthalle, pp.21-22.

Shaw, I., & Nicholson, P. (2008). *The British Museum Dictionary of Ancient Egypt*. London: British Museum Press.

Silver, K. E., & Golan, R. (1985). *The Circle of Montparnasse: Jewish Artists in Paris 1905-1945*. New York: The Jewish Museum, New York with Universe Books.

Silverman, D. (1991). Divinity and Deities in Ancient Egypt. In B. E. Shafer (Ed.), *Religion in Ancient Egypt* (pp. 7-87). Ithaca: Cornell University Press.

Singer, J. (1976). *Androgyny: toward a new theory of sexuality*. London: Routledge & Kegan Paul.

Smith, M. (1985). *Jesus the Magician* (2nd ed.). Wellingborough, England: The Aquarian Press.

Solomon, N. (1996). *Judaism: A Very Short Introduction*. Oxford: Oxford University Press.

Spencer, C. (1973). *Leon Bakst*. London: Royal Academy of Arts.

Spitz, E. H. (1985). *Art and Psyche*. New Haven, CT: Yale University Press.

Spitz, E. H. (1991). *Image and Insight*. New York: Colombia University Press.

Stein, M. (1986). *Jung's Treatment of Christianity* (2nd ed.). Wilmette, IL: Chiron Publications.

Stein, M. (1987). Jung's Green Christ: A Healing Symbol for Christianity. In M. Stein & R. L. Moore(Eds.). *Jung's Challenge to Contemporary Religion*. (pp. 1-13). Wilmette, IL: Chiron Publications.

Stein, M. (Ed.). (1999). *Jung on Christianity*. Princeton, NJ: Princeton University Press.

Stein, M. (2005). *Transformation: The Emergence of the Self*.College Station, TX: Texas A & M University Press.

Stein, M. (2006). *The Principle of Individuation.* Willmette: Chiron Publications.

Strom, Y. (2002). *The Book of Klezmer: the history, music, the folklore.* Chicago: Chicago Review Press.

T

Tacey, D. (2002). *Jung and the New Age.* Hove, England: Brunner-Routledge.

Tacey, D. (2004). *The Spirituality Revolution: The Emergence of Contemporary Spirituality.* Hove, England: Routledge.

Tarasov, O. (2002). *Icon and Devotion: Sacred Spaces in Imperial Russia.* (R. Milner-Gulland, Trans.) London: Reaktion Books.

V

Varley. (1976). *Seven The Number of Creation.* London: G. Bell & Sons.

U

Ulanov, A. B. (1994). Jung and Prayer. In J. Ryce-Menuhin (Ed.), *Jung and the Monotheisms* (pp. 91-110). London: Routledge.

Underhill, E. (1911). *The Hunting of the Greene Lyon.* Retrieved 3 25, 2012, from www.levity.com/alchemy/symbolic.html.

V

Veidlinger, J. (2008). Yiddish Constructivism: The Art of the Moscow State Yiddish Theater. In S. T. Goodman (Ed.), *Chagall and the Artists of the Russian Jewish Theater* (pp. 49-67). New Haven: Yale University Press.

von Franz, M.-L. (1980). *Alchemy: An Introduction to the Symbolism and the Psychology.* Toronto: Inner City Books.

W

West, S. (1994). *Chagall.* London: PRC Publishing Ltd.

Wilkinson, R. H. (2003). *The Complete Gods and Goddesses of Ancient Egypt.* London: Thames & Hudson Ltd.

Wullschläger, J. (2008). *Chagall Love and Exile.* London: Allen Lane Penguin Group.

Whitmont, E. (1958). Religious Aspects of Life Problems in Analysis. *Spring 1958*, 33-48.

ACKNOWLEDGEMENTS

The Author wishes to give thanks to the following individuals and organisations for their interest in this project, and support during the research process and publication of this book:

Jennifer Fitzgerald and Chiron Publications, United States

Professor Andrew Samuels and the Centre for Psychoanalytic Studies, England

University of Essex, England

Dr. Murray Stein and the International School of Analytical Psychology, Zurich

The Rev. Pamela Ive, and The Rev. Dr. Jeremy Ive

The Chagall Windows Preservation Trust, Tudeley, Kent, England

Artists' Rights Society, New York City

The Chagall Estate

The Musee National Marc Chagall, Nice, France

Wilhelmina De Boer Dekker

Eudokia Pastuch

Albert Schwarzkopf

ABOUT THE AUTHOR

J.A. Swan trained formally as a painter and later qualified as a psychologist in clinical and transpersonal modalities. She studied at the University of Pennsylvania, PAFA, and Moore College of Art & Design in the United States and received a research Ph.D. from the Centre for Psychoanalytic Studies in England. She has been a university lecturer and a therapist in private practice. Her research interests combine Archeology, Architecture, Religious Art, and Jungian Theory. She currently works as a writer and visual artist.

www.ingramcontent.com/pod-product-compliance
Lightning Source LLC
Chambersburg PA
CBHW041918180526
45172CB00013B/1330